J. Molenaer

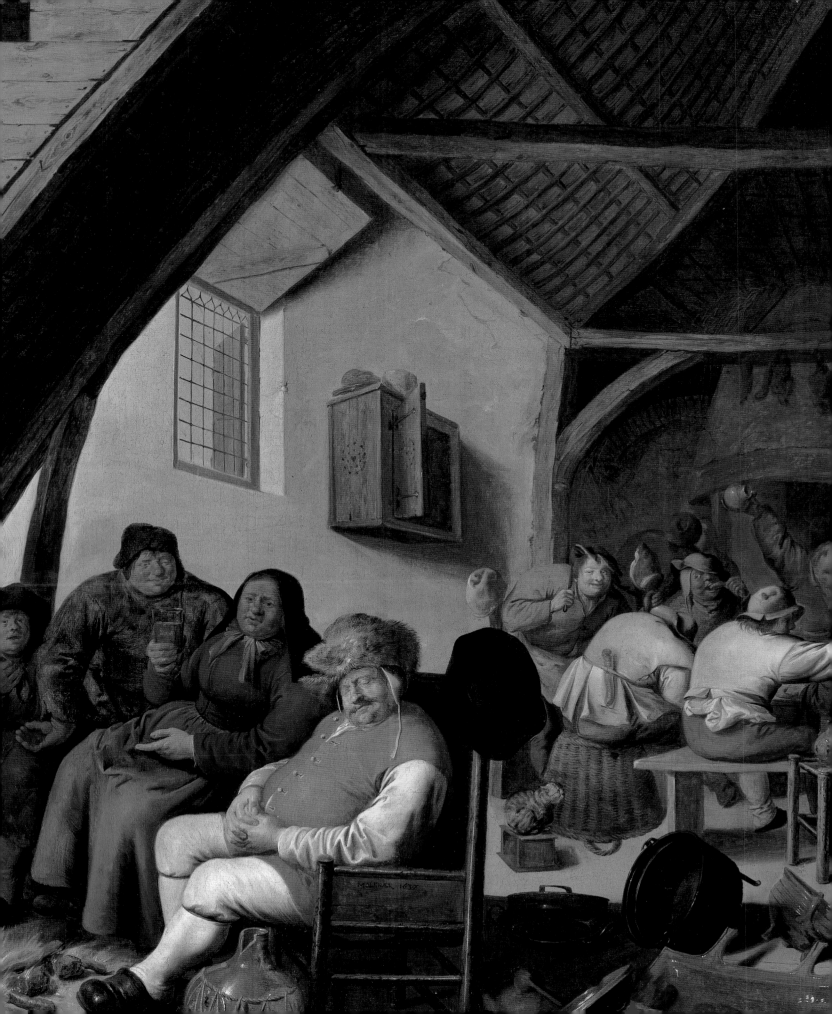

Jan Miense Molenaer

*Painter of the
Dutch Golden Age*

Dennis P. Weller

With essays by
Cynthia von Bogendorf Rupprath
and Mariët Westermann

North Carolina Museum of Art
Raleigh, North Carolina

2002

Published by the North Carolina Museum of Art on the occasion of the exhibition *Jan Miense Molenaer: Painter of the Dutch Golden Age*, organized by the North Carolina Museum of Art

EXHIBITION ITINERARY

North Carolina Museum of Art
Raleigh, North Carolina
13 October 2002–5 January 2003

Indianapolis Museum of Art (Columbus Gallery)
Columbus, Indiana
25 January 2003–16 March 2003

The Currier Museum of Art
Manchester, New Hampshire
6 April 2003–17 June 2003

The exhibition was made possible by support from the North Carolina Museum of Art Foundation, Inc. Additional support was provided by the National Endowment for the Arts, the William R. Kenan Jr. Fund for the Arts, and the William R. Kenan Jr. Charitable Trust.

NATIONAL
ENDOWMENT
FOR THE ARTS

The North Carolina Museum of Art, Lawrence J. Wheeler, director, is an agency of the North Carolina Department of Cultural Resources. Operating support is provided through state appropriations and generous contributions from individuals, foundations, and businesses.

Editor: Karen Cochran, North Carolina Museum of Art
Designers: Holland Macdonald and Heather Hensley, North Carolina Museum of Art
Typesetting: B. Williams and Associates
Printing: Butler and Tanner, Inc.

Library of Congress Control Number 2002105870
ISBN 0-88259-987-9 (hardcover)
 0-88259-988-7 (paperback)

Contents

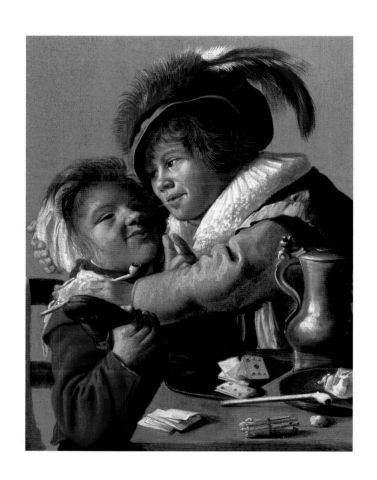

Lenders

Bayerische Staatsgemäldesammlungen, Munich

Cynthia von Bogendorf Rupprath

Collection SØR Rusche

The Currier Museum of Art

Frans Hals Museum, Haarlem, loan Institute Collection Netherlands

Indianapolis Museum of Art

Peter and Hanni Kaufmann

Mauritshuis, The Hague

Dr. and Mrs. Richard Mones

Museum Bredius, The Hague

Museum of Fine Arts, Boston

The Museum of Fine Arts, Budapest

The Museum of Fine Arts, Houston

The National Gallery, London

Otto Naumann Ltd., New York

Mr. Eric Noah

North Carolina Museum of Art, Raleigh

Phoenix Art Museum

Collections of the Prince of Liechtenstein, Vaduz Castle

Private collectors

Rheinisches Landesmuseum, Bonn

Rijksmuseum, Amsterdam

Seattle Art Museum

Staatliche Museen zu Berlin, Gemäldegalerie

Theatre Museum, Amsterdam

Toledo Museum of Art

Victoria & Albert Museum, London

Virginia Museum of Fine Arts, Richmond

Worcester Art Museum, Worcester, Mass.

The North Carolina Museum of Art is pleased to present *Jan Miense Molenaer: Painter of the Dutch Golden Age* to the public. Although Molenaer's masterful paintings represent another facet of the genius of seventeenth-century Dutch art, his accomplishments have been overlooked by scholars and collectors for nearly three centuries. Even recently, as his engaging and innovative compositions garnered increasing attention by specialists in the field, the painter's resurrection was largely obscured by the ascendancy of the artistic accomplishments of his wife, Judith Leyster. Nevertheless, and as the exhibition clearly demonstrates, Molenaer's spirited pictures identify him as one of the most important artists of his generation. We therefore consider it a privilege to provide the first retrospective exhibition of his work, and we wish to thank everyone who brought the show to fruition.

The exhibition was the brainchild of Dennis P. Weller, our curator of Northern European art. His tireless efforts in resurrecting the painter began with his doctoral dissertation on Molenaer (University of Maryland, 1992), and we are indeed fortunate he was able to apply his vast knowledge of Molenaer to the organization of the show and its accompanying catalogue. I would also like to thank Cynthia von Bogendorf Rupprath and Mariët Westermann for their valuable contributions to the publication.

Jan Miense Molenaer: Painter of the Dutch Golden Age contributes to a growing tradition here at the North Carolina Museum of Art of organizing exhibitions devoted to the work of artists who may have fallen from art historical grace over the decades and centuries. It follows upon *Color, Myth, and Music: Stanton Macdonald-Wright and Synchromism* (2001) and *The Landscapes of Louis Rémy Mignot: A Southern Painter Abroad* (1996). We hope to continue in this direction in the years to come, mindful of our commitment to furthering scholarship in the visual arts.

We are pleased that the Molenaer exhibition will be seen at the Columbus Gallery of the Indianapolis Museum of Art and the Currier Museum of Art in Manchester, New Hampshire. At the Indianapolis Museum of Art, we extend our gratitude to former director Bret Waller, his successor Anthony Hirschel, and Rhonda Kasl, curator of European painting. In Columbus, Indiana, where the exhibition will appear due to ongoing construction in Indianapolis, thanks go to Melissa Washburn and members of the staff. Similar sentiments are extended to Susan E. Striker, director of the Currier Museum of Art, and members of her staff, in particular Kurt Sundstrom, curator of European art.

Financial support for the exhibition came from a number of sources, both private and public. *Jan Miense Molenaer: Painter of the Dutch Golden Age* was funded in part by a grant from the National Endowment for the Arts. Grants from the William R. Kenan Jr. Fund for the Arts and the William R. Kenan Jr. Charitable Trust provided additional support for *Art in the Age of Rubens and Rembrandt*, of which the Molenaer exhibition is the largest component. Additional support was provided by individual donations and by the North Carolina Museum of Art Foundation, Inc. After nearly four hundred years since Molenaer's birth in the early seventeenth century, it is gratifying to know that so many individuals and organizations are willing to share in the resurrection of this most fascinating and innovative painter.

LAWRENCE J. WHEELER
DIRECTOR
NORTH CAROLINA MUSEUM OF ART

International loan exhibitions, never an easy undertaking due to complexities of shipping, insurance, and couriers, have become even more difficult to organize in light of recent world events. Considering art's enormous potential for healing, educating, and bringing joy to viewers, it can be argued that such exhibitions are more important than ever. With this in mind, I am enormously grateful to everyone who has contributed to make *Jan Miense Molenaer: Painter of the Dutch Golden Age* a reality. Special thanks are extended to our co-presenters, the Indianapolis Museum of Art (Columbus Gallery) and the Currier Museum of Art in Manchester, New Hampshire, and especially the museums and private collectors on both sides of the Atlantic whose generosity in parting with their treasures has made the show possible.

The genesis of the current exhibition has followed a path that is much too detailed to fully describe here. Nevertheless, early participation by the American Federation of the Arts and the Frans Hals Museum must be noted. Although both ultimately left the project, each made important contributions to the final product. In addition, a technical essay devoted to Molenaer's painting style had to be abandoned due to the untimely death of David Findley, chief conservator at the North Carolina Museum of Art. Fortunately, the Indianapolis Museum of Art (Columbus Gallery) and Currier Museum of Art filled the void left by Haarlem. Thanks are extended to the staffs of these institutions, especially Ronda Kasl and Melissa Washburn in Indianapolis and Columbus, respectively, and Kurt Sundstrom in Manchester.

My colleagues at the North Carolina Museum of Art have been instrumental in realizing the exhibition and its accompanying catalogue. I am especially indebted to Director Lawrence Wheeler, Exhibition Designer Doug Fisher, Graphic Designers Holland Macdonald and Heather Hensley, and Editor Karen Cochran. Registrar Carrie Hedrick and her assistant, Marcia Erickson, were indispensable, as were members of our conservation, education, and communication departments.

A debt is also owed to many colleagues who have shared with me their knowledge of Molenaer and his paintings. Unfortunately, space does not allow me to list all of their names. They include Daphne Alazraki, Ronni Baer, Pieter Biesboer, Roel Bogaards, Peter Bowron, Edwin Buijsen, David Carter, Malcolm Cormack, Ildikó Ember, Frederik Duparc, John Hoogsteder, Chiyo Ishikawa, Jan Kelch, Jan-Piet Filedt Kok, Salomon Lilian, David Miller, Miklós Mojzer, Lawrence Nichols, Robert Noortman, Joke van Pelt, Konrad Renger, Axel Rüger, Kathleen Schrader, Jim Welu, and Uwe Wieczorek. In addition, I am especially grateful to Cynthia von Bogendorf Rupprath and Mariët Westermann for their insightful catalogue essays.

Finally, special thanks are extended to three friends and colleagues who first introduced me to Molenaer and have supported my work on the artist over the years. They are Frima Hofrichter, Walter Liedtke, and Arthur Wheelock Jr. Another individual—my wife, Janis— has cheerfully lived with Molenaer over the years. It is to her that I dedicate this catalogue with much love and affection.

DENNIS P. WELLER
CURATOR OF NORTHERN EUROPEAN ART
NORTH CAROLINA MUSEUM OF ART

Acknowledgments

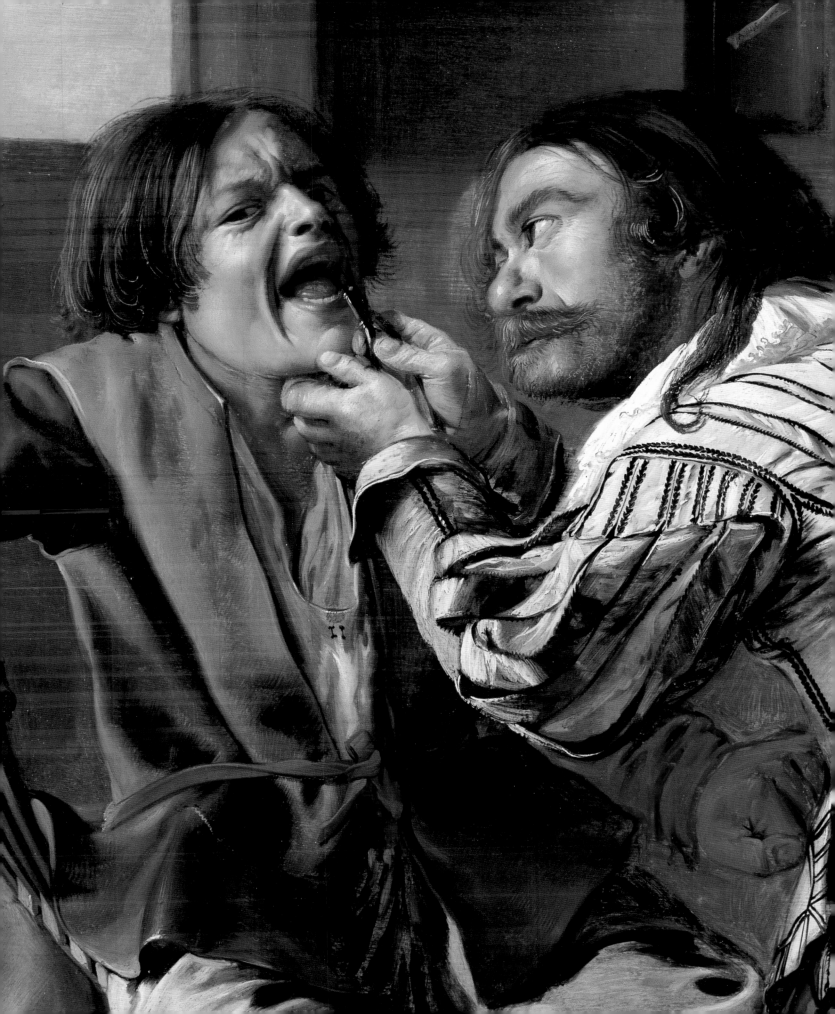

Introduction

DENNIS P. WELLER

The genius of seventeenth-century Dutch painting has long attracted the interest and imagination of the art public. Even today, as a technological world enters the twenty-first century, large crowds are more than willing to stand in freezing weather for the opportunity to see the masterpieces of Vermeer or Rembrandt. One feature of this enormous popularity has been a rapidly increasing number of monographic exhibitions devoted to Dutch artists during the last few decades. Since 1990 both well-known and more obscure painters have been the focus of major retrospectives—Frans Hals, Rembrandt, and Vermeer but also many of the so-called minor masters, including Bartholomeus Breenbergh, Aelbert Cuyp, Gerrit Dou, Aert de Gelder, Pieter de Hooch, Pieter Lastman, Judith Leyster, Pieter Saenredam, Jan Steen, and even Leonaert Bramer on two separate occasions.[1] Despite the fact that many of these painters specialized in a comparatively narrow range of subject matter and style, their accomplishments generally attracted large and enthusiastic crowds. To this growing list one can now add the name of the Haarlem painter Jan Miense Molenaer.

As the popularity of such exhibitions suggests, the inventiveness, quality, and craftsmanship of Dutch pictures clearly appeal to today's audiences. But how does Molenaer compare to his colleagues, and what did he contribute to the rich history of Dutch painting? Like most of his contemporaries, Molenaer has been identified as a specialist, a genre painter active in the circle of Frans Hals. Brief descriptions, however, are never complete and are rarely accurate. Such is the case for Molenaer, as his oeuvre extends into portraiture, history painting, and scenes of contemporary theater. He also showed himself to be open to many diverse influences. As is discussed throughout the catalogue, Molenaer was an active participant in a Bruegel revival that occurred during the second quarter of the seventeenth century. His pictures also serve as a link between the Bruegel tradition and the art of Jan Steen that followed. Steen, in fact, may have been greatly influenced by Molenaer's art. Inexplicably, such a relationship has been largely overlooked in the literature.[2]

Through the haze of centuries, what is known of this painter whose art remained largely in obscurity until the second half of the twentieth century? Only recently, and largely due to the efforts of iconographers and cultural historians, have researchers acknowledged Molenaer's creative combination of traditional themes and symbolically charged allegories.[3] Shortly thereafter, feminist studies scholars made mention of Molenaer, but solely in relation to his artist wife, Judith Leyster. While crucial to Molenaer's resurrection from near obscurity, these disciplines failed to adequately address his independence and skill as a painter. *Jan Miense Molenaer: Painter of the Dutch Golden Age* seeks to address these shortcomings.

Documents, inventories, and Molenaer's extant oeuvre assist in the determination of his

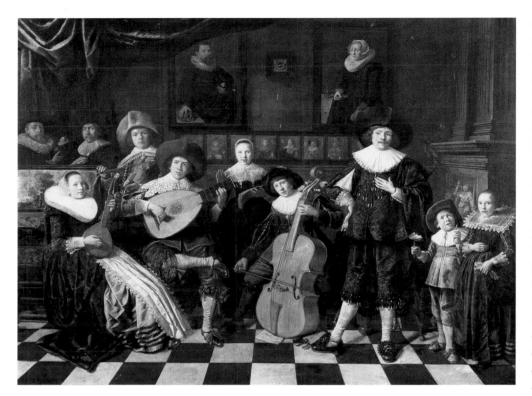

Fig. 1
Self-Portrait with Family Members,
ca. 1636
Oil on panel, 25 ⅜ x 31 ⅞ in.
Instituut Collectie Nederland, on loan
to the Frans Hals Museum, Haarlem

character and the degree of success he experienced during his career. His story was probably no different from the majority of his talented contemporaries who made a living selling their works in lotteries, the art market, and by commission. These sources indicate that Molenaer could be described in many ways. A number of painted self-portraits (cats. 22, 24, and 30) provide a picture of his physical attributes. He was good looking and determined, litigious, pugnacious and even combative, a male chauvinist according to current standards, a property speculator, a debtor, a husband, a father. More important, Molenaer can be identified as one of the most creative painters of his generation.[4]

Molenaer tells us much about himself and his craft in the *Self-Portrait with Family Members* (fig. 1), a painting aptly housed in Haarlem's Frans Hals Museum. The city of Haarlem figured significantly in the life of Molenaer, for it was where he was born and raised, received his artistic training during the mid-1620s, and was first listed as a member of its painters' guild in 1634. It was also in Haarlem that Molenaer became engaged to Judith Leyster in 1636, purchased property, and, with the exception of stays in Amsterdam and nearby Heemstede, spent most of his career.[5]

In *Self-Portrait with Family Members*, a curtain drawn to the left reveals eight well-dressed figures occupying the foreground of a shallow but lavishly decorated interior.[6] Striking similarities in the facial features of the figures identify them as young members of the same family. They all share cleft chins, bulbous noses, and broadly set dark eyes. Many of the group involve themselves with a musical performance, the exceptions being the three standing figures to the far right. Of these three, a young man in his mid-twenties stands out. He faces the viewer, one hand held to his chest and the other perched upon his hip as he holds a glove. His elaborate costume and cavalier pose reflect a sense of self-confidence largely missing in the others. For a number of reasons, including similarities with other self-portraits, this figure can be identified as the painter.

The composition includes two somewhat older, conservatively dressed men positioned behind a virginal at the far left. One of them holds a small oval portrait of a woman. The positioning of this pair is at odds with the overall balance of the composition and may have been added later. Their inclusion may be accounted for by the fact that Molenaer's father had two sons from a previous marriage.[7] The oval portrait held by one of these men is in all likelihood an image of their mother, Cornelia Jansdr., who died about 1609–10.

Molenaer also included pendant portraits of an older man and woman hanging on the

back wall on either side of a clock. The figures in these paintings within paintings appear with a traditional *memento mori* motif in addition to prayer books they clutch in their hands. The man grasps a skull with his right hand, and an hourglass appears on the table next to the woman, both references to the transience of life.

The imagery in this picture has been interpreted in a number of separate studies during the last three decades.[8] The idea of family harmony and *vanitas* has dominated these discussions, but the identity of this handsome, well-dressed family was largely ignored. Previous attempts to identify the figures focused on Molenaer and Leyster, including their two children who survived infancy, Helena and Constantijn. Because the dates of the children's births were 1643 and 1650 respectively, and because the picture's likely date is 1636, as will be seen, such a conclusion is untenable. An overwhelming amount of circumstantial evidence indicates the models are Molenaer, his brothers and sisters, and, on the back wall, his parents. In addition, the painter incorporated a number of carefully chosen motifs that provide for a broader context to the picture and, by association, the types of artistic concerns that touched much of his art.

Several documents, including one dated 12 August 1636 detailing the debts incurred by Molenaer's mother, indicate the painter maintained close ties with his immediate family throughout his lifetime.[9] This contact was especially true with two of his brothers, Klaes and Bartholomeus, as both became painters and were fellow members of the Haarlem Guild of Saint Luke. More important, Molenaer is also documented as having depicted group portraits of his family members. The inventory of his possessions (Appendix) taken shortly after his death, for example, lists *een stuck met de conterfijtsels van hem en sijn broers* (a picture with the portraits of him and his brothers) as the first item. While the *Self-Portrait with Family Members* now in Haarlem cannot be identified as the painting in the inventory, it does represent the most complex and accomplished of the many works painted by the artist that can now be identified as portraits of family members (see cats. 22, 23, and 24).

Documents also tell us the painter's father, Jan Mientsen Molenaer, died in 1636. He left behind his second wife, Grietgen Adriaens, and their three daughters and five sons.[10] The girls were named Geertruyt, Lucia, and Marietge Jans, and the boys were named Jan Miense (the oldest son and the one named after his father), Adriaen, Anthony, Bartholomeus, and Nicolaes (Klaes) Janssen. The youngest of Molenaer's seven siblings, the landscape painter Klaes Molenaer, was born about 1629. He is the boy about six years old who stands to the right and entertains himself by blowing bubbles. Jan Miense, a man in his mid-twenties, stands next to the boy. The painter's other siblings take their positions across the foreground of the composition. Since the birth dates for these youngsters are unrecorded, probably owing to the probability they were baptized as Catholics, it is not possible to link names to the individual portraits beyond Jan Miense and Klaes.[11] Watching over their children are the pendant portraits of the parents, Jan Mientsen and Grietgen Adriaens. The references to transience noted above have specific relevance here, for in the portrait of Molenaer's recently deceased father, the figure firmly grasps a skull. This telling motif also helps date the work to the year the father died. By contrast, the painter's mother lived until 1652. She is very much alive in this family portrait: The sand in the hourglass sitting next to her has yet to run out.

The *Self-Portrait with Family Members* includes a number of other figures, specifically the eight half-length images pictured beneath the portraits of Molenaer's parents. The inclusion of a coat-of-arms on some of them suggests they function as family portraits. Images of this type, nonetheless, are equally characteristic of the *4 tronijkens van Molenaer*

(4 faces by Molenaer) listed in a 17 November 1631 auction of works owned by the Haarlemer Hendrick Willemsz. den Abt.[12] This type of character study, as well as related images representing the senses (cat. 3), was much in evidence in Molenaer's early oeuvre.

When he completed the work, the mature, confident artist pictured in *Self-Portrait with Family Members* stood near a crossroads in his career. Within the year, he and Leyster had relocated to Amsterdam. Once there, and after some initial success in winning important commissions, he presented himself as a painter of peasant scenes, a niche Adriaen van Ostade occupied in Haarlem.[13] Covering some thirty years and resulting in a largely undistinguished body of work, this phase of his career pales in comparison to the production of his youth. As the primary focus of the current exhibition and nearly all scholarly investigations, the pictures Molenaer produced from about 1629 to 1640 merit closer attention, for they identify the painter as among the most creative artists of his generation. His surprisingly large output from this period consistently displays an inventive symbolism, wit, and humor that touched upon many of the issues debated in contemporary society. Among the topics explored in his compositions are instruction and discipline, love and marriage, virtue and vice, mortality, and the behavior of the underclass.[14]

The place and time of Molenaer's birth, Haarlem in 1610, could not have been more exciting for an artist. He entered the world just months after the beginning of a twelve-year truce in the war between the Dutch and the Spanish-controlled southern Netherlands. The result of this interruption in hostilities was a period of prolonged growth and prosperity that served to define the Dutch Golden Age. Haarlem became the most important and innovative artistic center in the northern Netherlands for much of the first half of the seventeenth century.[15] Innovations by the city's painters and draftsmen introduced a vast array of new subject matter depicted in a realistic style that replaced elements of European mannerism. Rising above this exciting mix was the genius of Frans Hals. Although his education is undocumented, Molenaer's early pictures suggest he received his training in the studio of Frans Hals, probably followed by a stay with Hals's younger brother Dirck.[16]

Four extant, dated paintings from 1629, including *The Dentist* (cat. 4) and a handful of others that must date earlier, provide a starting point for a career that continued without interruption until the late 1660s. Molenaer's last dated picture, *Merry Company at a Table* (cat. 37), comes from 1667, just a year before the artist's death. It is important that we consider how his art has been received since his death, but for much of this period, the sources are largely silent.

Seventeenth-century printed references to Jan Miense Molenaer begin and end with comments written by T. Schrevelius in the 1648 Dutch edition of his *Harlemias: Of, de eerste stichting der stad Haarlem*. Molenaer is simply mentioned in this town history only within the context of Judith Leyster. Schrevelius wrote that Leyster was "de huysvrouw van meulenaer, die oock een vermaerd schilder is, van Haerlem geboren, tot Amsterdam wel bekent" (the wife of Molenaer, who is also a famous painter, born in Haarlem, and well-known in Amsterdam).[17]

Writers in the following century were only slightly more generous with their words, as Molenaer and his colleagues who painted peasant scenes found few supporters. Against a backdrop of the Enlightenment, these artists were criticized for their choice of subject matter as well as the coarse, painterly manner they employed. De Lairesse, for example, had little patience for Molenaer and the other painters of ordinary life who had used ordinary models.[18] The same sentiments appear at the end of the century by Van Eynden, who in 1787 linked the peasant painter Molenaer to his better-known contemporaries such as Adriaen van Ostade and Jan Steen.[19] As might be expected, the negative character of this

art is contrasted with the accomplishments of classical painters such as Adriaen van der Werff and Jacob de Wit.

The nineteenth century witnessed a slow but growing interest in Molenaer's pictures. Many scholars of Dutch art took note of the artist and showed varying degrees of enthusiasm for his work. With this interest came much misinformation, resulting in a great deal of confusion regarding the painter and his oeuvre. Many of these errors still linger, including confusion over the identities of the various artists who carried the Molenaer surname. John Smith, for example, writing in 1833, cited a Mins Nicholas Molinaer in a section devoted to "scholars and imitators of Jan Steen."[20] In spite of describing the art of Jan Miense Molenaer, he created a hybrid with the names of Jan Miense and his youngest brother Nicolaes (Klaes). Adding to the confusion, he noted, "Molinaer was born at Amsterdam, in 1627." In a similarly confused manner, Nagler described Molenaer in 1863 as "a genre and landscape painter, who was active from 1640 to 1659 in Antwerp."[21]

In a strange way, Molenaer had created this confusion over his art during his own lifetime. The marked differences between his early and late pictures, both in subject matter and style, and changes in the way he signed his works over the course of his career confounded scholars working in the nineteenth century. In fact, some authors, among them Wilhelm von Bode in a publication of 1871, attributed Molenaer's oeuvre to two different painters.[22] To differentiate between Molenaer's early pictures and his later peasant compositions, he considered the *JMR* monogrammer as the painter responsible for the early works. Molenaer remained the artist associated with low-genre scenes. Fortunately, Bode corrected himself a decade later when he assigned the entire oeuvre to Jan Miense Molenaer.[23] At the same time he made an assessment of Molenaer's entire production, stressing the connections between the early work and paintings by Hals and his close followers and linking Molenaer's production from the 1640s, 1650s, and 1660s to works by Ostade and Rembrandt.

By the end of the nineteenth century, scholars associated with the golden age of art history had reached a much clearer understanding of the life and art of Molenaer. Archival research conducted by Abraham Bredius, and before him Van der Willegen, would correct much of the earlier misinformation about the painter.[24] Bredius, in fact, teamed with Bode to examine the years Molenaer spent in Amsterdam.[25] The authors insisted that Molenaer should be considered as a talented and esteemed member of the school of Dutch painters. They concluded by noting his paintings often fetched high prices and were found in good collections.

This positive assessment may have contributed to a heightened interest in Molenaer's art during the early years of the twentieth century. An immediate result was the inclusion of seven paintings identified as by Molenaer in the *Dutch Exhibition* held at London's Whitechapel Art Gallery in 1904. Unfortunately, most of the seven attributions to Molenaer are questionable at best. *The Expected Visit*, for example, catalogued as a collaborative effort between Molenaer and Leyster, has very little to do with either artist.[26] Far too often these and other questionable attributions have tarnished the artist's reputation.

Attribution questions, however, have not impacted the comparatively recent enthusiasm among scholars for the painter's artistic accomplishments. Intrigued by his choice of subject matter and use of symbolism, researchers have shown considerable interest in Molenaer and his art for much of the last half century. Counted in this number are Eddy de Jongh, Pieter van Thiel, Peter Sutton, Peter Hecht, Mary Francis Durentini, Cynthia von Bogendorf Rupprath, and Edwin Buijsen.[27] Unlike the authors of survey texts who look to place Molenaer and his art in the larger context of Dutch genre painting, these writers have generally focused on either a single picture or a group of related paintings. They have empha-

sized the innovative ways Molenaer linked his choice of subject matter with allegory and timely lessons. Many of their conclusions have been incorporated throughout the catalogue.

Iconographic investigation has been both a blessing and curse for an understanding of Molenaer and his artistic legacy. With some justification, there also has been a general disinterest in his peasant merry companies and related imagery that have proven to offer strong visual connections with the words of the important Dutch writer Gerbrand Bredero.[28] In addition, his religious and theatrical subjects, arguably the most important paintings in his entire body of work, have largely been overlooked.[29] Indicative of this situation, his large and imposing *Mocking of Christ* (Weller fig. 11) has received little attention in the literature, and *Lot and His Daughters* (cat. 12, fig. 1), a psychologically complex work of considerable quality, has escaped interest by scholars altogether and been attributed to others.[30]

While Molenaer has remained in relative obscurity until recently, documents and inventories from his lifetime paint a somewhat different story. Information gleaned from court appearances, inventories, auction lists, and fellow artists is enlightening. At best, however, this information provides a mixed message with regard to Molenaer's success as a painter. His name often appears in the inventories of collectors, and the prices fetched for his works were equal to or above the average. In addition, a number of his larger works, including *The Wedding Portrait of Willem van Loon and Margaretha Bas*, the *Mocking of Christ*, and the *Denial of Saint Peter* (cat. 14), were undoubtedly important and lucrative commissions for the artist.

Documents also attest to the pugnacious and generally unpleasant character of the painter.[31] Not only was he inclined toward abusive language and fighting, but he regularly was sued for nonpayment of goods and services. On other occasions Molenaer allegedly broke windows, confiscated property, failed to appear in court, and was admonished by a judge. Financial pressures figure significantly in many of these unflattering events, beginning with the court's confiscation of his property in 1636 to pay debts. One is confronted throughout the remainder of the painter's life with a wealth of contradictory evidence concerning his ability to find a market for his paintings and to maintain an adequate and constant source of income. Haggling before a notary over relatively insignificant matters and amounts became a second occupation for Molenaer. Everyone seems to have been fair game, from the butcher and grocer to the tailor and jeweler. More often than not, Molenaer's claims were denied by the authorities, forcing him to make restitution and pay court costs. Methods of payment often involved the bartering of his pictures.

Still, the inventory of Molenaer's household possessions (Appendix), undertaken a few days after his death, gives the impression of an individual of comfortable means with an extensive collection of paintings. In addition to works by the painter and his wife, the inventory includes paintings by Pieter Claesz, Adriaen van de Venne, Jan van Goyen, Frans Hals, Pieter Mulier, and Adriaen Brouwer. There were also pictures attributed to the sixteenth-century masters Maerten van Heemskerck, Pieter Aertsen, and Lucas van Leyden.

While this large collection suggests Molenaer also may have worked as an art dealer, it is his profession as a painter that merits our attention in *Jan Miense Molenaer: Painter of the Dutch Golden Age*. The catalogue and my essay surveying Molenaer's work will cast light on his artistic accomplishments, and intriguing essays by Cynthia von Bogendorf Rupprath on Molenaer's studio practices and Mariët Westermann regarding the painter's incorporation of the comic mode provide additional insight on the painter and his art. We hope this volume will give readers a vibrant and engaging picture of an artist now emerging from the shadows after more than three centuries.

1 Leonaert Bramer, certainly not one of the better-known Dutch artists, was given two separate exhibitions within a three-year period in the early 1990s (*Leonaert Bramer: A Painter of the Night*, The Patrick and Beatrice Haggerty Museum of Art, Marquette University, Milwaukee; and *Leonaert Bramer*, Stedelijk Museum Het Prinsenhof, Delft, 1994). These monographic exhibitions can be seen as complementing those shows that focus on a specific theme. Recent thematic exhibitions have addressed many topics, ranging from a focus on masterpieces (*The Glory of the Golden Age*, Rijksmuseum, Amsterdam, 2000) to ones exploring artistic styles (*Dutch Classicism*, Museum Boijmans van Beuningen, Rotterdam, 1999–2000) and artistic centers (*Vermeer and the Delft School*, The Metropolitan Museum of Art, New York, 2001).

2 For example, Molenaer rarely appears in the recent exhibition catalogue devoted to Steen (*Jan Steen: Painter and Storyteller*, National Gallery of Art, Washington, D.C., and Rijksmuseum, Amsterdam, 1996–97).

3 Here, Pieter van Thiel (1967–68) and Eddy de Jongh (1973) were among the first to become attracted to the importance of Molenaer's pictures and the messages they contained. Also see Bibliography.

4 Although the catalogue raisonné has yet to be completed, the number of Molenaer's extant oeuvre is estimated to be between 225 and 250 pictures.

5 Much of the biographical information known about Molenaer was published by Abraham Bredius in his *Künstler-Inventare* (vol. 1, 1915, pp. 1–26; supplement 1922, pp. 154–61). More recently Ellen Broersen (Haarlem and Worcester 1993, pp. 21–38) uncovered new information about Molenaer and especially his family.

6 Discussed below, this family can be identified as Molenaer's. Their expensive clothing seems out of character

for a working-class family, but artistic license and the fact that Molenaer's father had been a tailor no doubt contributed to this fictive presentation.

7 Identified by Broersen in the Molenaer family tree (ibid., p. 22), the sons from this marriage were named Meijndert and Cornelis.

8 Hinz 1973; Smith 1982, pp. 29–36; and De Jongh in Haarlem 1986, no. 69.

9 Bredius 1915, p. 10.

10 The primary document concerned with Molenaer's siblings dates from 24 January 1653 (Haarlem city archive, Tp. 76.68 folio 178 verso). It dealt with the sale of the house of Molenaer's mother after her death. In the translation provided below, one of the brothers, Bartholomeus, is not mentioned. He had already died in 1650.

Jan Molenaer, master painter, attorney of Adriaen and Claes Janssoen Molenaer, of Casparus Anthony Ijsvoort as married with Geertruyt Molenaer, of Pieter Floorte, as married with Maria Molenaer and Jacob Abrahams, as married with Lucia Molenaer, and Anthony Molenaer, all children and heirs of Grietgen Adriaens, in her life widow of Jan Miensen Molenaer, their mother and mother-in-law, sells in that quality to Hendrick Pieters Swarthooft a house in the Clercqstede. Neighbors are Cornelis Jans, the Vrouwengasthuis [Lady's Hospital], at the backside the Brouwershofje with free use of the land beside it, with charges of 1500 guilders.

11 The lack of baptism records for Molenaer and all of his siblings prompted Broersen (Haarlem and Worcester 1993, p. 21) to suggest the family belonged to the Catholic Church.

12 This auction is discussed by Van Hees (1959, pp. 36–42).

13 Arguably, the most important commission for Molenaer came from the Van Loon family in Amsterdam.

In 1637 he signed and dated *The Wedding Portrait of Willem van Loon and Margaretha Bas* (Weller fig. 9). This large, colorful work has no equal in Molenaer's oeuvre.

14 These issues will be explored in the essays and individual catalogue entries.

15 For discussions of Haarlem as an artistic center, see New Brunswick 1983 and Weller 1997.

16 Weller, pp. 11–12.

17 Schrevelius 1648, pp. 384–85.

18 De Lairesse 1740, p. 174.

19 Van Eynden 1787, p. 195.

20 Smith 1829–42, vol. 4, p. 69.

21 Nagler 1858–79, vol. 3, pp. 2,789, 2,829.

22 Bode 1871, pp. 47–48.

23 Bode 1883.

24 Bredius 1915–22, vol. 1, pp. 1–25, and vol. 7, pp. 154–61; Van der Willigen 1870, p. 225.

25 Bode and Bredius 1890, pp. 65–78.

26 Illustrated in London 1904.

27 For the publications by these authors, see Bibliography.

28 For a discussion of Bredero as a source for Molenaer, see Weller 1992, pp. 245–60, and cat. 29.

29 Ibid., pp. 215–22.

30 The *Mocking of Christ* was included in an exhibition devoted to images of Christ (Rotterdam 2000–01). Prior to this time, it was illustrated and briefly discussed by Schillemans (1992, p. 50) and Van Eck (1999, pp. 82–83).

31 Weller 1992 interprets many of the extant documents that concern Molenaer. Also see Bredius 1915–22.

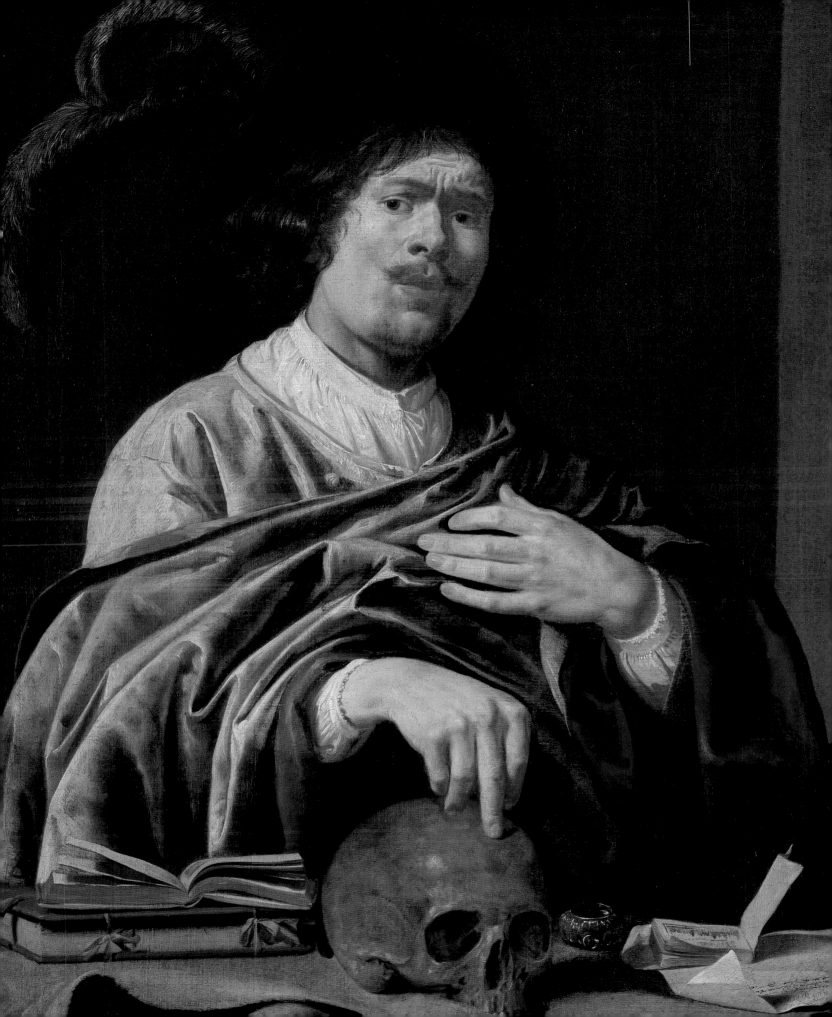

Jan Miense Molenaer
Painter of the Dutch Golden Age

DENNIS P. WELLER

Few artists explored as wide and diverse a range of subject matter as did Jan Miense Molenaer during his early years in Haarlem and later in Amsterdam. In doing so he distinguished himself from other Haarlem genre painters by producing imagery that is more didactic, literary, and iconographically sophisticated. He also provided a visual counterpart to written works by Jacob Cats and, especially, Gerbrand Adriaensz. Bredero.[1] Although his artistic independence has been largely ignored, the wit and inventiveness that consistently made their way into Molenaer's pictures are now attracting considerable attention.

Molenaer, like Jan Steen nearly a generation later, painted imagery based on the writings of Dutch playwrights, popular proverbs, and the Bible. These examples stand alongside tavern interiors, the five senses, village weddings, merry companies, ball players, genrelike portraits, single figures, schools, and family groups. Equally remarkable is the quality found in many of these works, including the pictures selected for the exhibition. Molenaer appears to have been equally adept in applying his paints in a more precise, descriptive manner, as well as employing a looser style usually reserved for his peasant subjects.

More than most of his contemporaries in the Dutch "Golden Age," Molenaer made visible the complex moral dilemmas faced by his countrymen. With humor as the best medicine, Molenaer may have eased the pain of his message through his numerous representations of boisterous merrymakers in comic situations (see Westermann essay). The question remains whether or not Molenaer took his own advice. Answers to this intriguing question are suggested by rare glimpses into his personality and character provided in the following survey of his life and art. More important, Molenaer speaks volumes about himself through his masterful paintings.[2]

Training and Early Works

The early years of Jan Miense Molenaer's career prove extremely difficult to reconstruct. Little documentation has surfaced concerning his life, his training, or other events prior to 1636 that could cast light on his artistic development.[3] Assumptions regarding the painter's early career must center, therefore, on his pictures and their connection with the artistic environment in Haarlem during the 1620s and early 1630s. As one of the most fertile artistic centers in the history of Western art, Haarlem provided a worthy setting in which Molenaer learned his craft and began his long career.[4]

Although one can begin to piece together this puzzle with Molenaer's four earliest-dated pictures of 1629, a work he signed and dated two years later effectively sets the stage by identifying the painter, his artistic concerns, and the early influences that led to its execution. *The Artist in His Studio* (fig. 1), its fragile condition unfortunately excluding it from

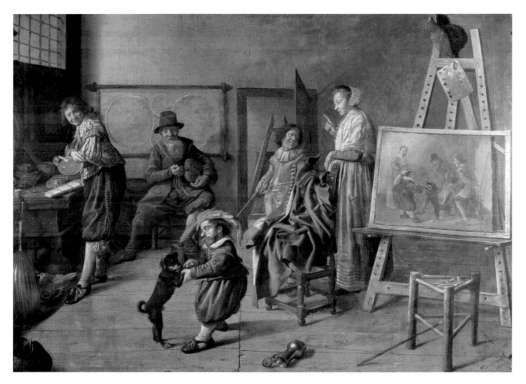

Fig. 1
The Artist in His Studio, 1631
Oil on canvas, 38 x 52 ¾ in.
Staatliche Museen zu Berlin,
Gemäldegalerie

the exhibition, is one of the painter's best-known and most important works. Accepting the topos that every painter paints himself, Molenaer imaginatively described himself and his world in this engaging work.

Within a large studio space, the viewer is witness to the world of the painter, including his models, his props, and the supplies essential to his craft. The composition's seemingly realistic nature has long attracted the attention of art historians. Early last century, for example, Wilhelm Martin stressed the verisimilitude of the scene as he featured the work in "The Life of a Dutch Artist in the Seventeenth Century."[5] The intervening decades, however, have seen extensive research devoted to the character of Dutch painting, particularly questions centering on the selective nature of genre scenes and whether these pictures are as realistic as they outwardly appear. Clearly, the picture's realistic tone owes much to the contemporary veneer Molenaer cast over the scene, especially the detail of a stretched canvas sitting on an easel to the far right. Serving as a key to meaning, this painting within a painting functioned on a number of levels. Rather than isolating the picture within a larger, iconographically unrelated composition, Molenaer approached his subject more like a moviemaker filming continuous action. The image raises fundamental questions regarding the realistic and selective nature of genre scenes, particularly the merry companies that had become popular in Haarlem.

Central to the painter's conceit is the relationship between the overall composition and the aforementioned merry company sitting on the easel. In picturing his models during a momentary break from their poses, he demonstrated the artificiality of such lifelike scenes. There is nothing particularly real about the arrangement of the four merrymakers and the dancing dog in the painting on the easel. Should the viewer, given the false nature of the scene, be equally skeptical about the "truths" within the larger composition and, by association, all of Molenaer's genre paintings?

By 1631, when he executed *The Artist in His Studio*, Molenaer had already established himself as a creative member of Haarlem's artist community. Dated pictures from the previous two years, and those that probably originated even earlier, mark Molenaer's path as he completed this early masterpiece. The four signed and dated paintings of 1629 effectively communicate the range of Molenaer's early artistic interests and serve as a starting point to track his career.[6] Collectively, the impact of his probable teachers Frans Hals and Dirck Hals is demonstrated. These works also reveal the expected shortcomings usually accompanying the juvenilia of artists. They include problems with anatomy and

perspective, forced expressions, and inconsistencies in paint application.

With the understandable exception of the grimacing patient in *The Dentist* (cat. 4), a common denominator of Halsian laughter links the figures in the four works. In each, the viewer responds to the toothy grins and the un-abashed good humor of the merrymakers. To understand the nature of Molenaer's early style, and by association his probable artistic sources, it is important to consider the character and differences found within this group of paint-ings. Among the variables are figure scale and placement, architectural settings, lighting, palette, and, to a degree, brushwork.

The Breakfast Scene (fig. 2) reveals a tightly knit group of three-quarter-length merrymakers celebrating with food and drink. The setting is suggested only by the intersection of the rear and side walls at the left, and the floor just to the right of the table. Much of the charm and immediacy of the scene comes with the placement of the large-scale figures next to the picture plane. Typical of many of the painter's early compositions, including *The Dentist* (cat. 4), are the spatial inconsistencies and anatomical problems associated with some of the figures in *The Breakfast Scene*. Of greater importance to this discussion, however, are the composi-tional prototypes to which the picture can be linked.

Lively merrymakers situated in the extreme foreground had become a popular compositional type for many North-ern artists during the period, among them Frans Hals. Better known for his lively portraits, Hals painted a num-ber of genre scenes featuring young merrymakers in the 1620s and 1630s. Timing being everything, it is no coinci-dence that Molenaer's artistic training coincided with the introduction of these compositions into the artistic reper-toire of Haarlem. It seems Molenaer moved in this compo-sitional direction by most likely studying with Frans Hals in the mid-1620s. In addition to using similar composi-tional techniques, Molenaer shows a further debt to Hals by choosing a similar palette and attempting, though fairly unsuccessfully, to imitate his brushwork. A comparison between *The Breakfast Scene* and Hals's sparkling *Merrymakers at Shrovetide* (fig. 3) not only demonstrates Molenaer's reliance on the Hals model but shows the gulf separating Hals's genius and the art of even his closest followers. Unlike Judith Leyster, who came closest to mastering Hals's virtuos-ity, Molenaer employed a more descriptive, finished manner, with the lively individual strokes that enhance the immediacy of Hals's genre figures largely missing.

It would be misleading to pigeonhole the young Molenaer merely as an imitator of Frans Hals. Clearly, the quality of his earliest-dated works suggests that by 1629 Molenaer was already finding an artistic niche for himself in Haarlem. As he gained experience and independence, Molenaer remained open to other influences. Among them was Dirck Hals,

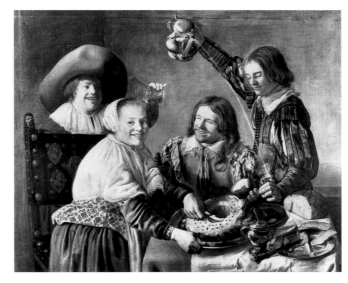

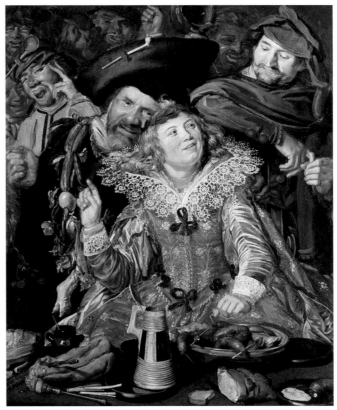

Fig. 2
The Breakfast Scene, 1629
Oil on canvas, 42 ½ x 50 ¾ in.
Museum Kunsthaus Heylshof, Worms

Fig. 3
Frans Hals
Merrymakers at Shrovetide,
ca. 1615–20
Oil on canvas, 51 ¾ x 39 ¼ in.
The Metropolitan Museum of Art,
New York

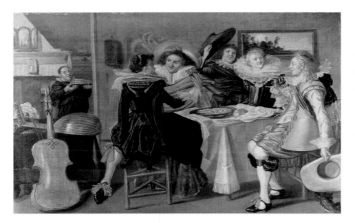

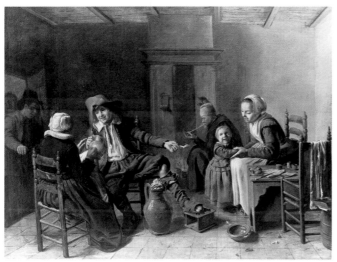

Fig. 4
Dirck Hals
Merry Company, ca. 1625–30
Oil on panel, 10 ⅞ x 17 ⅛ in.
Staatliche Museen zu Berlin,
Gemäldegalerie

Fig. 5
Family Scene, 1629
Oil on canvas, 27 ½ x 33 ⅝ in.
Mittelrheinisches Landesmuseum,
Mainz

cited by Houbraken as having studied with his famous older brother.[7] His impact on Molenaer, while occasionally mentioned in the literature, is only now being seriously explored. Dirck's *Merry Company* (fig. 4) reflects the strong and lively manner of painting he applied to his "neat little figures."[8] Perhaps as a form of sibling rivalry, Dirck largely turned his back to the art of his brother and adopted compositional formats popularized by Willem Buytewech and Esaias van de Velde in Haarlem earlier in the century.[9] Following the departures of Buytewech from the city in 1617, and Esaias the next year, it fell to Dirck to continue the tradition of depicting interior merry company scenes and outdoor garden parties. Perry Chapman has assessed the significance of such scenes.

Early merry companies and banquet scenes, in which elegant well-dressed figures engage in pleasurable pursuits, have long been seen as occupying that curious territory, handed down from the sixteenth century, between delight and instruction. Current concerns—conflicting pride and anxiety about the new state—give the old moralizing traditions a contemporary twist. High-life genre paintings simultaneously (or alternatively) celebrate the Republic as a demi-paradise of freedom, peace, and prosperity, and promote civic responsibility by warning of the vicissitudes of Fortune.[10]

Dirck Hals's subject matter, messages, and to some degree compositional solutions left a mark on the young Molenaer as he entered Haarlem's bustling art market. Molenaer's other two signed and dated paintings from 1629, *Family Scene* (fig. 5) and *Two Boys and a Girl Making Music* (fig. 6), make visible this connection. The Mainz *Family Scene* is particularly close in conception to Dirck's *Merry Company*, as both works incorporate merrymakers into a well-defined architectural space in a similar manner. Nevertheless, Molenaer's figure types are quite different. Unlike the young Hals, whose figures tend to be cut from the same mold (young, colorful, fashionably dressed, and doll-like in appearance), Molenaer gave his merrymakers more weight and a greater individuality. In some of his subsequent pictures, this individuality was so distinct that genre and portraiture often overlapped (cats. 23, 24). Molenaer's palette also differs from that of Dirck Hals, as it is less decorative and integrates strong local color with a range of earth tones.

What is known of Molenaer's oeuvre prior to 1629? Questions concerning his early works from about 1627–28 are troublesome, as there are no dated paintings from these years. In addition, there were other painters in the Hals circle, in particular Judith Leyster, who, like Molenaer, produced similar imagery and attempted to approximate the style of Frans Hals. Molenaer did, however, sign a handful of works that, in light of the artistic immaturity they exhibit, must predate 1629. Two examples in the exhibition (cats. 1, 2) are discussed in terms of the youthful inconsistencies they display. Predictably, viewers confront problems in anatomy, spatial inconsistencies, and uneven paint application.

A Master in Haarlem, 1630–1636

The signed and dated paintings of 1629, as well as those that came earlier, communicate the parameters of Molenaer's initial artistic concerns. As he refined his style, Molenaer referenced the art of Frans and Dirck Hals, Willem Buytewech, Adriaen Brouwer, and even the emerging talents of the young Judith Leyster. Each made a contribution to the painter's choice of compositional scheme, imagery, and brushwork. Regardless of these influences, the young Molenaer was not content to mimic his better-known contemporaries in Haarlem and elsewhere. For the years 1630–36, few could match his creativity. By the end of this productive period, Molenaer, like Rembrandt and so many others, was lured away from his hometown to find fame and fortune in Amsterdam.

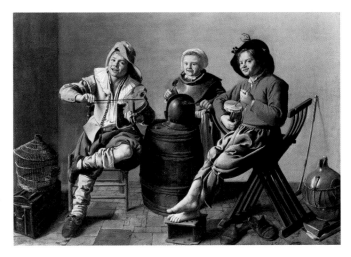

Fig. 6
Two Boys and a Girl Making Music, 1629
Oil on canvas, 26 ⅞ x 33 ¼ in.
The National Gallery, London

Without question Molenaer's production in the 1630s warrants his description as a Haarlem master. Although membership in the city's Guild of Saint Luke came only in 1634, his pictures from this decade tell the story of a painter of great ambition and talent who reached new plateaus seemingly on a yearly basis. It should come as no surprise, therefore, that the current exhibition focuses on this body of his work. Rather than an imitator of those individuals who influenced or inspired his art, including artists previously mentioned and others such as Pieter Bruegel the Elder, Molenaer quickly developed a very personal style.[11] It is one marked by great diversity in subject matter, paint application, and palette, and an increasingly proficient understanding of the relationship between his figures and their surroundings. Ongoing research tells us his greatest contribution is the sophisticated, innovative manner in which he conveyed timely messages to his audience.[12] The messages were not just moralizing in nature, as humor often surfaces in his works. Equally interesting is the fact that Molenaer, unlike most of his contemporaries, did not restrict himself to the production of a single genre. His wide-ranging choice of imagery, so evident in these early years in Haarlem, continued for a few years thereafter in Amsterdam.

As mentioned, Molenaer's innovations with regard to subject and meaning have long attracted the attention of art and cultural historians. The issues the painter addressed were wide ranging, and he was especially skillful in updating traditional subjects with a contemporary veneer. In 1630, for example, the deceit of a quack tooth puller and the gullibility of an all too trusting public provided the backdrop for *The Dentist* (cat. 4, fig. 2). Dated paintings for every year between 1630 and 1636 followed, documenting Molenaer's growing maturity as a painter, storyteller, and cultural commentator. As his confidence and ability as a painter grew, the shortcomings evident in his earliest pictures soon disappeared. The influence of Frans Hals also dimmed, as Molenaer occasionally turned to others for inspiration.

A small sampling of his pictures from these years provides indisputable evidence of his genius. Covering a range of artistic and iconographic concerns, and highlighted by his production in 1633 and 1636, Molenaer's work was hardly equaled among his peers. Only Jan Steen, working a generation later, would take Molenaer's example a step further. Since many of these pictures are discussed elsewhere, a listing of the dated pictures from these years provides strong evidence of the artist's wide-ranging interests.

1630 The Dentist, *Herzog Anton Ulrich-Museum, Braunschweig*
1631 The Artist in His Studio, *Staatliche Museen, Gemäldegalerie, Berlin*
 The Ball Players, *private collection, Rotterdam*

The painter's histories, allegories, portraits, and pastorals combine with his more representative scenes of everyday life to create a truly remarkable oeuvre. Diversity also applies to his choice of figure type, execution, palette, setting, and message. The paintings Molenaer completed in 1634, for example, are characteristic of this artistic virtuosity. *Two Children (Taste)* shows viewers the "peasant" Molenaer, as the coarse features of the youngsters are broadly defined by a tonal palette. By contrast, *Three Women at a Virginal* (Bogendorf Rupprath fig. 4) represents one of the painter's most sophisticated and colorful works, with the figures and their well-appointed setting finely painted.

It is interesting that the painter often combined his two "modes" within a single painting. The well-known *Allegory of Fidelity* (cat. 13), for example, employs a tonal palette with open brushwork for the fighting peasants on the far left, but the lion's share of the composition is assigned a more refined and colorful treatment. Molenaer's other painting from 1634, *Family Visiting a Village School* (fig. 7), best documents his two artistic worlds colliding. Foreshadowing his interest in low-genre subjects to follow, this painting effectively brought the unruly behavior of peasants to center stage.

The *Family Visiting a Village School* finds an upper-class family entering a schoolroom filled with peasant children and their teacher. The juxtaposition of this well-dressed family and their rowdy counterparts would not have been lost on contemporary viewers. The scene raised important issues ranging from the competence of the teaching and the poor learning environment to more complex questions regarding the disciplining of children.[13] While a cautionary note is provided the family, who are understandably alarmed by the behavior they witness, Molenaer applied many humorous touches to the scene. In the center fore-

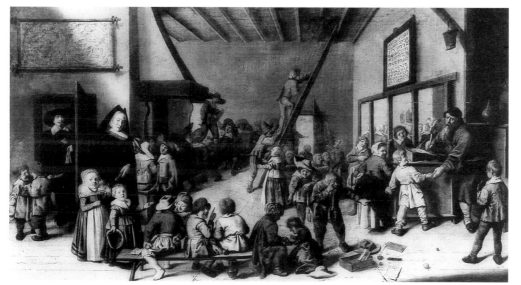

Fig. 7
Family Visiting a Village School, 1634
Oil on panel, 19 ½ x 34 in.
Staatliche Museen, Gemäldegalerie
Alte Meister, Kassel

ground, for example, a seated young boy with a wide grin points to two of his classmates who flee the classroom up a ladder. Clearly, the threat of punishment has little effect on these young scallywags. The upper-class children view events from a far different perspective. For them, proper instruction and discipline, rather than an endless state of recess, represent the way to knowledge. It is a path their serious-minded parents are sure to show them.

Molenaer's first Haarlem period ended in 1636, a productive year that would figure prominently in his life and career. Documents largely silent with regard to Molenaer prior to 1636 now spoke volumes.[14] When combined with Molenaer's signed and dated paintings from 1636, these documents present a remarkable picture of the artist and his activities. His earlier experimentation with a range of subjects, styles, and messages now came to full flower, for during 1636 he produced numerous works of exceptional quality and diversity.[15]

Molenaer's unusually large output in 1636 came in spite of events in his active personal life. Documents from the year confirm the painter appeared before the court on at least eight occasions. Several individuals had sued him for failure to pay for goods and services, while the artist initiated a number of other suits seeking payment for paintings and property. During one remarkable day, July 29, Molenaer sued two individuals in separate actions. The first of these suits alleged that Jacob Pieterszoon owed him 34 guilders toward the purchase price of paintings.[16] The second action was directed toward Huybert Persoons over the disposition of a watch belonging to Molenaer that he had left at Persoons's shop.[17]

These cases are not isolated examples, as Molenaer spent a great deal of time and energy in subsequent years embroiled in legal disputes. Besides being interesting reading, they ultimately reveal much about the artist's character and financial situation.[18] In addition, other documents from 1636 provide insight into Molenaer's personality. One from early May concerns a lottery Molenaer helped organize in Heemstede. He contested its outcome by withholding the prize money, since the winner allegedly had not paid for the winning ticket. His obvious anger over the situation is apparent in the accusation uttered by Molenaer and placed into the public record: "Daer kryckt dat hontsvotge een prijs" (There received that little scoundrel a prize).[19] The document thus portrays Molenaer as a rather vocal, if not belligerent, participant in the proceedings. As will be seen, such a characterization does not contradict evidence in other documented events in his life.

The most significant event to occur in 1636 was the marriage between Jan Miense Molenaer and Judith Leyster.[20] The couple posted their wedding banns in Haarlem on 11 May and were married in Heemstede on 1 June. Heemstede, located just south of Haarlem, figured significantly in the lives of Molenaer and Leyster. He spent much of his last twenty years in the village, having bought a house there in 1648. Leyster, who died eight years before her husband in 1660, was buried there.

Molenaer and Leyster, whose financial situation was not particularly healthy in 1636, were wed only after agreeing to an unusual financial arrangement. A document of 12 August 1636 cites several individuals who testified that Molenaer and Leyster promised to pay the debts incurred by Molenaer's mother and those family members still living with her.[21] Jan Miense Molenaer—named after his father, who died earlier in the year—assumed the responsibility to make good on these debts, an obligation required of the firstborn son. Creditors appear to have prompted the public record of this financial arrangement, as the document from 12 August lists both a druggist and a baker who demanded payment.

In fact, the court confiscated the painter's property on the first of November of the same year to pay debts owed to two other creditors, Philips Gerritsz and Hendrick Adriaensz.[22]

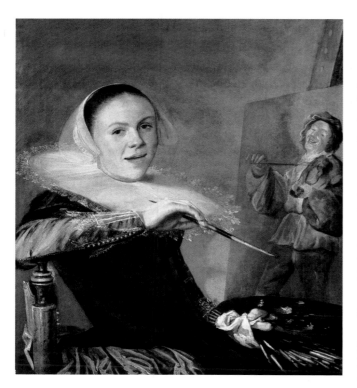

Fig. 8
Judith Leyster
Self-Portrait, ca. 1630
Oil on canvas, 29 ⅛ x 25 ⅞ in.
National Gallery of Art, Washington,
D.C., Gift of Mr. and Mrs. Robert
Woods Bliss

One suspects this setback only added to the newlyweds' decision to move to Amsterdam the following year.

Molenaer and Leyster

While their wedding in 1636 officially recognized the relationship between Molenaer and Leyster, the couple's artistic courtship certainly predated their nuptials by more than half a decade. Leyster, born in Haarlem in 1609, fell under an early spotlight. In 1628 Samuel Ampzing, in his *Beschryvinge ende Lof der Stad Haerlem in Holland*, alluded to her in a poem describing the talents of the De Grebber family.[23] Hofrichter notes, however, that Leyster's inclusion in this publication came at the tender age of nineteen and may have had as much to do with her gender as her talent.[24] Five years later, in 1633, Leyster (fig. 8) did become the first woman to be admitted into the Haarlem guild of St. Luke.

The promise of her early fame and the brilliance of her paintings dated between 1629 and 1635 proved to be short lived. Following her marriage to Molenaer and their move to Amsterdam, her production largely ceased. Still, in 1648, when her name again appeared in another history of Haarlem, she continued to receive top billing over Molenaer.

There also have been many experienced women in the field of painting who are still renowned in our time, and who could compete with men. Among them, one excels exceptionally—Judith Leyster, called "the true leading star" in art—she is the wife of Molenaer, another renowned painter born in Haarlem, and well known in Amsterdam.[25]

In spite of Schrevelius's use of the present tense, it appears that Leyster had abandoned her muse to concentrate on household and family matters. Chief among these responsibilities were her children, only two of whom, Helena and Constantinus (Constantijn), survived infancy.[26] Nevertheless, Leyster must have spent considerable time assisting Molenaer in his artistic enterprises as a painter and art dealer.[27] Documents also indicate that Leyster held power of attorney for Molenaer, indicating she played a role in his numerous legal affairs.

The key question regarding the relationship between Molenaer and Leyster is whether they collaborated on individual works, either before or after their marriage. Unfortunately answers are not forthcoming, and attempts to prove collaboration have been inconclusive. There are no documents describing collaboration; nor are there paintings that carry both of their signatures. Such attempts range from their purported collaboration on a picture entitled *The Unexpected Visit* to an unpublished paper on *The Dentist* (cat. 4).[28] Over the years there have been a number of pictures attributed first to one and then the other of the painters.[29]

Attribution questions do suggest that there existed a close working relationship between Molenaer and Leyster in the late 1620s and early 1630s. Bogendorf Rupprath offers proof in her essay devoted to workshop practices and the sharing of studio props. Pieter Biesboer addressed the topic with an essay in an exhibition catalogue entitled *Judith Leyster: Painter of 'Modern Figures.'*[30] He cited pictures that reflected Molenaer's influence on

Leyster and convincing examples suggesting they were both trained in the workshops of Frans and Dirck Hals.

The early artistic influence of Molenaer on Leyster can definitely be seen in Carousing Couple, *a work dated 1630. Here, the brilliant red, blue, and reddish orange, and the positioning of the figures around a corner of the table, are reminiscent of Molenaer's early paintings, all of which hark back to examples by Dirck Hals.* Carousing Couple *again shows Leyster's preference for focusing on one or a few figures in her paintings, whereas when her contemporaries painted such "modern figures," they often included more.*[31]

The Lure of Amsterdam

During 1637 Molenaer and his bride moved to Amsterdam. Drawn to the city like so many others, they resided there for the next twelve years. Unmatched as a center of trade, Amsterdam's enormous growth was fueled by a booming economy. These extraordinary circumstances translated into expendable income for the growing middle and upper classes, bringing with it commissions and sales to Molenaer and his contemporaries.

The twelve years that Molenaer lived in Amsterdam saw many developments in both his personal and artistic life. He began the period by continuing to paint many of the same subjects found in pictures completed in the previous years, including theatrical scenes, the five senses, religious narratives, and well-dressed figures in interiors. These works often exhibit the same inventiveness and high quality of execution discernible in many of his earlier paintings. Peasant imagery, which had attracted Molenaer only sporadically prior to his move from Haarlem, eventually became the major focus of his art after 1640.

If one considers that 1636 represented a peak in his artistic production and inventiveness, there is ample reason to believe Molenaer was preparing for his move throughout this period. His preparation clearly paid rich dividends, as the artist quickly garnered a major commission and seems to have found a market for some of the same subjects he painted in Haarlem. Documented income generated from his extant works from this period, and a small inheritance Leyster received in 1639, suggests that Molenaer's desperate financial situation improved during the early years of their stay in Amsterdam.[32] Documents also reveal Molenaer possessed a business savvy that enabled him to make the best of his new situation.

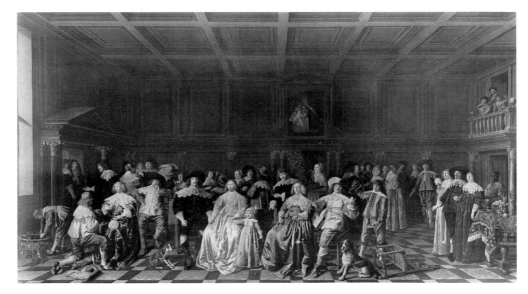

Fig. 9
The Wedding Portrait of Willem van Loon and Margaretha Bas, 1637
Oil on canvas, 37 x 65 ¾ in.
Museum van Loon, Amsterdam

It must have been shortly after the move that Molenaer received the commission to paint a large group portrait of one of Amsterdam's most important patrician families. Molenaer completed the work, arguably the major achievement of his forty-year career, before the end of 1637. *The Wedding Portrait of Willem van Loon and Margaretha Bas* (fig. 9) repre-

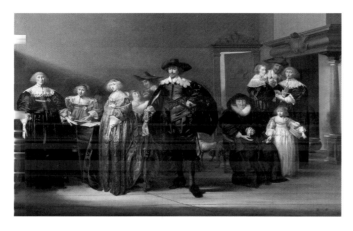

Fig. 10
Pieter Codde
Portrait of the Family Twent in an Interior, 1633
Oil on panel, 19 ¼ x 30 in.
Johnny van Haeften, Ltd., London

sents the lavish marriage party of the couple. Married 6 October 1637, the newlyweds appear at the composition's center. Over forty figures, many of them members of the Van Loon family, are among those pictured within the large banqueting hall. Missing is Hans van Loon the Younger, one of the groom's brothers. He had died in battle four years earlier. His absence is indicated by the empty chair tipped on its side in the foreground.

In many ways this large portrait expands upon the stylistic and iconographic goals Molenaer realized in some of his genrelike portraits from the mid-1630s (cats. 23, 24). Here he skillfully integrates the festive nature of the event with the portrait requirements of the commission, a vehicle through which he helped establish his artistic reputation in Amsterdam. The quality of the individual portraits, the representation of their colorful and expensive clothing, and the nature of the still-life elements, while occasionally equaled in his works, were never surpassed. In fact, there is nothing in Molenaer's earlier works approaching the scale and complexity of the *The Wedding Portrait of Willem van Loon and Margaretha Bas*. A deeper understanding of this remarkable achievement requires that we look beyond Molenaer to his possible influences. Among those artists who painted small-scale, full-length portraits within genrelike domestic interiors were Hendrick Pot in Haarlem and the Amsterdam portraitists Thomas de Keyser and Dirck Santvoort. It was another Amsterdam painter, Pieter Codde, who may have had the greatest impact on Molenaer. His pictures skillfully combined portraiture and genre in a manner very similar to the approach taken by Molenaer (fig. 10).[33]

Once in Amsterdam, Molenaer and Leyster settled in a house on the Gasthuismolensteeg, a street near the Dam connecting the Herengracht with the Singel. Painting sales and Leyster's modest inheritance enabled the couple to move into a larger house on the Kalverstraat near the Doelen within a few years. This house came with a yearly rent of 450 guilders and was described as having "a clock in the gable."[34] Molenaer and his family would reside there for nearly ten years.[35]

Throughout 1637 Molenaer continued to explore a variety of subjects and painting styles. In contrast to the refinement in brushwork and palette displayed in the wedding portrait, he adopted a largely tonal, painterly manner for his other signed and dated pictures from the year. Discussed in the catalogue, *The Five Senses* (cat. 26) and *The Fat Kitchen* (cat. 25) serve as an introduction to the amusing peasant narratives Molenaer favored in the last three decades of his career. Such pictures betray other important artistic influences for Molenaer. They include Adriaen Brouwer, who spent time in Haarlem in the 1620s, and especially Adriaen van Ostade.[36]

Documents and other sources point to the fact that Molenaer attracted buyers to his peasant pictures in Amsterdam's highly competitive art market. Nevertheless, his increasing focus on painting low-genre scenes did not prevent him from receiving important commissions in the waning years of the 1630s. A signed and dated picture from 1639, the *Mocking of Christ* (fig. 11), underscores his continued success in this genre.[37] A major commission for the artist, this altarpiece represents Molenaer's largest and most emotionally compelling work. In the *Mocking of Christ*, a repulsive assortment of disheveled characters enthusiastically participates in the humiliating event. They stand in direct contrast to Christ, who retains his dignity in spite of humanity's ugliness. He looks directly out to the viewer, showing neither pain nor anger. The narrative closely matches the biblical source,

and Molenaer's composition adapts a number of motifs he used six years earlier in the *Denial of Saint Peter* (cat. 14).

The subject's particular popularity in Catholic Flanders may offer insight into the painting's genesis. For example, Molenaer must have known a reproductive print of Anthony van Dyck's thematically related *Christ Crowned by Thorns*.[38] In both compositions, Christ sits at the center, his wrists lashed together, a robe falling off his knees to the ground, and his right foot extended beyond the edge of the garment. He is pictured within a semicircle of tormentors, including one who kneels at the lower right and places a reed cane in Christ's hand.

The serious issue raised in the *Mocking of Christ* and the closely dated *Self-Portrait with a Skull* (cat. 30) finds its opposite in the peasant merry companies that increasingly occupied Molenaer's energy into the 1640s. Perhaps hoping to occupy the low-genre niche in Amsterdam comparable to the one occupied by Adriaen and Isack van Ostade in Haarlem, Molenaer painted both interior and outdoor merry company scenes and related subjects. Typically, his compositions showcasing the unruly behavior of the underclass embrace a largely tonal palette, with smaller scale figures occupying larger spaces. His paint application continued to evolve, however, as he reserved a more descriptive mode and occasional flashes of local color for the foreground figures in his more ambitious works.

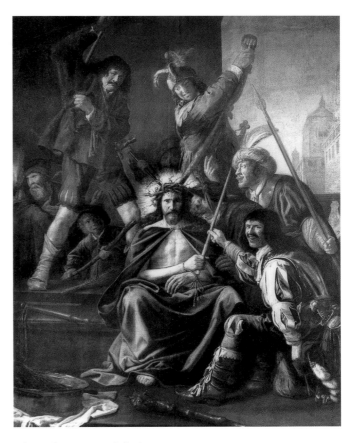

Fig. 11
Mocking of Christ, 1639
Oil on canvas, 80 x 103 ¼ in.
Saint Odulphus Kerk, Assendelft

The changing nature of Molenaer's work, from the early didactic pictures to the peasant scenes that followed, is clearly on view in another transitional work, *Family Portrait with Slap Hands* (fig. 12). Here a well-dressed, upper-class family poses within the spacious confines of a rustic interior. They share the room with a group of lower-class rowdies playing a game of "slap hands."[39] As unlikely as this combination of figures may seem, it again highlights Molenaer's willingness to populate his scenes with individuals from different social classes. Like its counterpart in the previously discussed *Family Visiting a Village School* (fig. 7), the reserved family is neither amused by the behavior of the lower-class merrymakers nor inclined to participate in the game.

Molenaer showed the family's disdain for such unacceptable behavior by emphasizing their gestures and by physically separating the two groups. One is certain this conservative family would have sided with the preachers of the Reformed Church who railed against such games.[40] Many believed parlor games of this type undermined accepted moral values and were to be avoided. According to Bredero, an acknowledged authority on rowdy behavior and an author whose words were certainly known to Molenaer (see cat. 36), "fine and cheerful burghers should not get mixed up in peasant parties because these are not sweet occasions."[41]

The *Family Portrait with Slap Hands* focuses the viewer's attention on the disdain of

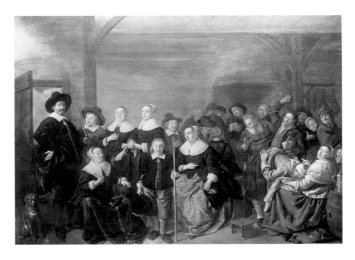

Fig. 12
Family Portrait with Slap Hands,
ca. 1635–40
Oil on panel, 19 ¼ x 26 ⅜ in.
Whereabouts unknown

one group toward the actions of another. Molenaer's images of peasants are typically filled with merriment, as the viewer is engaged by the riotous actions of musicians, dancers, drinkers, smokers, card players, lovers, and even fighters. Without exception, the upbeat merrymakers far outnumber those individuals whose lot in life is filled with pain and suffering. Did peasants live such happy, carefree lives, and if not, why did Molenaer fictionalize them in this way? By emphasizing their pleasures, did he intend a didactic message for the onlooker? In the *Family Portrait with Slap Hands*, the painter seems to have showcased merrymaking by the lower classes without overtly condemning it. Lurking in the background of such scenes, however, are warnings regarding excess and overindulgence.

One remarkable example from this period of his activity, *Merry Company in an Inn* (fig. 13), chillingly details the consequences associated with a life consumed by vice. Inside a bordello a prostitute sits on the lap of her customer. As she shakes loose the coins in his money purse, her accomplice collects the gold pieces before they hit the floor. Behind them, others drink, smoke, and participate in lascivious thoughts and deeds, while a pair of musicians provides accompaniment to the debauch. Questions as to whether or not the painter intended to warn the viewer against such behavior are answered with his inclusion of one additional motif. Silhouetted in the doorway at the far right is the skeletal figure of death, holding its attributes of an hourglass and sickle. While death has yet to quiet the festivities, Molenaer assured the onlooker that the merrymaker's time on earth is short and one will ultimately be held responsible for one's actions.

Molenaer's remaining years in Amsterdam, from about 1640 to 1648, continued to be eventful, as he claimed the position as one of the city's premier painters of peasant merry companies. At the same time, documents show him engaged in both personal and related professional commitments, including family births and funerals, numerous court cases, and the marketing of his paintings.[42] While peasant interiors and village scenes dominated his artistic interests, he occasionally returned to subjects he painted in the 1630s. Unfortunately, few dated pictures remain from these years. This lacuna, as well as the fact that Molenaer increasingly recycled motifs (see cat. 32), makes it difficult to fully assess the parameters of his stylistic development during these years and afterward.

Chief among his accomplishments from the 1640s are a number of outdoor scenes, a handful of which carry dates. A survey of these pictures is enlightening, for such a listing reflects the diversity and inventiveness he brought to the subject. Included in this outstanding group of pictures are *A Village Wedding Procession*, *The Poultry Seller*, *A Game of Slap Hands*, *Peasants before a Windmill* (1643), *Shooting the Parrot* (Westermann fig. 6), *A Village Feast* (1644), *Saint John Preaching in the Wilderness* (1646), *An Itinerant Ballad*

Reader on a Bridge (cat. 31), and *Peasants Merrymaking Out-of-Doors* (fig. 14).

Reflecting changes in Molenaer's artistic aims, *Peasants Merrymaking Out-of-Doors* (fig. 14) probably dates near the end of the decade. Missing is the naiveté that marked his earlier outdoor scenes from the 1630s. Typically the figures are now painted on a smaller scale in relationship to their setting, and Molenaer extended them well into the middle ground of an extensive village landscape. Forced expressions and questionable proportions have also been eliminated. Generally Molenaer adopted the compositional format found in village scenes painted by Isack van Ostade.[43]

Peasants Merrymaking Out-of-Doors is particularly interesting in that the figures appear involved with "some form of pastoral play, accompanied by music and dancing."[44] The imagery is in keeping with the sentiments Johan van Heemskerck expresses in his popular *Batavische Arcadia*. First published in 1637 and released in an expanded edition ten years later, *Batavische Arcadia* describes a journey through the countryside by a group of young people.[45] During their wanderings they come in contact with the peasant class, including a disheveled mistress of an inn and ignorant shepherds. By detailing the encounter between the city visitors and the villagers, Molenaer, it can be argued, followed popular perception that affirmed by contrast the moral, social, and intellectual superiority of the young people.

By the end of 1648, Molenaer and his family left Amsterdam and settled into a heavily mortgaged house in the village of Heemstede, south of Haarlem.[46] It appears the rural setting that served as a backdrop in so many of his village scenes now became a part of his everyday life.

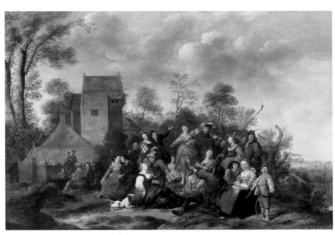

Fig. 14
Peasants Merrymaking Out-of-Doors, ca. 1640s
Oil on panel, 29 ¾ x 41 ⅞ in.
Collection of Her Majesty Queen Elizabeth II, Hampton Court Palace

Late Career: 1649–1668

If one accepts the adage that it is the quality, not the quantity, that counts, then Molenaer's unexpectedly large production from the last two decades of his career largely disappoints. There are exceptions, however, for in spite of scores of uninspired paintings highlighting the antics of merrymaking peasants, he managed to produce many fine examples during the 1650s and 1660s. These compositions include attempts to mimic the painters of high genre (cat. 34), elaborate outdoor feasts and celebrations (fig. 15), and engaging and beautifully crafted interior merry companies, including one important example (cat. 36) linking the painter to the words of Bredero.

The final phase of Molenaer's career began with the move to Heemstede in 1648. For the next twenty years, until his death in 1668, documents concerning the painter are plentiful and his production is large. No works or documents, however, offer many clues in determining the chronology of his uneven oeuvre. In addition, works by copyists and his close followers have clouded the understanding of Molenaer's late paintings. Similarly, pictures by his brother Bartholomeus (d. 1650) and the unrelated Jan Jacobsz. Molenaer (d. 1685; fig. 16) have long carried attri-

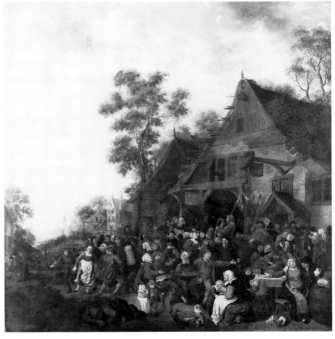

Fig. 15
The Tavern Swan, 1657
Oil on panel, 40 ½ x 37 ⅞ in.
Rheinisches Landesmuseum, Bonn

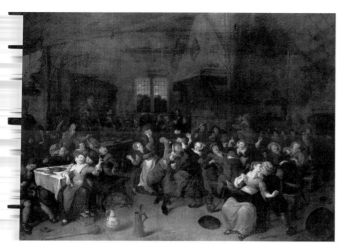

Fig. 16
Jan Jacobsz.(?) Molenaer
Peasants Drinking and Dancing,
1670s
Oil on canvas
Westfällisches Landesmuseum für
Kunst und Kulturgeschichte, Münster

butions to Jan Miense, usually to his detriment. Unfortunately, attribution questions are not always easy to resolve. The issue even surfaced during the painter's lifetime, as is documented in a suit presented before a Haarlem notary on 8 July 1653.

Jan Miense Molenaer declares before a notary at the request of Aechie Harmens, the wife of Claes Jansz. in Amsterdam, that two small pictures she has acquired second or third hand were painted by him . . . Molenaer painted the two pictures three months ago, and no one else has painted any part of them.[47]

With relative ease, one could select groups of paintings that argue for and against Molenaer's ability as a painter during the last phase of his career. Late works in the exhibition were understandably selected to highlight his considerable skills. By contrast, a search of auction catalogues over the last decades shows those pictures likely to dampen enthusiasm for his art. These lesser works, however, provide insights into the circumstances behind their execution, in particular his habitual use of paintings as barter. Since some of these business dealings ended up in court, they tell us how Molenaer and other interested parties judged the quality and value of his paintings.

An important document dated 2 February 1662 recounts one instance of this practice.[48] It concerns the interest on the capital with which Molenear's home in Heemstede was encumbered. An agreement between Jacob van Amersfoort and Molenaer stipulated that the latter was to execute for Amersfoort a large painting depicting the subject *Arent Pieter Gijsen* taken from a songbook by Bredero (see cat. 36, fig. 1). The value of the picture was set at the considerable sum of 380 guilders. Upon its completion Amersfoort would deduct the amount Molenaer owed him. In addition, Molenaer was also to paint a second, smaller work for Amersfoort, this time a subject of the artist's choosing. Its value could not be less than the cost of the frame for the large painting. The document indicates Molenaer's paintings were assigned values depending on size, quality, and subject.

The final two decades of his career were not always kind to Molenaer, as mounting debt, relocations, energy directed to finding a second income, illness, and, above all, the death of Leyster in 1660 all took their toll. His irritable nature surfaced more than once in the documents. By contrast, the birth of his son Constantijn in 1651, the entry of his brother Klaes into the Haarlem painter's guild in the same year, and the satisfaction associated with likely commissions represent highlights from this period. A number of these observations relate to a signed and dated panel from 1657, *The Tavern "Swan"* (fig. 15).

The "Swan" serves as the backdrop for an animated outdoor celebration.[49] Villagers experience the pleasures of food and drink, dancing, and serious flirtation. For some, in particular the man passed out in the left foreground, overindulgence is beginning to show its negative effects. While the tone of the scene is humorous, questions are again raised regarding how Molenaer's contemporaries viewed this scene. Specifically, were they disdainful of such overindulgence and waste? A resounding answer comes via the man defecating in the foreground.[50] As he holds his pants below his knees, a dog sniffs at his ex-

posed buttocks. It was no coincidence that Molenaer positioned him at the very center of the scene. As the picture's *clavis interpretandi*, this squatting man informed contemporary viewers that this gathering, both literally and metaphorically, was not, to use the words of Bredero, a "sweet occasion."

In 1657, the year Molenaer dated *The Tavern "Swan,"* a document described the painter as "a tavern owner on the Clerksteeg in Haarlem."[51] In need of a second, and possibly a third, income as a picture dealer, the painter found his financial situation again perilous as he approached the last decade of his life. Other documents seem to confirm his plight, as he brought suit against a number of individuals who allegedly owed him money. Molenaer's name surfaced in other cases as well, including one detailing the violent side of his character. Again, the year is 1657. On 7 March, Seger Roelofsz, a carriage maker in Haarlem, stated in a deposition that

[t]he latter [Molenaer] beat him so badly on the preceding February 19 in the evening between eight and nine, that he still had to spit blood for several days afterwards. Also Molenaer called him and all the inhabitants of Heemstede thieves and committed other improper acts.[52]

Molenaer's difficulties reached a critical juncture late in 1659, when both he and Leyster, described as sickly, made their last will and testament.[53] Three months later, Judith Leyster died at the age of fifty and was laid to rest in Heemstede.[54] Molenaer recovered, however, and produced a remarkable group of pictures between the years 1659 and 1662. Discussed elsewhere (see cats. 35, 36), these paintings are unequaled in ambition and quality among works produced during the last quarter century of his career. In each, a subtle silvery light illuminates cavernous, barnlike interiors where crowds of animated merrymakers are described with great detail. The muddy browns and related earth tones found in so many of his late works were kept at a minimum, as was his typically coarse paint application.

Following this outburst of creativity, Molenaer never again reached the level achieved in these pictures. A near lack of dated paintings from 1663 to 1668 also makes it difficult to assess further stylistic development. A final clue to Molenaer's artistic identity is offered in his last signed and dated painting, the 1667 *Merry Company at a Table* (cat. 37). The painter limited himself here to a handful of large-scale figures around a table in the foreground. While the compositional format is reminiscent of many of his early works, its focus, like the vast majority of his peasant merry companies, remains on the spirited behavior of the merrymakers. Palette and execution differ greatly, however, from his paintings dated a few years earlier. Browns, grays, and rusts dominate, and the paint application becomes far less descriptive.

Conclusion

It has been observed that one of Molenaer's late masterpieces, *Peasants Carousing* (cat. 36), "continued the Haarlem tradition of peasant scenes founded by Adriaen Brouwer and Adriaen van Ostade," as it "resembles in many ways the work of Molenaer's younger contemporary Jan Steen."[55] This brief description serves as a fitting conclusion to this discussion on Molenaer and his art. A comparison between the oeuvres of Molenaer and Steen finds many points of convergence that must be more than coincidental.[56]

The year following his last dated painting in 1667 (cat. 37), Molenaer died in his hometown of Haarlem. He was laid to rest at St. Bavo's on 19 September.[57] An inventory of his

possessions was recorded with the Haarlem notary on 10 October 1668 (Appendix). Interestingly, this inventory suggests an individual of means, not someone constantly fighting over finances with his creditors. At a distance of more than three hundred years, this discrepancy remains puzzling and, like his art, contributes to the mystery of this enigmatic and complex painter.

1 Discussed below and especially in cat. 36, Bredero's *Boertigh, amorous, an aendachtig Groot lied-boeck* of 1622 appears to have been an important source to Molenaer. Also see Weller 1992, pp. 254–60.

2 Although a catalogue raisonné has not been published, Weller 1992 provides an account of the artist's life and artistic concerns. Additional information regarding the painter is found in Haarlem and Worcester 1993, especially pp. 21–31, and cats. 27–35.

3 Bredius 1915–22, vol. 1, pp. 1–26 (1915), and supplement, pp. 154–61 (1922) published most of the documents concerning Molenaer. Also consult Broersen in Haarlem and Worcester 1993, pp. 15–38.

4 See New Brunswick 1983 and Weller 1997, pp. 165–68.

5 Martin 1905–07.

6 The four pictures are *The Breakfast Scene*, Museum Kunsthaus Heylshof, Worms; *Family Scene*, Mittelrheinisches Landesmuseum, Mainz; *The Dentist*, North Carolina Museum of Art, Raleigh; and *Two Boys and a Girl Making Music*, The National Gallery, London.

7 Houbraken 1718–21, vol. 1, p. 93.

8 Ampzing 1628, p. 371.

9 For discussion of their respective works, see Haverkamp-Begemann 1959 and Keyes 1984.

10 Excerpt from "The Rise of Dutch Painting during the Twelve Years' Truce" delivered by H. Perry Chapman at the Woodrow Wilson Center for International Study, Washington, D.C., 1 August 1991.

11 Molenaer showed a strong interest in subjects painted by Pieter Bruegel the Elder the previous century. As is discussed throughout the catalogue, Molenaer should be identified as a leading practitioner of a Bruegel revival.

12 The *Allegory of Fidelity* in Richmond is the painting most strongly linked with Molenaer's innovative approach to subject and message. See

cat. 13 for the literature devoted to this picture.

13 Weller 1992, pp. 236–41, examines Molenaer's peasant school scenes and the possible messages they conveyed to the contemporary viewer.

14 Bredius 1888–90 was the first to explore the documents relating to Molenaer's activity in Amsterdam from 1637 to 1648.

15 In addition to the signed and dated works from 1636 listed above, stylistic evidence points to a number of others that must have been executed the same year. Chief among them is the *Self-Portrait with Family Members* in the Frans Hals Museum, Haarlem. This work is illustrated and discussed in the Introduction.

16 Bredius 1915–22, vol. 1, p. 10.

17 Ibid.

18 Molenaer exhibited a combative nature throughout his lifetime, especially in regard to financial matters. This aspect of his character, as well as other documented events, prompted his inclusion in Rudolf and Margot Wittkower's *Born under Saturn: The Character and Conduct of Artists*, 1963, p. 217. They write:

Molenaer (1610–1668), married to the well-known painter Judith Leyster, the daughter of a bankrupt, also appears in a great many court cases for a variety of offenses. Among others he was twice convicted for using insulting language in brawls which sprang up when he was raffling his paintings.

19 Bredius 1915–22, vol. 1, p. 9.

20 Documentation concerning the betrothal of marriage between Joannes Molenaer and Judith Leyster, both of Haarlem, appears in the Haarlem *DTB* (Death, Marriage, Birth registers), vol. 50, folio 321. Published by Van der Willigen 1870, p. 151, the most complete account of the documentation concerning the couple's betrothal and marriage, as well as information on their children and property speculation, is found in Hofrichter 1989. Also see Weller 1992.

21 Bredius 1915–22, vol. 1, p. 10.

22 Ibid., supplement, p. 155.

23 Ampzing 1628, p. 370. The passage, including the note in the margin, reads in translation:

*Now I have to mention Grebber / The father and the son and also the daughter I have to praise. / Who ever saw a painting made by the hand of a daughter? / *Here is somebody else painting with good and bold sense / The Grebbers are well known because of their big pictures. / Who saw that somebody's hand and mind were playing here in a bolder way?*

[marginalia:]
*Frans Grebber, With his Son Pieter, and daughter Maria. *JudithLeyster.*

24 Hofrichter 1989, p. 29.

25 Schrevelius 1648, pp. 384–85.

26 Helena was baptized in Amsterdam's Nieuwekerk on 8 March 1643 (*DTB*, vol. 42, folio 348), and Constantinus on 15 March 1650 in the Reformed Church of Haarlem (*DTB*, vol. 14, folio 137).

27 The large number of pictures listed in the inventory of Molenaer's possessions following his death (Appendix) casts light on Molenaer's profession as an art dealer.

28 *The Unexpected Visit* (whereabouts unknown) was one of many misattributed pictures appearing in the *Dutch Exhibition* at London's Whitechapel Art Gallery in 1904.

29 See, for example, cat. 2.

30 Haarlem and Worcester 1993, pp. 75–92.

31 Ibid., p. 83.

32 On 10 March 1639, Leyster received an inheritance amounting to nearly 724 guilders (Hofrichter 1989, p. 83). A week later, on 19 March, Molenaer took possession of her inheritance (see Bode and Bredius 1890, p. 67, and Hofrichter 1989, p. 83).

33 Later in his career, Molenaer and Codde were linked in a document dated 14 April 1654, which states that Codde, mentioned as a friend of Molenaer, served as a judge in a dispute between Molenaer and

Herman Coerten (Bode and Bredius 1890, p. 69).

34 Bredius 1915–22, vol. 1, p. 13.

35 After stays in Heemstede and Haarlem, Molenaer and Leyster returned briefly to Amsterdam in 1655–56. Throughout this period Molenaer seems to have been involved with property speculation, as he bought, sold, and rented properties in each location. Even earlier, in 1644, he and Leyster had rented a room to the painter Jan Lievens. Like so many of his business dealings, however, things quickly soured. In a suit heard by the Amsterdam notary J. Q. Spithoff on 1 March 1644 (Bode and Bredius 1890, p. 68), Lievens sought the return of one of his unfinished paintings held by his landlord Molenaer. Molenaer stated he had purchased art supplies for Lievens and considered the painting his property.

36 Another painter, Rembrandt van Rijn, may also have influenced Molenaer with regard to the quality of light found in some of his peasant merry companies.

37 See Weller 1992, pp. 215–22, for a discussion of Molenaer's religious paintings.

38 Van Dyck's interest in this subject is discussed in Princeton 1979, pp. 60–72, with numerous illustrations.

39 This game, also known in French as *la main chaude* and in Dutch as *handjeklap*, was a parlor game where "a young man lays his head in a girl's lap while he tried to guess the identity of those who, in playful turns, smacked his rump" (Schama 1987, p. 439).

40 Ibid., 439–40.

41 Taken from Bredero 1622, cited in Alpers 1975/76, pp. 121–22.

42 These issues are discussed in Weller 1992, pp. 126–77.

43 See cat. 31 for one example of Molenaer's reliance on a composition by Isack van Ostade.

44 London 1982, p. 81.

45 Kettering (1983, pp. 71–73) discusses the significance of Heemskerck's *Batavische Arcadia*.

46 Molenaer entered into a contract with Lodewijk de Bas for the purchase of this house in Heemstede on 24 November 1648. The price for the house and property, including a garden and woods, was set at 8,200 guilders. The purchase price was to be paid in three installments of equal amounts: the first due immediately, the second on 24 May 1649, and the third on 24 November 1649. The first two payments were to be made half in cash and half in pictures. See discussion by Hofrichter 1989, p. 19.

47 Bredius 1915–22, vol. 1, p. 15.

48 Ibid., p. 22.

49 The landscape setting for *The Tavern "Swan"* is reminiscent of examples painted by Molenaer's

youngest brother, Nicolaes (Klaes), who entered the Haarlem painters' guild in 1651. If the brothers did collaborate on this picture, then it can be added to a handful of others in which the painters appear to have worked together.

50 The argument can be made that this figure functions in a manner similar to the woman potty training her young child in the foreground of *Peasants near a Tavern* (cat. 17).

51 Bredius 1915–22, vol. 1, p. 19.

52 Ibid., supplement, p. 157.

53 Ibid., vol. 1, p. 22.

54 Leyster's interment took place on 10 February 1660. The invitation was published by Van der Willigen 1866, p. 152. Unfortunately, this invitation is now lost. Hofrichter 1989, p. 84, provides a translation.

You are invited to attend, on Tuesday, February 10, 1660, at precisely two o'clock in the afternoon, the interment of Judith Leyster, wife of Molenaer, brother-in-law of Jan Radinger and Gerrit ten Bergh, who will be buried at Heemstede on the farm named "The Lamb" near Mr. Paeuw's woods. Enter the mortuary as a friend dressed in a long cloak.
 Church of Heemstede

55 Walsh and Schneider 1979, p. 504.

56 These connections are addressed throughout the catalogue.

57 Van der Willigen 1870, p. 225.

Molenaer in His Studio
Props, Models, and Motifs

CYNTHIA VON BOGENDORF RUPPRATH

Jan Miense Molenaer has been generous. Not only has he provided us with two authenticated works illustrating an artist's studio (fig. 1 and Weller fig. 1),[1] but two other paintings of the subject are attributed to him as well (fig. 2 and cat. 10).[2] Each of the four works offers rare insight into the workshop methods and mechanics of an early-seventeenth-century Dutch artist. In contrast to several other contemporary renditions of studio interiors, in which easels are often turned away from the viewer and artists are not actively engaged in painting (e.g., Rembrandt, *Artist in His Studio*, ca. 1627–28, Boston, Museum of Fine Arts), Molenaer's views depict basic studio operating procedures. He encourages the viewer to observe studio practice. In three of these pictures, the artist is purposely positioned with his back to the spectator, enticing the viewer to peer curiously over his shoulder in order to view the work in progress.[3]

The Artist in His Studio of 1631 (Weller fig. 1) provides a totally unobstructed view of a work in progress. On the easel at the far right, the work appears as the painting representing four figures and a dog. In the studio the models for three of these figures (the old bearded man, the girl, and the dwarf) as well as the dog relax after posing. (The fourth painted figure, a youth in a shaggy blue fisherman's cap, is missing.) They are joined in the studio by the artist, who helpfully points them out to us, and his smiling young assistant, who holds a mahlstick. This composition reveals important information concerning the nature of Dutch genre painting. For all the spontaneity seemingly encountered in them, it is very clear these scenes of everyday life were, in fact, staged. As will be demonstrated, in these works by and attributed to Molenaer, models, props, motifs, and studio equipment are not only intriguingly displayed, but, because they tend to reappear in painting after painting, they can actually be inventoried. Cataloguing these items and personages is useful in assisting attribution and determining chronology. Perhaps even more important, this study lends insight into the working methods and studio practice of Jan Miense Molenaer in particular and of his contemporary Dutch genre painters in general.

Studio Practice: The Use of Artist Handbooks

Against expectation, artist handbooks of the seventeenth century rarely, if ever, advise the painter on exactly what kind of props to stockpile. Nor do they specifically detail what type of model the artist should choose, what sort of clothing he should wear, and what objects should be positioned around him. Models are discussed, of course, but often only in general terms of positioning and demeanor.[4] These theoretical texts are largely devoted to the more technical aspects of painting: color, highlights and shadow, perspective, proportion, and composition. They advocate both copying the masters (mainly from drawings and prints) and sketching *naer het leven* (from life).[5] Yet if a specific studio prop or model

is cited at all, it is often a plaster cast of a classical statue, which authors recommended apprentices draw[6] and which many artists faithfully reproduce in their paintings of studio interiors (e.g., Jan Steen, *The Drawing Lesson*, ca. 1663–65, Malibu, J. Paul Getty Museum). Other didactic materials mentioned and pictured are flayed anatomical figures (e.g., Gerrit van Honthorst, *Self-Portrait*, 1655, Amsterdam, Rijksmuseum)[7] and lay figures—articulated models of the human figure, jointed to render all variety of poses (e.g., Werner van den Valckert, *Portrait of a Man*, 1624, Louisville, Ky., The J. B. Speed Art Museum).[8] A lay figure is also seen in one of the works attributed to Jan Miense Molenaer (fig. 2).

Art theorists also advocated the use of skulls as artistic aids, and they are accordingly depicted in numerous renditions of artists' studios, including those of Molenaer (fig. 1 and cat. 10). Benvenuto Cellini, in particular, in his discourse *Sopra i principii e 'l modo dímparare l'arte del disegno*, advises students to draw skeletal parts, for only then will they be able to reproduce an anatomically correct figure.[9] And indeed, as if to prove the point, Enea Vico's ca. 1550 engraving after Baccio Bandinelli, *The Academy of Baccio Bandinelli in Florence*, dutifully depicts several human skulls, rib cages, vertebrae, hip joints, and femurs strewn across the foreground on the floor of the artist's studio.

Mercifully, Molenaer and his fellow Dutch artists were more restrained, and usually only the skull—of a human or animal—was illustrated. In his *Self-Portrait with a Skull* (cat. 30), Molenaer actually juxtaposes himself with one—an obvious reference to the artist as the personification of *memento mori*. His fellow Haarlemer Pieter de Grebber and the artist and theorist Gerard de Lairesse portrayed themselves in similar fashion.[10] The theme of a youth with a skull, representing Vanitas, is also encountered in Dutch art, as exhibited in the work of Lucas van Leyden, Hendrick Goltzius, Jan Muller, Joos van Craesbeeck, and Frans Hals.

Skulls are also found in the *vanitas* still life, often grouped together with other objects indicative of the transcience of human existence. Molenaer presumably depicted himself painting just such a still life in *Artist in His Studio with an Old Woman* (fig. 1).[11] The painting on the easel illustrates a human skull surrounded by an unlit oil lamp, an overturned empty glass, and a helmet (denoting fleeting earthly power). In the attributed studio scene (cat. 10), his props include musical instruments, a watch, and a book (alluding to the fleeting nature of sound, time, and knowledge), a snuffed-out candle (time), a shell (a collector's piece, denoting temporary wealth), and both human and animal skulls—the sheep and horse skulls at the bottom left were uncovered during recent restoration. Similar items are found on the floor next to the workbench in the 1631 Berlin painting (Weller fig. 1): a lute, gorget, and horse skull. In another Molenaer work, *The Departure of the Prodigal Son* (cat. 9), oversized human, horse, and sheep skulls litter the foreground, as if to impress upon the departing youth the folly of his impetuousness and the brevity of his anticipated pleasure. Probably initially collected by Molenaer as didactic studio aids, these skeletal props used here assume symbolic significance, as do the props in *Allegory of Vanity* (cat. 12), in which a skull serves as a footstool for the personification of Worldly Vanity.[12]

In addition to skeletal remains, musical instruments are frequently featured as standard props in *vanitas* still-life compositions, like those found on the table and in the painting on the easel within the Bredius work (cat. 10). However, Molenaer also includes them in two other studio scenes: a violin and two flutes adorn the wall in *Artist in His Studio with an Old Woman* (fig. 1), and a hurdy-gurdy is being played by the old man in *The Artist in His Studio* (Weller fig. 1). The appearance of these musical instruments within a studio setting is not accidental. Contemporary art theorists recommended them as being essential to the artistic environment. Karel van Mander compares the harmony of music with the ordered art of painting,[13] and Houbraken reports that Gerard de Lairisse at times interrupted his painting to play his violin, suggesting that music served to inspire him.[14] In Molenaer's 1631 studio interior (Weller fig. 1), another aspect of music played in the workroom is encountered: entertainment. Models relax after posing and dance to the tune of the hurdy-gurdy. The mood of gaeity captured in the painting on the easel is easily transferred to the studio itself.

Molenaer's Studio Props: A Visual Record

Fortunately, an inventory of Jan Miense Molenaer's effects recorded on 10 October 1668 (Appendix) gives an indication of the various materials (mostly frames and painting tools), paintings, and graphic works the artist had in his studio.[15] In addition, scattered throughout the house are a number of statues and curiosities. Especially interesting are the objects found in the studio and its vicinity: statues of a naked child and a nude, five plaster casts, guns, and Molenaer's entire collection of musical instruments. As the statues and casts do not appear in any known Molenaer painting, they well may have served merely as didactic material. However, the musical instruments in the studio were most definitely used as props (see below).

The 1668 inventory provides a comparatively small list of studio effects, not at all the cornucopia of props or cabinet of curiosities one might expect of an artist who produced so many paintings. Examination of Molenaer's compositions reveals, however, that he relied on relatively few basic and often inconspicuous props. Most of these articles were common household objects appropriate to genre settings and apparently selected for their ready availability rather than for any obvious symbolic intent. Many are easily recognizable as specific objects because of their unique and distinguishable markings. Painted from life, these props are seen from different points of view in different paintings.

No group of props is reproduced more than the various drinking vessels and containers: pewter wine flagons and tankards, glass wine roemers, stoneware beer jugs, and beer barrels often marked with brewery insignias feature in the majority of Molenaer's numerous merrymaking scenes. In his earliest works, one of the oldest types of brown stoneware is depicted: a large, unadorned transport/storage beer jug (Weller figs. 5, 6).[16] It was quickly superseded in works of the late 1620s and early 1630s by the *baardmankruik* (bearded man's flask),[17] so named for the embossed ornamental head of a bearded man located just under the lip of the vessel, opposite the handle. The sides of this pewter-topped jug type

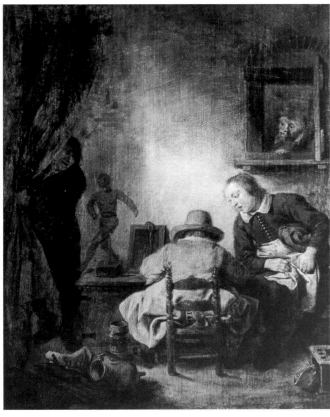

Fig. 2
Attributed to Jan Miense Molenaer
The Drawing Lesson, ca. 1630
Oil on panel, dimensions unknown
Formerly S. Nijstad, The Hague, 1956

were usually decorated with Renaissance motifs: round medallions containing profile heads surrounded by text bands. These medallions are clearly seen in *The Departure of the Prodigal Son* (cat. 9) and *Card Players* (cat. 20), whereas the bearded man's flask is best witnessed in *The King Drinks* (cat. 19). In this latter work, the glutton in the left foreground guzzles from the hoisted *baardmankruik*, much to the startled surprise of his fellow celebrators. Their reaction is of little wonder, as this large vessel was intended to store beer, not dispense it in such a manner.

In the late 1630s and early 1640s, Molenaer introduced two smaller versions of the *baardmankruik* into his compositions. One features a twisted handle and a medallion containing two dancing figures (e.g., *The Young Musicians*, formerly London, Phillips 1990); the other (e.g., cat. 20) illustrates the coat of arms of the city of Amsterdam, the city to which Molenaer moved in 1637. Nevertheless, the particular *baardmankruik* the artist most favored was the elaborately corded stoneware beer jug with a broken neck and handle. It is featured in at least fifteen paintings from 1629 to 1637, by which time the jagged top seems to have been repaired.[18] Since the 1631 *The Artist in His Studio* (Weller fig. 1) shows it placed under the workbench, one can conclude this prop was stored in Molenaer's atelier in Haarlem. It does not appear in dated works following his move from his native city.

Inevitably Molenaer's preference for the *baardmankruik*-type vessel was replaced in his compositions from the 1640s and 1650s by smaller, more fashionable, pewter-lidded white stoneware beer jugs decorated with cobalt blue designs (e.g., cat. 36).[19] Works of the late 1650s and 1660s illustrate two new and often depicted receptacles: a large, lidded beer pitcher bound with brass fittings and a large, kidney-shaped leather wine flask. Both types appear in the foregrounds of *The Peasant Wedding Feast* (cat. 35) and the 1662 *Peasants Carousing* (cat. 36).

A few pieces of household furniture must also have found their way into Molenaer's studio, where they also served as props. One particular high-backed armchair with paneled sides and straw seat is first seen in the 1629 *Family Scene* (Weller fig. 5); it last appears in the 1637 *The Fat Kitchen* (cat. 25). Like the corded *baardmankruik*, it is another prop that apparently was left behind when the artist moved to Amsterdam.[20] Another chair that makes its last appearance in 1637 is the three-legged one seen in *Taste* from the *Five Senses* series in the Mauritshuis (cat. 26). This series is so much influenced by the Antwerp painter Adriaen Brouwer (who resided in Haarlem from ca. 1621/23 to ca. 1625 and again from ca. 1626 to ca. 1631/32 and greatly influenced a number of other local artists) that Molenaer's five paintings were very probably executed before his move to Amsterdam. The three-legged chair also appears in six other works, including the *Card Players* (cat. 20) and *The Artist in His Studio* (Weller fig. 1). Molenaer's 1668 inventory does not mention a three-legged chair, although two three-legged stools were listed in the studio, a type found in his paintings of studio interiors (Weller fig. 1 and cat. 10).

The inventory also mentions twelve "Spanish chairs," so named because of their introduction in the sixteenth century during the Spanish dominion. Originally this design featured high, straight backs, with side posts surmounted by carved lion head finials, straight or scrolled arms, and carved or plain straight legs connected by stretchers. The back and seat were most often upholstered with stamped leather fixed to the frame by large brass-headed nails. By the seventeenth century, a more simplified version of the Spanish (now also called Flemish) chair had evolved, one without arms and a lower back.[21] This represents the type found in many early Molenaer paintings and, presumably, also in his inventory. Although six of the chairs recorded in this document were blue, the paintings display

only black (e.g., cat. 23) or red (e.g., cat. 22) examples stamped with gold medallions. While these chairs reappear in many of his early pictures, their relative exclusion from his later works is probably due to his preference in the 1640s, 1650s, and 1660s for depicting low-life tavern scenes, where such a luxury item would be out of place. One chair that did make the transition as a prop from Molenaer's early to his later periods is the *klapstoel* (folding chair), with or without its removable backrest. Found in some seventeen paintings from his earliest works of 1629 (cat. 4) through the 1640s (cat. 27), it appears in religious scenes (cat. 14) as well as genre scenes (cat. 19).

Molenaer's inventory also lists a great many paintings: some fifty-six works by the artist or his wife, Judith Leyster; ninety-three by named artists; and 105 by anonymous artists. An impressive amount, but Molenaer appears to have reproduced very few of them, if any, in his painted interiors. Only a mere sprinkling of portraits, sea- and landscapes, and genre and still-life subjects are displayed, mostly in the early works.[22] None of them can be attributed with any certainty to any specific artist. More commonly depicted (though notably absent from his inventory) are images of engraved wall maps, a favorite prop for several seventeenth-century Dutch artists. The majority of these painters, however, represented only one or two known examples of maps. By contrast, Molenaer employed at least seven: Petrus Plancius's *The World*, 1604 (e.g., Weller fig. 1 and cats. 9, 12); Nicolaes van Geelkerck's *The World*, published by Johannes Janssonius, 1618 (e.g., cat. 10); Pieter van den Keere's *Italy*, 1615 (e.g., cat. 24); Nicolaes van Geelkerck's *Friesland*, 1618 (e.g., *A Musical Company*, Belgium, private collection, fig. 3); and Claes Jansz Visscher's *The Seventeen Provinces*, 1621 (e.g., *Peasants Merrymaking in an Interior*, Vaduz, private collection).[23] Of all of these examples, only the last dates from the period after Molenaer left Haarlem in 1637. Generally, he restricted his use of artistic license in reproducing these maps to alterations in their actual dimensions, in order to accommodate his compositions.

Of all the musical instruments to be found in Molenaer paintings—the more professional (lutes, theorboes, recorders, transverse flutes, virginals, citterns, scrolled and ebony-headed violins, viola da gambas) and the more folksy (*rommelpots*, tambourines, drums, bagpipes, hurdy-gurdies, triangles, spoons, tongs, and roasters)—a mere handful were recorded in his possession at the time of his death. These included a violin (or viola da gamba), three citterns, two transverse flutes, and a *clopscheen* (the so-named pocket violin, a small and easily portable type commonly associated with contemporary dancing masters).[24] All these instruments were recorded as being located in Molenaer's studio, and he undoubtedly used them as

Fig. 3
A Musical Company, 1636
Oil on canvas, 39 ⅛ x 49 ¼ in.
Private collection

Fig. 4
Three Women at a Virginal, 1634
Oil on panel, 20 x 13 ¾ in.
Private collection

fig. 5
Violin Player, ca. 1633–34
[oil] on panel, 11 ¼ x 9 ⁷⁄₁₆ in.
Private collection

props, as he did countless others throughout his career. There is, however, one notable exception: the virginal, which appears in five works from his early Haarlem period (e.g., cats. 12, 23, and fig. 4). Only one of these (cat. 12) is a small-scale octavo spinet, unusually decorated with three inset-framed paintings of a landscape, seascape, and darkened ovoid. The basic features of the remaining depicted virginals are so similar that, given their high cost and limited accessibility to the painter, all appear to be based on a single model: a rectangular Flemish *muselar* associated with the workshop of Johannes Ruckers of Antwerp.[25]

In keeping with the Ruckers tradition, all of Molenaer's examples are decorated on the drop panel beneath the keyboard and on the frieze above it with block-printed paper containing a Moorish tracery design.[26] The paper on the soundboard depicts strewn flowers, and the exterior cases are decorated with imitation marble. Typically, the interior lid was inscribed with a motto or Psalm, as in Gabriel Metsu's *Man and Woman Seated at a Virginal*, London, National Gallery. Occasionally, however, a landscape was depicted, as in Johannes Vermeer's *Lady Standing at a Virginal* and *A Lady Seated at the Virginal*, works also from the National Gallery. Both of Vermeer's virginals display similar marbling, yet each lid illustrates a different landscape. Molenaer's paintings betray the same incongruity, and it is probable that he, like Vermeer a generation later, asserted his artistic license here.

Clothing suggests an air of distinction, an expression of individual taste. Yet it too was exploited as a common prop by Molenaer and many of his contemporaries. It would seem that Molenaer's taste in costume props varied from the expensive to the ragged, from the military to the everyday, whatever best suited the atmosphere he tried to convey within each painting.

Military apparel appears in several inventories of contemporary artists and their pictures.[27] Rembrandt, for example, pictured himself wearing an iron gorget in several self-portraits of the 1620s and early 1630s (e.g., *Self-Portrait*, Nuremberg, Germanisches Nationalmuseum). It has been suggested that Rembrandt purposely chose the military neckpiece to enhance his image.[28] By contrast, no such grand association is conveyed in Molenaer's depiction of the object. In some paintings Molenaer uses the gorget simply to identify soldiers, who gawk at a folk dance (cat. 6), laughingly observe a dim-witted peasant being outmanuevered in cards (cat. 20), ruthlessly attack carnival revelers (cat. 18), or theatrically accuse a cringing St. Peter (cat. 14). The appearance of the gorget on the floor of his studio in the *The Artist in His Studio* and among the still-life articles scattered on the floor of *The Departure of the Prodigal Son* attests to its prop status. Yet Molenaer does not confine its use to military display. Rather jokingly he sets the iron protection atop the shoulders of a music-making little girl (Weller fig. 6), and it uncomfortably encircles the stretched neck of an inspired adolescent violinist (fig. 5). In these latter examples, Molenaer seems to play with the object; the manner of its display defies its function. He does so as well with other military accoutrements: the large, center-ridged helmet used as a drum by the same little girl (Weller fig. 6) and the spiked helmet capping a skull in the painting

on the easel in *Artist in His Studio with an Old Woman* (fig. 1).[29] The question remains whether his intention was humor, satire, or both.

Headdress props were a special favorite with Molenaer in his early Haarlem period. Apparently stored in the studio and quickly accessed to accommodate a number of different models, they contribute to the staged atmosphere of the artist's early genre scenes and lend color and personality to his painted performers. The black, brushed felt hat trimmed with acornlike frogs that is placed atop a beer barrel in the Raleigh *The Dentist* (cat. 4) goes almost unnoticed. When festooned with a pipe (fig. 6) or bird's claw (Weller fig. 6) and jauntily sported by mischievous youths, this hat lends a sense of merriment to the scene. Molenaer went even further in striving for humor in the lost *Children Making Merry* (fig. 7). Here the youth's cap is decorated with feathers, a spoon, candle, and candlesnuffer. Two other hats regularly reappear during this period: a torn and tattered beige cavalier one with tied brim (e.g., *Hearing*, cat. 3), which sometimes also is depicted with parallel slits to accommodate a pipe (e.g., Weller fig. 6), and a large *bontemuts*, a soft hat with a large, split, turned-up fur brim. The latter hangs atop the easel in the Berlin studio interior (Weller fig. 1), another studio prop. In its gray or red versions, this hat appears in some twenty-three works by Molenaer and is usually worn by older men or by mischief-making children (e.g., *Two Children with a Cat*, location unknown, fig. 8). The last sighting of it is in 1637 (cats. 25, 26), once again the year the artist departs for Amsterdam, leaving many favorite props behind.[30]

Other common attire seems to have been similarly kept at hand: a red cloak with gold-braided buttons and black-embroidered flap collar (Weller fig. 1), a white apron distinguished by its openwork border (cat. 7), and a black-dotted, gray-green doublet (fig. 1 and cat. 22). Here, too, Molenaer had his favorites. Among them was a black fur-lined sleeveless jacket adorned at the shoulders with metal studs. Employed in at least six early paintings,[31] it is worn by a number of different female models, including a young girl (cat. 7) and an old woman (fig. 1). Although the majority of these figures wear the garment belted, the old servant in *Allegory of Vanity* (cat. 12) has it draped over her shoulders, revealing its actual loose-fitting construction.

Two other frequently depicted costume props betray another aspect of Molenaer's early studio practice.[32] They are one-of-a-kind items, singularly distinguishable, yet their color varies from painting to painting. The more elegant of the two, best displayed in *The Dentist* (cat. 4), is a waisted doublet, fashionably slashed along the upper front and back and on the sleeves from just below the shoulder to just below the elbow. These slashed areas, plus the shoulder seams and borders of each tabbed, skirted extension below the waist, are decorated with parallel black lines. This costly doublet appears in at least eleven of

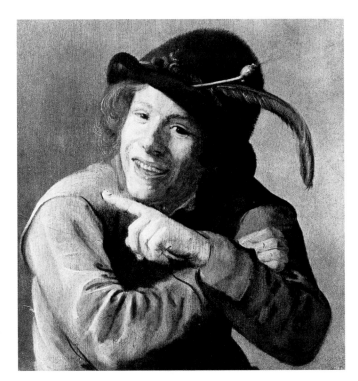

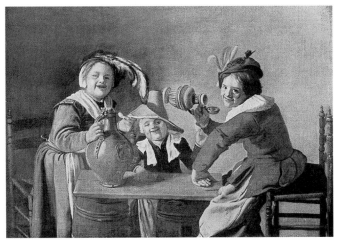

Fig. 6
A Smiling Youth, Pointing,
ca. 1628–30
Oil on panel, 7 1/8 x 6 1/2 in.
Formerly Trafalgar Gallery, London, 1978

Fig. 7
Children Making Merry, ca. 1628–30
Oil on canvas, 20 1/2 x 26 1/8 in.
Formerly art market, 1936

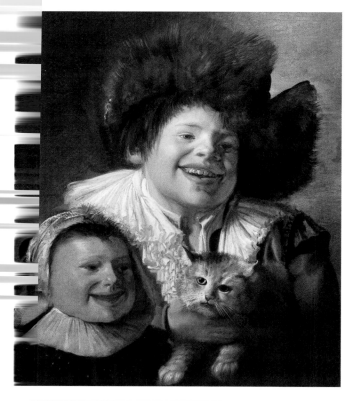

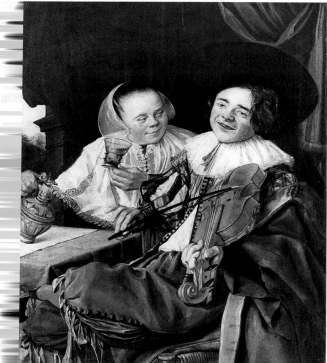

Molenaer's early Haarlem works, four of which are dated between 1629 and 1631. In most cases a robin's egg blue coloring is retained, but in other examples Molenaer employed ivory (cat. 20), mustard (cats. 7, 8), and gray (Weller fig. 2). The pale blue-green version is also seen in two contemporary works by Judith Leyster (*Serenade*, 1629, Amsterdam, Rijksmuseum, and *Carousing Couple*, fig. 9), indicating the two artists shared this prop long before their marriage in 1636. The same expensive doublet also appears in several works of the late 1620s by Dirck Hals.[33]

Reappearing Models

In addition to recycling stockpiled studio props, Molenaer tended to "employ" a number of familiar models to pose for his genre scenes. In spite of the advice found in contemporary artist handbooks on how to pose models, what qualities to capture, how to group them, and what propositions to use, relatively little is said about what kind of model one should seek. There is at least one significant exception. In his discussion of multifigured compositions, fellow Haarlemer Karel van Mander extols the merits of a large pool of potential models. Included in his list are "an abundance of . . . dogs or other domestic animals, . . . refreshing youths and pretty young women, old men, matrons, all sorts of children, old and young."[34] Molenaer seems to have taken this recommendation to heart. Throughout his career he reveled in the depiction of all sorts of models engaged in all types of activity and displaying all manner of expression and gesture.

Not surprisingly, Molenaer had his favorites among the vast array of both human and animal types. A particular gray-and-white-striped cat turns up in at least sixteen works, all datable before 1637 (e.g., cats. 14, 25), and four very different fettered monkeys appear in four other works from the same period (e.g., cats. 12, 13, and 23). Molenaer's favorite animal model, however, were dogs of all breeds and sizes. Some appear to have been painted from life, most notably a large black dog with brown markings over the eyebrows. This canine wears an identical collar in two paintings, although it assumes two very different poses (standing in cat. 19 and lying down in cat. 8). This change suggests the artist had access to the animal on both occasions. At other times Molenaer seems to rely on a sketch or a painting he kept in his possession. Apparently such is the case for a small black dog with tan markings first encountered in *Self-Portrait with Family Members* (Introduction fig. 1). He is seen in the left foreground, curled up in a sleeping position and resting on a pillow. He reappears in the same pose (without pillow) in *The Duet* (cat. 24), a work dated about the same time. The dog's inclusion in both works suggests he may well have been the fam-

ily pet, yet his unchanged pose indicates he was not drawn from life. This supposition is strengthened by the fact that the same dog in the same pose resurfaced nearly ten years later in *Figures Smoking and Playing Music in an Inn* (cat. 33) and in three other works spanning this same time frame.

Similarly, Molenaer repeatedly used a number of clearly recognizable men, women, and children as models. The old matron in the Toledo painting of 1633 (cat. 12), characterized by her long, pointed nose and prominent chin, is also portrayed in the *Artist in His Studio with an Old Woman* (fig. 1). She even wears the same costume in both works—a fur-lined black vest with blue skirt and red sleeves. The old crone may well appear even earlier, in the 1630 *Dentist* (cat. 4, fig. 2) and *Dance in a Village Street* (cat. 6). Her male counterpart, an old bearded and balding figure, is found in some six paintings, including *Card Players* (cat. 20) and *The King Drinks* (cat. 19), dating from the same early Haarlem period.

Figure types synonymous with the "refreshing youths and pretty young maidens" mentioned by Van Mander also found their way into Molenaer's paintings. His young couples engaged in music making (e.g., cats. 7, 8, and 25) are reminiscent of those found in the merry company scenes of Haarlem's older generation of artists: Dirck Hals, Willem Buytewech, and Hendrick Pot. Molenaer's compositions of the late 1620s and early 1630s contain fewer figures, however, including many with recognizable faces. The young couple in *The Duet* (cat. 7) reappears in the so-called *Breakfast Scene* of 1629 (Weller fig. 2). The moustached figure between them in the latter work reemerges in the title role in the Raleigh *The Dentist* (cat. 4) of that same year. A brown-haired adolescent girl is seen in three other paintings of the same time: *Family Scene* (Weller fig. 5), *The Lacemaker* (St. Petersburg, The Hermitage), and the *Soldier's Family* (fig. 10), a picture often attributed to Judith Leyster. In all three works she wears a similar costume and bears the same distinctive features: small eyes, puffy cheeks, and a small upturned nose.

Of all the worthy model types designated by Karel van Mander, it is the children, "all sorts of children, old and young," who seem to have inspired Molenaer the most in his early career. His early compositions abound with young rascals who squirm with mischief (cat. 2), gleefully play (Weller fig. 6), or simply radiate joy (cat. 2, fig. 1). Their very spontaneity suggests the atmosphere of a snapshot pose capturing a transitory moment of time. Nothing was further from the truth, however, as models were carefully selected and their poses carefully staged.

Among the many children depicted by Molenaer, two may be regarded as particular favorites. The little blond who laughingly smiles at us in *Girl with a Flute* (fig. 11) was

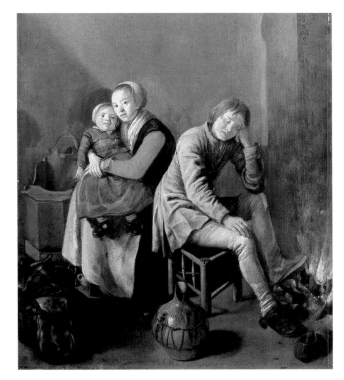

Fig. 10
Attributed to Jan Miense Molenaer
Soldier's Family, ca. 1630
Oil on panel, 15 ¾ x 11 ¾ in.
Art market, Amsterdam

Fig. 11
Girl with a Flute, ca. 1632–34
Oil on canvas, 25 ¼ x 20 ⅛ in.
Private collection, Canada

portrayed numerous times by the artist, initially as a very small child in 1629 (Weller fig. 6) and throughout the early 1630s. Her easily recognizable face is accentuated by chubby cheeks, half-lidded eyes, a pudgy upturned nose, a cleft chin, and a wide mouth with a pointy upper lip. In a few paintings she wears the same outfit: a lace-trimmed white cap and black jacket patterned with small white dots (e.g., fig. 12). Beside her is another often painted model during this period, a stocky boy with dark wispy hair (also seen in *Touch*, cat. 3). In nearly every appearance, this urchin oozes mischief, typically taunting some poor animal, boldly confident of his swaggering self.

The seemingly spontaneous stances of these children, like all the stances of Molenaer's figures, imply that he painted his models *naar het leven* (directly from life). Indeed, several seventeenth-century inventories listing Molenaer's paintings pointedly state this incorrect supposition as fact.[35] Molenaer seems to have carefully staged this seeming spontaneity and immediacy. Two extant paintings (figs. 13, 14) clearly demonstrate this working procedure. Both pictures depict the same four children—three boys (two musicians and a dancer) and a little girl. If one contrasts the two compositions, the figures have either changed position (the little girl and the dancer),[36] shifted their gazes (the violinist), been given other instruments to play (the tambourine/flute player), or exchanged apparel (the tattered, sleeveless blue jerkin depicted on the violinist in the Krakow painting is worn by the tambourine player in the lost work). These variations, along with repositioned and replaced props, indicate the artist was not simply copying his own work. In effect, Molenaer approached these two genre scenes as if they were still-life compositions, repositioning objects at will. Both the overall parallels (in models) and subtle variations (in poses) suggest these works were painted directly after one another from live models.[37]

Molenaer's depiction of recognizable models in different poses also helps determine several "sets" of paintings, which, due to the ready availability of the model, must have been produced around the same time. In turn, these "sets" assist in the chronological grouping of works and help to approximate dating. For example, the same youth who posed as the bare-chested dancer on the right in *Children Playing and Merrymaking* (cat. 16) is also depicted in the red vest beside the dog in the right foreground of *The King Drinks* (cat. 19) and as beating up another boy in an outdoor scene in The Hermitage (fig. 15). The fist-fighting youth with the large nose in the left background of this latter work is also portrayed in the center background of *Children Playing and Merrymaking*. The reappearance of these same models posed in different positions argues that these three works were likely painted in close proximity to one another.[38]

Fig. 12
Children Playing with a Cat,
1630–32
Oil on canvas, 26 x 21 ¼ in.
Musée des Beaux-Arts, Dunkirk

13
Children Making Music and Dancing,
ca. 1628–30
Oil on panel, 15 ¾ x 17 ½ in.
Wawel Castle, Kracow

Favored Motifs

In addition to reemploying specific models and various props, Molenaer continually repeated certain poses and narrative elements. They include foreground figures seen from behind (e.g., cat. 20; *The Ball Players*, 1631, private collection), the clandestine action of a boy stealing a duck from the basket of an unsuspecting peasant (e.g., *The Dentist*, 1630, cat. 4, fig. 2 and cat. 20), and a howling foreground youth sprawled flat on his back being attacked by another youth (e.g., fig. 15 and cat. 18). These particular motifs are among those cited by Van Mander in his advocacy of the illustration of a great variety of figural activities in a composition.[39]

Van Mander also encouraged the artist to properly represent fabric: "Let the folds arise from one another like the branches of a tree . . . Make . . . a drapery that richly and freely flows, especially on a woman . . . with natural undulation, but avoid . . . angular projections."[40] Many of Molenaer's early compositions pay heed, knowingly or not, to Van Mander's words, as another favored motif of this period is the foreground positioning of a seated female figure in three-quarter view (e.g., fig. 1 and cats. 7, 8, 11, and 12). Much attention is lavished on the undulating projection and indentation of the folds of the women's skirts, exactly as prescribed by the writer.[41]

The same is true for Molenaer's fondness for gesturing figures. Many paintings from the early Haarlem period depict a figure pointing to a principal action of the scene (e.g., Weller figs. 1, 15, and cat. 6). Invariably the object of attention is some boisterous activity: boys fighting (e.g., fig. 15), children taunting an animal (e.g., fig. 12), and even peasants dancing (e.g., cat. 6). Compositionally, this gesture may be interpreted as a rather simplistic one used by a young artist to focus the viewer's attention. Yet the use of a pointing figure was highly recommended to professional artists by Van Mander, precisely because it heightened the viewer's reaction. His remarks are contained in a passage entitled "Over the making of a figure who appears to be speaking and pointing to something awful that is happening."[42]

Van Mander also urged the painter to depict "all expressions of emotion, correct attitudes, reflections, everything that is mentioned about our art in the figure piece must come forth immediately."[43] Paintings like *The Dentist* (cat. 4) echo this instruction. The determined expression of the quack to remove the stubborn tooth, the wretched contortions of his hapless patient, and the bemused amazement of the rather clumsily rendered onlooker are all intended to evoke reaction from the viewer. While not necessarily the "compassion" and "misery" mentioned by Van Mander in this same passage, our reaction reflects the sense of amusement so commonly found in Molenaer's art.

Related to the Raleigh work are two paintings (figs. 6, 16) that illustrate young people gesticulating: a boy pointing and grinning and a girl raising her arms in wonder, surprise,

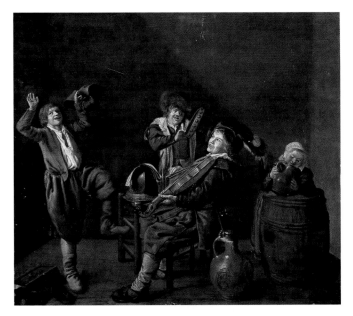

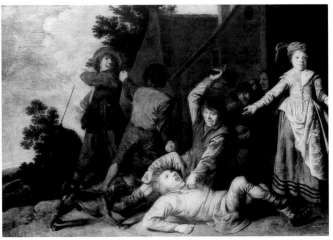

Fig. 14
Children Making Music and Dancing,
ca. 1628–30
Oil on panel, 15 ¾ x 17 in.
Formerly Xavier Scheidwimmer,
Munich, 1983 (variant of fig. 13)

Fig. 15
Fighting Boys, ca. 1630
Oil on panel, 15 ¾ x 21 ⅝ in.
The Hermitage, Saint Petersburg

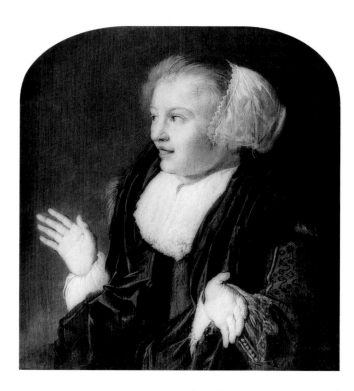

Fig. 16
Girl with Raised Arms, ca. 1630–32
Oil on panel, 13 ½ x 11 in.
Formerly Christie's, London,
10 July 1933

or amazement. Their facial expressions convincingly reinforce their actions.[44] The paintings are quite small, and given the fact that each figure references someone or something unseen, one wonders if these works constituted a series of studies by Molenaer displaying different gestures and emotions.[45]

Among Molenaer's most intriguing and often repeated motifs were middle-class couples observing the boisterous antics of the locals at play. Juxtaposed with villagers who dance, play ball, tease dwarfs, and mock an old man before a brothel, these well-dressed couples appear in at least seven works from the early 1630s (e.g., cat. 6). In some, the woman helpfully points out the boorish behavior to her companion. Their obviously out-of-place appearance makes one wonder why Molenaer included them in his early peasant scenes.

The pictorial juxtaposition of these same two social classes is earlier seen in Pieter Bruegel's *Peasant Wedding Feast* (ca. 1567–68, Vienna, Kunsthistorisches Museum), in which city folk are comfortably ensconced at the banquet table.[46] In his biography of Bruegel, Van Mander relates that the artist, together with his friend and patron the merchant Hans Franckert, would often venture into the countryside to witness bucolic activities:

Bruegel delighted in observing the manners of the peasants in eating, drinking, dancing, jumping, making love and engaging in various drolleries, all of which he knew how to copy in color very comically and skillfully . . . He knew well the characteristics of the peasant men and women . . . how to dress them naturally and how to portray their rural, uncouth bearing while dancing, walking, standing or moving in different ways.[47]

Molenaer was probably well aware of this famous Van Mander passage, but it was not necessarily a direct inspiration for his own depictions of city folk observing those of the country. Several seventeenth-century songs mention this pastime, and at least one writer cautions the wisdom of it. In his 1622 *Boertig Liedboek*, G. A. Bredero warns of the possible hazards of such activity by recounting the tale of one dapperly dressed Arent Pieter Gijsen and five of his fellow city dwellers, who impose themselves upon a peasant festivity in the village of Vinkenveen. After much rustic cavorting (i.e., drinking, singing, dice playing, and lovemaking), a fight breaks out. The resulting pandemonium ultimately claims the life of one of the locals and the wounding of six others. The first ten stanzas of Bredero's song are sung in local boorish dialect, but the last—a warning from the municipal narrator—is annunciated in proper Dutch: Take heed of the lesson: avoid peasant festivities.[48] Nevertheless, Molenaer's middle-class observers seem more bemused than wary of country activities.

The artist himself often took a lighthearted approach to his subject matter. The rich variety of genre scenes presented in this exhibition attests to his love of the pleasurable antics, sometimes mischievous, sometimes comic, of his fellow Dutchmen. By reengaging favorite models and reassembling favorite props and motifs, Molenaer succeeded in producing a vast array of these subjects, capturing what appear to be fleeting moments of time but are in effect artfully arranged compositions. A careful comparative study of the ele-

ments of these compositions reveals a great deal about his working method and helps to attribute and date his paintings. In at least one instance, however, it also seems to betray a unique aspect of the artist's humor that has hitherto gone unnoticed.

Several of Molenaer's pictures of the early 1630s portray a dwarf—playing with a dog (Weller fig. 1), dancing with a jug (cat. 5), posing before a still-life display (fig. 17), playing a violin (cat. 6), fending off taunting youths (cat. 5, fig. 1), and astutely prancing in the midst of a biblical event (cat. 14). In most of these paintings, the dwarf is bearded and appears to be one and the same person. There remains one exception. In the 1633 *Denial of Saint Peter*, the dwarf on the left of the composition is clean shaven, save for a moustache. He also sports a rather bushy hairdo, as opposed to the softly curled hair of the other. Clearly, the physiognomy of the bearded dwarf and the one depicted in the Budapest painting do not accord. Another discrepancy emerges in comparing the canon of the figures, as the head of the bearded dwarf in all of the compositions seems to accord with actual observation. The canon of the dwarf in the *Denial of Saint Peter* appears to have changed, as the scale of the body is now at odds with the size of his head. Close examination of the Budapest dwarf's features reveals an uncanny likeness to those of Molenaer in his *Self-Portrait with a Skull* (cat. 30). The same vertical grooves between the eyebrows, the bumpy nose, fleshy jaw, thick lips, cleft chin, fluffed hair, and eyes that droop at the corners are exhibited. In essence, it appears Molenaer has placed his own head upon a stunted body. He has become his own disfigured model.[49]

From what we know of his predilection for humor, the painter's intention may have been simply to amuse. Or there may be a deeper significance. It seems fitting that for all the information about his studio practice that can be extracted from this detailed study of his use of models, props, and motifs, we are at a loss to explain why the artist displayed himself in such a manner. Molenaer, the consummate jester, the ever innovative juggler of images, has had the last word.

Fig. 17
Attributed to Jan Miense Molenaer
Dwarf Smoking, ca. 1630
Oil on panel, 9 1/16 x 12 3/16 in.
Formerly Leger Gallery, London
(as Thomas Wijk)

1 For a complete discussion of *Artist in His Studio with an Old Woman*, see Haarlem and Worcester 1993, cat. 32, pp. 302–07.

2 According to notes in the RKD, this painting was initially regarded by S. J. Gudlaugsson as a collaborative effort by Judith Leyster ("at least the middle figure") and Jan Miense Molenaer (who "retouched" the work). This shared attribution seems improbable. In the 1950s the work was believed to be done solely by Molenaer (with S. Nijstad, The Hague 1956). The figures on the left and right resemble others by the artist, and the motif of a person leaning out a window is certainly one Molenaer employed frequently. However, until this lost painting is recovered and examined, the attribution to Molenaer cannot be verified.

3 The fourth work, the *Artist in His Studio with an Old Woman* (fig. 1), shows the painter pausing in his work. He turns toward the viewer and smiles, thus psychologically engaging us. The onlooker is compelled to contemplate not only clearly presented studio procedure but veiled allusions concerning them as well. See Haarlem and Worcester 1993, cat. 33, pp. 302–07.

4 For example, Van Mander 1604, especially fols. 9v, 12v–13v, 14r, 16v–18v, 22v–28v.

5 The best-known Dutch theoretical texts and/or biographical sketches are by Van Mander (1604), Angel (1642), Goeree (1668), Van Hoogstraten (1678), De Lairesse (1701), Houbraken (1718–21), and Weyerman (1729–69). Although perspective is not covered by Van Mander, it is

addressed early in the century by Hans Vredeman de Vries (1604–5), who devoted an entire book to the subject; Cornelis Pietersz Biens (1636) accords it an entire chapter.

6 Goeree 1668, fols. 34r–35r; Van Hoogstraten 1678, fols. 26r–36r.

7 Perhaps the most famous contemporary reference to an anatomical figure was made by Philips Angel in his speech before the Leiden guild, published in 1642 (pp. 52–53), in which he praised the Haarlem masters Hendrick Goltzius and Cornelis Cornelisz van Haarlem for using plaster casts of skinned models. Taverne 1972–73, pp. 53–54; Van Thiel 1965, pp. 124, 129. On Honthorst, see Amerson 1975, p. 326; Judson 1956 and 1999.

8 According to Vasari, the first artist to use a lay figure was Fra Bartolom-

meo (1472/75–1517); it was a life-sized wooden model. However, articulated dolls and marionettes were known in antiquity, and the earliest description of an artist's small-scale lay figure appears in Book 3 of Filarete's 1461–64 *Treatise on Architecture* (see Eastlake 1847, vol. 2, p. 193). An early Dutch description for the construction and mechanics of such a figure—assembled from fifteen parts made according to correct proportion—can be found in chapter 8 of Cornelis Pietersz Biens's *De Teecken-Const* (Amsterdam 1636). Crispijn van de Passe also comments on the use of the lay figure and describes the keys by which it is positioned (see De Klerk 1982). Apparently lay figures were already employed in Dutch painters' studios in the sixteenth century (see Van der Grinten 1962). Artists also employed small, unarticulated clay models. Vasari mentions that Piero della Francesca used such a model draped with wet cloth arranged in folds in order to study drapery (see Vasari 1968, p. 196; on Van den Valckert's imagery, see Van Thiel 1983, pp. 165–78). For a general discussion of artistic academic practice during this period, see Laura Olmstead Tonelli, "Academic Practice in the Sixteenth and Seventeenth Centuries," in Providence 1984, pp. 96–118.

9 See Ferrero 1971, p. 829ff.

10 Pieter de Grebber (*Self-Portrait*, 1647, Amsterdam, Rijksmuseum); Gerard de Lairesse (*Self-Portrait*, ca. 1675–80, Bayonne, Musée Bonnat). See Raupp (1984, pp. 266–74) for more discussion on this subject. Perhaps the earliest pairing of the skull motif and an artist's self-portrait is to be found in an engraving by Lucas van Leyden. Van Mander (1604, fol. 212v) describes a self-portrait of the young Lucas in a large cap decorated with feathers with a skull design emblazoned on his costume.

11 It should be noted that no known *vanitas* still life by Molenaer exists. The juxtaposition of *vanitas* objects with the artist in his studio is discussed by Raupp (1984, pp. 283–88).

12 Apparently this grisly prop was not appreciated by a previous owner. A photograph taken at the time of the painting's sale in 1926 (26 February, Christie's [London], no. 91) shows that it was overpainted with a footstool.

13 Van Mander 1604, fol. 16v; Miedema 1973, vol. 2, pp. 471–72.

14 Van Houbraken 1718–21, vol. 3, pp. 110–11. Jan van Swieten's *Lute Playing Artist* (Leiden, Museum De Lakenhal) gives a similar impression.

15 In addition to the inventory of Molenaer's effects, other inventories and biographies of artists provide important information regarding standard studio props of the period. Arnold Houbraken, for example, described the studio of the Amsterdam painter Govert Flinck (Houbraken 1718–21, vol. 2, p. 22). The best-known inventory is associated with Flinck's teacher Rembrandt. In 1656 an inventory of Rembrandt's household effects was taken as a consequence of his insolvency. The catalogue for *Rembrandt's Treasures* (The Rembrandt House Museum, Amsterdam, 1999) lists the inventory (pp. 147–52).

16 This type of stoneware was initially imported as early as the late twelfth century from Sieburg, a city near Cologne, which maintained a monopoly on the export of beer mugs and jugs through the sixteenth century. Its principal features are the evident potter's ridges along the sides and the chunky, unfinished foot (J. M. Baart, in Amsterdam 1994, p. 53).

17 The *baardmankruik* was initially produced in Cologne in the early sixteenth century. Originally it was decorated with a Gothic design of oak leaves, twigs, and acorns, but after the second quarter of the sixteenth century, these were replaced by Renaissance motifs (J. M. Baart, in Amsterdam 1994, p. 57).

18 The lip of the corded jug is also filed down in the ca. 1635 *Children Playing Cards and Teaching a Dog to Sweep* (Zurich, Kunsthaus Ruzicka-Stiftung). The other two exhibited works, *Peasants near a Tavern* (cat. 17) and *Children Playing and Merrymaking* (cat. 16), display the earlier jagged edge seen in the 1629 painting. The earliest occurrence of this stoneware jug is found in the so-called *Soldier's Family*, attributed by this author to Molenaer (currently with Lilian, Amsterdam, as a Judith Leyster).

19 These elegantly shaped, highly saltglazed stoneware beer tankards originated in Westerwald and were decorated with freely sketched flower motifs surmounted by a scalloped line or with bands containing repeated leaf shapes (J. M. Baart, in Amsterdam 1994, p. 59).

20 This jug is also depicted in two other exhibited works, *The King Drinks* (cat. 19) and *Children Playing and Merrymaking* (cat. 16).

21 Singleton 1907, pp. 160–61.

22 Paintings within paintings are only found in Molenaer's early Haarlem period. Family portraits appear in *Self-Portrait with Family Members* (Introduction fig. 1) and *Three Women at a Virginal* (fig. 4). The portrait of Frederick Hendrick, which adorns the rear wall in the London *A Young Man and Woman Making Music* (cat. 8), is believed by Salomon (1986) to have symbolic significance. Genre paintings are even more scarce, appearing only twice: the work-in-progress picture of cavorting models on the easel in the Berlin *The Artist in His Studio* (Weller fig. 1) and a painting of nude boys swimming in *Three Women at a Virginal* (fig. 4). Still-life paintings are limited to two studio interior scenes (fig. 1 and cat. 10); the former also includes a seascape as well as a landscape, a subject also featured in *Allegory of Vanity* (cat. 12).

23 Welu 1977, p. 135.

24 Leppert (1978, pp. 89–90) states the pocket violin was used from the mid-sixteenth century until the end of the eighteenth century for private dancing lessons. Its name derives from the fact that dancing masters often carried the instrument in their coat pocket.

25 Michael Latcham et al., in The Hague/Antwerp 1994, p. 338. The Rucker type of virginal differs from others in that the strings run slightly oblique to the keys, and the keyboard is placed to the right of center.

26 Ibid., p. 334. Moorish tracery designs are composed of organically linked and stylized tendrils and leaves. They were used from about 1580 through the first quarter of the seventeenth century by the Ruckers firm. The patterns derive from designs by Bernard Salomon from friezes by Pellegrin and from frontispieces in books published in Antwerp by Christophe Plantin (Gruber 1994, pp. 278, 342).

27 It can be assumed that these pieces of armor were mainly of standard size. However, a *Self-Portrait* (Edinburgh, Scottish National Portrait Gallery) of the seventeenth-century Scottish painter George Jamesone (1587–1644) depicts a miniature suit of armor, undoubtedly used by the artist as a model for larger-scale renditions.

28 Schwartz 1985, p. 59.

29 The motif of the helmet used as a drum is also seen in Molenaer's *Children Teaching a Cat and Dog to*

Dance (Dublin, The National Gallery of Art); this large, center-ribbed helmet is also found in *Card Players* (cat. 20). The same spiked helmet appears in the foreground of *The Departure of the Prodigal Son* (cat. 9) and on the soldier stealing a duck in *The Dentist* (cat. 4, fig. 2).

30 Less used, but also a headdress costume prop of the 1620s and 1630s, is a straw hat always worn by an old woman (fig. 1) or a young girl (fig. 11).

31 A nearly identical jacket, yet without the fur lining and with black-fringed strips hanging from the shoulder seams, is seen in four additional paintings (e.g., *The Lacemaker*, St. Petersburg, The Hermitage).

32 In addition to the waisted doublet discussed below, the second jacket that consistently reappears in early Molenaer paintings is a sleeveless jerkin with hooks and eyes poking out along the edges of its front closure. In each of the eight known examples (e.g., cat. 2), the oversized garment is worn by a number of mischievous young boys. The only full-length version of the jerkin (see fig. 13) reveals its true tattered condition: the skirt is literally ripped to shreds. Like the expensive slashed doublet, this very unique jerkin changes color, as blue and red examples are found.

33 Examples include *Merry Company*, 1626 (San Francisco, California Palace of the Legion of Honor), *Tric-Trac Players* (Vienna, Kunsthistorisches Museum), *Tavern Scene* (sale Raedt van Oldenbarnevelt, 15–16 April 1902, Amsterdam, Frederik Müller), and the oil sketch *Seated Man with His Hand on His Hat* (Berlin, Kupferstichkabinett der Staatlichen Museen).

34 Van Mander 1604, fol. 17r.

35 For example, the Amsterdam notary P. de Bary specifically lists Molenaer's paintings as such in recording the 1642 inventory of Emanuel Burck of Amsterdam (Bredius 1915–21, vol. 1, pp. 13–14).

36 The same model seen as the dancer in these two works also appears as a singer in a third painting, *Children Making Music*, The Hague, Instituut Collectie Nederland.

37 Molenaer continued to produce variations of a particular composition throughout his career. For a discussion of another "set," see cat. 32.

38 Furthermore, the inclusion of particular studio props (side-paneled chair, corded jug with broken spout,

etc.) within these compositions relates them in turn to others discussed above, all dating before Molenaer's move to Amsterdam in 1637.

39 Van Mander 1604, fols. 15r, 17r, 18r.

40 Van Mander 1604, fols. 43r–43v.

41 Van Mander 1604, fol. 43r.

42 Van Mander 1604, fol. 18r.

43 Van Mander 1604, fol. 18r.

44 A third related painting, most likely a copy after an original by Molenaer, depicts a girl laughingly pointing over her shoulder (formerly The Hague, private collection, 1968).

45 Admittedly, no such series is known to have been produced by any of Molenaer's contemporaries. Comparable in effect is the series of small portraits of presumed Molenaer relations in the background of *Self-Portrait with Family Members* (Introduction fig. 1).

46 Actually, the contrast between peaceful country and often corrupt city life is an old one; it occurs frequently in classical literature (e.g., Virgil's *Georgics*). But awareness of the discrepancy between the two was significantly heightened in the sixteenth century with the overwhelming growth of European cities and towns. Some littérateurs of the day, such as Erasmus, Luther, and Montaigne, all extolled the peasant for his simple honesty and morality. However, most of their municipal contemporaries thought otherwise. Rather than idealizing the countryfolk, popular *rederijker* farces mimic their rustic dialects and habits. Painters of the period tended to take a moderate approach, some depicting fashionably attired city dwellers mingling with the peasantry at village kermises and celebrations (e.g., Joachim Beuckelaer, *Peasant Festival*, St. Petersburg, The Hermitage). These works attest to the popularity of country excursions and indicate many artists witnessed these events themselves.

47 Karel van Mander, *Het Schilder-boeck. Het Leven der doorluchtige Nederlandsche en Hoogduitsche Schilders.* Haarlem 1604; reprinted Amsterdam 1946, p. 97. Van Mander further reports that for these excursions, Bruegel and Franckert disguised themselves as peasants.

48 *Ghy Heeren, ghy Burgers, vroom en wel gemoet, / Mydt der Boeren Feesten, sy zijn selden soo soet / Oft kost yemant jijn bloet, / En drink met mijn, een roemer Wijn. / Dat is jou wel so goet.*

G. A. Bredero. *Boertigh, Amoreus en Aendachtigh. Groot Lied-Boeck.* Amsterdam 1622. In his late career (1662), Molenaer received a commission from one Jacob van Amersfoort for a large painting depicting the story told by this very song of Bredero (see cat. 36).

49 In addition to the generally accepted self-portraits (i.e., fig. 1, Introduction fig. 1, and cat. 30), Molenaer's visage also appears in other works: as the lutenist in both *The Duet* (cat. 24) and the *Lute Player* (cat. 22) and as the smoker in a painting of the same title in Frankfurt am Main (Städelsches Kunstinstitut). These likenesses differ slightly from one another insofar as they are affected by the formality or informality of the portrayal and the passage of time, but all exhibit the artist's unique physiognomy. With so many examples at hand, it is tempting to reexamine the portraits of unknown gentlemen by Frans Hals, whose portraits of both Leyster and Molenaer are listed in the latter's postmortem inventory of 1668. There is indeed one from the early 1630s (Berlin, Gemäldegalerie, Staatliche Museen, fig. 18)—a period when Molenaer was closely associated with the Haarlem Hals circle—that does resemble him. The portrait depicts a man who bears Molenaer's specific features: thick, curly black hair with bangs and fluffed out at the sides; brown eyes turned down at the corners; puffy underlids; a bumpy, upturned nose with a somewhat prominent tip; full lips, heavily underscored by thick padding; a cleft chin; and a vertical ridge between the eyebrows. A strong jawline is indicated but is not pronounced. Hals seems to have purposely concealed this area by having the collar rest quite high and by emphasizing the boundary between the face and the collar with a broad, flesh-toned brushstroke and a thin white one. The Berlin *Portrait of a Woman*, which was once thought to be the pendant of this painting, is no longer regarded as such by the museum.

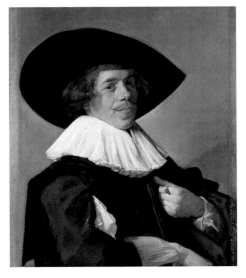

Fig. 18
Frans Hals
Portrait of a Man (Jan Miense Molenaer?), ca. 1630–33
Oil on canvas, 29 ½ x 22 ⅞ in.
Staatliche Museen zu Berlin, Gemäldegalerie

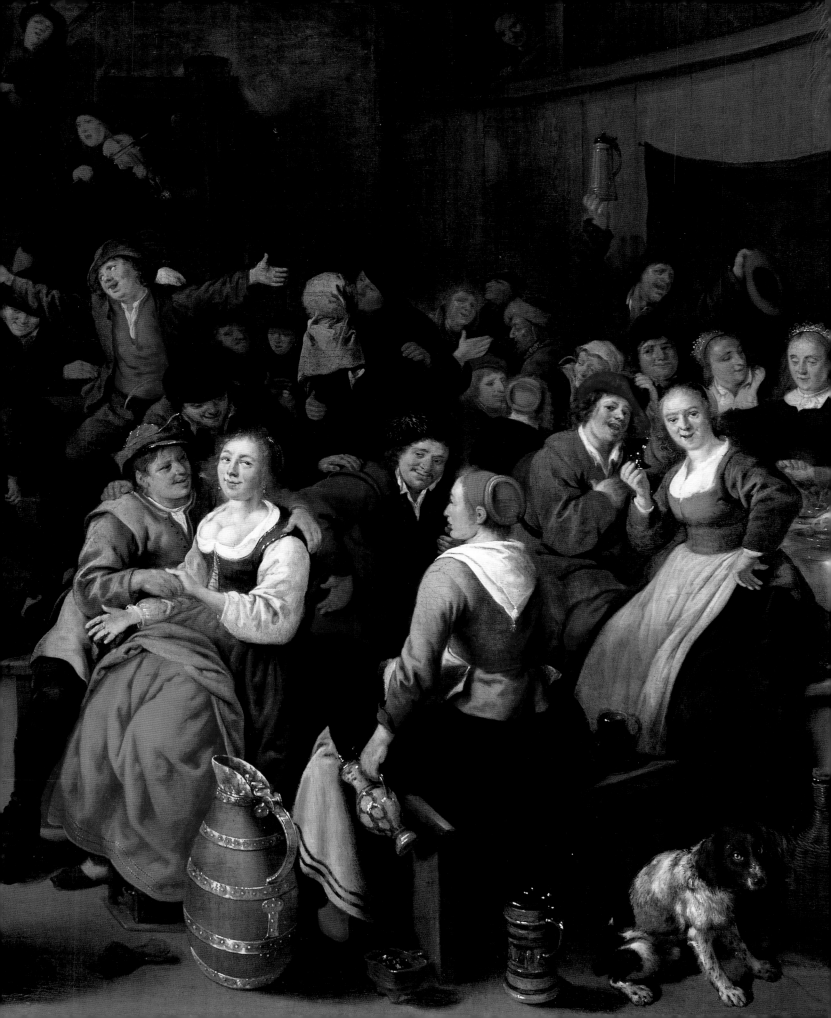

Jan Miense Molenaer in the Comic Mode

MARIËT WESTERMANN

Seventeenth-century humor can be difficult to take, and Jan Miense Molenaer's *Boys with a Dwarf* (fig. 1) is a case in point. A crowd of young lads—street urchins, by the looks of their tattered clothes—are falling over themselves and each other and down a hillock as they seek cover from rocks hurled by an angry dwarf. One boy has fallen and clasps his upper arm in pain; the others sneer and howl, their faces contorted with derisive laughter. Nothing encourages us to empathize with the dwarf and his wife: we are not positioned to assume their point of view, and the normally proportioned family behind them appear mildly amused at the dwarf couple's ire and worry. Only the dog in the center foreground engages us directly, as if asking us to judge for ourselves.

A quarrel between street youths and a man of arrested growth: not much to laugh at by twenty-first-century standards. And yet Molenaer offered standard cues that his picture should be seen as funny. The scene is set before a village inn (signed "in the chilled peasant"), the preferred setting for comic pictures ever since Pieter Bruegel standardized it (fig. 2 and cat. 18, fig. 2).

Fig. 1
Boys with a Dwarf, 1646
Oil on canvas, 42 ½ x 49 ⅝ in.
Stedelijk van Abbe Museum, on loan to the Dordrechts Museum, Dordrecht

Like canned laughter in sitcoms, laughing faces in paintings frequently served as indicators that a scene was meant to induce laughter.[1] Here not only the guffawing boys but also the well-dressed, smiling couple appear to prompt viewers to laugh along with them at the row. In this essay I will consider why this picture, and indeed much of Molenaer's production, would have struck contemporaries as comic, and what purposes such seemingly crude pictorial comedy could have served him and his audiences. Molenaer was deliberate and

Fig. 2
Joannes and Lucas van Doetecum
after Pieter Bruegel the Elder
Kermis of Saint George, ca. 1559
Etching with engraving,
13 ⅛ x 20 ⅝ in.
The Metropolitan Museum of Art,
New York

clever in his reworking of themes and techniques borrowed from comic literature and painting. His responses to comic theatrical tradition and his innovations in the comic pictorial mode are crucial for our understanding of his artistic success, both in terms of collector interest in his pictures and in terms of his influence on peers and followers.

Situating Molenaer in the Comic Tradition

Molenaer was an accomplished portraitist (Weller fig. 9), an unconventional history painter (cat. 14), and an occasional designer of allegories (cats. 12, 13), but his distinctive specialty was what we would now call comic painting. Tavern revels, merry companies, peasant pleasures, tooth pullers, dwarves, and broad-grinned children: these themes and figures were the classic and contemporary stuff of comedy. It is modern art history that has lumped Molenaer's comic works together with his unfunny vernacular allegories under the catchall term *genre*, a designation inherited and transformed from eighteenth-century academic theory. Seventeenth-century viewers would have received Molenaer's "genre paintings" in finely differentiated, often quite specific terms, probably finding some witty or noble in ethical content, others worth a smile or even hilarious.

Although "comic painting" was not theorized as a pictorial genre in the seventeenth century any more than "genre" was, the earliest recorded responses to Pieter Bruegel (1521/25–69) and Jan Steen (1626–79), arguably the two greatest comic painters in the Netherlandish tradition, clarify the outlines of a broad category of paintings meant to be seen as humorous and discussed with delight.[2] Laughter-inducing pictures had distinctive repertoires of themes and motifs, many familiar from old European traditions of theatrical comedy, carnivalesque festival, and oral joke culture. Together with certain pictorial techniques (including particular ways of typecasting figures), describing the scene, standardizing gestures, and addressing the audience, these repertoires constituted a distinctive comic mode of visual representation.[3] We can recover the features and conscious functions of early modern comic painting by studying the content and structure of contemporary comedies, farces, and collections of jokes; by examining theoretical writings on comedy; and by analyzing the production of artists who were known early on for their visual drolleries, including Hieronymus Bosch, Bruegel, and Steen.[4]

Seventeenth-century comic theory was profoundly indebted to its classical sources. Theorists followed Aristotle's demand that the comic poet represent people as they are, or as worse than they are, as opposed to the tragedian, who invents characters larger than life, and they repeated Cicero's dictum that comedy should be "an imitation of life, a mirror of good mores, an image of truth." The stylistic implications of Cicero's definition were drawn out summarily by Cornelis vanden Plasse, in his 1638 edition of the works of Ger-

brand Adriaensz. Bredero, the finest comic poet in the Dutch Republic. In comic scenes, Vanden Plasse noted, "the banter should be that of the common man, the scenes farcical and jolly," imbued with "almost excessive exuberance, and roaring laughter."[5] Later in the century, the literary association Nil Volentibus Arduum (Nothing Is Difficult for the Willing) argued for a hierarchy of theatrical style: the highest for tragedy; a medium, realist form for comedy; and the coarsest manner for farce.[6]

For themes, scenes, and characters, comic theorists and practitioners accordingly favored the ordinary and less than ordinary: "only common plain persons, such as rich burghers, blokes, youngsters, maidens; the indecent love of adolescents and the deceitful tricks of whores," in a formulation of 1555,[7] or in Vanden Plasse's words of 1638

the lightest sort and the scum of the people, shepherds, peasants, workers, innkeepers, matchmakers, whores, midwives, sailors, spendthrifts, tramps, and spongers: on fields, in woods, in hovels, in shops, taverns, pubs, in the street, in back alleys and slums, in the meat hall, and on the fish market.[8]

Although these statements specify the favored settings, situations, and characters of comedy, they are mute about narrative. This silence stands in sharp contrast to contemporary writing on tragedy, which concerned itself largely with the ways in which tragic plot structures prompted ethical insight in the protagonists and the audience.[9] Although comedies, farces, and jokes did, of course, have plots full of jilted lovers, fooled bumpkins, and duped misers, their primary brief was the recognizable rendering of flawed types, questionable morals, and embarrassing situations, presented in such laughable fashion, the assumption went, that every audience member would want to avoid them. To rephrase Cicero: comedy was inevitably a cracked mirror, an imitation of life as it should not be lived, an upside-down image of moral truth as understood by a consensus of mostly urban producers and consumers of comedy. Through laughter the audience would grasp the moral point, or at the very least be reminded of it. One of the explicit functions of comedy was to entertain and instruct, or rather, to instruct by way of delight.[10] Other arguments for comedy and laughter included relief for the studious and the melancholy, and the sharpening of wits.

In its premium on realism of setting, character type, and scene, rather than sequential narrative, as the preferred means for articulating shared urban values, Netherlandish comedy since the sixteenth century had become increasingly aligned with vernacular painting, dedicated as it had been since Bosch to the middling, plain, and lower sorts. In this period many themes and dramatic strategies of the comic theater were indeed transformed into ambitious paintings and prints that mobilized laughter and ridicule to articulate the presumed characteristics of particular classes: earthy peasants, gullible consumers, dandified aristocrats, irresponsible burghers (city residents, from *bourg*, or *burg*, for town), lazy good-for-nothings.[11] Made by middle-class artists for (upper-)middle-class customers in the cities, these pictures helped shape civic identities by ridiculing the sorts of people that the owners and primary viewers of such pictures were not. Comic representations were appreciated particularly for their gentle or not-so-subtle reinforcement of social structure and attendant behavioral norms through laughter—in other words, for some of the same reasons our culture relishes and needs stand-up comedians and television sitcoms.

Two comic images from the sixteenth century may serve to sketch some of these central themes and functions of comic visual representation. The versatile artist Lucas van Leyden made several dozen prints of scenes and characters from the lowly farcical repertoire, occasionally signaling the humorous charge by including a jester who, paradoxically, points out

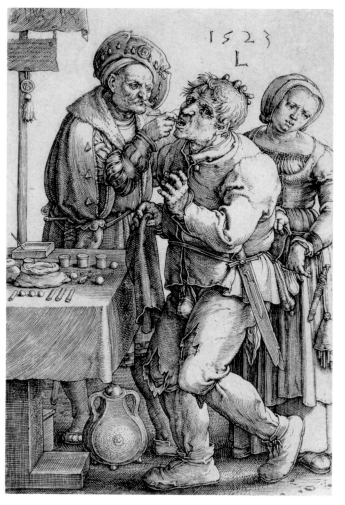

Fig. 3
Lucas van Leyden
The Dentist, 1523
Engraving
National Gallery of Art, Rosenwald
Collection, Washington, D.C.

the folly of the simple folk in the scene.[12] An engraving of a tooth puller from 1523 (fig. 3) must have done much to popularize a cherished farcical theme for artists, for in 1604 Karel van Mander described it admiringly in his *Schilderboeck* (*Book of Painting*), the most authoritative Netherlandish treatise on painting of the seventeenth century.[13] Here an excessively decked-out quack doctor performs needless dental surgery on a disheveled peasant, giving his female assistant an opportunity to pickpocket the patient. As so often in the world of comedy, neither charlatan nor peasant comes off well. No self-respecting urban citizen, of the kind able to afford Lucas's coveted engravings, would have identified with the quack, the disreputable companion, or the doltish peasant, whose rough-hewn features, unkempt hair, and tattered clothes would have evoked anything but pity. In the urbane milieu that spawned and consumed such exquisitely made prints, professional honesty, financial dependability, and keeping one's social station were cherished moral principles, essential to the functioning of a developing capitalist economy.[14]

Frans Hogenberg's engraving after Bruegel's *Kermis at Hoboken* (fig. 4) is endowed with a verbal commentary that shows such comic workings more directly than the master's paintings, which tend to be more subtle in their coding of class and gender characteristics.[15] Taking an elevated point of view that allows for the distant and simultaneous viewing of numerous small vignettes, Bruegel described the fair at Hoboken as a scene of diminutive, short-necked humanoids and animals swirling through the village engaged in a range of entertaining but, by the standards of productivity, idle actions. Peasants play games and coarse instruments; they dance, drink, and make merry. Behind a tree a couple embraces; elsewhere men relieve themselves with less cover. In the background a religious procession vies for public attention with a theatrical performance. As one might expect from Bruegel, a man who appears to have had Protestant leanings, the juxtaposition seems to liken traditional Catholic feasts to folk theater. The inscription below leaves little doubt of the writer's—and thus the reader-viewer's—social distance from the festivities:

The peasants rejoice at such feasts in dancing, leaping, and drinking themselves drunk as beasts
They have to observe their church festivals even if it means fasting and dying of cold

Made in the period when Antwerp transformed itself into the most successful northern European economy—an economy dependent on an ethos of productivity—the easily circulated print could reinforce a middle-class viewer's understanding of himself as not peasant-like, not lazy, not wasteful, not belligerent. Such a good citizen would be in control of the bodily functions and mental faculties essential to the work of building communal prosperity and responsible polity.[16]

The class-affirming efficacy of Bruegel's peasant images has often been argued, and yet satiric sharpness and class interest alone cannot account for the painter's success.[17] Bruegel

structured his compositions cleverly to suggest similes (besides the comparison of religious worship to comic spectacle, note the delightful pigs among the peasants), to identify ironies (two children and a fool in the foreground appear to turn away from the mayhem), and to offer maximum anecdotal entertainment to the wandering eye. His individual figures and vignettes are sharply drawn, from the eager hunch of the ballplayers to the varied steps of the dancers, from the inquisitive nuzzling of the pigs to the greedy guzzling of the peasant on

Fig. 4
Frans Hogenberg after Pieter Bruegel the Elder
Kermis at Hoboken, ca. 1559
Etching with engraving, 11 ¼ x 16 ⅛ in.

horseback. These characterizations, however standardized they look if we line up all of Bruegel's works, must have struck contemporary viewers as highly realist—a requirement of comedy—because they brilliantly rendered aristocratic and middle-class expectations of what rustics should look like. In their copious variety of incident, Bruegel's paintings and prints stimulate keen attentiveness and clever conversation, and prompting these faculties had always been a function of the comic. Early modern elites used witty talk and crude jokes to build intimacy and community, much as informal associations or groups do today. A seventeenth-century lawyer in The Hague amassed five volumes of jokes, from the subtle to the smutty, undoubtedly to spice up the dinner party conversation with his peers.[18] In a visual culture less saturated than our own, paintings in private houses could serve much the same function, all the while further substantiating class identity.

 That some measure of desire on the urban viewer's part for the illicit pleasure of peasants could enhance the appeal of comic pictures that detailed such joys seems plausible. The suggestion has come under fire from those who consider explicit inscriptions of the type quoted above as keys to interpreting peasant imagery as primarily vehicles of moral instruction and upper-middle-class distinction.[19] Psychoanalytic understanding of humor, however, suggests the hard work of rejecting and controlling bodily pleasures no longer allowed under codes of middle-class civilization may well have yielded mechanisms of vicarious enjoyment of just such joys, by transposing them onto the figure of the peasant, close to nature and the earth by his place in the seasonal cycle of the land.[20] Allowing for the workings of the unconscious in the reception of humor may help account for some of the distinct oddities of comic painting in the early modern period: its lack of strong plots, its repetitive detailing of standard comic motifs such as the defecating and urinating peasant or the uncontrolled peasant brawl, its relishing of the bodily detail in sharp drawing and lush paint. Calvinist theologians indeed expressed great skepticism about the instructional pretenses of comedy, finding them a thinly veiled excuse for lecherous display; classicist theater critics voiced similar doubts on aesthetic rather than moral grounds.[21] The

substitutional pleasure offered by the comic mode seems manifest in several of Bruegel's peasant paintings that eschew outright rejection of rustic behavior, even as they mobilize the peasant for satiric purposes. In the *Kermis at Hoboken*, for example, the pitchfork-and-knife battle and vomiting boors typical of much peasant imagery are conspicuously absent, and in the *Kermis of Saint George* (fig. 2), a brawl is relegated to the left background. When Van Mander wrote that Bruegel and his friend Hans Franckert amused themselves by dressing up as peasants, the better to meet and observe the peasants at their fairs, he phrased something of the secret delight Bruegel's paintings offered, to maker and viewer. He linked Bruegel's identification with peasants directly to his ability to "imitate them most animatedly and subtly in paint" and noted there were "few pictures by him that a viewer can contemplate seriously and without laughing, however straight-faced and stately he may be."[22]

The majority of Molenaer's surviving paintings and the earliest known written references to his paintings make clear they are in the comic mode whose outlines I have just sketched. Descriptions of Molenaer's paintings in seventeenth-century inventories are frequently specific about his themes, and many can therefore still be linked to certain kinds of painting or even to individual pictures. The majority of more than one hundred such references catalogued by the Getty Provenance Index are of conventional comic themes, and several even classify the paintings as comic by such terms as *grappig* (funny, amusing) and *vrolijk* (merry, jolly) or by mentioning the laughing figures in them.[23] The descriptions given are revealing of the widespread reception of Molenaer's works in the low-to-middling mode associated with the comic tradition. The detailed character of many listings suggests a standard practice of sustained looking at such paintings, and examining this source material can therefore be instructive.

A few inventory titles refer to known comic literature, proverbs, and stock comic characters. One of the most explicit is "Arent Pieter Gijsen," which designates the first three folksy characters in the song "Boerengeselschap" ("Peasant Company"), which opens Bredero's *Groot lied-boeck* (*Large Songbook*) of 1622. This painting has plausibly been identified as a large painting of *Peasants Carousing* (cat. 36), commissioned in 1662 by Jacob van Amersfoort for a princely 380 guilders.[24] Bredero's first-person narrator, a city slicker, visits and describes a peasant fair in lush detail. He takes cover, however, as soon as the scene begins to deteriorate into a brawl—the very moment we see developing in the right middle ground of Molenaer's barnlike structure teeming with peasant revelers. Like Bredero, Molenaer here takes on the distant role of observer of amusing but ultimately

reprehensible peasant pleasures. Emanuel Bürck's inventory of 1642 described one of Molenaer's paintings with another quotation from a poem by Bredero. "A peasant woman and peasant women, playing *Sijmen de lieverde laverde bock*," uses the poet's exact words for a scene in which a husband is being cuckolded. The painting is not immediately identifiable, although it most likely involved the rough or mocking treatment of a man by several women. Molenaer's picture of a man floored

Fig. 6
Shooting the Parrot, ca. 1640–45
Oil on panel, 22 ⅞ x 32 ¼ in.
Museum voor Schone Kunsten, Antwerp

and otherwise distracted by a gaggle of women, to the hilarity of all bystanders, comes to mind (fig. 5).[25] "As the Old Sang" indicates the proverb "As the old sing, so pipe the young," which was usually represented in comic fashion. Jacob Jordaens's and Jan Steen's paintings of boisterous, devil-may-care (grand)parents setting egregiously jolly models for their (grand)children are famous examples, but Molenaer held his own with a large scene of vigorous singing, piping (with bagpipes, recorder, flute, trumpet, and actual pipes), dancing, and drinking (cat. 28).[26] A painting of a *Mallekeesje* (a *Silly Kees*, found twice) must have been of a stock comic character, Kees being a favorite folk name in farce and comedy.[27]

Inventories describe comic paintings without identifiable ties to literature in comparable detail, as a sampling of the versatile designations for Molenaer's peasant paintings indicates. On record, among many others, are "a peasant company with a rooster," "peasants, in which a woman dances with a dog," "a peasant company by the fire and at the table," "peasants sucking tobacco," "a peasant fair," "a peasant feast," "a peasant wedding," "a peasant dance," "a peasant shed with peasants," "a piping peasant woman with a few other peasant men and women" (perhaps another rendering of "As the Old Sing, so Pipe the Young"), and pictures of peasants playing a variety of games. "A goose-pulling" must have looked like a village fair entertainment comparable to Molenaer's *Shooting the Parrot* (fig. 6). Comic themes not necessarily involving rustics include "a little merry company," "a little smoker," "a little milkmaid," "little tric-trac players," "a little old woman" (frequently considered humorous subjects for *tronies* in early modern literature and art), "a little tooth puller," "a little drunk," "a little drunkards' feast," "a little horn blower" (perhaps a baker blowing his horn, a favorite theme of Haarlem painters),[28] "a cat scratcher," "a tryst," "a little brothel," "a mocking [or scolding] woman," "a quack," "a little singer," "a little company in which a lute player appears," "little fighters," and on and on. Most of these descriptions readily evoke Molenaer's versatile efforts in the comic mode, as illustrated in this catalogue. The diminutive form inventory takers used to describe many of these paintings, even if they were of sizable dimensions, indicates their "low" comic flavor: the "little" should be taken in the sense of "a trifle."

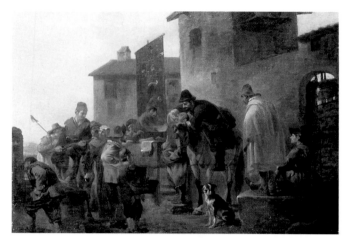

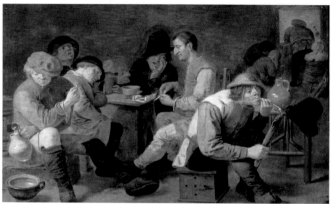

Fig. 7
Pieter van Laer, known as Bamboccio
Mountebanks, ca. 1635–37
Oil on canvas, laid down on panel,
15 ⅛ x 19 ⅝ in.
Christ Church Picture Gallery, Oxford

Fig. 8
Adriaen Brouwer (copy)
Tavern Revel, 17th century
Oil on panel, 9 ⅞ x 14 ⅝ in.
Staatliche Kunstsammlungen, Kassel

For trifles, small fry, was what paintings of stock comic themes were considered to be—at least in the earliest Netherlandish attempts to write a theory of art. In the seventeenth century, the fullest such statement on figural scenes of a comic cast was given by Samuel van Hoogstraten, in his *Inleyding tot de hooge schoole der schilderkonst* (*Introduction to the High School of Painting*) of 1678. Following Van Mander and Italian tradition, Van Hoogstraten attempted to create a three-tiered hierarchy of subject matter.[29] The highest and lowest ranks were relatively obvious to him. "The third and highest" kind of painting shows "the noblest actions and intentions of rational beings," that is, it concerned itself with classical and biblical history, and perhaps grand portraiture of exemplary aristocratic figures. Still-life painters plied their trade on the first and lowest rung of the ladder, being "foot soldiers in the army of art." But things got murkier in-between these extremes. "The second bunch [of painters]," as Van Hoogstraten sets out somewhat dismissively, "comes forth with a thousand different decorations, and plays with cabinet pieces of all sorts." He then sums up a range of these *kleyne beuzelingen* (little trifles) that suggests minimal coherence to the modern eye: scenes of satyrs, shepherds, and wood nymphs in Arcadia; animals in Paradise; night scenes; fires; scenes of Twelfth Night; Bambocciaden (tavern scenes named for Bamboccio, the Dutch painter Pieter van Laer; fig. 7); "farces of Jan Hagel" (another low comic name); barbers and cobblers; gold diggers; and sorcerers.[30] Molenaer painted almost all of these themes, from pastoral landscapes to Twelfth Night, from scenes of comic theater to tavern revels (Weller fig. 14 and cats. 19, 29, 33, and 35).

Van Hoogstraten elaborates the humorous nature of much of the second grade of painting in a later passage, where he links several types of cabinet pieces to particular artists, playing on their lowly names. He itemizes middle-tier paintings as "all jests, Bambocciaden, *Brouwers* (brewer's) jokes, modern games, *molenaers* (miller's) pubs, Ludius landscapes, and Pyreykus donkeys."[31] The Bambocciaden again refers to Bamboccio, whose fame in the tavern and lowlife genres was so great that his name became the brand mark for it. "*Brouwers* jokes" are literally "Brewer's jokes" and thus refer to Adriaen Brouwer's comic tavern scenes with their liberal flow of beer (fig. 8). Ludius landscapes are the unassuming scenes of the famous Greek painter Ludius; his name also evokes the Latin root *ludo* (to play or jest, as in our *ludicrous*). Peiraikos was the great Greek painter who stuck to such trifles as donkeys and cobbler shops, and yet gained both fame and wealth for them, as seventeenth-century artists knew very well.[32] Within this lineup of subjects identified by their most famous artist practitioners, the "*molenaers* pubs" are surely not just miller's taverns but more specifically Molenaer's taverns. The reference is probably the first bit of academic writing about Molenaer, and it ranks him with four of the greatest trifling painters of classical Greece and the seventeenth-century Netherlands.

This apparent recognition by a knowledgeable peer of Molenaer's particular strength is

echoed in seventeenth-century inventories of collections. Several collectors and art sellers who owned Molenaer's works, in Haarlem, Amsterdam, and elsewhere, apparently had a distinct preference for comic pictures. A very early example is characteristic for a small pattern of Molenaer's presence in collections with a comic flavor. In 1631 Hendrick Willemsz den Apt, innkeeper in Haarlem, was given permission to auction about a hundred paintings.[33] At least a quarter can be identified as comic pictures by some of Molenaer's funniest predecessors, including the Bruegelian peasant painters Verbeeck and Maerten van Cleef and Molenaer's contemporaries Frans Hals, Dirck Hals, and Adriaen van de Venne. The young Molenaer was represented with four *tronijkens* (little faces), a fluid seventeenth-century word for single-figure, bust-length paintings of mostly anonymous models. *Tronies* were valued for such qualities as spirited design, interesting costume, and trenchant expression.[34] While *tronies* could be serious and elegant, they were equally favored for comic expression. One of Frans Hals's pictures in the auction, for example, is identified as a *tronie* in the guise of a *peekelharing*, the stock comic character Pickleherring (fig. 9). Van Cleef, a sixteenth-century comic specialist, also appears with a *tronie* in this sale.[35] Molenaer's *tronies*, listed together, are perhaps identical with, or at least similar to, his series of half-length figures of children representing the Senses (cat. 3). The early date of those works substantiates this possibility.

The inventory of Molenaer's estate taken after his death in 1668 (see Appendix) lists a similar range of pictures, possibly for sale (many artists dealt in pictures on the side) and certainly for artistic inspiration.[36] His effects included not only a stock of some four dozen of his own works and several paintings by Judith Leyster and by his brothers Klaes and Bartholomeus but also "an old little piece" and "a large piece" by Lucas van Leyden, six paintings by or after Brouwer, and anonymous works such as a "Child on a Pottystool," "a drunkards' feast," and several rough-looking *tronies*. "A large pancake wedding" attributed to Bruegel was probably a version of one of Bruegel's rustic wedding scenes by one of his followers. Molenaer painted several village wedding scenes indebted to a composition popularized by Pieter Bruegel the Younger (figs. 10, 11) and later taken up in comic variation by Steen (fig. 12). Several pictures attributed to Hals (Frans, Dirk, or Harmen) may well have been of comic figures: "a little round one" evokes Frans Hals's spirited, smiling figures of children, which were so formative for Leyster's and Molenaer's interest in the ebullient child (Bogendorf Rupprath figs. 6, 11, and cat. 3, fig. 1). Three little pieces by Adriaen van de Venne must have been of the grisaille variety, small panels with roughly brushed, near-monochrome images of lowlife (fig. 13). His pic-

Fig. 9
Frans Hals
Pickleherring, ca. 1628–30
Oil on canvas, , 29 ½ x 24 ¼ in.
Staatliche Kunstsammlungen, Kassel

Fig. 10
Village Wedding, ca. 1650
Oil on panel, 26 ⅛ x 34 ¼ in.
Musée d'Art et d'Histoire, Geneva

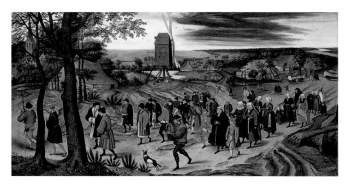

tures were typically inscribed with captions that comment on the scene through derisive but witty and complex word-play.[37] All of these artists shaped the comic character of Molenaer's work, as indicated throughout this catalogue. His absorption of the sixteenth- and early-seventeenth-century comic painting is on display especially in paintings of such distinctive Bosch-like and Bruegelian themes as the tooth puller (cat. 4 and cat. 4, fig. 2), *Dance in a Village Street* (cat. 6, strongly redolent also of David Teniers), *The Fat Kitchen* (cat. 25), *Battle between Carnival and Lent* (cat. 18), and *The King Drinks* (cat. 19). By the mid-seventeenth century, no comic Nether-landish painter could do without such self-conscious references to Bruegel, whose achieve-ments had been touted by Van Mander and disseminated by his sons and followers. Steen famously revised and updated Bruegel from the early 1650s through the 1670s, and it is characteristic of his debts to Molenaer that the older artist had preceded him in virtually all of the Bruegelian themes at which he tried his hand.[38]

How did Molenaer come to specialize in the middling, comic mode to such a consider-able and varied extent? By the late 1620s, when Molenaer appears to have established himself as an independent painter, some measure of specialization had become the norm for painters on the competitive Dutch art market.[39] For many artists, producing small- to medium-sized paintings in one particular genre—landscape, portraiture, still life—that might be sold with relative ease through the various open-market channels was a more secure way of plying the artist's trade than experimenting in all genres, sizes, and media, as, for example, Rembrandt did. In Haarlem, such accomplished painters as Frans Hals, Hendrick Gerritsz Pot, and Johannes Verspronck already had a corner on the bread-and-butter market for portraiture, each specializing in a distinctive manner of portraiture as if producing a sort of brand-name product. History painting in a grand manner was also a well-practiced genre there, but as a likely product of the Hals workshop, Molenaer may never have considered it seriously as a specialty.[40] Although Molenaer bucked the specializ-

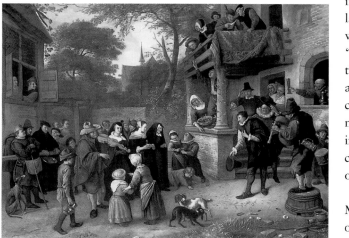

ing trend to some extent—he did paint several portraits, landscapes, and history paintings—he seems to have settled well and willingly into the mid-grade specialty of figural "cabinet pieces," as Van Hoogstraten would have called them. His earliest-dated paintings, made in 1629, virtually amount to a statement of intention: they represent three children making music on folksy and makeshift instru-ments, a tooth puller, and a family merrymaking in an interior (Weller figs. 5, 6, and cat. 4). All of the paintings considered to have been painted a year or two earlier are of such merry themes.[41]

This thematic predilection is certainly consonant with Molenaer's presumed training in Haarlem, in the workshop of Frans Hals, and the specialization made good economic sense in a town with a young but vibrant tradition in the comic mode. With their lowly subjects, noticeable brushwork, and colorful palette, Mole-naer's first works clearly responded to pictures of similar themes by Frans and especially Dirk Hals, Brouwer, and perhaps Van de Venne. Molenaer's robust figures, boldly drawn in the round, are unlike the daintier, more flatly rendered characters of Dirk Hals, and they

suggest his absorption of Brouwer's updated versions of the Bruegelian repertoire. Through its many immigrants from late-sixteenth-century Antwerp, Haarlem had the strongest ties of any Dutch artistic center to the lineage of southern Netherlandish painting, including its peasant repertoire. Van Mander painted several rustic festivals in the Bruegelian mode (fig. 14). Frans Hals had been born in Antwerp, and his figures of comic characters appear to acknowledge these origins. When Brouwer came north from Antwerp, he spent significant time developing his lowlife scenes in Haarlem.

Sheer availability of a lively tradition of comic painting in Haarlem cannot by itself account for Molenaer's particular interests, nor can the economic argument for specialization. How Molenaer's temperament shaped his choice cannot now be recovered, but it is plausible the versatile challenges of the middling mode would have appealed to someone of his apparent imaginative resources and reasonable intellectual interests.[42] Although comic pictures did not by their themes and motifs belong in the highest order of painting, even Van Hoogstraten readily admitted that thematic classification alone did not constitute a picture's financial or artistic worth. Not only did individual paintings within a grade vary in quality, but it was even possible for a painting of the lowest order to exceed some of the middle or highest grades in value.[43] The Greek painter Pyreykus, as noted above, gained fame and wealth precisely for specializing in his lowly scenes. Once on his comic course, Molenaer transformed available pictorial models into innovative paintings of the lives of doltish peasants, deceitful rakes, incorrigible children, and spendthrift youths. More versatile than his peer Adriaen van Ostade (1610–85), who specialized in peasant painting, Molenaer helped Haarlem become the preeminent center for varied comic painting from his generation through those of Jan Steen and Cornelis Dusart, both of whom

were trained in the city and in their mold. Molenaer's move to Amsterdam in 1637 seems to have had no diminishing impact on his significance for comic painting in the town where his comedy was rooted.

Fig. 13
Adriaen van de Venne
Poverty Seeks Cunning, ca. 1635
Oil on panel, 30 x 23 cm.
Private collection

Fig. 14
Karel van Mander
Peasant Kermis, 1600
Oil on panel, 49 x 77 cm.
Hermitage, St. Petersburg

Comic Workings of Molenaer's Art

Molenaer demonstrated his conscious engagement with comic painting in two unconventional paintings of a painter in his studio (Weller fig. 1 and Bogendorf Rupprath fig. 1).[44] The *Artist in His Studio with an Old Woman* has plausibly been identified as a self-portrait, but even if it were not, its juxtaposition of a well-dressed painter smiling at us with an elderly woman who beseeches him in insistent profile makes the painting into something of a manifesto on Molenaer's art.[45] Women were favored and versatile presences in early modern representations of studios, figuring as models, muses, and even

rewards (as in the case of Campaspe, the favorite mistress whom Alexander the Great gave to Apelles). The only legendary elderly female model, known in the seventeenth century through Van Mander's writing, was an old crone who sat for Zeuxis when the painter himself was quite old. Van Hoogstraten repeated the tale approvingly in a theoretical digression on the expression of the passions and noted the comic nature of the situation: "when Zeuxis was painting a comical old hag, he burst out in such uproarious laughter that he choked and died."[46] The artist here certainly laughs, and the still life in the making on the easel may, through its *vanitas* elements, have reinforced the memory of Zeuxis in erudite viewers.[47] Molenaer's woman indeed is at best a comic muse: hunched, bony, and wrinkled, she resembles a model for a *tronie* or, with her pleading gesture and lapful of coins, the would-be lover of an unwilling, strapping young man. Both themes belonged to Molenaer's comic repertoire.[48]

In his *The Artist in His Studio* of 1631 (Weller fig. 1), Molenaer presented a similarly ironic view of the comic artist, or at least of the artist of merry company scenes. The painter, smiling at us and at a dwarf dancing with a dog, has interrupted his painting to restock his palette. The other figures in the room form a motley bunch: an old man playing the folksy hurdy-gurdy, a laughing painter's apprentice, and a properly dressed middle-class woman who raises her finger. A look at the prominently displayed canvas on the easel clarifies their odd presence, for these are the very figures the painter is composing into a merry company not unlike his *Young Musicians and a Dancing Dwarf* (cat. 5). During their break the various actors are practicing their various roles, except for the laughing apprentice, who has been enlisted to do some jolly dance steps to the tunes of the hurdy-gurdy. The painting acknowledges, even proclaims, the constructed and essentially theatrical character of all comic realism.

The required realism of comedy could thus be attained in numerous pictorial ways. What any culture considers "real-looking" is highly contingent on historical circumstance, as any comparison of Molenaer's realist strategies to those of Vermeer or of nineteenth-century photography to contemporary virtual reality games makes immediately evident.[49] By the standards of comic representation in Molenaer's day, the lifelike quality of comedy inhered in effective stereotyping and compelling, recognizable communication of standard foibles and virtues. Molenaer was impressively creative in rendering impressions of the real on those terms.

To the seventeenth-century eye, one of the most convincing mechanisms of imitating life was a carefully structured disorder. In the apparent randomness with which incidental details might catch the viewer's eye, a disorderly composition could mimic the somewhat unpredictable hierarchies of our daily perception. That unruliness appeared more truthful than an orderly composition, and that it required hard work was obvious to the playwright Jan Vos, who created chaotic seeming plays for the Amsterdam Theater. In defense of these grand machines, he wrote:

The lives of the great and the small, which one shows on the stage, exist mostly in licentious extravagances. Whoever wishes to keep order in this disorder of life, will himself become disorderly, for he would depart from the truth. But whoever wants to represent disorder properly must use disorder, and thus disorder becomes order.[50]

Some such thoughtfully arranged disorder seems to have governed many of Molenaer's compositions. Many of his merry company scenes and peasant groupings have a studied artlessness in their grouping, where figures are jostled impossibly close or posed in appar-

ently disconnected fashion. The composite character of paintings such as the early *Family Scene* (Weller fig. 5) gives an unpremeditated effect, implying the painter just stumbled upon the situation. Incidental details, often rendered with a high degree of textural veracity and distributed throughout the scene, further heighten the impression of a moment witnessed (cats. 2, 17, and 19). In comic painting, such realist details—a favored technique of joke telling—are preferably inserted in disorderly fashion. Molenaer exploited this tactic throughout his career. In the *Family Scene*, a broken pipe, casually discarded cloths, and various bits of crockery clutter the room without apparent narrative impetus.

The realist brief of comedy, its mandate of representing people as or as worse than they are, permitted and even required an abundance of bodily motifs that would be out of place in portraiture or grand history painting. Even Van Mander agreed that scatological details could be warranted in droll scenes. Molenaer reserved such motifs for his peasant scenes, in one case enlivening his *Peasants near a Tavern* with a child on a potty stool and a man urinating near a rustic cottage (cat. 17). He mustered all the bodily resources of the unruly in his series *The Five Senses* (cat. 26). These situation sketches are perhaps even more humorous than Brouwer's precedents in their frank acknowledgment of abject pain and in-your-face stench. Cruelty to animals, hardly a laugh to us, gets top comic billing in Molenaer's paintings of children (cat. 16 and cat. 16, fig. 1) and in the occasional scene of peasants pulling the goose at village fairs.[51]

None of Molenaer's paintings look "realistic" in the smooth sense of Gerard Dou or Johannes Vermeer, who in their different ways effected stunning textural and optical mimesis by hiding the work of the brush.[52] In the earlier period of Molenaer's beginnings, and especially in Hals's entourage, the *rouwe* (rough) manner identified by Van Mander as a viable mode of painting, alternative to the *nette* (neat or smooth) style, appears to have functioned as a quite different realist strategy. Whereas the slick surfaces of fine painters such as Frans van Mieris rendered the work of their maker nigh invisible, the unblended strokes of Hals and his followers, apparent to the viewer even at a considerable distance, seem to express the artist's feverish pace of work in registering the scene at hand. The visible handiwork functions as an effect of direct witness, no matter how composed the scene.[53] In rendering lowly themes, the rough style, also known as *los* (loose), was also well suited to evoke coarse behavior and undisciplined temperament.[54] Molenaer's handling never quite achieves Frans Hals's dashing brilliance (fig. 9) or Brouwer's controlled crudeness (fig. 8)—it is mostly quite polite. He and his customers may have considered his finer but relatively unblended painterly marks a middle-of-the-road solution appropriate to his preferred range of themes.

In comparison to the protophotographic, optically and mathematically informed rooms of Vermeer, Molenaer's spaces do not strike us as particularly realist either. Realism in comic representation meant setting a stage suitable to the communication of the moral truths comedy purveyed, and in contemporary theater this meant tableaulike rather than illusionist *mise-en-scène*. Early in his career, especially, Molenaer used this principle of comic staging, placing his figures along a few planes in shallow, boxlike spaces and letting a few or all of them address the viewer directly. He inherited this style of presentation from Dirk Hals (Weller fig. 4 and cat. 27, fig. 1), among other Haarlem painters, but the bolder presence and roomier disposition of his figures seem to suggest direct borrowing from theatrical practice as well. Molenaer's interest in contemporary theater is particularly well documented in his two paintings of episodes from Bredero's *Lucelle*, a classic tragicomic narrative of socially mismatched lovers who are permitted their love once it is dis-

covered the pauper is really a Polish prince (cat. 29 and cat. 29, fig. 1). Although technically history paintings, in their histrionics they look like grandly scaled versions of his merry companies involving a variety of characters in heightened emotional states.[55]

A standard figure of (tragi)comic theater was the actor who steps out of role and, in a move that paradoxically undermines the illusion that we are witnessing a real situation, addresses us directly to comment on or mock the scene.[56] In his representation of *Lucelle* in the Muiderslot (cat. 29, fig. 1), the cavalier with drawn sword performs this function of making us sit up and take notice. Tellingly, dramatic theorists considered direct commentary to the audience more appropriate for comedies than for tragedies, and they recommended it particularly for drunkards and fools. By laughing, smiling, or just telling people to laugh, such actors frequently exhorted the audience to see the comic point of the scene. Molenaer used this technique frequently and in varied ways, having proper burghers smile condescendingly (fig. 1), girls laugh infectiously (Bogendorf Rupprath fig. 11), lager louts guffaw without moderation (cat. 19), and cheats grin with *Schadenfreude* (cat. 20). All of these mirthful faces—of which at least some inventories take explicit note, as we have seen—did much to cue the viewer that the scene should be taken as fodder for amusement.

Molenaer's tableaulike compositions are highly dependent on gestural repertoire for their situational clarity. Expert manipulation of gesture, physiognomy, and posture—either apposite or deliberately malapropos—was a flexible communicative tool of comic theater as well as painting. Steen's finely differentiated gestures and physiques for readily recognizable social types accorded with standard recommendations for playwrights and painters. Arnold Houbraken, his first biographer, recommended Steen's gestural brilliance as a model for young painters and saw it as a clear mark of his comic temperament.[57] Steen's telltale gestures suggest he looked hard at Molenaer's example. With Molenaer, peasants are the neckless, rounded, fat-cheeked wonders of Bruegel's and Brouwer's stock, rarely caught in the upright poses that were highly valued, then and now, by the citizen elite.[58] Molenaer capitalized on such distinctions in pictures such as his *Family Visiting a Village School* (Weller fig. 7), where the well-groomed, urban family processes upright into a barnlike interior full of hunched, swaying, laughing, and otherwise uncouth kids. Molenaer's introduction of serious urban bystanders makes the painting a more explicit mocking commentary on the ineffectiveness of rural schooling than the purely rustic representations of the theme by Bruegel and Adriaen van Ostade.[59] The rustics who act out *The Five Senses* (cat. 26) are perfectly suitable to the task because their generous, unrestricted bodies identify them as driven by sensual desires, unhampered by rational thought. The distorted physiognomies and grand posturing of Molenaer's rakes, cardsharps, and other con men exude untrustworthiness (cat. 4; cat. 4, fig. 2; and cat. 20).

High-keyed facial expressions suggest a lack of civilized self-control in Molenaer's ill-behaved children and boors. Following the practices of Frans Hals, Gerrit van Honthorst, and the young Rembrandt, Molenaer favored open-mouthed grins for naughty kids and for peasants in pain (cats. 4, 18). Revealing one's teeth in laughter or pain was not the way of polite folk, as contemporary portraits make very clear (Weller fig. 9 and cat. 15). The artists who used this technique may well have known that the Greek painter Polygnotus was credited with inventing it for the purpose of ratcheting up emotional expression.[60] Molenaer certainly exploited this capacity of the wide-open mouth. With his tattered clothes and alarmed grimace, Molenaer's dental patient is a mere peasant fool deserving of his unnecessary torment or, as someone who addresses us directly, perhaps

even an accomplice to a theft—in this case an interested woman is robbed of a fowl (cat. 4, fig. 2).[61]

In its elaborateness, Molenaer's use of pointed individual gestures was an especially innovative characteristic of his comic works. Many of these hand signs must have had quite specific meaning in seventeenth-century culture, and some can be identified with a measure of precision by reference to John Bulwer's illustrated manual of gestures, published in London in 1644. Molenaer need not have known this book for it to help us understand the sharpness of his gestural language, for Bulwer's extensive catalogue registers common (and some uncommon) European conventions of spoken rhetoric. One of his favorite hand motions is the explicitly extended index finger, a pointing device probably used more frequently by Molenaer than by any other painter of his time.[62] When directed upward, this gesture is one of upbraiding, as seems appropriate for the woman in *The Artist in His Studio* (Weller fig. 1), who seems to rehearse it to tell off the dwarf, or the smiling child in the foreground of the *Family Visiting a Village School* (Weller fig. 7), who may be applying it in censure to the bawling boy or perhaps in imitation of the schoolteacher, who is about to inflict corporal punishment on a smirking pupil.[63] Molenaer's most outlandish revelers throw up both hands in triumph, an approved gesture of excess celebration, in Bulwer's classification (cat. 6).[64] The cupped hand of the woman in *The Artist in His Studio with an Old Woman* (Bogendorf Rupprath fig. 1) is a characteristic gesture for those who "crave, beg, covet, and show a greedy readiness to receive." The hand sign must have facilitated contemporary understanding that this woman may have been seeking the attentions of the young painter.[65] Bystanders in Molenaer's paintings often hold up one hand with the palm outward to signify their approbation and amusement at the misfortune of others (cats. 6, 17); it is one of Molenaer's most cruel comic signs.[66] In *The Dentist* (cat. 4), a young woman uses it to underscore her smiling pleasure in the pain of a yokel, who himself clenches his fists in the prescribed gesture for great suffering.[67] Not all bystanders are so mean spirited. A female witness of another needless dental procedure has entwined her hands in the hand-wringing action Bulwer identifies as the most convenient gesture of grief and sorrow (cat. 4, fig. 2).[68] Ironically, this sanctimonious woman is coming to grief herself this very moment.

While many of these gestures may seem fairly obvious because we still use them (the finger raised in disapproval), or even natural in the case of the pointing finger or the fist clenched in pain, others are so subtle that they enrich the situation in unexpected ways. Once in a while, for example, even Molenaer's comic actors signal they are fed up with all the noise. The elderly woman in Molenaer's finest rendering of *As the Old Sing, so Pipe the Young* folds her fingers in a plea for silence that is likely to go unheard (cat. 28).[69] Decoding such gestures, from the obvious to the arcane, must have enhanced viewer pleasure in Molenaer's scenes.

Even if an understanding of seventeenth-century comic practice may not make us enjoy the brand of humor tapped in Molenaer's *Boys with a Dwarf* (fig. 1), it can clarify how the painting could have functioned as a successful, innovative comic painting. The central conflict between dwarfs and howling lads would immediately have classified this painting as comic, for both types were standard figures of fun in an age that cared little for people with nanism and less for impoverished youths. This situation alone suggests the sorts of viewers who would have been likely to find comic pleasure or relief in the specter of an irate dwarf attacking an adolescent rabble. Like most seventeenth-century paintings, Molenaer's was unquestionably intended for sale to well-heeled, urban citizens, to people who

might dress much like the couple that sets the proper example for the viewer's response. The man's rhetorical gesture was understood in this period as one of demonstration and admonishment, as Bulwer suggests.[70] The rebuke appears twofold. On the one hand, it addresses the dwarf's inflamed response at youthful teasing, a presumably harmless offense that, by age-old Judeo-Christian and classical tenets, the dwarf should just grin and bear.[71] The dwarf's lack of self-control may have seemed in particularly bad taste, because in early modern Europe anyone of abnormally short posture was a rightful figure of fun, beloved jester at courts, freak of nature at fairs. And perhaps worst of all, his unimpeachable costume suggests he is or pretends to be of considerable social standing, and here violates the behavioral code of his class.

As a painting, *Boys with a Dwarf* must have been something of a novelty in that it transforms several pictorial models and standard comic motifs into a new type. It has been pointed out that the downward diagonal of tumbling boys may acknowledge the composition of Bruegel's *Blind Leading the Blind*, in a quotation that might be meaningful as much as formally convenient. The dwarf as cherished figure of fun in European court settings has here literally become a joke, losing his temper in ways that would be out of line in proper court portraiture. Postures, gestures, and physiognomies are incisively drawn and, in the case of the boys, differentiated from one another with painful sharpness. And the commenting couple has wandered in from an allegorical genre in which married couples are placed next to or in front of scenes exemplary of proper marital and social behavior. Molenaer himself made memorable, serious paintings of this kind, following the convention of not letting the couple participate in the scene—indeed, the other actors in these pictures typically seem unaware of these stand-in spectators (Weller fig. 7 and cat. 13). In *Boys with a Dwarf*, the exemplary husband and wife very much participate in the action and are almost crowded out by the rabble. Their "real" presence confers on them the status of witnesses, prompters of laughter, and stand-aside observers—in other words, of the cherished comic mediators of theatrical practice. One other character in the scene prompts us to pass judgment on the scene: the dog who regards us insistently. With his concerned expression, he may be encouraging us to regard the scene cynically, as cynics (from the Greek *kunikos* [doglike, churlish, dismissive]). Or, as cynic by linguistic nature, he may remind us how the dwarf should have responded, by turning his back on the provocation, as the great Cynic Diogenes would have.[72] Brash, clever, and socially real for its audience, the painting would have proved to anyone in the know that comic painting had new, relevant issues to tackle beyond the Bruegelian peasant, who was rapidly becoming a quaint figure of yore in the art of Molenaer's peer Adriaen van Ostade.[73] Although Jan Steen trained with Van Ostade in the late 1640s, Molenaer taught him the modern viability of comic painting.

I gratefully acknowledge Jennifer King and Elizabeth Winborne for their expert and thoughtful assistance.

1 On the laughing face as comic marker and prompt, see Mariët Westermann, *The Amusements of Jan Steen: Comic Painting in the Seventeenth Century* (Zwolle: Waanders, 1997), esp. pp. 113–15, and further commentary below.

2 Much of the following discussion of the comic mode in seventeenth-century Dutch painting is based on Westermann 1997, esp. pp. 89–135. For a short survey of the comic mode in Netherlandish art, see my entry "Comic Modes, Sixteenth and Seventeenth Centuries" in Muller 1997, pp. 72–74.

3 I use the term *mode* rather than *genre* because it allows for the possibility of comic elements infiltrating "serious" genres that are not comic, strictly speaking. On distinctions and relationships between genre and

mode, see Westermann 1997, pp. 13–14, with the relevant literature.

4 Particularly helpful studies of early modern comic representation are Alpers 1972–73, Alpers 1975–76, Pleij 1975–76, Pleij 1979, Vandenbroeck 1984, Antwerp 1987, Sullivan 1994, Kavaler 1999, and Dekker 2001.

5 Vanden Plasse 1638, fol. [A3]v.

6 Harmsen 1989, passim. Nil Volentibus Arduum was founded to reform

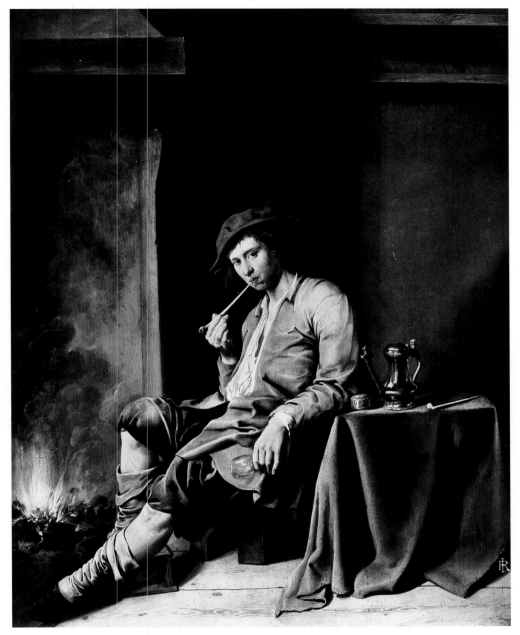

Fig. 3
Smoker Seated before a Fire,
ca. 1632–34
Oil on panel, 27 ½ x 21 ⅝ in.
Carrara Gallery, Bergamo

Notes

1 Among those artists treating the
subject during their years in Haarlem
were Willem Buytewech, Frans Hals,
Dirck Hals, Judith Leyster, and the
Fleming Adriaen Brouwer (see discus-
sion below).

2 Many authors have discussed this
topic, including Bogendorf Rupprath
in Haarlem and Worcester 1993, pp.
246–51; and De Jongh in Amsterdam
1997, pp. 358–61.

3 For a discussion of the oil sketches
by Dirck Hals, see Schatborn 1973.

4 Brouwer, in fact, may have left
Flanders and spent time in the north-
ern Netherlands as early as 1621; see
Bogendorf Rupprath essay, p. 30.

5 Houbraken 1718–21, vol. I, p. 319.

6 See note 2 above and Weller 1992
regarding Molenaer's use of the
subject and its related iconography.
For a survey on the history of tobacco
and its usage in The Netherlands, see
Brongers 1964.

7 Scriverius/Ampzing 1630; transla-
tion by Brongers 1964, p. 140.

8 See cat. 26 for a discussion of the
iconography of the five senses.

9 Quoted by Schama 1987, p. 201:
"Voetius was so exercised by students'
enslavement to the vice [smoking] that
in his inaugural lecture at Utrecht in
1634, he spoke of hellish vapors rising
like so many Sodoms and Gomorrahs
in the sky."

In subsequent pictures of smokers, Molenaer generally communicated a more traditional message. One example is *Taste* (cat. 26), from his series of the five senses dated 1637.[8] Here, a strong warning of excess competes with a comic view of peasant behavior. A different approach, one more relevant to the *Boy Holding a Tankard and Pipe*, appears in a picture dated about 1632–34. *Smoker Seated before a Fire* (fig. 3) shows a youth in similar circumstances, albeit a few years older. As the figure draws smoke from his pipe after emptying his glass, the "hellish vapors" and alcohol seem to have dulled both his mind and his body.[9] Slumped in his chair, the boy has an addiction that may seal his fate. For the alert youngster confronting us in the *Boy Holding a Tankard and Pipe*, however, such a fate thankfully seems uncertain.

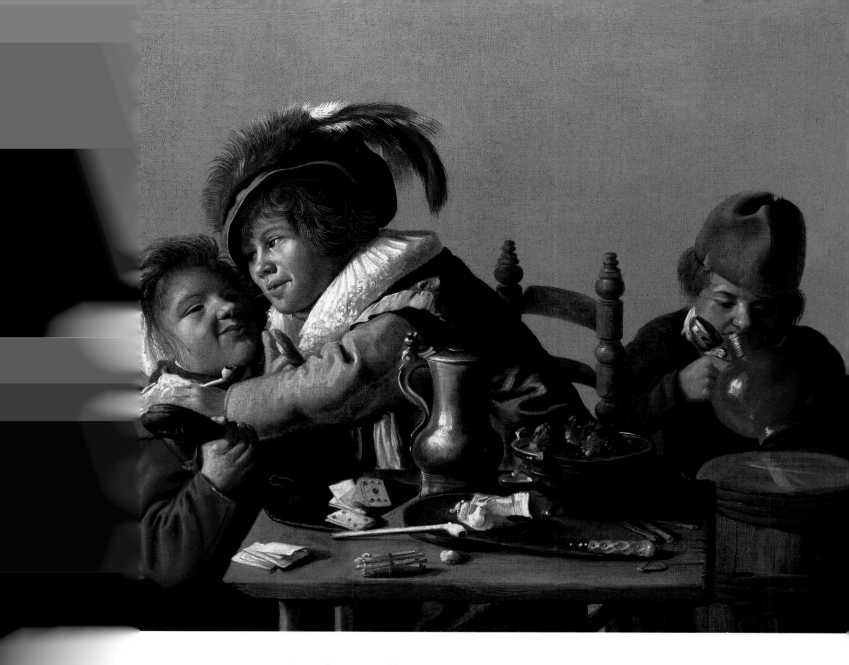

ree Children
a Table

28–29

inctly monogrammed on back of
at center: IMR

s, 18 ⅛ x 24 in. (46 x 61 cm.)
e collection

nance:
adnitsky and Muller, Amster-
16–18 May 1831, no. 38 (as
Galerie Charles Brunner, Paris,
2 (as Leyster); collection
hn, Brünn, by 1925; sale,
ler, Amsterdam, 4 June 1929,
. (as Leyster); dealer Goud-
r, Amsterdam; sale, Dr. L. D.
e Hengel, Ellecom, 19–21 May

From the outset of his career, Molenaer turned frequently to the world of children for inspiration. Not surprisingly, many of his scenes of young merrymakers have strong affinities with works by his contemporaries, specifically Frans Hals, Dirck Hals, and Judith Leyster. Whether shown smoking, drinking, flirting, playing cards, teasing pets, or making music, the young models generate such energy and high spirits that viewers instinctively delight in their escapades. Due to the shared interests shown by the other painters within the Hals circle for such subjects, attribution questions have followed. *Three Children at a Table* has not escaped this fate, as Frans Hals, Leyster, and most recently Molenaer have been assigned its authorship over recent decades.[1] Based on stylistic affinities to other works by Molenaer, including his *Three Musicians* (fig. 1), as well the discovery of remnants of the painter's monogram, *Three Children at a Table* can be counted among the artist's earliest and most engaging pictures.

The composition shows two boys and a girl positioned somewhat awkwardly within an ill-defined space. While the table, chairs, and barrel suggest an interior setting, the room lacks any architectural feature. The format—in which half-length figures appear just be-

hind the picture plane—represents a compositional type popular with Molenaer from the late 1620s. Inspiration may have come from Frans Hals, who painted a number of merrymaking children and young adults in the 1620s. Nearly all of these pictures, including *The Smoker* (fig. 2), provide viewers with close-up views of half-length merrymakers.[2] Although Molenaer could not match Hals's sparkling technique, he did try to capture the spirit of his figures through their actions and facial expressions.

The children in Molenaer's picture seem to partake in behavior better suited to older sinners: smoking, drinking, card playing, flirting, and fighting. The girl may make good her promise of clubbing her companion with the shoe she holds, suggesting the excesses acted out by the children serve as the real subject of the picture. In Haarlem children would not have spent their leisure hours drinking and smoking. What, then, did such scenes represent? The spirited actions of the children, however engaging, undoubtedly touched upon issues directed to an adult audience.

Durantini wrote about this picture in her study of children in Dutch painting. She found the imagery reflecting moral corruption, as youngsters "seem to be mocking or burlesquing adult behavior and excesses."[3] She further noted that certain elements "underline the suggestion of moral corruption to which the scene as a whole alludes."[4]

In using children as mirrors of adult behavior, Molenaer drew on a long history of visual and literary traditions. In the sixteenth century, for example, Pieter Bruegel the Elder exposed adult folly in his masterful *Children's Games*.[5] His

1953, no. 373; S. Nystad, The Hague, by 1955; sale, Sotheby Mak van Waay, Amsterdam, 18 November 1985, no. 164 (as Leyster); private collection.

Exhibitions:
Paris 1912, no. 23 (as Leyster); Brünn 1925, no. 96 (as Leyster).

Literature:
Hofstede de Groot 1910, vol. 3, no. 144a (as Hals); Harms 1927, pp. 145, 238, no. 16, illus. (as Leyster); Hofstede de Groot 1929 (as Molenaer); Von Schneider 1933, p. 66, note 5 (as Molenaer); Durantini 1983, pp. 258–59, fig. 142 (as Leyster); Hofrichter 1989, p. 69, no. B3, pl. 92 (as Molenaer); Haarlem and Worcester 1993, pp. 244–45, fig. 20b

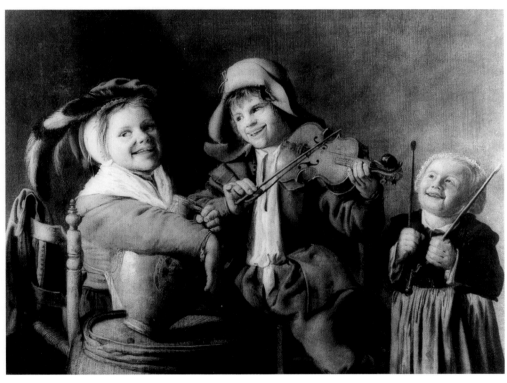

Fig. 1
Three Musicians, ca. 1628–29
Oil on canvas, 19 x 25 in.
Whereabouts unknown

artistic heirs, including both Molenaer and Jan Steen, effectively kept the Bruegel tradition alive a century later. Toward this end the popular seventeenth-century proverb "As the old sing, so pipe the young" may best describe what Molenaer intended his viewers to consider. Based on the idea that children seek to imitate their elders, this proverb became a popular subject for many Dutch and Flemish painters. Among them was Jan Steen, whose picture of this subject in Amsterdam (cat. 28, fig. 1) contains a song sheet on which he inscribed the proverb. Represented are children who drink, smoke, and play musical instruments with the knowing participation of the elders. The overindulgence and excessive behavior practiced by the adults represent an attractive option for the children to imitate. It appears the children in Molenaer's *Three Children at a Table* enact this proverb, for, despite the absence of their elders, they appear fully engaged in imitating adult behavior.

For some viewers Molenaer's merrymaking children also may have brought attention to

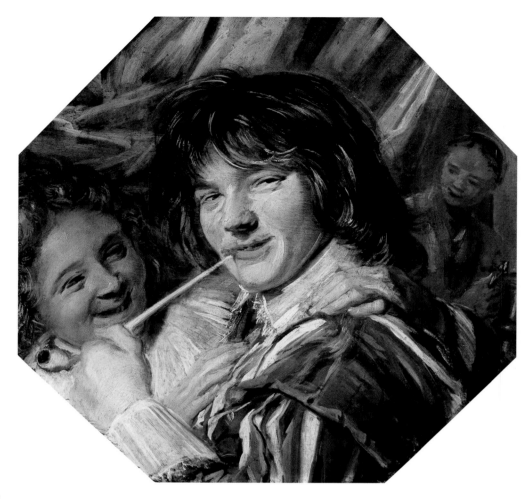

... literature above for a history of
... cture's attributions.

... umber of scholars do not accept
...moker as an autograph work by
... Slive 1970–74, vol. 3, cat. 21,
... 4–15, discusses scholarly opinion
... ding the two known versions of
the work. Regardless of its author-
... however, the composition is
... y based on a Hals model.

... rantini 1983, p. 258.

... l.

...ldren's Games, signed and dated
... panel, 46 ½ x 63 ⅜ in., Vienna,
... thistorisches Museum.

... shington and Amsterdam
... –97, cat. 23, pp. 172–75.

... l., p. 174.

... l.

a related issue in seventeenth-century Dutch thought: the debate between nature versus nurture. Discussing another Steen version of *As the Old Sing, So Pipe the Young*, Perry Chapman outlined the controversy.[6] Is human behavior, even at its most foolish, inborn, or does "the importance of example and upbringing" determine a child's future?[7] She compared the words of the Protestant Jacob Cats ("all those born of cats are inclined to catch mice") with writings by the Jesuit Adriaen Poirters, who warned parents "not to indulge themselves, for it was their responsibility to set good examples for their children."[8] While Molenaer's playful imagery seems removed from the concept of nature versus nurture, the painter did, in a few examples, show a willingness to link his imagery with important issues of the day. Such a connection is questionable here, but one cannot debate the humorous tone Molenaer provided viewers in his delightful *Three Children at a Table*.

Jan Miense Molenaer

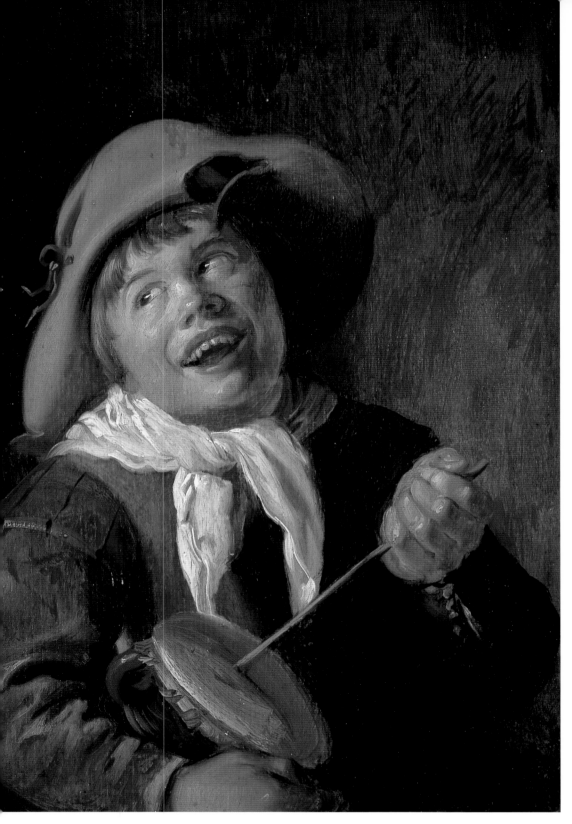

3
Hearing; Smell; Touch

ca. 1628–29

Each unsigned

Each on panel, 11 ½ x 8 ½ in. (29.2 x 21.6 cm.); 11 ½ x 8 in. (29.2 x 20.3 cm.); 12 ⅜ x 8 ½ in. (31.5 x 21.6 cm.)

Hearing
Phoenix Art Museum
Gift of Friends of Art (62/100)

Smell
Cynthia von Bogendorf Rupprath

Touch
Phoenix Art Museum
Museum purchase (66/70)

Provenance:
Arthur Kay, Esq. (d. 1939), London and Glasgow, before 1929 (as by Leyster); probably Georges Wildenstein, by 1941; *Hearing* and *Touch*, Phoenix Art Museum; *Smell*, Brian Koetser Gallery, London, by 1973; sale, Dorotheum, Vienna; Galerie Sanct Lucas, Vienna; dealer, Solomon Lilian, Amsterdam; to present owner.

Exhibitions:
Smell, London 1973, no. 49; *Smell*, Vienna 1986, no. 14.

Literature:
Hearing and *Touch*, Sutton 1986, p. 235; *Smell*, Haarlem and Worcester 1993, pp. 194, 196, fig. 12a.

Seventeenth-century Haarlem artists excelled in their depictions of the five senses.[1] Whether shown within a single composition or as five individual pictures, numerous examples suggest the subject was also a favorite among members of the Hals circle in the 1620s and 1630s.[2] Molenaer was no exception, as he painted a number of sets devoted to the theme. One set remains intact (cat. 26), while others have been broken up over the cen-

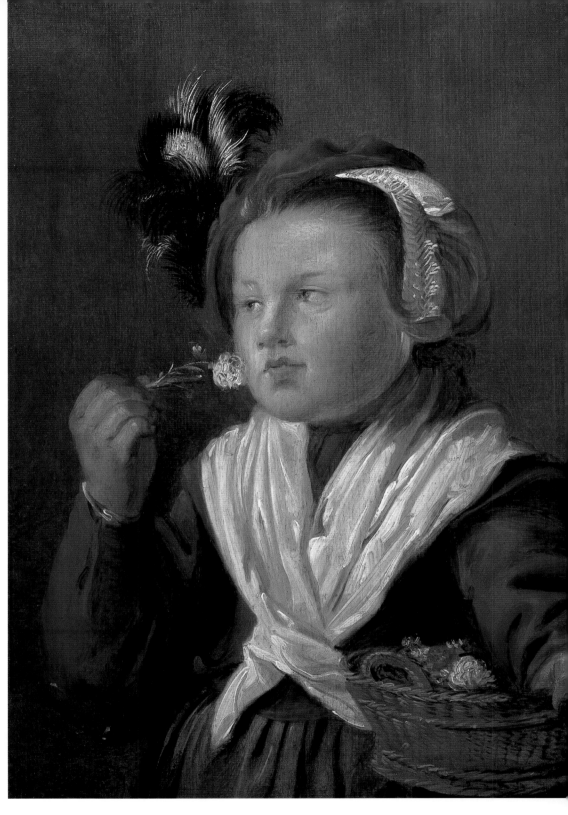

turies. The last to suffer this fate is the set previously owned by Arthur Kay and dispersed only during the second quarter of the twentieth century. Three of the five panels have been reassembled for the exhibition.

This series, painted late in the 1620s, shows Molenaer's debt to the half-length depictions of playful children and young adults painted by Frans Hals during the 1620s. As did Hals in his spirited depiction of *Taste* (fig. 1), now in Schwerin, Molenaer also isolated his child

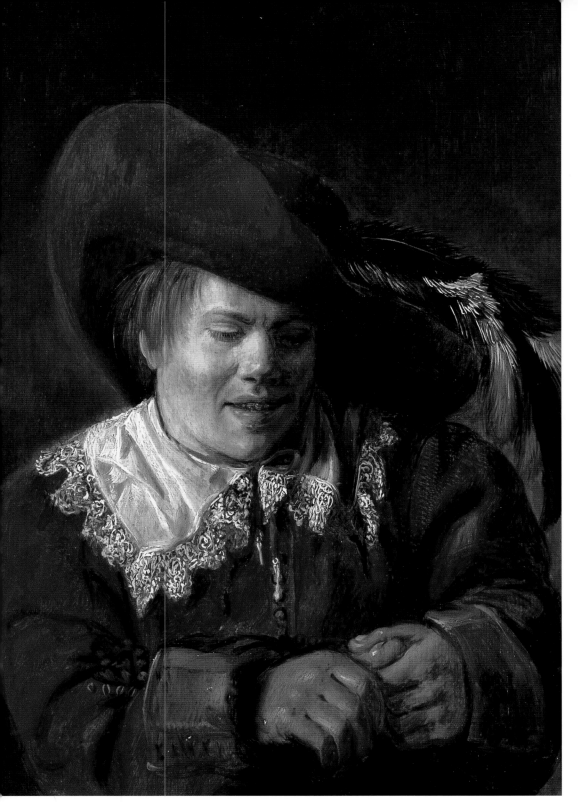

protagonists against neutral backdrops.[3] *Sight* (fig. 2) shows a young boy whose wide smile sets a tone further enhanced by his feathered hat, open lace collar, and unbuttoned jacket. Assuming the pose of a *kannekijker*, this boy looks longingly into a tankard held in his right hand.[4] His intense gaze will do little to replenish his empty vessel with liquid. In *Hearing*, a young rommel pot player appears overjoyed by the ear-splitting squeal emanating from his crude instrument. By contrast and possibly befitting her gender, the young girl

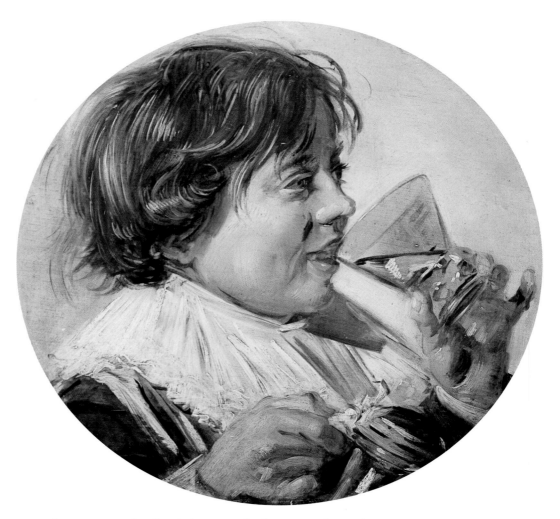

Hals
ca. 1626–28
circular panel, D. 15 in.
ches Museum, Schwerin

who represents *Smell* quietly savors the fragrance of a single blossom taken from a basket of flowers secured under her arm. *Taste* (fig. 3), possibly the most sophisticated of the series, shows a similar restraint as he smokes from his pipe and holds a *roemer* containing wine. The sitter's sympathetic and thoughtful look, fur-trimmed hat, and fine clothing seem largely out of character with most of Molenaer's carefree children. Finally, *Touch*, traditionally the concluding sense in these series, shows a boy in a wide-brimmed hat with feathers squeezing his thumb. His large and powerful hands are featured, but the boy's expression gives little indication as to whether his action caused him any pain.

As mentioned, this set of panels remained intact until 1939. At the time they were attributed to Judith Leyster. In the years since, they have been divided up, and attribution questions of the individual panels of this set have yet to be fully answered. Stylistic comparisons among the three panels assembled for the exhibition and the photographs of the other two show differences in overall quality and paint application. Are all the works by the same hand, or do they come from different artists contributing to one or more sets? Or did the set once owned by Arthur Kay represent a combination of prime versions and replicas by Molenaer or others?

If one considers the stylistic differences between some of the pictures, one can understand why the most painterly example from the group, *Sight*, carried a Judith Leyster attribution at a recent auction.[5] Of the three pictures in the exhibition, *Hearing* and *Touch* are undoubtedly by the same hand. By contrast *Smell*—whether painted slightly earlier, reflect-

ing differences in the representation of girls versus boys, or owing to condition —stands somewhat apart from *Hearing* and *Touch*. The other work, *Taste*, appears from photographs to be more sophisticated in its brushwork and higher in overall quality. Again, is this difference based on condition, on Molenaer's increasing maturity as a painter, or because it was painted by another hand? *Hearing*, *Touch*, and *Smell*, nevertheless, do fall within the stylistic parameters of Molenaer's signed and dated works from the period. His authorship has thus been retained for the exhibition. It must be emphasized, however, that the genesis of the series from which they came needs to be explored further.

Stylistic questions aside, the subjects depicted in these panels are unquestionably related to Molenaer's production during the late 1620s and early 1630s. As close cousins to the playful children depicted in many of his earliest multifigured compositions, these youngsters may have served as inspiration for a series of musicians and smokers he

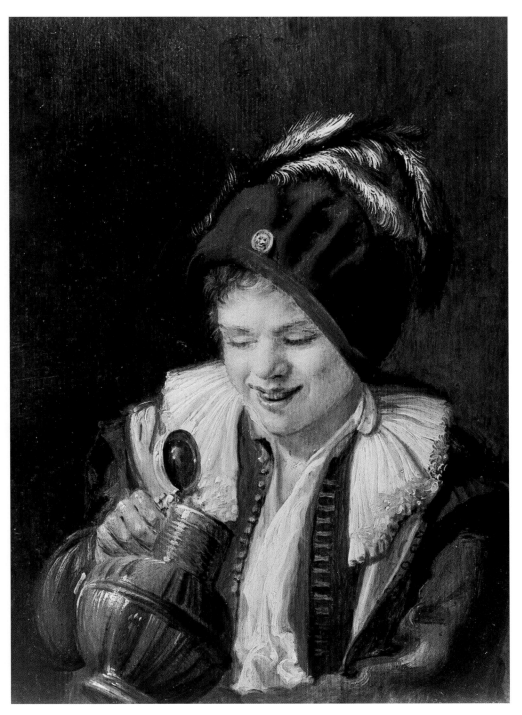

Fig. 2
Sight, ca. 1628–29
Oil on panel, 12 ¼ x 8 ½ in.
Private collection

painted just a few years later. For example, in *Man [Self-Portrait] with a Pipe* (see cat. 21, fig. 2), Molenaer recycled the actions of the young boy holding a wine glass and a pipe to his lips in *Taste*. Later, in 1637, Molenaer returned to the theme of the five senses (cat. 26). Using older models, Molenear in each of these five scenes provides viewers with humorous messages based on encounters between hapless peasants and one of the senses. Just like their youthful counterparts shown here, viewers are both charmed and amused by Molenaer's artistic brilliance.

ca. 1628–29
ı panel, 12 x 8 in.
e collection

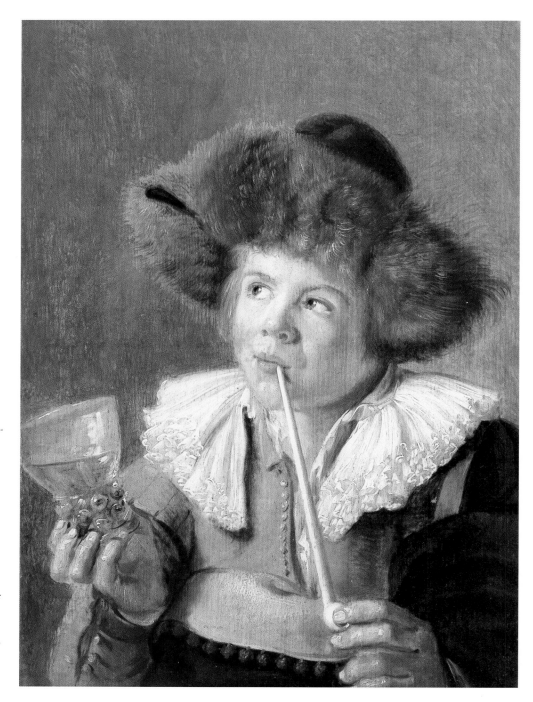

drick Goltzius was among the
earliest of Haarlem's artists to show
terest; see Haarlem and Worces-
ɔ3, p. 328, fig. 36a.

Molenaer and Frans Hals,
Hals was also attracted to the
t. At least one of the painter's
mains intact: *The Five Senses*,
tshuis, The Hague, mono-
ned and dated 1636, each 12
diameter.

Hals painting is discussed by
ı Washington 1989, no. 27,

nnekijker, which describes one
ɔoks into an (empty) tankard or
is a Dutch word often associ-
ith a "tippler" or "soak." Van
1967–68, pp. 93–94) was the
use this term in relationship to
ɪgs by Molenaer.

eby's, New York, 11 April
ɪ no. 183.

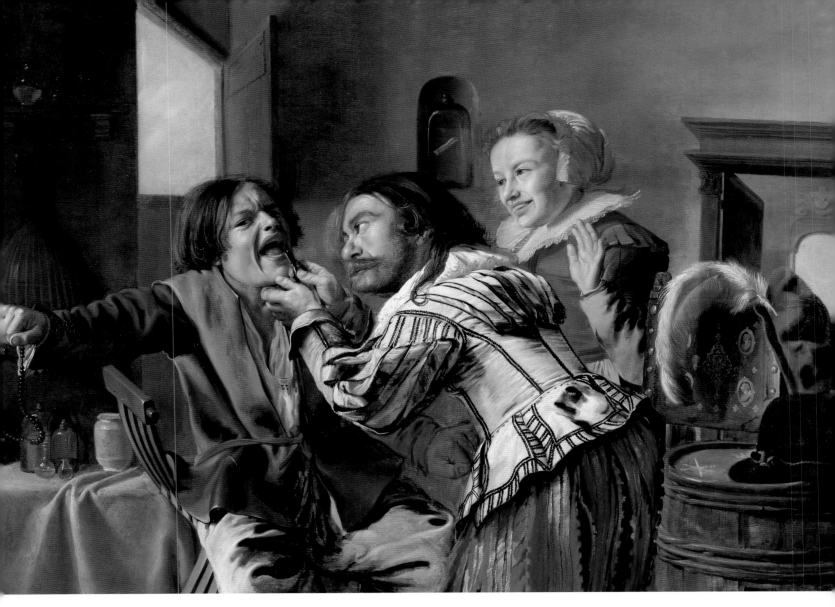

Molenaer excelled in scenes of figures captured in comical situations. In doing so he drew inspiration from a variety of iconographic and artistic sources, ranging from the words of Gerband Adriaensz. Bredero to images by Pieter Bruegel and Adriaen Brouwer. Arguably, only Jan Steen surpassed Molenaer in this regard during the whole of the Golden Age. Among the earliest and most engaging of his comic tableaus is *The Dentist* from Raleigh. Although spatial inconsistencies and the occasional anatomical shortcoming confirm its early date of 1629, other elements within the composition show the rapidly maturing painter finding his artistic voice. The picture highlights the reactions expressed by the three protagonists in the scene: pain, concentration, and amusement.

In an era before Novocain, a young boy is forced to endure the pain inflicted by a dentist who pulls a tooth. The rosary the young patient clutches in his outstretched hand seems to provide little comfort to his suffering. Similarly, the young woman, most likely the boy's companion, appears unsympathetic to her friend's plight. Her toothy smile and dancing eyes offer clear evidence of the scene's comic intent. The punch line to this light-hearted drama, however, falls upon the third figure in the composition, the quack dentist. By dressing the dentist in a fancy doublet with slashed sleeves and colorful bouffant knee britches, Molenaer called attention to the pretentious nature of such self-declared professionals.[1]

4

The Dentist

1629

Signed and dated on the door lintel, upper right: I MOLENAER ANNO 1629

Oak panel, with cradle, 23 ⅛ x 31 ⁹/₁₆ in. (58.8 x 80.2 cm.)
The North Carolina Museum of Art, Raleigh (52.9.50)
Purchased with funds from the State of North Carolina, 1952

Provenance:
Mortimer Brandt Gallery, New York, before 1952.

Exhibitions:
Raleigh 1986–87; Raleigh 1995–96.

ture:
h 1956, no. 59, p. 50; Valen-
956, p. 49, illus.; Raleigh 1983,
illus.; rev. ed., 1992, p. 91,
Braunschweig 1983, p. 141;
:hter 1989, p. 76, fig. 121;
· 1992, pp. 64–68, 100, 346,
Worcester and Haarlem 1993,
·, fig. 4g, p. 289; Raleigh 1998,
ǀ, color plate.

Like their counterparts in medicine, dentists could expect little sympathy from the critical eye of artists and writers during the era. In an engraving from 1523, for example, Lucas van Leyden (fig. 1) depicted another pretentiously dressed itinerant dentist removing a peasant's tooth. As in the Raleigh *Dentist*, the artist added a female companion to complete the trio. Compared to the Molenaer, however, her role has changed. Instead of wearing a wide smile, the woman attends to the more serious business of robbing the unsuspecting patient. She and the quack dentist have teamed together to remove both the tooth and the money of their gullible victim. Interestingly, most representations of dentists in the sixteenth and seventeenth centuries display this negative orientation. A seventeenth-century proverb offers insight into the public's distaste for the profession: *Hy liegt als een tandtrekker* (He lies like a tooth puller).[2]

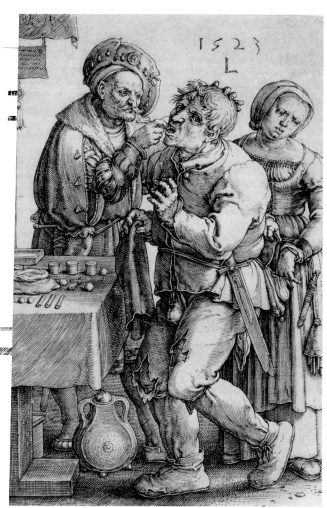

As for Molenaer's composition, the viewer will look in vain for clear-cut thievery. Nevertheless, deceit and gullibility could not have been too far from the painter's mind, for in another example (fig. 2), dated just a year later in 1630, he left little to the imagination. Here viewers observe another fancifully dressed dentist practicing his profession, this time out-of-doors. Such occasions probably coincided with village fairs, as a crowd has gathered to watch patients squirm in pain. If misery loves company, then at least one of the onlookers in Molenaer's scene will soon share in the suffering. Among the crowd is a woman at the center of the composition who shows genuine concern for the patient, perhaps a relative. Unbeknownst to her, a young man in a helmet and gorget distracts her attention long enough to steal a duck from the basket she holds.

Molenaer may have intended a similar cautionary tale for the Raleigh painting.[3] Nevertheless, it is the picture's comic appeal that takes center stage. In this regard the spirited children featured in the genre pictures by Frans Hals and works by Judith Leyster no doubt inspired the young Molenaer.[4] Although he was unable to match the lively brushwork of Hals (or Leyster at her best), his efforts to capture a range of emotions were largely successful. As noted above, however, other elements within the composition demonstrate the painter's youthful inconsistencies. These shortcomings range from the awkward proportions of the young woman, to the crowding of the foreground space, to the unfinished left hand of the patient and the perspective of the room. The doorway to the right, for example, appears out of scale and much too low to accommodate the figures.

The painting suffers somewhat from selective overcleaning, most noticeably in the area of the signature and date on the lintel of the doorway. The third digit of the date was previously altered to read as a 4. Cleaning removed this addition, and the original 1629 date is confirmed by the early style of the painting.

1
as van Leyden
Dentist, 1523
graving
tional Gallery of Art, Rosenwald
llection, Washington, D.C.

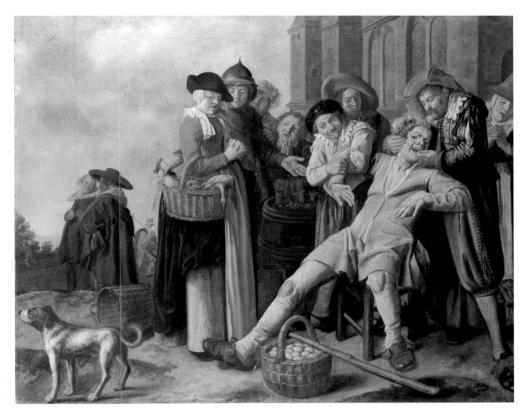

Fig. 2
The Dentist, 1630
Oil on canvas, 26 x 31 ⅞ in.
Herzog Anton Ulrich-Museum,
Braunschweig

Notes

1 The dentist's doublet is of particular
interest, for it reappears in a number
of paintings by both Molenaer and
Leyster. On the issue of shared studio
props, see Bogendorf Rupprath in
Haarlem and Worcester 1993, pp.
147–48, and her essay in this volume.

2 See Braunschweig 1978, p. 107.

3 See Amsterdam 1997, pp. 221–25,
and Judson 1999, pp. 210–13, for
discussions on quack dentists and
those individuals duped by them.

4 Leyster may have played a more
active role in the execution of *The
Dentist*. At least one scholar has
identified two hands in the execution
of the painting, identifying Leyster as
responsible for the smiling woman.
See unpublished manuscript in the
curatorial file of the North Carolina
Museum of Art, Raleigh.

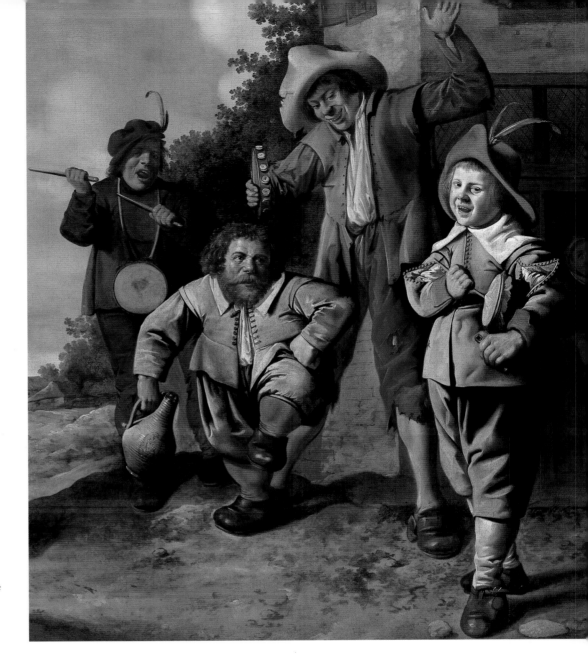

*ung Musicians
d a Dancing
varf*

>30

*>grammed on door bottom at
IMOR (in ligature)*

as, 40 ¼ x 35 ½ in. (102.4 x
cm.)
ction SØR Rusche

mance:
te collection

>itions:
n 1996–97; Paderborn 1998;
chengladbach 1998; and Oelde
.

iture:
p 1996, no. 40, pp. 168–71,
ill., p. 169.

Young Musicians and a Dancing Dwarf represents one of Molenaer's first representations of merrymakers out-of-doors. While little known, this important picture must date very near 1630. As in many of his early compositions in which children take center stage, Molenaer combined imagery popularized by Frans Hals, and other artists in the Hals circle, with his own innovation and comic appeal. In addition, he included a dwarf as a key element in the scene. In this painting, arguably his first in a handful of pictures showing dwarfs, Molenaer's stance toward this dancing figure seems decidedly ambiguous compared to his other representations of small people. Typically, dwarfs shown in seventeenth-century Dutch genre scenes usually appear in a negative light, ranging from being hot tempered to outright evil. Molenaer, for example, expressed such a message in his *Boys with a Dwarf* (fig. 1),[1] where the dwarf throws rocks at his youthful tormentors.

Molenaer's earliest forays into the great outdoors saw him emphasizing figures over their settings. Here he severely limited his view, incorporating only the corner of one building and a partially obscured view to structures situated on the edge of a wood in the far dis-

tance. Against this back-
drop appear three boys and
the dwarf, who fill the fore-
ground. These merrymakers
engage the viewer with their
high spirits, and one can
almost hear the cacophony
of noise produced.

The class distinctions and
associated messages Mole-
naer exploited in the major-
ity of his outdoor merry
companies from the 1630s
are absent here.[2] The sim-
ple, rather disheveled cos-
tumes of the children iden-
tify them as members of
working-class families, with
the older tambourine player
serving as a poster child for
the underclass. He is de-
picted without stockings
and in dire need of a needle

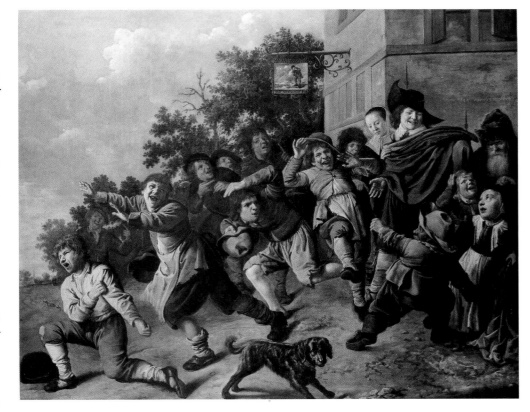

Fig. 1
Boys with a Dwarf, 1646
Oil on canvas, 42 ½ x 49 ⅝ in.
Stedelijk van Abbe Museum, Eind-
hoven, on loan to the Dordrechts
Museum, Dordrecht

and in thread to patch holes on his torn trousers, shirt, and hat. Equally common are the
instruments played by the untalented young musicians. Among them the painter placed
special emphasis on the rommel pot player. Not only does he make direct eye contact with
the onlooker, but he appears more prosperous and alert than his older colleagues.

Rommel pot players were among those subjects portrayed by Frans Hals and later
adopted by painters in his circle, including Molenaer on at least three occasions. The best
known of all these images is *The Rommel Pot Player*, painted by Frans Hals around 1620.
This composition was copied often during the seventeenth century, including a fine exam-
ple at The Art Institute of Chicago attributed to Judith Leyster (fig. 2).[3] Stylistic and com-
positional differences between this work and *Young Musicians and a Dancing Dwarf* serve
to remind viewers of Molenaer's increasing artistic independence.

The Chicago picture shows a tight grouping of happy youngsters mesmerized by the
sounds emitted by the rommel pot. The player, a grizzly old adult with a gapped-tooth
smile and wearing a foxtail hat, is associated with foolish behavior of the type practiced
during Shrovetide celebrations. As Slive noted in discussing another version of the compo-
sition, the large foxtail dangling from the old man's hat is "a traditional attribute of a
fool."[4] Foolishness abounds in this scene, for was it not equally foolish for children to pay
the rommel pot player to produce horrific sounds for them?[5]

In *Young Musicians and a Dancing Dwarf*, Molenaer seems to have de-emphasized the
foolishness associated with the actions of Hals's older rommel pot player. In distancing his
work from the Hals model, Molenaer employed a more descriptive, less painterly applica-
tion of the paints, made significant compositional changes, and redirected possible mean-
ing. With the focus now on the dancing dwarf rather than the musicians, the question
arises as to how contemporary viewers may have interpreted his actions. The dwarf dances
to the music, his inhibitions undoubtedly loosened by the effects of alcohol. Does the

uted to Judith Leyster
ommel Pot Player, ca. 1630
panel, 15 ⅜ x 12 in.
rt Institute of Chicago,
s H. and Mary F. S. Worcester
tion

ough fully signed and dated
the composition is more likely a
ct of the same period as the
ted picture, ca. 1630. For a
sion of the iconography of the
shown in this work, see Sutton
adelphia, Berlin, and London
pp. 264–65, and Hecht 1986,
2–85.

discuss in cats. 6, 13, and
ere, Molenaer provided in-
on by picturing members of
per classes observing varying
s of vice perpetrated by the
lass.

live in Washington, London,
aarlem 1989, pp. 148–51, for a
sion of the Hals painting and
uent copies. In the Judith
r exhibition (Haarlem and
ster 1993, no. 40, pp. 356–61),
ommel Pot Player from Chicago
l a label "Circle of Frans Hals."

ington, London, and Haarlem
p. 151.

e listeners may have been more
d to pay to have him stop
g! The woman standing in the
doorway of Molenaer's picture shows
atience for the performance of
the rommel pot player.

6 Hecht 1986, p. 182.

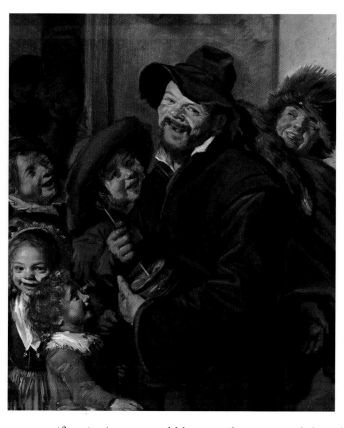

dwarf's dancing allude to other character traits, and if so, were they so ingrained in the consciousness of the age that additional allusions were unnecessary?

While Molenaer's other paintings featuring dwarfs range from carefree fun to aggressive acts against those individuals who taunt and tease them, the painter's stance here is as much neutral as negative. Were contemporary viewers able "to recognize, and share, the merriment of our representatives about the outrageous anger of the little hothead"?[6] As Peter Hecht wrote while discussing the Molenaer dwarf who throws stones at his tormentors (fig. 1), viewers would have easily recognized the call to "bear and forbear."[7] In the *Young Musicians and a Dancing Dwarf*, Molenaer may have been less concerned about such a specific message, instead leaving the prejudices rampant in the century to carry an unspoken meaning.

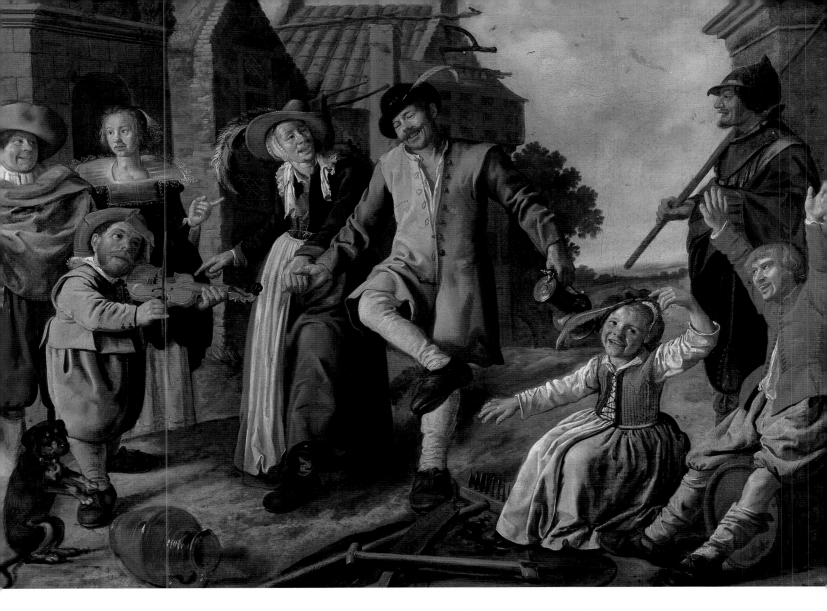

About 1630 Molenaer expanded his repertoire with the introduction of village scenes populated by merrymakers. He continued to paint outdoor genre scenes throughout his career, but those examples completed during the early years of the 1630s stand among the painter's most distinctive and iconographically intriguing compositions. The first of the dated pictures in this format is *The Dentist* of 1630 in Braunschweig (discussed and illustrated in cat. 4). Equally humorous and very close in date is the *Dance in a Village Street*. In it, Molenaer attracts the interest of viewers through his eye for detail, a strong dose of prescriptive meaning, and an undercurrent of humor. Additionally, the picture's compositional format and, to a degree, its subject matter may also serve as key examples of Molenaer's taking inspiration from the art of Pieter Bruegel the Elder.

Dance in a Village Street gives the impression that the eight figures and their pet dog are in the midst of an animated, vaudevillian type of performance. Positioned across the foreground of the composition, these large-scale figures assume a variety of roles. The upbeat tone of the scene is set, for example, by the music offered by a dwarf who reappears in some of Molenaer's early pictures (cat. 5). As noted by Sutton, and as is certainly applicable here, "Dwarfs frequently assumed their traditional roles as street entertainers, exposing themselves to ridicule."[1] Ridicule falls not on the dwarf, however, but on the couple at the center. Dancing to the music, an activity aped by the dog standing on its rear haunches

6

Dance in a Village Street

ca. 1630–31

Monogrammed on saw at center: IMR

Canvas, 28 ½ x 39 ¾ in. (72.5 x 101 cm.)
Rheinisches Landesmuseum, Bonn

Provenance:
Otto Wesendonck, Bonn, before 1896; gift to the museum in 1927.

Exhibitions:
None

Literature:
Harms 1927, pp. 225–26, fig. 17; Bonn 1959, p. 31, fig. 41; Bonn 1982, pp. 354–55, illus.; Philadelphia, Berlin, and London 1984, pp. 264–65, fig. 2; Hecht 1986, p. 182, note 28; Hofrichter 1989, p. 18, fig. 117; Weller 1992, pp. 84–87, fig. 28; Enderle 1992, pp. 188–89, color illus.

Drunken Peddler, ca. 1630–31
canvas, 24 x 27 ¾ in.
eabouts unknown

next to the dwarf, this peasant couple is clearly the center of attention. A village boy and girl enthusiastically imitate some of their dance moves at the right, while on the left a fashionably dressed couple responds in a far different manner. Discussed below, this couple holds the key to the message provided by Molenaer. Completing the ensemble, a soldier watches the events from his vantage point at the far right.

The picture's meaning centers on the well-dressed couple's reactions to the dancing pair. In addition, strategically placed objects in the extreme foreground, that is, the tools and overturned jug, serve to enhance Molenaer's intended message. Issues he raised may have involved the nature of personal responsibility, the effects of overindulgence, the behavior of the underclass, and perhaps the battle of the sexes. In looking at the couple at the left, we find the young woman shows little sympathy for the dancers. She gestures to them while turning to look at her partner.[2] Although he smiles, she appears troubled by the scene before her. In itself, dancing is probably not the target of her disdain. Clearly the older woman and her dance partner are motivated by the effects of alcohol. He, in fact, clutches a large tankard in his left hand, and an empty jug lies before them. As a result, he ignores his work, having abandoned the rake, shovel, and saw lying unattended in the foreground. The abandonment of one's responsibilities is not well received by the young woman and, by association, her partner. From the perspective of her social position, she confirms the message that one must constantly be on guard against falling prey to the vices continually indulged in by the lower classes.[3]

As if to underscore this warning, the painter included the boy and girl seen at the lower right. By mimicking the actions of the older dancing couple, these young villagers may reflect a cultural bias suggesting that laziness, overindulgence, and other forms of vice are to be expected from peasants. Further suggestive of the fact that such behavior will pass from generation to generation, the boy sits on a barrel of beer, and the girl wears a feathered hat much like the one worn by the old woman.

Molenaer's practice of mingling the social classes for iconographic purposes became rather commonplace in his oeuvre during the 1630s. Among the early examples are *Boys with a Dwarf*, *The Ball Players*, and *The Drunken Peddler* (fig. 1).[4] *The Drunken Peddler*, for example, shows a number of upper-class figures witnessing the fate of a drunken old man carrying a basket of eggs. Mocked by a small crowd of villagers, including a pair of

well-dressed boys at the far left, the old peddler is doomed to stumble. One boy tips his egg basket, while another has tied a string around his ankle in order to trip him. As a comic figure, the drunken peddler fulfills the same role as the drunken couple in *Dance in a Village Street*. Both his behavior and the behavior of his tormentors seem to have drawn the disdain of at least one person in the crowd, the woman standing to the far right. Like her counterpart's in *Dance in a Village Street*, the features on this woman's face mark her displeasure.

As for Molenaer's composition of *Dance in a Village Street*, one can argue that prints after drawings by Pieter Bruegel the Elder may have influenced his choices. Specifically, *Summer* (fig. 2), an engraving by Pieter van der Heyden, shares a number of similarities with the Molenaer picture. In each, large peasant figures fill the foreground space, while behind them a village landscape serves as a backdrop. Of particular interest are the discarded tools in the extreme foreground of each work, as well as a prominently displayed jug. As will be discussed elsewhere in this catalogue, artistic connections between Bruegel and Molenaer were deep rooted, extending beyond compositional similarities to choices of peasant subject matter and related themes.

Fig. 2
Pieter van der Heyden, after Pieter Bruegel the Elder
Summer, 1570
Engraving
National Gallery of Art, Washington, D.C.

Notes

1 Philadelphia, Berlin, and London 1984, p. 264.

2 This female figure had been painted out of the composition prior to 1927. She reappeared during a recent restoration. For a reproduction of the picture before the woman's reappearance, see Harms 1927, p. 29, fig. 17.

3 This issue reappears repeatedly in Molenaer's work. See below and discussion in Weller 1992, pp. 85, 88–89, 238–41.

4 For *Boys with a Dwarf*, see cat. 5, fig. 1. *The Ball Players*, 1631 (private collection, The Netherlands), is illustrated and discussed in Daniëls 1976. Also see Weller 1992, pp. 87–89.

...e Duet

...630–31

...ed at lower right on foot warmer:
...OLENAER

...vas, 25 1/24 x 19 7/8 in. (64.1 x
...cm.)
...tle Art Museum, Gift of the
...uel H. Kress Foundation

...venance:
...vard Young, New York, by 1935;
...er, D. Katz Gallery, Dieren, The
...herlands, by 1937; Leroy M.
...kus, Seattle; Schaeffer Galleries,
...v York, by 1948; Samuel H. Kress
...ndation, New York, 1954
...998); loan to the Seattle Art
...seum, 1954–61; gift of the Kress
...ndation to Seattle Art Museum,
...1.

...hibitions:
...roit 1935; Providence 1938–39, no.
...San Francisco 1939; Indianapolis
...l San Diego 1958, no. 52; Allen-
...vn 1965, no. 50; Milwaukee 1966,
...68; Philadelphia, Berlin, and
...ndon 1984, no. 77; Haarlem and
...rcester 1993, no. 29; Kress
...94–95, no. 23.

...erature:
...t News 1939, vol. 37, no. 35, p. 12,
...s.; Seattle 1954, pp. 66–67; Eisler
...77, pp. 335–36, no. K1998, fig. 122;
...die 1980, vol. 11, p. 353; Sutton
...86, pp. 284–85; Hofrichter 1989,
...69; Weller 1992, pp. 26–27, 348,
...7; Weller 1996, p. 813; Seattle
...97, pp. 63–64, fig. 40.

The impish young models Molenaer favored in many of his earliest paintings appear a few years older and in much better circumstances in *The Duet*. Interrupted from their music making, this well-dressed young couple serves as an interesting counterpoint to the disheveled youngsters featured in *Two Boys and a Girl Making Music* (Weller fig. 6). Nevertheless, the two works share many stylistic features, suggesting that Molenaer turned to *The Duet* not long after completing the London picture in 1629. One is justified in arguing that *The Duet* represents the painter's first masterpiece, for in it he brought a skill level not previously seen in his oeuvre. The picture combines subtleties in the effects of light, a surprising sophistication in the brushwork, and a charm and descriptiveness to the figures and their costumes. After surfacing on the art market during the 1930s, *The Duet* has deservedly become one of Molenaer's most exhibited pictures.

A darkened room provides the setting for the confident young couple who pose with their instruments in *The Duet*. The setting is defined only by the wood floor and the shadows cast on a back wall. The boy strums a theorbo, a two-necked lute especially popular during the period, while his female companion fingers the holes on a *handfluit* (recorder).[1] As works in the exhibition confirm, from the outset of his career to its end, Molenaer took pleasure in painting music makers. Through a seemingly endless rearrangement of performers, instruments, and settings, these compositions allow for a range of interpretations.[2] The simplicity and cozy feeling generated by the respectable young couple in *The Duet*, for example, seem to "suggest the harmony of a love match."[3] Only the prominently placed foot warmer seems to interfere with the scene's quiet, prompting suggestions of an additional interpretation.[4] In writing about the picture's symbolism, however, Chiyo Ishikawa took a reasoned approach to interpreting the appearance of this motif. She suggests it may have served as a convenient studio prop as much as a symbol of erotic love.[5]

The elaborate costumes worn by the seated boy and girl in *The Duet* were also among the painter's studio props. They reappear in a number of his pictures from the late 1620s and 1630s, and Molenaer even changed the fabric's color to extend its usefulness (see Bogendorf Rupprath essay). For example, the boy's rust-colored doublet with slashed sleeves and black edging is seen in blue, mustard yellow, and gray in some of his paintings.[6] This unusual doublet (in blue-gray) also surfaces in examples by Judith Leyster, including her *Carousing Couple* (Bogendorf Rupprath fig. 9) of 1630. The fact that Molenaer and Leyster shared props offers strong evidence of their involvement at least six years before their wedding in 1636, evidence convincing enough that Valentiner and others incorrectly concluded the young couple pictured in *The Duet* were Leyster and Molenaer.[7] Similarities to sitters in his genrelike portraits of family members, for example his *Self-Portrait with Family Members* (Weller fig. 1), imply it is more likely the two represent a brother and sister of the painter.

Indicative of Molenaer's rapid artistic maturity, compared to an earlier treatment of the theme (fig. 1), are the many choices he made in completing *The Duet*. The engaging, informal tone of the scene is enhanced by the starkness of the setting, the incorporation of just a few anecdotal details, the oblique placement of the figures, the angled lighting, and perhaps, above all else, the choice of color and paint application. Many of these same features identify paintings by members of the Utrecht Caravaggisti but with far different meaning. Ter Brugghen's *The Amorous Couple* (fig. 2), for example, shows behavior very different from the behavior Molenaer depicts. In further describing *The Duet*, Ishikawa wrote with great insight on the artist's technique.

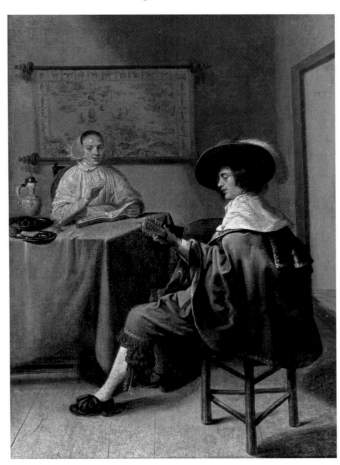

Fig. 1
Couple Making Music, ca. 1629–30
Oil on canvas, 24 ¾ x 18 ⅛ in.
The Museum of Fine Arts
(Szépmüvészeti Muzeum), Budapest

One source of pleasure in this picture is Molenaer's own delight in the activity of painting. The slanted light gave him the opportunity to show areas of brightness and deep shadow and excitingly reflective fabrics, such as the green skirt that shimmers with yellow high-

ı
ılrick Ter Brugghen
Amorous Couple, ca. 1624–26
ın canvas, 41 ¾ x 33 ½ in.
:o de Arte de Ponce, Puerto Rico

s

· a discussion of these and other
:al instruments appearing in
h paintings from the period, see
Hague and Antwerp 1994.

ıong these examples is one of
naer's masterpieces; see cat. 24.

ttle 1997, p. 63.

ler (1977, pp. 135–36), for
ıple, considered the foot warmer
ıbol carrying erotic overtones.

ttle 1997, pp. 63–64.

discussion by Bogendorf Rup-
in Haarlem and Worcester
, p. 288.

entiner was quoted in Seattle
, p. 66. Eisler (1977, p. 135)
ed the same conclusion.

ttle 1997, p. 64.

lights. In shading the man's red cloak, Molenaer became a draftsman, creating shadows by hatching black strokes on the surface of the red paint. For the plumes and the man's hair, he removed paint by scraping through it with a stiff instrument.[8]

As discussed elsewhere, Molenaer's path to this artistic sophistication came through the genius of Frans Hals. Bravura painting technique, compositional choices, and comparable subjects are all found in the genre pictures painted by Hals in the 1620s. Although unable to fully imitate the magic of Hals's virtuosity and ability to capture the momentary, Molenaer nevertheless must have begun to assert his presence on Haarlem's competitive art market at this time. An early masterpiece such as *The Duet* must have been appreciated by informed collectors, who may have owned similar works by Willem Buytewech, the Halses, and Leyster. The model served Molenaer well for years to follow.

Visitors to Molenaer's studio during the early 1630s must have experienced a rather lively and creative workplace. Paintings provide the proof, typified by his boisterous interior scenes of disheveled children and young adults drinking, smoking, and making music, and his representations of the five senses and children with pets.[1] After limiting himself to this type of imagery in the late 1620s, Molenaer started to add to his repertoire around 1630. Outdoor scenes and depictions of upper-class couples in well-furnished interiors now appeared. *A Young Man and a Woman Making Music* represents one of his earliest efforts in this direction. Dirck Hals had long provided the example for genre scenes of this type, and because of Hals's lock on this market, Molenaer ultimately showed only a passing interest in such imagery.[2] Nevertheless, the London picture serves as a precursor to his masterful *Allegory of Fidelity* (cat. 13) of 1633 and the group of stunning portraitlike genre paintings (cats. 23, 24) started about the same time.

A Young Man and a Woman Making Music reveals a colorful young couple wearing

8

A Young Man and Woman Making Music

ca. 1630–32

Monogrammed on the foot warmer: IMR (in ligature)

Canvas, 26 ¼ x 33 in. (68 x 84 cm.)
The National Gallery, London
Museum purchase, Clarke Fund (NG 1293)

Provenance:
Dealer Colnaghi, London, by 1889; museum purchase in 1889.

itions:
on 1976, no. 73; London 1978,

ture:
and Bredius 1890, pp. 73, 78;
on 1899, vol. II, pp. 38–39,
.; Wilenski 1955, p. 162;
rkamp-Begemann 1959, p. 26f;
aren 1960, pp. 257–58; Phila-
ia, Berlin, and London 1984,
.61–62, fig. 2; Brown 1984,
4, repro.; London 1986, p. 406,
.; Solomon 1986; Brown 1992,
I, pp. 271–72, vol. II, plate 228;
er 1992, pp. 23–25, 345, fig. 4;
lon 1995, p. 461, color repro.;
ijean 2001, pp. 84–85, 260, fig. 46.

expensive clothing and engaged in a musical performance. The man strums a theorbo, while his female companion plays her part of the duet on a cittern. Joining the couple in the room are a serving girl, who places a platter with a roasted fowl on the table, and a dog that lies on the floor next to the cittern player. The interior is extraordinarily opulent for a composition by Molenaer. With the exception of simple wooden flooring, the room is outfitted with expensive moldings, faux-marble columns, and pilasters topped by Corinthian capitals on either side of a doorway cut into the back wall. Furnishings include a small table with elaborately carved legs, a large credenza at the far left, a portrait of Frederick Henry, a dining table, and the two chairs for the musicians.

A stylistic assessment of the room and its inhabitants confirms its dating to the early 1630s. Typical for Molenaer's early compositions are the compact arrangement and the stilted outward orientation of the figures. Such an approach also appears in works by

Willem Buytewech, whose genre scenes clearly influenced Haarlem painters.[3] The composition used by Buytewech in his *Merry Company* (fig. 1), for example, strikes a similar tone and even shares a number of motifs with Molenaer's picture. In an article devoted to *A Young Man and Woman Making Music*, Salomon based a number of her observations on Molenaer's adaptation of the Buytewech model.

It is in Buytewech's work that Würtenberger and Haverkamp-Begemann have convincingly interpreted this formal device as indicative of emblematic meaning. In Molenaer, this self-conscious tendency is even more pronounced, and with the unusual juxtaposition of a hat placed on a cello it even breaks with the general "realistic" tenor of the painting as a whole.[4]

ig. 1
Villem Buytewech
Merry Company, ca. 1617–20
Oil on canvas, 19 ⅜ x 26 ¾ in.
Museum Boijmans Van Beuningen,
Rotterdam

The author then builds an argument around this "formal device" to support a political interpretation for *A Young Man and Woman Making Music*. The concluding paragraph of her intriguing but problematic study serves as a summary.

Together, the larger signs of the political intention of Molenaer's painting would have been clear to many educated Dutchmen of the 1630s. The portrait of Frederick Henry, the liberty hat, the columns and the harmonizing, music-making couple all point to the political concerns of the period and celebrate the harmony achieved by Frederick Henry. A proper, if somewhat cumbersome title for the painting might well be The Harmony and Well-Being of the Prosperous Dutch Republic under the Leadership of the House of Orange.[5]

While Molenaer's iconographical inventiveness was diverse and far reaching, neither he nor his closest contemporaries in Haarlem had shown much interest in interpreting political issues. Therefore, rather than analyzing the Frederick Henry portrait and the hat, one needs to look to the music-making couple as a key to the work's meaning. The young man and woman are representative of a group of pictures in which the painter details the harmony of true love. An illustration from an Amsterdam songbook published in 1613 (fig. 2) depicts a comparable music-making couple, in this instance in a love garden. Discussed elsewhere in relationship to *A Young Man and Woman Making Music*, this image provides a context for Molenaer's message. "The metaphor of love as a harmonious duet was particularly popular . . . the duet stands for the couple's mutual love—as it had done, for example, in an illustration in a songbook of 1613 entitled *Cupidos Lusthof* [Cupid's Pleasure-Garden]."[6]

The harmony of true love represented by the young couple is further defined by a restraint in their passions. Like their musical counterparts in *The Duet* (cat. 7) from Seattle, "the couple here scarcely appear to be burning with desire."[7] Building on this observation, it is worth noting that Molenaer included a foot warmer in both compositions. This motif, when viewed in the context of these well-mannered couples, further served to amplify the positive nature of their relationships.[8]

Eij hemel vreucht wat leucht ons t'hert
als t'soet accoort vereenicht wert

Fig. 2
Illustration from *Cupido's lusthof
ende der amoureussen boogaert . . .*
Amsterdam, 1613

Notes

1 The best example to support this observation is Molenaer's *The Artist in His Studio* (Weller fig. 1) in Berlin.

2 Still, Molenaer painted a handful of young couples making music during this period. In addition to the example in Seattle (cat. 7), others are in Schwerin (illustrated in Müller-Hofstede 1995, fig. 2) and the Budapest picture (cat. 7, fig. 1).

3 Haverkamp-Begemann 1959 was among the first to recognize this connection. Also see Salomon 1986, p. 23.

4 Salomon 1986, p. 23.

5 Ibid., p. 33.

6 Brown 1984, p. 134. This image was also used to interpret another Molenaer picture; see Amsterdam 1976, p. 184.

7 Philadelphia, Berlin, and London 1984, p. 261.

8 Sutton (ibid.) explored this concept in writing on the Seattle picture. "Roemer Visscher explained that men who attempt to win women's favors with gallantries could take a lesson from the humble foot stove, which owes its popularity with the ladies to its simple utility."

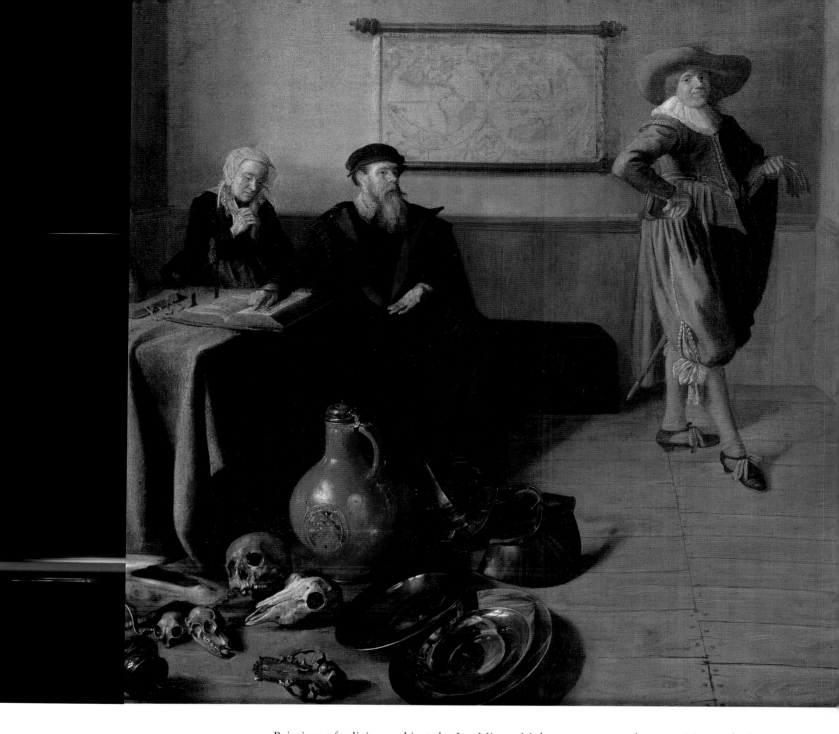

(chester only)

*e Departure of
Prodigal Son*

631–32

*s of signature on the trunk:
ENAER (AE in ligature)*

as, 21 ⅝ x 26 ⅝ in. (55 x 66.7

te collection

enance:
te collection, Germany, before

Paintings of religious subjects by Jan Miense Molenaer are somewhat surprising, as he is always described as a genre painter. Nevertheless, he showed himself to be a master story-teller. His depictions of biblical stories, particularly those incorporating a rustic element (cat. 14), effectively communicate religious truths in a direct and understandable manner. Molenaer's extant religious pictures now number more than a dozen, all of them coincid-ing with the most diverse and inventive years of his career, ca. 1631 to 1646. The most recent addition to this growing list is *The Departure of the Prodigal Son*. It is also the earliest and, considering its contemporary staging, serves as one of the most unusual.[1] Stylistically, the simple interior and tilted perspective to the floor are among the features identifying the picture as an early work. A similar approach appears in *The Artist in His Studio*, a work dated 1631 (Weller fig. 1). Equally characteristic of Molenaer pictures from

the early 1630s are the dry brushwork, superficial highlights on the still-life elements, and lack of finish to the figures.[2]

Masquerading as a genre scene, the subject of the picture might easily be overlooked by most viewers. Nevertheless, Müller-Hofstede, who first published the work in 1995, correctly identified its biblical source.[3] The story of the prodigal son, found in Luke 15:11–32, had become a favorite for artists and writers in the sixteenth and seventeenth centuries. The relevant verses, as they relate to Molenaer's composition, center on the division of a man's property between his two sons. "A few days later the younger son turned the whole of his share into cash and left home for a distant country, where he squandered it in reckless living."[4] In Molenaer's picture we are witness to the point in the narrative when the well-dressed young man makes good on his plans to leave home. Poised before the doorway at the right, he strikes a haughty attitude in spite of the pleas of his family, to whom he has already turned his back. His journey to a distant land, including its agonizing consequences, lies ahead. As a symbol of the worldliness he seeks, a map hangs next to him on the rear wall. This map thus reminds viewers that the young man "is about to leave home to enter into a frivolous and disorderly life."[5] At the same time he leaves behind the values symbolized by his family.

The values abandoned by the Prodigal Son are personified by his parents and his sister: the father with an open book and reasoning gesture of his left hand seems to symbolize studium, *the praying mother* pietas, *and the sister with her attitude of melancholy, grieving over the errant course of her brother, may embody* contemplation.[6]

The still-life elements that appear prominently in the foreground have been interpreted as further symbolizing aspects of home and family that the prodigal son recklessly leaves behind. According to Müller-Hofstede:

The large cranium of a bull signifies labor, *the human skull as a* vanitas *motif stands for the transience of life, the tipped tankard and the large water jug allude to the importance of sobriety over pleasure, and the armor and pewter plates are reminders of the duties of military service and domestic work. The symbols of earthly transience are the most prominent in the still-life arrangement.*[7]

By depicting this biblical narrative beneath a contemporary veneer, Molenaer presented his message of moderation and reason in understandable terms. Interestingly, seventeenth-

1995; dealer Johnny Van Haeften, London, 2000; dealer Salomon Lilian, Amsterdam; to present owner.

Exhibitions:
Amsterdam 2001, no. 17.

Literature:
Müller-Hofstede 1995.

Fig. 1
Govaert Flinck
The Return of the Prodigal Son,
ca. 1640
Oil on canvas, 52 ½ x 67 in.
North Carolina Museum of Art,
Raleigh

century artists rarely depicted this subject. Most preferred to show events occurring later in the story. Featured were the prodigal son's reckless living, his destitute circumstances, and finally his return as a penitent sinner to his father's welcoming arms, "for this son of mine was dead and has come back to life; he was lost and is found."[8] Govaert Flinck's *The Return of the Prodigal Son* (fig. 1) typifies these interests. In this composition the son kneels in shame before his welcoming father. The fanciful costumes of the father and those who prepare the celebration of the son's return, while perhaps not biblical in their origin, do suggest a distant time and place.

Among those few artists who did focus on the early scenes from the story of the prodigal son, it was Willem Buytewech who may have inspired Molenaer. Buytewech's drawing *The Prodigal Son Receiving His Inheritance* (fig. 2) shares many elements with the Molenaer painting, including the finely dressed prodigal son in contemporary clothing, family members, and a still-life display at the lower left. Nevertheless, the tone of Buytewech's scene is far removed from a contemporary context, particularly in the architectural details and the clothing of the prodigal son's parents. These differences stand at the core of Molenaer's innovation and preview his approach to the biblical scenes that followed.

As mentioned, the subject of the composition could easily be overlooked due to its contemporary veneer. Are there comparable subjects hidden under the trappings of everyday life in other pictures by Molenaer? Certainly his many merry company scenes offer behavior suggestive of the "reckless" living experienced by the prodigal son. The difficulty encountered in this type of speculation is seen in another work attributed to Molenaer from the early 1630s, *Portrait of a Man* (fig. 3). Assuming a nearly identical pose as the prodigal son, wearing a similar costume, and incorporating the same haughty attitude, the dramatically lit man in this "portrait" appears ready to exit the

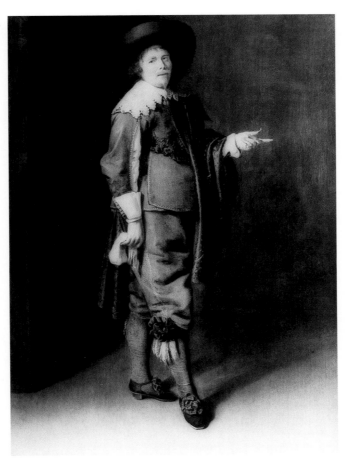

Fig. 3
Attributed to Jan Miense Molenaer
Portrait of a Man, ca. 1630–35
Oil on panel, 33 ⅛ x 22 ⅞ in.
The Norton Simon Museum, Los Angeles

scene. Since the stark setting offers no clues as to context, the question remains whether the figure represents another prodigal son. If not a simple portrait or half of a pendant pair, perhaps the figure in *The Departure of the Prodigal Son* provides just enough evidence to suggest such an identification is at least plausible. As with so many Molenaer pictures, however, questions are more plentiful than answers.

Notes

1 The early date for this picture had previously isolated it by a few years within Molenaer's oeuvre devoted to religious subjects. The recent cleaning of the Budapest *Denial of Saint Peter* (cat. 14) uncovered a date of 1633 under the previously read date of 1636, revealing a greater continuity between works.

2 With regard to the brushwork and glazing, the overall effect is somewhat diminished by areas of abrasion throughout the picture.

3 Müller-Hofstede 1995.

4 Luke 15:13.

5 Müller-Hofstede 1995, p. 182.

6 Ibid.

7 Ibid.

8 Luke 15:24.

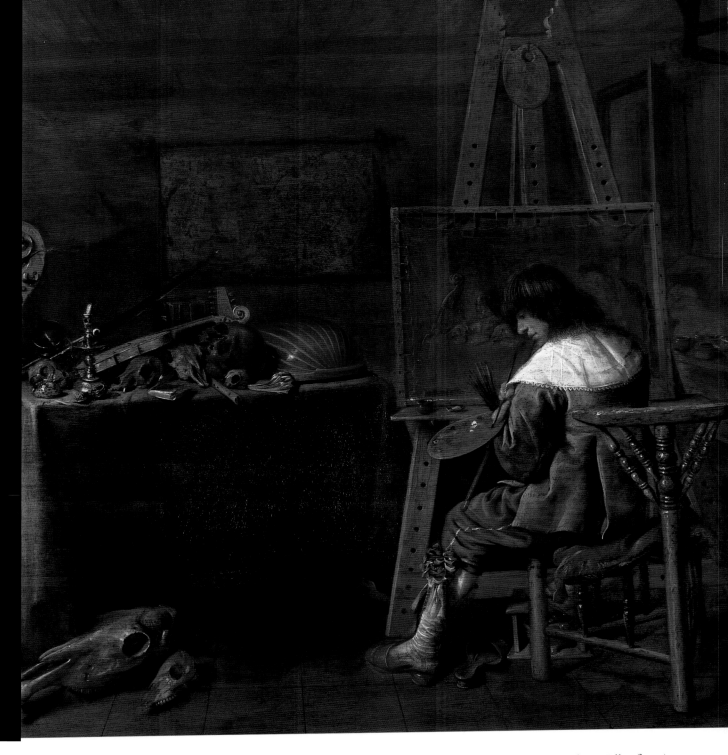

• O

*he Painter
t Work*

*1632 (attributed to Jan Miense
olenaer)*

ars signature at lower left: H Pot

nel, 16 ⅝ x 19 ¼ in. (42.2 x
.8 cm.)
useum Bredius, The Hague

Far different from the relaxed moment pictured in *The Artist in His Studio* (Weller fig. 1)
is the activity shown in *The Painter at Work*. As the title suggests, the painter practices his
profession by sitting before his canvas mixing paints on his palette with his brush. Both
works, however, incorporate the device of a painting within a painting to bring a focus to
the intended message. While this conceit centers on the artificiality of merry company
scenes in the Berlin painting, *The Painter at Work* addresses a more serious and universal
issue—the reminder of the brevity of human life and the vanity of worldly possessions.

Only recently attributed to Jan Miense Molenaer, *The Painter at Work* offers many
parallels to other early works by the artist.[1] Its previous identification as a painting by

Hendrick Pot has centered on the *H Pot* signature it carries at the lower left, but there is little additional evidence to recommend Pot as its author. The brushwork is coarser than the manner usually associated with Pot, and the tonal palette is similarly uncharacteristic. Fortunately the exhibition allows for closer scrutiny of this painting against verified Molenaers. The inclusion of *The Painter at Work* calls attention to a belief long held by many curators that exhibition catalogues should be written after shows close rather than before they open.

The Painter at Work centers on the image of a painter practicing his craft. In describing the studio, the artist responsible for its execution surveyed both the techniques and materials used to begin the composition. The studio appears small and relatively crowded, perhaps because a second easel (the artist's) and more painting materials probably filled the empty foreground of the room. Nevertheless, the elements pictured provide a surprisingly realistic account of artistic production by Molenaer and his contemporaries. The painter sits on a low, three-legged stool, with a backrest and cushion to ease the long hours of labor. Comfort is also provided by the foot warmer, as the painter has removed his right slipper to gain the full effect of the hot coals. Paints, brushes, jars, and other artist supplies sit on a table to the far right, above which two simple black frames hang from the ceiling.

The composition also reveals changes the artist made.[2] Originally, to the left of the animal skulls, two paintings rested on the floor against the table. The infrared-reflectogram (fig. 1) of the picture reveals that one of these two works represented a standing male figure. Reflectograms detail other changes, including the position of the easel. Perhaps the most interesting aspect of this examination is the vast difference in style between the rather simple underdrawings found here (fig. 1) and those of a more complex and detailed character appearing in *Peasants Merrymaking in an Interior* (cat. 33, fig. 2). Until more technical examinations of Molenaer's pictures are completed, it remains to be seen whether these differences are consistent with changes associated with his early or his later paintings, or whether *The Painter at Work* should remain attributed to Molenaer.

It appears that the painter's focus, a *vanitas* still-life painting laced to the stretcher sitting on the easel, is nearing completion. The viewer is allowed to see not only the painting on the easel but also the arrangement of objects on the table serving as his models. Included are musical instruments, skulls, books, a pipe, an extinguished candle, an overturned roemer, a watch, and a globe (?). Some of the objects, especially the cello resting against the left edge of the table, appear at a different angle in the painting within the painting, which emphasizes the different vantage points of painter and onlooker.

The unfinished still life the painter works on is clearly the key to the picture's meaning. Composed of typical *memento mori* motifs, his composition addresses well-known concerns among contemporary viewers. In addition, Molenaer may have expanded upon this

Provenance:
Abraham Bredius Collection, Monaco, before 1636.

Exhibitions:
New York et al. 1985–87, no. 30; Nagasaki 1987–88, no. 33; Caen 1990, no. 57; The Hague 1994, no. 34; The Hague 2001, unnumbered (attributed to Molenaer).

Literature:
Van Gelder 1937; De Mirimonde 1962, p. 181 (as Pieter Codde); De Jongh 1973, p. 205, note 30; Blankert 1977, p. 12, fig. 6; Blankert 1978/80, pp. 98–99, ill.; Kyrova 1982, p. 30, fig. 52; Welu 1982, pp. 34–35, fig. 10; Schneider 1989, color ill.; Blankert 1991, no. 125, color plate on p. 179; Weller 1992, pp. xiv, 91–92, comp. fig. 12; Haarlem and Worcester 1993, pp. 306–07, fig. 33d (as Hendrick Pot?); Frankfurt 1993–94, p. 271.

Fig. 1
Attributed to Jan Miense Molenaer
The Painter at Work (detail), ca. 1632
IRR computer assembly

message by including the painter and the map hanging on the rear wall. Citing Karel van Mander, Bogendorf Rupprath discussed a related picture by Molenaer (Bogendorf Rupprath fig. 1) that raised similar concerns.

The pictorial associations of the artist with images of death and the transience of life is no accident. In Het Schilder-Boeck *of 1604, Karel van Mander draws a similar parallel when reminding artists that both they and their art "will pass away; however elegant, however witty [they be], Death [will claim everything]."*[3]

The Painter at Work sends the same message, as the painter and the still life he paints are held up to the map on the rear wall. Symbolizing worldly pleasures and the vanity of worldly possessions, this map served as an added warning.[4] Viewers will come to realize that they, like the painter pictured before them, are merely transitory.

In spite of its seeming realism and sobering message, *The Painter at Work* has an artificiality that, after all, stands at the core of all paintings. Would a painter, for example, wear such fine clothing in his studio? From the linen collar to the blue ribbons used to tie the cuffs of his britches, the painter's outward appearance may have had little to do with actual practice. In creating a false image of the painter at his easel, perhaps the artist responsible for this picture again reminded viewers of the false nature of the seemingly realistic image. Buijsen correctly notes that while the painter "does his best to capture the objects displayed on his canvas, in the end his endeavour is also fruitless. He can only depict outward appearances and not the essence of things."[5]

s
gendorf Rupprath (Haarlem and :ester 1993, p. 306) was the first 1estion the Pot attribution in r of Molenaer. Buijsen (The Hague j, p. 271) thought it "possible that painter used the work of the other model." The same author (The .ue 2001, pp. 22–25) identified the ure as "attributed to Jan Miense lenaer."

ɔr a discussion of the results erated by infrared reflectography mination, see The Hague 2001.

Iaarlem and Worcester 1993, ;04.

'or a discussion of Molenaer's use maps, see Bogendorf Rupprath's ay in this catalogue.

The Hague 1994, p. 268.

11

*A Young Woman
Seated by a Table*

ca. 1632–34

Unsigned

Panel, 20 ½ x 16 ½ in. (52 x 41 cm.)
Private collection

Provenance:
Sir William van Horne, Montreal;
E. J. Traver; sale, Christie's, New
York, 18 January 1983, no. 192;
current owner.

Exhibitions:
Montreal 1933, no. 49; Boston 1992,
no. 89 (color plate).

Literature:
Sutton in Boston 1992, p. 178.

Paintings showing domestic interiors featuring a single full-length woman engaged in various activities are among the lasting images from the Dutch Golden Age. Within this great flowering, however, these images tend to be linked to the generation of genre painters active after midcentury. Among the best-known examples are pictures by Gabriel Metsu, Gerard TerBorch, Pieter de Hooch, and, above all, masterpieces by Johannes Vermeer. During the early decades of the 1600s, such images were much rarer, largely limited to isolated examples by Dirck Hals, Pieter Codde, Willem Duyster, and just a few of their contemporaries.[1] Quite understandably, it seems that Judith Leyster was the painter most sympathetic to such subjects, for within her small oeuvre is a handful of paintings representing a girl or young woman isolated within an interior. Among them is her charming *Young Woman with a Lute* (fig. 1), a work Hofrichter dates to about 1631.

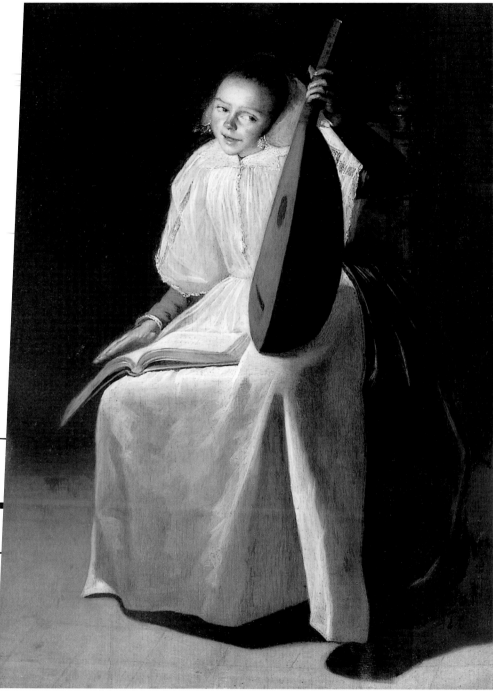

It is probably no coincidence that Molenaer turned to the motif at about the same time. Stylistically, his *Young Woman Seated by a Table* seems to have been completed early in the 1630s. As in the Leyster, music provided the context for Molenaer's narrative, as a wooden transverse flute sits on the table next to the woman, who holds a sheet of paper. In writing about the painting, Peter Sutton noted that while "the sheet of paper the woman holds appears to contain only words and not music, the flute, the gesture of her hand, and her open mouth suggest that she may be singing."[2] While musical performance links the two pictures, Molenaer may have provided for additional associations through the appearance of a number of well-positioned motifs. They include the open jewel box with a string of pearls draped over its front, an expensive Turkish table carpet, and the foot warmer upon which the woman rests her left foot. The stark interior, defined by wooden floor planks, an unadorned back wall, and a baroque swag of drapery at the upper right, contrasts with these luxury items as well as the expensive garments worn by the woman.

Many of these objects appear elsewhere in his works. Elements of the woman's costume, for example—the lace collar, silk skirt, and overjacket, with its elaborate border—were reused in his *Allegory of Vanity (Lady World)* (cat. 12), from 1633. In that picture the combination of luxury items, the map, and the central character's expensive costume support her identification as *Lady World*. It would be misleading, however, to identify the *Young Woman Seated by a Table* as an earlier version of this persona. Instead, the woman

may be associated with another narrative, one prompted by the inclusion of the foot warmer under her foot.[3] According to Franits, this motif served as a well-known symbol for "proper courting strategies."[4] Roemer Visscher's emblem showing a foot warmer taken from his *Sinne-poppen* of 1614 is accompanied by a text demonstrating its connection with the topic of courtship. The translation of the emblem's *subscriptio* gives face to the unseen recipient of the woman's words.

He who aspires to win second place in [the ladies'] esteem [first place belongs to the foot warmer, of course!] must embark upon serving them with sweet, witty and amusing talk, avoiding all boorishness and vulgarity, without reprimanding their cackling and chattering and never mocking their fussy and showy clothes; but praising them for everything they do and propose, then he will be praised in their company as a perfect courtier.[5]

Young Woman Seated by a Table may represent the first example of a remarkable group of family portraits Molenaer executed between about 1632 and 1636. These works (cats. 22, 23, and 24) are among the painter's most beautiful and finely executed pictures. Here, the sitter's facial features and elements of her costume make her a close cousin to some of the women identified in these slightly later works. Molenaer was not the only artist to paint such portraits, as a pendant portrait by Hendrick Pot suggests. *Portrait of a Young Woman* (fig. 2) shares many elements with the Molenaer composition, including the expensive clothing, luxurious trappings, and musical context (the woman fingers a songbook). Like Molenaer's, his interests encompass a number of different concerns and take many forms. Seen in this light, *Young Woman Seated by a Table* represents yet another aspect of the painter's unique contributions to the fertile Haarlem art scene in the early 1630s.

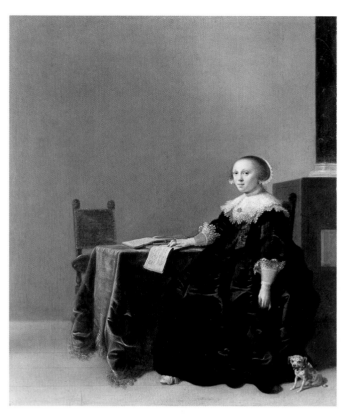

Fig. 2
Hendrick Gerritsz. Pot
Portrait of a Young Woman, ca. 1635
Oil on panel, 17 1/8 x 13 3/8 in.
Collections of the Prince of Liechtenstein, Vaduz Castle

Notes

1 In finding comparisons with the *Young Woman Seated by a Table*, Sutton (Boston 1992, p. 178) noted that "very similar in conception is Dirck Hals's *Flute Player*" (signed and dated 1630; Haarlem, Frans Halsmuseum). In this example "a young woman is again depicted, full length and seated by a table, playing a flute and gaily kicking out her foot."

2 Ibid.

3 The *Lady World* figure in the Toledo picture also rests her foot on another iconographically charged object, a human skull. This motif confirms Molenaer's interest in the *vanitas* theme (see discussion, cat. 12).

4 Franits 1993, p. 51.

5 Ibid.

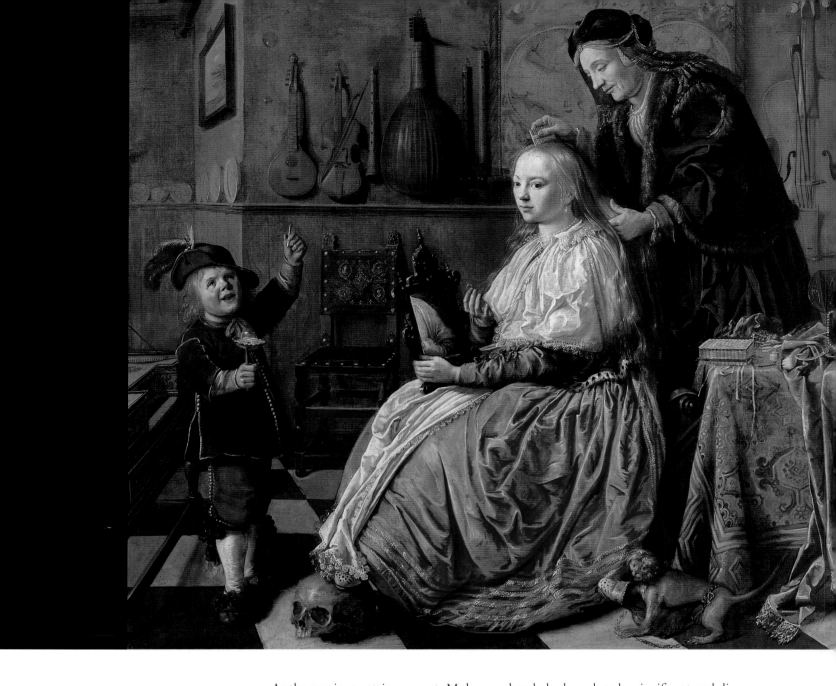

egory of Vanity *dy World)*

and dated on leg of virginal at left: MOLENAER 1633

s, 40 ¼ x 50 in. (102 x 127 cm.)
Museum of Art, Purchased
unds from the Libbey Endow-
Gift of Edward Drummond

iance:
hristie's, London, 26 February
no. 91; Sabin, London; dealers
A. Silberman, New York,
46; Julius Held, Old Benning-

Jan Miense Molenaer

As the previous entries suggest, Molenaer already had produced a significant and diverse body of work during the early 1630s, but by 1633, the year he completed four of his most sophisticated and, with the exception of the newly discovered *Portrait of a Woman with Embroidered Gloves*, well-known pictures, Molenaer would become one of Haarlem's most inventive painters. The four pictures in question, *Allegory of Vanity* (cat. 12), *Allegory of Fidelity* (cat. 13), the *Denial of Saint Peter* (cat. 14), and the portrait (cat. 15) offer ample evidence of his creativity, as well as the fact that he was competing for the attention of important collectors. In the two allegories, for example, Molenaer combined symbolically charged motifs with imagery taken from contemporary Dutch culture. What resulted were intriguing images that provide traditional themes within a modern context. Not surprisingly, one scholar has theorized that the two pictures originally were conceived as thematic pendants.[1]

 Lacking some of the pictorial refinements found in the *Allegory of Fidelity*, the *Allegory of Vanity* was probably painted before its counterpart. In many ways the picture serves as

a brilliant summation of the painter's artistic development up to 1633, just as the Richmond picture (cat. 13) represents a blueprint of many of his concerns to follow. The figures in the *Allegory of Vanity*, for example, dominate their architectural setting, as do the individuals in nearly all of Molenaer's early works. In addition, minor perspective problems continue to plague the artist, best seen in the far reaches of the room at the left. Clearly, the scale of the doorway is much too small for the huge figures in the foreground. If the viewer follows the height of the molding that bisects the height of the rear wall from the seated woman to this doorway, the irregularity becomes obvious.[2] Also suggesting a slightly earlier date are a number of details that lack the polish Molenaer brought to many of his works to follow. The table still life and especially the overworked folds of the woman's pink skirt stand out in this regard. Interestingly, Molenaer displayed a similar approach in a painting that seems to have been completed about a year earlier, *Lot and His Daughters* (fig. 1). In this little-known Old Testament picture, Molenaer described the same deep folds of the pink skirt, minus the brocade at the bottom, as well as another array of still-life elements on a table to the right.[3]

As the literature devoted to the Toledo picture emphasizes, a thorough description of the *Allegory of Vanity* is essential for understanding the painter's message. Even in this regard, however, visual evidence could be misleading. The key element of the skull upon which the seated woman rests her foot had been overpainted with a footstool prior to the 1940s.[4] The subsequent discovery and reappearance of this important motif has prompted telling changes in the interpretation of the scene. Not surprisingly, the work has carried a number of titles during the last half-century, including *Woman at Her Toilet*, *Lady World*, *The Preparation for the Wedding*, and, as is used here, *Allegory of Vanity*.

The composition for the *Allegory of Vanity* features a seated young woman, her older attendant, and a boy within an elegant interior. Indicative of the woman's wealth is her clothing and most of the objects in the room. Among these items are the virginal at the left, the expensive stringed instruments, a transverse flute, recorders hanging on the back wall, a painting, Delft plates, a leather chair, a Persian rug, jewels, and a jewelry box. By themselves such objects do not necessarily carry specific meaning, but when combined with some of the other motifs within the room, specifically the skull, mirror, and boy blowing bubbles, they enhance the *vanitas* message of the composition. Such images connote human vanity and the vanity of worldly goods and concerns.[5] For example, the skull and the boy blowing bubbles reflect the sobering message that "Man is like a bubble" (*homo bulla*). *The Allegory of Transitoriness* (fig. 2), an engraving by Hendrick Goltzius, expressed this concept in text and image. Like the Molenaer painting, it features a young boy with bubbles and a skull.

Closely related to the picture's *vanitas* theme, the motif of the map hanging on the wall directly behind the seated woman provides a secondary message, one centering on the theme of Lady World. Eddy de Jongh was the first to make this connection.[6] His conclusions were further refined by Sutton and subsequent authors.

This conjunction [the circle of the map and the crown of the young woman's head] identifies her as Vrouw Wereld (Frau Welt or Lady World), the beautiful and seductive

ton, Vermont, 1946–68. J. M. Cath, New York, by 1973; dealer S. Nijstad, The Hague.

Exhibitions:
Grand Rapids 1940, no. 53; San Francisco 1942, no. 42; Baltimore 1946, no. 32; Pittsburgh 1954, no. 37; Leiden 1970, no. 18; Amsterdam 1976, no. 43; Philadelphia, Berlin, and London 1984, no. 78.

Selected Literature:
Winternitz 1946, p. 27, fig. 56; Ellenius 1959, p. 118; De Jongh 1970, p. 7; De Jongh 1971, pp. 181–83, fig. 19; De Jongh 1973, pp. 202–03, fig. 7; Toledo 1976, p. 113, illus.; Welu 1977, p. 104, fig. 44; Mirimonde 1978, pp. 125–26, illus.; Gorney 1978, pp. 94, 96, 99, 101, 116, fig. 5; Washington, Detroit, and Amsterdam 1980, p. 19, fig. 4; Gaskell 1983, pp. 237–38; Wheelock 1983, p. 199, fig. 221; Sutton in Philadelphia, Berlin, and London 1984, xxiii; Liedtke 1984, p. 64, illus.; Brown 1984, p. 228; Hecht 1986, pp. 180–82, fig. 21; Schama 1987, p. 513, fig. 259; Bal 1987, p. 16; Sluijter 1988, p. 157, fig. 13; The Hague and San Francisco 1990, p. 106; Emmer 1991, p. 29, figs. 18, 19; De Jongh in Freedberg and De Vries 1991, pp. 130–31, fig. 7; Weller 1992, pp. 27, 98–100, 349, fig. 8; Chaney 1992, pp. 128–29, fig. 28; Haarlem and Worcester 1993, pp. 288–89, 305–06, fig. 33b; Boston 1992, p. 178; Peacock 1993–94, pp. 5–6, fig. 7; San Francisco, Baltimore, and London 1997, pp. 24, 191–92, fig. 1; Weller 1996, p. 813; De Jongh in Franits 1997, pp. 51–53, fig. 32; Helgerson 1998, p. 138, fig. 6; De Jongh 2000, pp. 74–75, fig. 27.

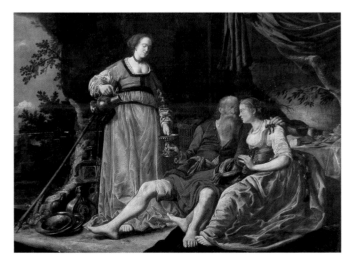

Fig. 1
Lot and His Daughters, ca. 1632
Oil on panel, 25 ¼ x 33 ½ in.
Private collection

...ick Goltzius
...llegory of Transitoriness*, 1594
...ving
...rentenkabinet, Rijksmuseum,
...rdam

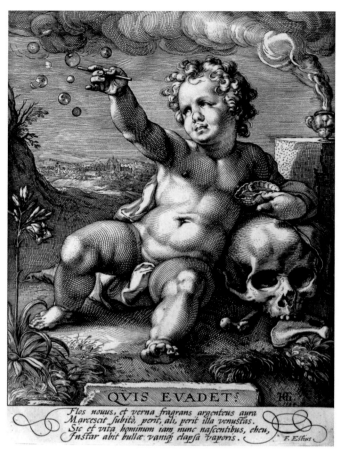

QVIS EVADET?

Flos nouus, et verna fragrans argenteus aura
Marcescit subitò, perit, ali, perit illa venustas.
Sic et vita hominum iam, nunc nascentibus, eheu,
Instar abit bullæ vaniq; elapsa vaporis. F. Estius

...
...edo 1976, p. 113.

...lenaer appears to have used
... of the same architectural
...nts in *The Dentist* (cat. 4), as
...s the *Denial of Saint Peter*,
...er painting from 1633 (see cat.

...* and His Daughters* had previ-
...been attributed to Pieter Last-
...see Weller 1992, pp. 94–95,
...2, note 92. Its stylistic similari-
...vith a signed and dated picture of
...support the dating of ca. 1632.

...ton discusses the history of this
...ge in Philadelphia, Berlin, and
...lon 1984, pp. 262–63, note 1.

...d., p. 262.

...Jongh in Leiden 1970, pp.
...–18.

...iladelphia, Berlin, and London
..., p. 263.

...e issue of Molenaer's moderniz-
...hemes is addressed throughout
...atalogue, especially with regard
...eter Bruegel the Elder.

personification of all vice and lust. The allegorical figure of Lady World was earlier depicted with a globe or an imperial orb on her head and often held a mirror or a bubble as a secondary attribute. In a print after Pieter Baltens depicting the popular theme De dans om de wereld *(Dance around the world),* Lady World, *outfitted with her traditional symbols and stepping on a pile of straw labeled* vanitas, *stands at the center of a wild dance of motley characters personifying various vices. In Molenaer's painting other details allude to Lady World's seductive and sinful ways. The chained monkey, here making a potentially obscene gesture, was a traditional inhabitant of medieval love gardens and alluded to those who are voluntary prisoners of sin.*[7]

In draping established allegorical themes over a framework with a contemporary veneer, Molenaer again demonstrated an inventive genius, enhanced by his debt to earlier traditions. As other works selected for the exhibition suggest, this juxtaposition does not represent an isolated example within the painter's oeuvre. Counted in this group are the *Five Senses* (cat. 26), a number of his merry company scenes, and to a limited degree the next entry and arguably his best-known picture, the *Allegory of Fidelity*, now in Richmond.[8]

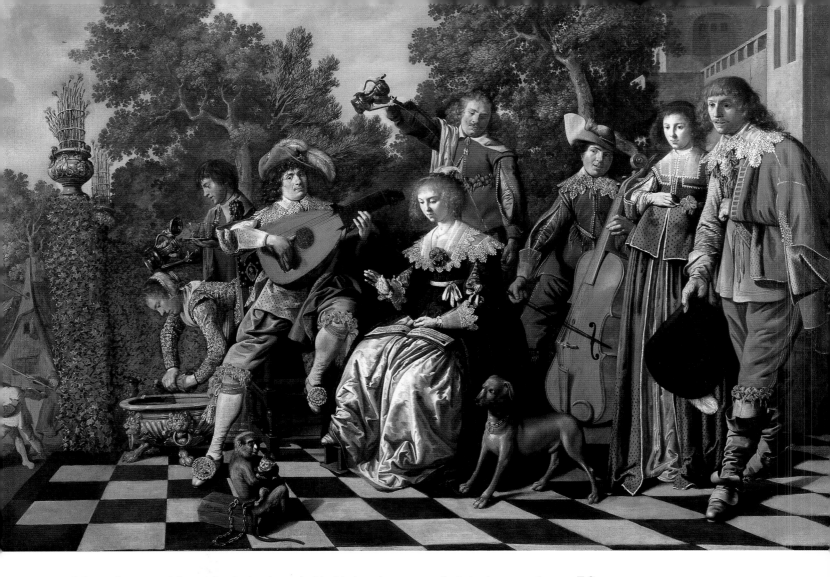

While Molenaer's Richmond painting is probably his best-known work, it is also one of his most puzzling. Variously identified by scholars as a merry company, an allegory of marital fidelity, an allegorical engagement portrait, and a *tafelspel* (a type of domestic play) presented to honor newlyweds, the picture's complex and highly debated iconography serves as a reminder of Molenaer's artistic development and inventiveness at a relatively early stage in his career. The interpretation proposed by Pieter van Thiel in his influential article "Marriage Symbolism in *A Musical Party* by Jan Miense Molenaer" remains at the core of subsequent discussions on the picture and is largely adopted here.[1]

Viewed within the larger arena of seventeenth-century Dutch genre painting, *Allegory of Fidelity* has proven valuable in furthering our understanding of how the messages embedded in these scenes functioned for Molenaer's contemporaries. A brief description of the work by Hofstede de Groot exactly a century ago also serves as a reminder of other aspects of the picture, namely its quality and authorship. During a visit to the collection of Baron Rothschild in Vienna in 1902, he made note of the painting and suggested an attribution to Molenaer (from Dirck Hals). "Eight music-making figures on a terrace. To the right a gentleman in red. Named Dirk Hals. Is a handsome early painting with fairly large figures."[2] While contemporary discussions have centered almost exclusively on interpreting the work, often overlooked are its masterful technique, large scale, and sparkling palette. Truly one of the artist's masterpieces, this painting and the three other important works by Molenaer dated 1633 (cats. 12, 14, and 15)[3] mark an early plateau in his career.

13
Allegory of Fidelity

1633

Signed and dated on the woodblock, lower left: MLE NAE R 1633 (MLE and NAE in ligature)

Canvas, 39 x 55 ½ in. (99.1 x 140.9 cm.)
Virginia Museum of Fine Arts
Williams Collection, Richmond
(inv. no. 49.11.19)

Provenance:
Albert Baron von Rothschild Collection, Vienna, by 1902; Eugene Baron von Rothschild Collection, Vienna/Long Island, New York, 1911–49; Newhouse Galleries, New York, 1949; Virginia Museum of Fine Arts, Richmond, 1949, gift of Mrs. A. D. Williams.

Exhibitions:
San Francisco, Toledo, and Boston 1966–67, no. 79; Sarasota 1980–81,

no. 52; New Brunswick 1983, no. 80; Pittsburgh 1986, no. 26; The Hague and San Francisco 1990–91, no. 45; Haarlem and Worcester 1993, no. 35.

Selected Literature:
Art News (November 1952), pp. 34–35, 65–66; Richmond 1966, p. 56, no. 88 (ill.); Van Thiel 1967–68; Leiden 1970, p. 17; Toledo 1976, p. 113; Daniëls 1976, pp. 331, 337; Kren 1980, pp. 75–79, fig. 14; Zafran 1981, p. 329; Smith 1982, pp. 32–35, 64, 127, 177, note 79; Philadelphia, Berlin, and London 1984, p. 246; Haak 1984, p. 235; Near 1985, pp. 441–43, fig. 4; Hecht 1986, pp. 182, 184; Haarlem 1986, p. 68, fig. 2a; Smith 1986, p. 21; Sutton 1986, p. 255; Hofrichter 1988, p. 16, fig. 120; Weller 1992, pp. 30, 41, 88–89, 100–01, 108, 128–29, 212, 239, 253, 351, fig. 10; Boston 1992, p. 178; The Hague and Antwerp 1994, pp. 48–49, fig. 15; Müller-Hofstede 1995, pp. 182, 374; Weller 1996, p. 813; Raupp 1996, p. 171, note 12.

Allegory of Fidelity features a group of large, well-dressed figures posed on a terrace defined by a checkerboard floor. Behind this group an ivy-covered wall, trees, and architectural features to the far left and right serve as the backdrop. Stylistically, Molenaer used broader brushstrokes for the background areas and much of the figures' clothing, while he refined his technique in the faces and the more intricate details of the costumes. The palette used for the fabrics ranges from blacks, whites, grays, and rust to dusty yellows, blues, greens, and reds. The strongest color accent is found in the costume of the standing man to the extreme right. He wears a yellow jacket, red trousers, and a cape with a lime-green lining. While others make music or busy themselves with refreshments, this man and his female companion appear strangely removed from the others. Contributing to this conclusion are the facial expressions and positioning of this couple, who, as will be seen, figure significantly in the iconographic program of the painting.

Closer scrutiny of the scene reveals a pair of disquieting elements—a monkey embracing a cat in the foreground and the broadly painted fighting villagers depicted to the far left.[4] In addition, a prominently placed dog alertly stands guard before the couple at the right. None of these details would have escaped viewers, nor have they been missing from the recent literature devoted to the picture.

In surveying the various interpretations of the picture, researchers have attempted to create a framework for its interpretation by contemporary viewers. As mentioned, Van Thiel described the imagery as an allegorical marriage portrait.[5] He identified the pair to the far right as the lucky couple, with the scene to their right serving as instruction on the dos and don'ts of a successful marriage. Among the virtues represented are harmony and moderation or temperance, expressed by the musicians and in the actions of the man in the background pouring wine and the seated woman before him maintaining the tempo of the music with her raised hand. Another virtue, fidelity, appears in the form of the dog standing before the couple. By contrast, the newlyweds are warned against vice,

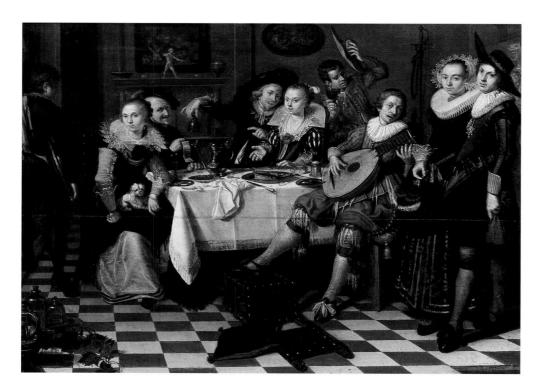

Fig. 1
Isack Elyas
Merry Company, 1620s
Oil on panel, 18 ½ x 24 ¾ in.
Rijksmuseum, Amsterdam

seen in the unusual coupling of the monkey and cat, and the fighting peasants to the far left.[6]

Although most agree with his general premise, a number of authors have made small changes to Van Thiel's complicated allegory. De Jongh and Broos, for example, see the couple as unmarried, since the woman appears on the man's right rather than his left, the wife's traditional placement in Dutch marriage portraiture.[7] Wilson offered a possible identification for the couple, suggesting they might be members of the Van Loon family.[8] Kren, who accepted Van Thiel's theory of newlyweds, placed the scene within the larger context of *tafelspelen*, "or similar form of theater."[9] He concluded that the couple "are probably newlyweds witnessing a *tafelspel* performance in their honor."[10] Müller-Hofstede also noted the theatrical aspect of the composition, as did Wilson, who described many of the figures, including the newlyweds, as portraits.[11]

A far different interpretation for *Allegory of Fidelity* was outlined in a catalogue entry on the work by Cynthia von Bogendorf Rupprath. She cited a number of prints and their inscriptions to support her argument that the scene expresses the idle pretensions and selfishness of "Molenaer's pampered young fops."[12] Accordingly she entitled the picture with the more generic title *A Merry Company on a Terrace*. While intriguing, such an identification seems improbable under the weight of Molenaer's iconographic specificity in this example and elsewhere in his art. Finally, Barbara Haeger, in an unpublished paper, followed another avenue in interpreting the composition, one related to the senses. Her conclusions suggest, perhaps rightly, that the viewer takes a more active role in looking at the scene.

Instead of depicting an easily read representation that portrays either behavior to be emulated or to be avoided [Van Thiel], the Richmond painting shows a group of intentionally ambiguous figures whose dual character simultaneously reflects that of the senses and actively solicits the viewer's involvement in the process of interpretation. The painting indicates that when confronted with sensual pleasures the viewer has a choice; s/he can enjoy them in moderation or, abandoning all restraint, succumb completely and be reduced to the level of beasts. This is made clear by the picture's structure, its symbolism, and the differing roles played by the humans and the animals.[13]

Besides its intriguing, albeit debatable, message, the painting offers many visual rewards. As mentioned, its rich palette and diverse brushwork are very impressive, as are the frequently discussed portraitlike features of the protagonists. Technical evidence suggests Molenaer paid great attention to this painting's execution, as it was undoubtedly an early and important commission.[14] The composition may even provide a clue to a missing piece of Molenaer's biography, his undocumented training. Motifs including the well-dressed couple standing to the far right, merrymakers with music and drink, the checkerboard flooring, and even the servant and wine cooler on the left are found in a painting dated to the early 1620s by the little-known Haarlem painter Isack Elyas. His *Merry Company* (fig. 1) clearly offered Molenaer a prototype for the Richmond painting. Whether or not it also reflected a stronger tie between the two painters still remains, like so many of the iconographic issues raised, unanswered.

Notes

1 Van Thiel 1967–68.

2 Hofstede de Groot, index cards, Rijksbureau voor Kunsthistorishe Documentatie (RKD), The Hague.

3 It can be argued that only the extant signed and dated pictures from the years 1636 and 1637 have done more to establish the current reputation of the painter. See discussion in Weller, pp. 17–18.

4 The fighting villagers at the far left were painted in a far different palette than their counterparts on the terrace. Perhaps adhering to Van Mander's instruction that the painter of peasants should "spare not yellow ochre with your vermillion," Molenaer would further exploit this difference in many of his village scenes from later in his career. See Weller 1992, p. 101.

5 Van Thiel 1967–68.

6 In arguing these identifications, Van Thiel (ibid.) cites many visual and literary sources in support of his conclusions.

7 De Jongh in Haarlem 1986, p. 68, and Broos in The Hague and San Francisco 1990–91, pp. 347, 349.

8 Sarasota 1980–81, no. 52, unpaginated.

9 Kren 1980, p. 78.

10 Ibid.

11 Müller-Hofstede 1995, p. 182.

12 Haarlem and Worcester 1993, p. 319.

13 I would like to thank Professor Haeger for sharing her research with me.

14 A dog, for example, originally appeared in the left foreground before the fighting peasants.

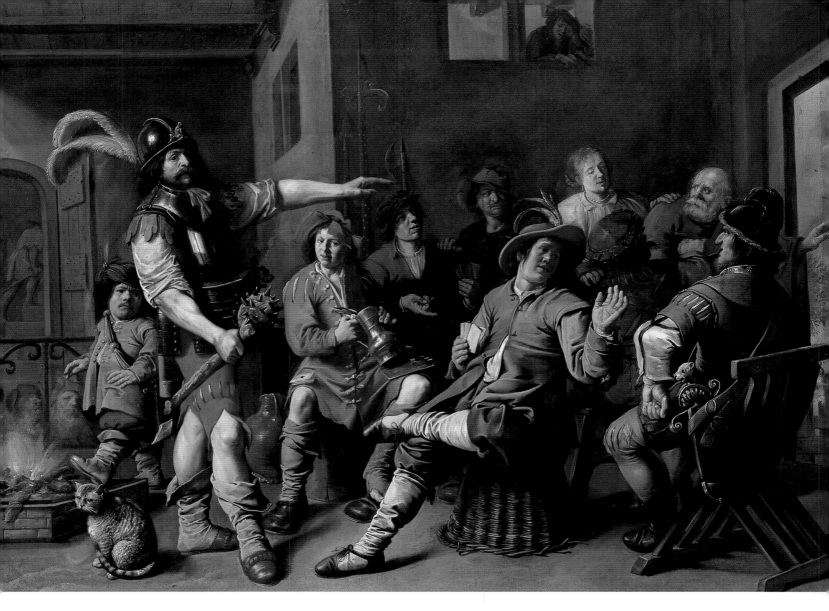

14
Denial of Saint Peter

1633

*Signed and dated on chair at right:
IMOLENAER f 1633 (IM in ligature)*

Canvas, 40 ⅛ x 54 ¾ in. (102 x
139 cm.)
The Museum of Fine Arts (Szép-
müvészeti Muzeum), Budapest

Provenance:
J. L. J. de Man (?); sale, Brussels,
Jorez, 19 July 1820, no. 144.
A. Philips Neven, Maastricht, by
1890; sale, Berlin, 4 May 1897.
Richárd Tószeghy, Budapest, before
1957; acquired in 1957 from Mrs.
Richárd Tószeghy by the museum.

Molenaer's oeuvre holds many surprises for the viewer, among them his large and colorful *Denial of Saint Peter*, the earliest-dated of his biblical subjects. Its imagery allowed the painter to bring a rustic element into his art well before his move to Amsterdam by 1637.[1] In it Molenaer focuses his energy on an animated group of soldiers and card players wearing brightly colored, fanciful costumes.[2] Taking center stage in the drama, these individuals nearly obscure the true subject of the painting, Peter's denial. Peter appears at the far right next to the doorway. Confronted by a scornful serving girl, he is about to make his exit. A rooster may be seen through the doorway, alluding to the prophecy that Peter would deny Christ three times before the cock crowed. This narrative appears in all four gospels, with John (18:17–18, 25–27) providing the most complete account of Peter's actions following the arrest of Christ.

The maid who was on duty at the door, said to Peter, "Are you another of this man's disciples?" "I am not." And the servants and the police, had made a charcoal fire, because it was cold, and it warmed them. Peter stood with them and warmed himself. And Simon Peter stood warming himself: They said to him, "Are you not another of his disciples?"

He denied it, and said "I am not." One of the servants of the High-priest, the relation of the man whose ear Peter had cut off, said, "Had I not seen you in the garden with him?" Peter denied again; and just then crowed the cock.[3]

In terms of its scale and visual impact, the *Denial of Saint Peter* ranks just behind Molenaer's other masterpiece in religious narrative, the little-known *Mocking of Christ* (Weller fig. 11), dated 1639. Neither picture is documented, although both were surely commissioned for altars in churches or other religious institutions. Like the *Mocking of Christ*, the *Denial of Saint Peter* provides a striking contrast between the aggressive behavior of the underclass and a vulnerable religious figure. Molenaer also delighted in describing the colorful clothing, fanciful headdresses, weapons, and other objects in the crowded room.[4]

Unlike the subject of the rarely depicted *The Departure of the Prodigal Son* (cat. 9), the denial of Saint Peter was a popular theme with Dutch painters. Among the best known are works by Rembrandt, Hendrick Ter Brugghen, and Gerrit van Honthorst. Honthorst's *The Denial of Saint Peter* (fig. 1), for example, represents the interests of many of these artists in that it demonstrates the impact generated by the genius of Caravaggio. Strong contrasts of light and dark, forward placement of the three-quarter-length figures, and a heightened sense of realism bring an immediacy and overwhelming drama to Honthorst's scene. By contrast, Molenaer adopted an anecdotal reading for the subject. Susan Kuretsky called attention to the work's unpretentious attitude, noting that "the biblical subject is translated so fully into the vocabulary of everyday life that one's recognition of the subject comes as something of a surprise."[5] She observed that "the incident occurs within a tavern interior dominated by card playing, beer drinking ruffians: a witty and appropriate moral context for Peter's betrayal of Christ."[6]

Molenaer may have been guided in his approach to the subject by a fellow Haarlem artist, rather than a follower of Caravaggio. An engraving representing *The Denial of Saint Peter* (fig. 2) by W. Akersloot, after a drawing of 1626 by Pieter Molijn, offers a conceptual approach remarkably similar to the one taken by Molenaer just a few years later. In both, full-length soldiers and servants strike casual poses and play cards, while behind them appears the confrontation between the maid and Peter. The works also share motifs

Exhibitions:
Cologne and Utrecht 1987, no. 27; Milan 1995, no. 12.

Literature:
Bode and Bredius 1890, p. 72; Bulletin 1958, pp. 78–80, fig. 47; Pigler 1967, pp. 455–56, fig. 290; Mojzer 1967, pls. 9, 10; Garas 1973, p. 265; Daniëls 1976, pp. 334–35, fig. 5; Kuretsky in Washington, Detroit, and Amsterdam 1980, pp. 252–54, fig. 1; Bonn 1982, p. 354; Philadelphia, Berlin, and London 1984, p. 264; New York 1985, p. 267; Garas 1985, p. 71, color plate 61; Weller 1992, pp. 37–42, 357, fig. 16; Slive 1995, p. 130; Bodnár 1995, pp. 95–96, fig. 146; Hahn 1996, p. 174, fig. 44; Budapest 2000, p. 109, illus.

Fig. 1
Gerrit van Honthorst
The Denial of Saint Peter, ca. 1620–25
Oil on canvas, 43 ½ x 57 in.
The Minneapolis Institute of Art, The Putnam Dana McMillan Fund

Fig. 2
Willem Akersloot, after Pieter Molijn
The Denial of Saint Peter, ca. 1626
Engraving
Rijksprentenkabinet, Rijksmuseum,
Amsterdam

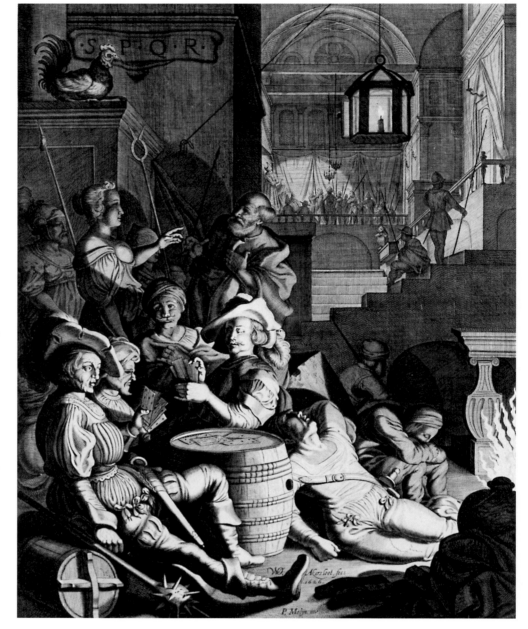

Notes

1 Although the painting long carried
a date of 1636, recent conservation
treatment on the *Denial of Saint Peter*
removed overpaint to reveal a clearly
legible date of 1633.

2 It is interesting that the setting in
this scene is strangely reminiscent of
the one found in Molenaer's *Allegory
of Vanity* (cat. 12), a work also dated
1633. While the architecture in the
Budapest picture extends further to
the right with an additional wall
and doorway, the painter, with just
a few cosmetic changes, has described
the same interior space.

3 Translated from *Biblia dat is de
gantsche Heylige Schrifture* (Leiden
1663); see Weller 1992, pp. 53–54.

4 Included in the composition is a cat
prominently placed in the lower left
corner of the painting. Its presence
may be symbolic of fickleness, deceit,
or even cruelty, human characteristics
often associated with this animal. If
so, the message may be associated
with the actions of Peter in his mo-
ment of crisis, or with his tormenters.
See Van Thiel 1967–68, pp. 95–98,
for a discussion of a cat in another
painting by Molenaer.

5 Washington, Detroit, and Amster-
dam 1980, p. 254.

6 Ibid.

such as the blazing fire, the weapons used by the soldiers, and a strong emphasis on archi-
tectural backdrop for the unfolding events. Unlike the print, however, Molenaer's large
painting makes a powerful and immediate impact on the viewer. The individuality of his
figures, the range of their emotions, and the coarse brushwork and atypical palette all
speak to the unique character and inventive quality of his *Denial of Saint Peter*.

15

Portrait of a Woman with Embroidered Gloves

1633

Signed and dated on arm of chair at right: Jan Molenaer 1633

Panel, 42 ⅞ x 32 ¼ in. (109 x 82 cm.)
Courtesy of Otto Naumann Ltd.,
New York

Provenance:
Private collection, Brussels, in the
nineteenth century; by descent to the
French branch of the same family; sale
Paris, Millon & Associés, 3 December
2001, no. 68; acquired by Otto
Naumann Ltd., New York.

Exhibitions:
None

Literature:
Unpublished

Although a newly discovered work rarely prompts a reevaluation of an artist's oeuvre, this remarkable picture does provide new insights into Molenaer's early interest in portraiture. Dated 1633 and forcefully signed in cursive rather than the more typical block lettering found in most of his pictures from the 1630s, the *Portrait of a Woman with Embroidered Gloves* is one of the artist's most accomplished paintings.[1] It is also one of the most unique.[2] The work joins the three other extant paintings signed and dated the same year, all of which are included in the exhibition (cats. 12–14).

Like Molenaer's religious pictures (cat. 14), his theatrical scenes (cat. 29), and especially

Fig. 1
Frans Hals
Portrait of an Elderly Lady, 1633
Oil on canvas, 40 ⅜ x 34 ³⁄₁₆ in.
National Gallery of Art, Washington,
D.C.

his group portraits (cats. 23, 24), the *Portrait of a Woman with Embroidered Gloves*
shows another side of Molenaer's diverse artistic interests. Here he adopts conventional
marriage portrait iconography, presenting the woman in three-quarter length and turned to
the left, presumably toward her husband.[3] His portrait would have hung to the viewer's
left, thus maintaining the dominant (dexter) position of the male in relationship to his
spouse. This tradition had a long history in Northern portraiture.[4] Nearly a century earlier,
for example, the Haarlem artist Maerten van Heemskerck painted portraits of a husband
and wife that display many of the same features found in Molenaer's female portrait (and
its presumed pendant), including her placement, elaborate costume, gloves held in her
hand, and coat-of-arms positioned in the upper left corner.[5]

The *Portrait of a Woman with Embroidered Gloves* shows a figure sitting in an expen-
sive chair with a curved arm extended around the wooden relief of a head flanked by
wings. To her right is a table, upon which lie two small books, one with metal clasps and
the other tied by ribbons. She wears a fashionable and undoubtedly expensive costume

that suggests her elevated social position. Hofrichter described the woman's garments, or *vliegerkostum*, in her gallery notes on the painting.[6]

The vest-like upper garment with padded shoulders and probably made of velvet, is known as a vlieger. *The padded shoulder coils are known as* bragoenen. *The woman's bodice, or* borst *(a stomacher), is closed with a long row of gold buttons, embroidered with flowers at the chest, on her sleeves and on each of the tongues of the stomacher as it lies across the lap of her skirt. She wears a large millstone ruff, a double cap, and several inches of bobbin lace at the cuffs of her sleeves. The linen of her ruff, cuff and cap is probably cambric, a high quality Haarlem linen.*[7]

Hofrichter noted a number of other costume details to suggest the picture is a wedding portrait. These details include the "images of flowers on her bodice and sleeves, as well as on her rings on both hands and the embroidered long cuffs of her gloves."[8] The white kid gloves she holds are particularly noteworthy, as they "were typical of the type of glove given to a woman by her intended husband at the betrothal ceremony, when the marriage contract would be signed."[9]

Her costume and accessories, while beautiful in detail and elaborately sewn, are comparatively conservative by contemporary standards.[10] This characterization may well reflect the sentiments of the sitter, whose identity has yet to be determined in spite of the coat-of-arms at the upper left.[11] Molenaer's manner of execution may also be considered conservative. His painting technique is marked by precision and restraint, an approach better appreciated alongside a work by his probable teacher, Frans Hals. Hals's *Portrait of an Elderly Lady* (fig. 1) in Washington, D.C., carries the same 1633 date and shows the sitter in a nearly identical *vliegerkostum*, millstone ruff collar, and double cap.[12] Only the gold buttons and gold brocade on the sleeves and stomacher of the costume worn by Molenaer's woman stand at odds with the one worn by the Hals counterpart.

Like Molenaer, Hals applied a more descriptive and precise brushwork to the details of the lace cuffs, ruff, and cap. Molenaer also used the same treatment for the other elements of his composition, whereas Hals used unblended brushstrokes to define the skirt, hands, and, to some degree, the woman's face. Molenaer, either by choice, lack of ability, or the constraints of the commission, did not attempt to compete with Hals's genius. Instead, he formulated his own solution for the traditional portrait format, one that thankfully has now resurfaced.

Notes

1 This elaborate signature rarely appears prior to 1640 in Molenaer's works. Due to the nature of the commission and the skill Molenaer applied to its execution, it is likely the painter took the opportunity to use it here to identify himself as one of Haarlem's masters.

2 Although there are no other known examples of traditional portraits of this type in Molenaer's oeuvre, he did include comparable portrait pendants of his parents on the back wall of his *Self-Portrait with Family Members* (Introduction fig. 1).

3 While a male pendant portrait is to be expected, there are examples of free-standing female portraits. As Otto Naumann writes in the gallery notes for the picture, "The coincidentally comparable *Portrait of Catherina Hooghsaet* (1657, Penrhyn Castle, Gwynedd) by Rembrandt may be a case in point."

4 For an excellent overview of this topic, see Haarlem 1986.

5 Illustrated and discussed (ibid., nr. 12, pp. 102–03).

6 Hofrichter for Otto Naumann, Ltd., 2002.

7 Ibid.

8 Ibid.

9 Ibid.

10 See cat. 13, another painting dated 1633, that probably shows young newlyweds standing to the far right. Their clothing reflects a far less conservative nature than the costume painted by Molenaer in his *Portrait of a Woman with Embroidered Gloves*.

11 The coat-of-arms appears to be part of the original paint and not a later addition, as is often the case. Further research may well reveal the name of the sitter.

12 See Wheelock 1995, pp. 69–71, for a discussion of the Hals portrait.

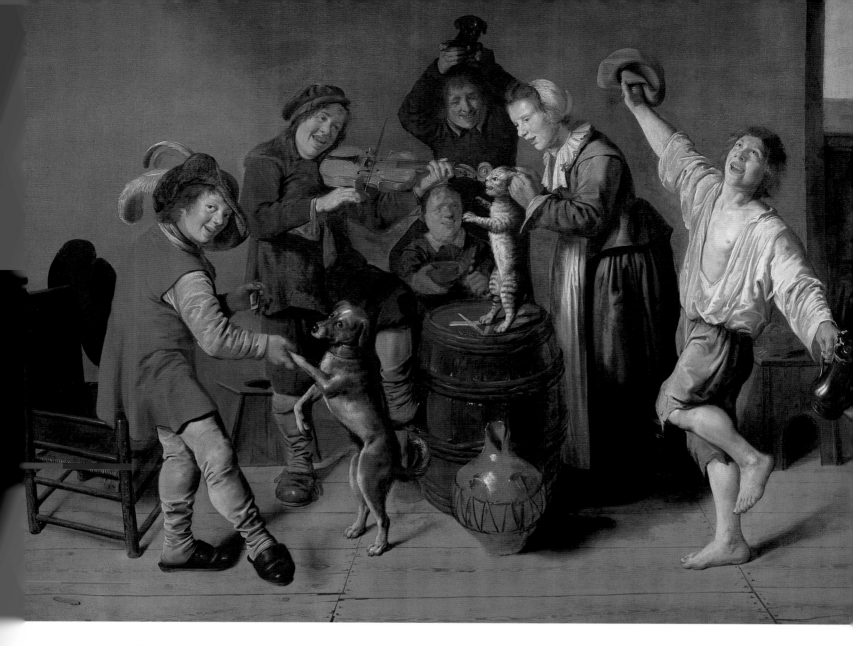

16

(Manchester only)

Children Playing and Merrymaking

ca. 1633

Signed on barrel: JMolenaer (JM in ligature)

Canvas, 34 ⅞ x 45 ¼ in. (88.5 x 115 cm.)
Peter and Hanni Kaufmann

Provenance:
Art market, London, in 1969; sale, London, Christie's, 29 June 1979, no. 94; sale, London, Christie's, 8 July 1983, no. 32; dealer Douwes, Amsterdam and London; to present owner.

Exhibitions:
None

Children Playing and Merrymaking serves as a highly entertaining work in Molenaer's oeuvre from the first half of the 1630s. Unlike his half-length scenes of youngsters with pets painted just a few years earlier, here he expanded his stage by depicting six older children in a simple, yet clearly defined, interior space. Close cousins to the revelers who populate the painter's peasant interiors from later in his career, each figure revels in the joy of the moment. From left to right: a boy dances with his understandably apprehensive canine partner; an older boy plays his fiddle with great abandon; and a third youngster holds a puppy above his head and assesses the action, while a young girl pulls on the tail of a "dancing" cat that an older girl holds by the ears. The sixth participant, the older boy at the far right, certainly feels no pain. Recklessly overwhelmed by the effects of both alcohol and music, this young man has removed part of his clothing and begun to dance.

Molenaer was drawn to the subject of children playing with animals throughout much of the 1630s. Among the other examples is *Peasants Teaching a Cat and Dog to Dance* (fig. 1), a painting that shares many of the artistic and iconographic concerns found in *Children Playing and Merrymaking*. Unlike its counterpart, however, the action in the

Dublin picture takes place in a dark, rustic interior. Its architectural elements are more akin to a barn or shed. In keeping with the style of Molenaer's peasant merry company scenes, the figures in this work are smaller in scale, the brushwork freer, and the interior space more fully articulated. In discussing the *Peasants Teaching a Cat and Dog to Dance*, Potterman seems to be correct in dating this work to the late 1630s.[1] By contrast, *Children Playing and Merrymaking* must have been painted during the first half of the decade. The

large figures, colorful palette, and compression of space are all characteristic of Molenaer's earlier stylistic concerns. Only the signature stands stylistically at odds with his paintings from the early 1630s.[2]

While the style of the two pictures may vary, Molenaer forged a consistent message by repeating the motifs of children teaching pets to dance in both paintings. Identified as "the main practitioner of this type of genre in seventeenth-century Dutch painting,"[3] Molenaer probably understood that the popularity of these scenes may have been due to the engaging combination of spirited children, the

Literature:
Durentini 1983, pp. 283, 285, fig. 159; Potterton 1986, p. 95, note 2; Weller 1992, pp. 143–45, 392, fig. 51; Westermann 1997, pp. 213, 246, note 46.

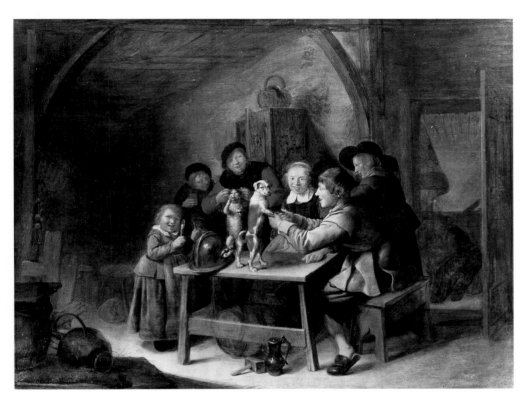

Fig. 1
Peasants Teaching a Cat and Dog to Dance, ca. 1635–40
Oil on panel, 21 ½ x 28 ⅛ in.
The National Gallery of Ireland, Dublin

animals, and the implied messages conveyed to the viewer. Consequently, a number of authors have suggested the "training of animals could function as a metaphor for the training of children."[4] In linking the subject with the effects of proper versus improper upbringing, Molenaer may have exploited the differences between the natures of cats and dogs. Dogs are obedient to their masters, easily trainable, and willing "dance" partners. Experience, however, tells us that cats are very different. In spite of undergoing physical abuse, as the girl pulls its tail and holds it upright by its ears, the feline in *Children Playing and Merrymaking* will never be a willing participant in the revels.

In a broader context, one wonders if Molenaer intended the children pictured in the composition to serve as surrogate teachers. Questions can also be asked whether these youngsters had received proper schooling themselves, or if children of lower social strata were even teachable?[5] Nevertheless, Molenaer hid these concerns beneath a façade of merriment, perhaps suggesting that children should be allowed to be children. Youth is fleeting. Interestingly, it was Molenaer's successor Jan Steen who brought his genius to the subject a generation later. Writing on Steen's *Children Teaching a Cat and a Dog to Dance* (fig. 2) in Amsterdam, Mariët Westermann makes a similar case for the hilarious imagery Steen provided the viewer.

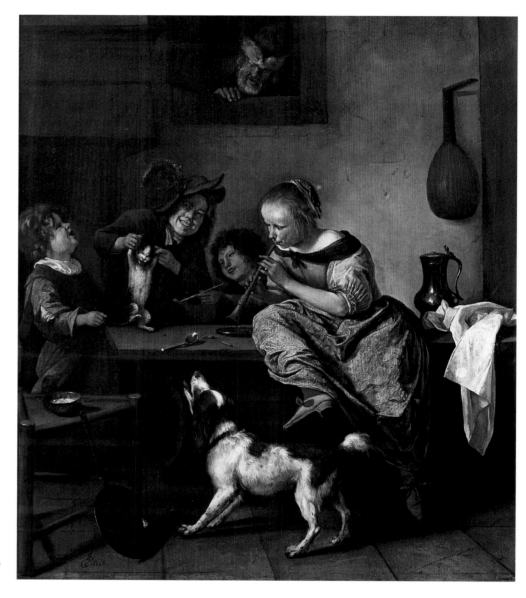

Fig. 2
Jan Steen
Children Teaching a Cat and a Dog to Dance, ca. 1665–68
Oil on panel, 27 x 23 ¼ in.
Rijksmuseum, Amsterdam

Notes

1 Potterton 1986, p. 95.

2 Here the signature found on the top section of the side of the barrel is written in script, with the *J* and *M* in ligature rather than in block letters. This signature occurs more frequently in Molenaer's oeuvre after his move to Amsterdam.

3 Potterton 1986, p. 94.

4 Durantini 1983, p. 278. Among the authors who have focused on this issue, Durantini has made the most exhaustive study on the topic.

5 The issue of how teachable these children were may stand at the core of a series of peasant and village school scenes Molenaer painted between 1634 and the early 1640s. See Weller 1992, pp. 236–41.

6 Westermann 1997, p. 213.

In Steen's painting at the Rijksmuseum, not even the loudest piping will make the cat dance to the children's tune. A barking dog joins in the laughter to reinforce the point . . . But even if cruelty to cats was an accepted feature of a pet world that condoned cat pulling for kermis amusement, it is clear that Steen's kids are no proper teachers. Like their pets, they lack effective models, if the sleeping elderly man in the Amsterdam picture is any indication.[6]

The ages of Molenaer's merrymakers suggest that the cycle of negative role models will soon repeat itself.

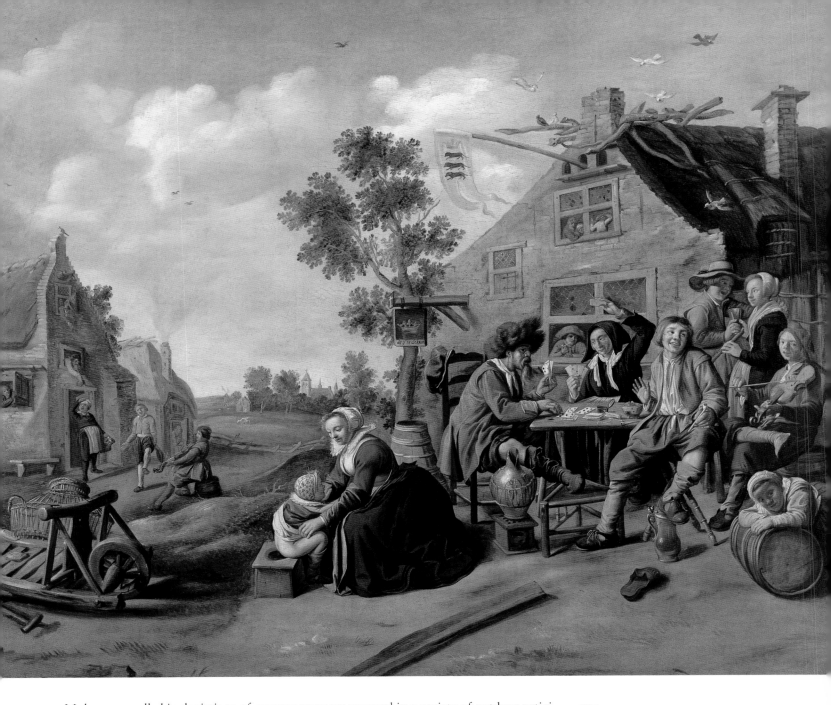

Molenaer excelled in depictions of country peasants engaged in a variety of outdoor activities. These paintings were often negative in tone, such as his *Dance in a Village Street* (cat. 6), one of the earliest of these works, dating to about 1630. For the next couple of years, the painter occasionally returned to the subject, and from this period comes the undated *Peasants near a Tavern*. The most ambitious and inventive of this early group of outdoor scenes, the picture is rich in symbolism. According to one writer, "This painting illustrates the seventeenth-century idea that the beholder might be incited to virtue at the sight of vice."[1] This assessment may well be correct, but before considering reasons for such a conclusion, the viewer is first assaulted by the upbeat tone of the scene, in which villagers amuse themselves with a variety of activities. While this subject matter may not be new to Haarlem painting, it clearly identifies Molenaer as an important contributor to this tradition.[2]

Compared to his other representations of outdoor scenes from a few years earlier, Molenaer adopted a more sophisticated composition for *Peasants near a Tavern*. He struck a

17

Peasants near a Tavern

ca. 1633–34

Monogrammed on the child's potty stool at center: JMR
Inscribed on flag at center: dit is in die kron

Canvas, 37 ⅛ x 45 ⅝ in. (95 x 116 cm.)
Frans Hals Museum, Haarlem, loan Institute Collection, Netherlands

Provenance:
State-owned art collections,
The Hague, in 1946.

Exhibitions:
Osaka 1988, no. 23.

Literature:
Haarlem 1955, p. 19; Haarlem 1969,
p. 51, no. 213a; Diepen and Snethlage
1990, pp. 126–27, fig. 127; The Hague
1992, p. 209, no. 1775 ill.; Weller
1992, pp. 247–49, fig. 93.

better balance between the figures and their setting, thus providing a larger, more convincing stage for the painter. In his *Dance in a Village Street*, for example, somewhat stiff and awkward villagers appear in a friezelike arrangement in the extreme foreground. The setting serves as little more than a backdrop. By contrast, the Haarlem picture incorporates figures smaller in scale and better integrated into the composition's middle ground. Molenaer took a similar approach to composition in *The Ball Players* (1631) (fig. 1). This work falls just short of its counterpart in balancing the merrymakers with their village setting.[3] In keeping with his usual practice, Molenaer populated both scenes with many of the same models, including the old man with a beard and fur-trimmed hat.

Still retaining their naive character, the demeanors of the villagers in *Peasants near a Tavern* have nevertheless become more realistic and less contrived, their expressions less forced. In addition, the village setting is now described with greater specificity, particularly

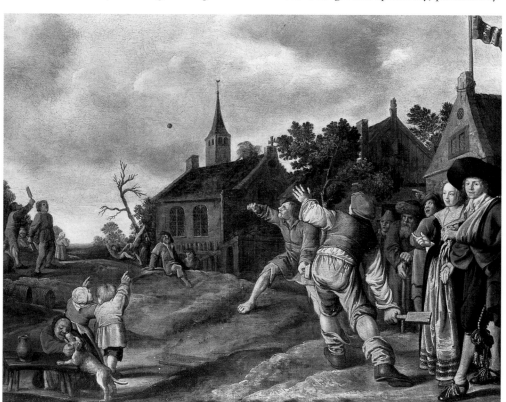

Fig. 1
The Ball Players, 1631
Oil on canvas, 31 7⁄8 x 39 in.
Private collection

the iconographically important tavern standing to the right. The painter also paid careful attention to his choice of color. Following Van Mander's instruction that earth tones be reserved for peasant subjects, Molenear largely painted *Peasants near a Tavern* in these terms.[4] Browns, grays, and greens dominate. Local color was reserved for just a few details, in particular the red and blue in the costume of the woman at the center and in the costumes of a few of her companions. By way of its palette and subject matter, the painting, as will be discussed elsewhere, effectively previews Molenaer's interest in peasant merry company scenes to follow.

As mentioned, representations of merrymaking villagers were becoming commonplace in seventeenth-century Haarlem painting. Still, Molenaer brought his own perspective to the subject, as *Peasants near a Tavern* reveals itself as another example in which the painter intermingled the old with the new. Disguising older visual traditions in the guise of "mod-

ern" figures, he provided a meaningful yet entertaining message to his contemporaries. Here, the painter focused his efforts around the theme of the five senses. "Sight is represented by the card-players, smell by the youth smoking a pipe, touch by the couple behind him, hearing by the fiddler and taste by the girl leaning over the beer-barrel."[5]

Our senses, although indispensable, could give rise to temptation. The effects of vice are seen everywhere. That viewers should resist such temptation serves as Molenaer's broader message. The sense of taste, for example, prompts overindulgence, as is seen in the tobacco-"drunk" pipe smokers and the tipsy old card player seated next to a jug of beer. By contrast, virtuous activities, represented by the basket, tools, and wheelbarrow at the left, have been abandoned for the pursuit of pleasure.[6] In addition to the pleasures specifically related to the five senses, other motifs in the picture strengthen Molenaer's message.

Fig. 2
Johan de Brune
Dit lift, wat ist, als stanck en mist?,
from *Emblemata of zinne-werck*,
Amsterdam, 1624

Doves have always been associated with love. Here several of them are circling the roof of the inn where there is a dovecote, the epitome of the love-nest. A flag decorated with three pigs under a crown hangs from the roof. The pig was regarded as a greedy animal in the seventeenth century, and was associated with lechery and drunkenness; the flag therefore identifies the tavern as a house of ill repute.[7]

Vice continues unabated on both sides of the village, as peasants drink, dance, and make music. Another detail, nearly lost to the far left, is the man urinating against a wall. His actions bring the viewer back to the focal point of the composition, the young mother and her child on the potty stool. A popular emblem page by Johan de Brune (fig. 2) shows a mother wiping a child's bottom. Carrying the motto *Dit lift, wat ist, als stanck en mist?* (This life, what is it but stink and shit?), it serves as another warning about the temptations of the flesh. As Molenaer demonstrated to his viewers, however, such warnings are made more entertaining and palatable when seen through the antics of village bumpkins.

Notes

1 Osaka 1988, pp. 126–27.

2 A handful of Haarlem artists depicted outdoor village scenes during the early years of the seventeenth century. Among those painters active in the city for at least part of their careers were Adriaen Brouwer, Esaias van de Velde, and Willem Buytewech. Ultimately it was the art of Pieter Bruegel the Elder and his followers that provided Molenaer his greatest model.

3 If one considers the stylistic and compositional similarities between *The Ball Players* and *Peasants near a Tavern*, it appears the undated picture from Haarlem must have been completed within a couple of years of the other. Interestingly, a copy of *Peasants near a Tavern* (Sotheby's, London, 7 July 1993, no. 26) carries a 1638 date.

4 Discussed by Bomford in London 1986a, p. 46. Also see cat. 14.

5 Osaka 1988, p. 127.

6 Similar tools associated with a related message appear in *Dance in a Village Street* (cat. 6).

7 Osaka 1988, p. 127.

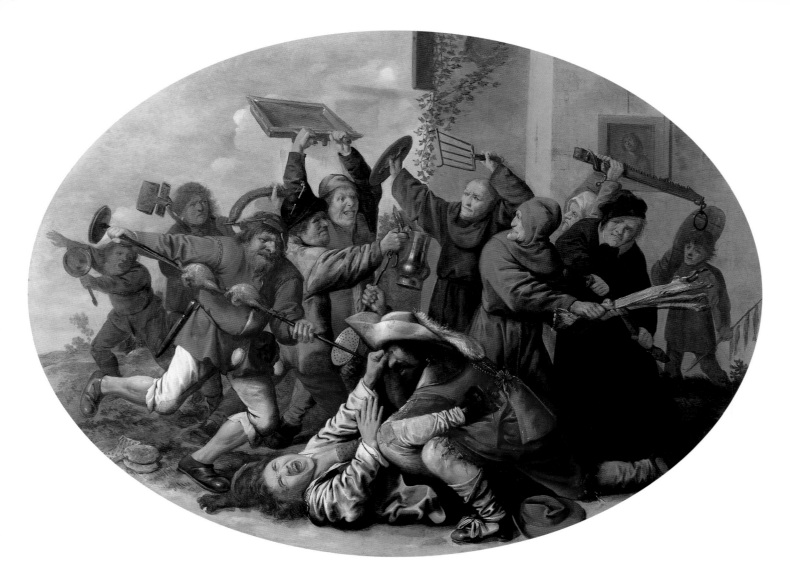

18

Battle between Carnival and Lent

ca. 1633–34

Unsigned

Panel, oval 16 x 21 ¼ in. (40.6 x 55.3 cm.)
Indianapolis Museum of Art, Indianapolis
In honor of A. Ian Fraser, with funds provided by David L. Chambers Jr. Fund, Dr. V. K. Stoelting Art Fund, and Mrs. Jane W. Myers

Provenance:
Private collection, United States; dealer Jack Kilgore, New York; private collection; dealer Otto Naumann, New York, in 1997; acquired by the Indianapolis Museum of Art in 1998.

Exhibitions:
None

In pictures from the 1630s, Molenaer excelled in reinterpreting popular sixteenth-century subjects. The middle years of the decade, for example, saw the painter completing two of his most unique and intriguing scenes in this arena: *Battle between Carnival and Lent* and its presumed pendant, *The King Drinks* (cat. 19). Again drawing from the deep waters of the Bruegel tradition, the painter put a comic face on the individuals called upon to act out these Catholic festivals. The vigor with which the participants assume their roles suggests Molenaer approached these subjects with a critical eye focused on contemporary religious and political controversies of his day.

Prior to when *Battle between Carnival and Lent* appeared on the art market in the early 1990s, the picture's format had been changed into a rectangle (fig. 1).[1] After the corner additions were removed, its original oval shape suggested a close connection with *The King Drinks*, from Vaduz. Not only are the two similar in size and related in subject matter, they are virtually unique in Molenaer's extant oeuvre in this format. In spite of these similarities, however, one cannot be certain if they originally were intended as pendants. The proposed dating of the two panels tends to argue against this conclusion, as the *Battle between Carnival and Lent* seems somewhat more polished and sophisticated, suggesting a later dating.

While quite animated and engaging, many of the figures in the Indianapolis painting betray some of the anatomical shortcomings common to Molenaer's works from the early

1630s. A good point of reference is his *Boys with a Dwarf* (cat. 5, fig. 1), a picture that should be dated to this period.[2] In both, Molenaer showed a crowd of outdoor merrymakers with awkward poses and anatomical inconsistencies. He, in fact, recycled the pose of the boy shown with outstretched arms and looking over his shoulder. *Boys with a Dwarf* and the *Battle between Carnival and Lent* also share similar settings. In both, the foreground figures largely obscure the simple landscapes. A sign hanging from the building identifies the structure in *Boys with a Dwarf* as an inn. An inn also served as the architectural backdrop to the Indianapolis painting as well, for a clearly visible pentimento at the top center shows a comparable sign.[3]

Literature:
Gazette des Beaux Arts, March 1999, p. 51, fig. 191.

By comparison, the treatment of the drinkers in the Vaduz *The King Drinks* shows a more mature painter probably working a year or two later. Here Molenaer reveals a far better understanding of the relationship between the figures and their setting, a more polished execution, and poses less forced and more realistic.

As noted, Molenaer's *Battle between Carnival and Lent* represents a subject popular with Pieter Bruegel the Elder and his followers. Bruegel's painting of the theme (fig. 2) differs significantly from Molenaer's, but in its basic iconography, comic tone, and probable moral condemnation, the two works share many similarities. Walter Gibson captured the spectacle of Bruegel's *Carnival and Lent* in his description of the picture.

Fig. 1
Battle between Carnival and Lent, ca. 1633–34, during conservation

In the Carnival and Lent *a town square surrounded by Late Gothic architecture provides the setting for the mock combat in the foreground. Straddling a barrel and precariously balancing a fat pie on his head, pot-bellied Carnival jousts with an emaciated, dour-faced Lent. Carnival is attended by costumed mummers and musicians, and his weapon is a spit filled with roasted meats. Lent defends herself with a broiling-iron containing two small fish; her beehive crown resembles the one worn by Hope in Bruegel's Virtue series, but in this case symbolizes the Church, and her other attributes include a bundle of switches for scourging penitents. At her feet lie pretzels and other traditional Lenten fare. Followed by a group of children, her wagon is appropriately drawn by a monk and nun.*[4]

The same author wrote on the popularity of such scenes in the art and literature of the sixteenth century, including several *rederijker* (rhetorician) plays and related images of the war between Shrovetide and the sausages. More important, he suggested the work possessed a deeper significance for contemporary viewers. "The moral license which inevitably

Notes

1 Condition reports outlining the
changes are on file at the Indianapolis
Museum of Art.

2 Although *Boys with a Dwarf* carries
a date of 1646, it is clearly a work
from the early 1630s. As I have argued
elsewhere, its overall composition,
palette, figure type, and style are
entirely consistent with Molenaer's
early outdoor scenes.

3 Other, less visible pentimenti and
underdrawings also appear in this
work. In addition, x-radiographs and
infrared reflectography show a num-
ber of changes made by the artist.

4 Gibson 1977, p. 79.

5 Ibid., p. 84.

prevailed at carnival time, despite repeated efforts to control it, was condemned by many preachers and satirists of the period."[5]

Molenaer may have assumed the same condemnatory tone in his work, although he greatly reduced the spectacle by focusing on just a dozen revelers. Nevertheless, a pitched battle rages between the gluttonous merrymakers of Carnival to the left and their ecclesiastical counterparts in monks' garb representing Lent on the right. They arm themselves with many of the same weapons depicted by Bruegel, including the spit with roasted game, the iron grill, and various pots and cooking utensils. The mock battle in Bruegel's masterpiece has turned deadly serious in Molenaer's eyes. At the center of his composition, and serving as its focal point, are two men locked in a life-and-death struggle. Seemingly unrelated to the merrymakers behind them, this pair may reflect broader concerns for the contemporary viewer. The older bearded man on the left has been described as a Spanish soldier who strangles a Dutch peasant. If correct, the picture may represent not only a criticism of a Catholic religious festival but a broader reflection of the political and religious struggles between the Dutch Republic and the Spanish-controlled southern Netherlands.

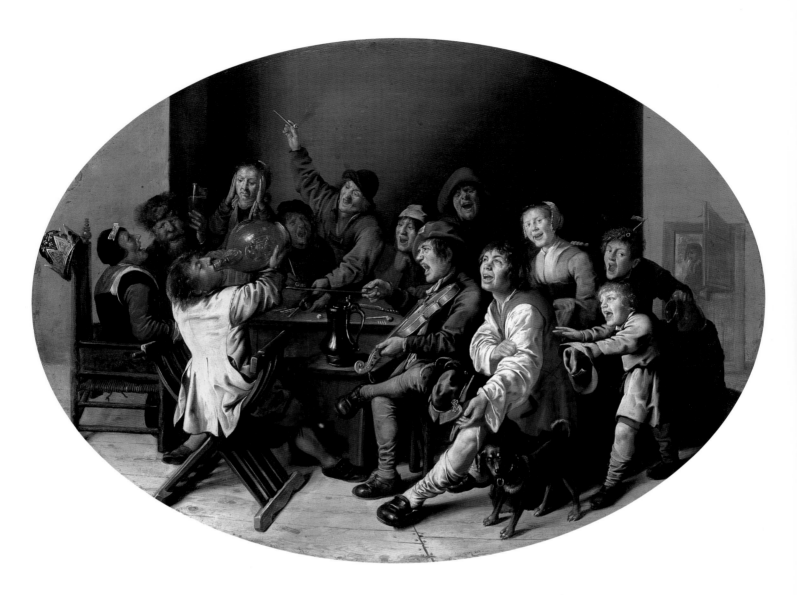

Molenaer seems to have taken as much delight in expressing the high spirits of the merry-makers in *The King Drinks* as he did in depicting the combatants in the *Battle between Carnival and Lent* (cat. 18), its presumed pendant. The subject comes from the Twelfth Night Feast celebrated on Epiphany (Matthew 2:1–12), January 6. This commemoration of the Adoration of the Magi is also known as the Feast of the Epiphany, the Feast of the Kings, and the Feast of the Bean. The Bean Feast, a Netherlandish variant on the theme, centered on the person who discovered the bean hidden in a cake served during the celebration. As king of the festivities, he wore a paper crown and appointed members of his "court," with each person receiving a slip of paper bearing a title.

During the century, both printed and painted representations of this feast were popular in both the Catholic southern Netherlands and the northern provinces.[1] The best-known examples were painted by Jacob Jordaens, Jan Steen, and David Teniers the Younger, with pictures by the latter showing the greatest similarities with the painting by Molenaer.[2] Teniers's *Peasants Celebrating Twelfth Night* (fig. 1), for example, carries a date of 1635 and shows a similarly stark interior filled with boisterous merrymakers. Included in the group is a young man seated at the left foreground corner of the table who shares many features with a similarly positioned figure by Molenaer.

Molenaer's painting shows the Twelfth Night celebration in full swing. Although he

19
The King Drinks

ca. 1634–35

Signed on chair at far left: J miensen molenaer

Panel, 16 ⅛ x 21 ⅞ in. (41.5 x 55.5 cm.)
Collections of the Prince of Liechtenstein, Vaduz Castle

Provenance:
Prince of Liechtenstein Collection by 1780

Exhibitions:
Lucerne 1948, no. 194; Vaduz 1970, no. 57; New York 1985, no. 169; Basel 1987, no. 58.

Literature:
Vienna 1780, no. 613; Vienna 1873, no. 683; Bode 1883, p. 203; Vienna 1885, no. 447; Bode 1894, pp. 84–85; Währen 1958, pp. 45–46; Bauch 1960, p. 37; Baumstark 1980, pp. 216–17,

no. 85, illus.; Philadelphia, Berlin, and London 1984, p. 265, note 3; Weller 1992, pp. 142–45, 393, fig. 52; Haarlem and Worcester 1993, p. 158, fig. 6c.

Fig. 1
David Teniers the Younger
Peasants Celebrating Twelfth Night, 1635
Oil on panel, 18 5/8 x 27 1/2 in.
National Gallery of Art, Washington, D.C.

did not include a cake or bean, the subject of the work is easily identified by the figures and their actions. A number of the drinkers have affixed to their hats and vests the slips of paper indicating their newly assigned titles. The "king" sits to the left and enjoys a generous drink from the jug he holds to his lips. To his left sits the "queen" of the celebration, and on the back of her chair his crown. The manner in which the king throws back his head to receive his alcoholic reward implies the crown may have made its way to the floor before finding its current location. Everyone in the room, except the serving woman who covers her ears with her hands, follows tradition by shouting in unison, "The king drinks," in response to the king's action. Punishment for failing to follow this custom could involve having soot applied to one's face, but in this scene "no one runs the risk."[3]

As was suggested in the previous entry, *The King Drinks* seems to date a year or two later than the *Battle between Carnival and Lent*. Liedtke's conclusions regarding the dating of the picture remain valid, although a date near the middle of the decade is preferable to the late 1630s, in light of the recent discovery that the Budapest *Denial of Saint Peter* (cat. 14) carries a date of 1633 rather than 1636.

This painting has been dated to about 1637 because it "reveals traits of the Utrecht style"; because a knowledge of this manner would have come to Molenaer through his wife, the painter Judith Leyster; and because the couple married in 1636. However, the vigorous modeling and energetic contrasts of light and shade do not, at this date, require any reference to the Caravaggesque genre scenes of Utrecht; Molenaer must have been familiar with them, and probably knew his wife, before 1636. A dating to the mid- to late 1630s is convincing, nonetheless, on the strength of comparisons with other works by the artist, such as The Denial of Peter, *dated 1636.*[4]

Typical of a number of his works painted in the mid-1630s, *The King Drinks* is largely transitional in terms of its subject matter and style. Peasant imagery began to appear with greater frequency in Molenaer's work after his move to Amsterdam, and with this change came a reduction of the scale of the figures to their settings. Nevertheless, evidence drawn

Fig. 2
After (?) Hieronymus Bosch
Tabletop of the Seven Deadly Sins,
detail of *Gluttony*, ca. 1475–85
The Prado, Madrid

from a number of his dated works between 1633 and 1637 suggests the painter moved freely between these two modes even before he relocated and sought a niche in Amsterdam's booming art market. If, in fact, *The King Drinks* was painted as a pendant to the *Battle between Carnival and Lent* shortly after its completion, then an earlier date around 1634 is suggested. Otherwise, and owing in part to the picture's more vigorous and descriptive modeling, a slightly later date seems plausible.

Regardless of its date, *The King Drinks* represents one of Molenaer's most engaging and masterful works. In asking contemporary viewers to share a moment with the merrymakers, Molenaer also may have provided a strong warning against overindulgence. Drawing on sixteenth-century sources and using peasant behavior as a model for such misbehavior, scholars have compared the scene with Bosch's representation of *gula* (gluttony) (fig. 2) from the *Tabletop of the Seven Deadly Sins*.[5] Here a figure drains a jug in a manner much like Molenaer's king. Closely related and worthy of consideration were the words added to an engraving of another image of gluttony after a drawing by Pieter Bruegel the Elder. The message might have crossed the minds of Molenaer's contemporaries when they viewed his captivating picture.

Drunkenness and gluttony are to be shunned.
Shun drunkenness and gluttony, for excess makes a man forget both God and himself.[6]

Notes

1 For an analysis of this imagery in Northern European art, see Wagenberg-Ter Hoeven 1993–94.

2 Molenaer's interest in the theme appears in a handful of works besides the exhibited picture, among them the appealing *The King Drinks* in Copenhagen. This canvas can be dated after the Liechtenstein panel, ca. 1637–39.

3 Liedtke discussed the customs involved in Molenaer's picture in New York 1985, p. 267.

4 Ibid.

5 Bogendorf Rupprath in Haarlem and Worcester 1994, pp. 156, 158.

6 Pieter van der Heyden after Bruegel, *Gluttony*, 1558, engraving, 223 x 293 mm. The print is discussed and the inscription translated into English in Saint Louis and Cambridge 1995, no. 26.

20

Card Players

ca. 1634–35

Monogrammed on back of chair at right: MR (in ligature)

Panel, 22 ¾ x 29 ¹⁄₁₆ in. (57.8 x 73.8 cm.)
Currier Museum of Art, Manchester, New Hampshire
Gift of David Giles Carter and museum purchase, 2001.21

Provenance:
Ivan Trancotts Collection, Russia; Alfred Bergs Collection, Sweden; sale Bukowski, Stockholm, 16–19 October 1957, no. 162; Alfred Brod Gallery, London; David G. Carter, New Haven, Connecticut, in 1961.

Molenaer, like many of his colleagues in Haarlem and elsewhere, showed a keen interest in depicting the trials and tribulations of card players. Among his first pictures, for example, is *Card Players by Lamplight* (fig. 1), a work from 1627 or 1628. In it, he set an upbeat tone that he repeated about six years later in the *Card Players*. In both, a bearded old man from the peasant class plays the fool to a group of young cheats. In his misguided eagerness to place trust in his cards, he will surely lose what little he brought to the table. Adding insult to injury, the old fool in *Card Players* is tricked twice, for the young cheat at the left steals a duck from his basket.[1]

In witnessing these deceitful events, today's viewer is placed in the uncomfortable position of weighing the scene's inherent comic appeal against possible empathy felt toward the foolish old man. For Molenaer and his contemporaries, however, such a choice seems unlikely. Viewers back then did not necessarily distinguish between the individual card players and the game they played.

By the seventeenth century, artists on both sides of the Alps regularly found inspiration in the subject of card players. Painters from Molenaer's generation, for example, were

influenced by genrelike scenes painted by Lucas van Leyden and his followers a century earlier. *The Card Players* (fig. 2), a work dating from the second half of the sixteenth century, reflects this tradition. A group of expensively dressed men and women engage in a high stakes game, as gold coins fill the pot. Describing more than a simple game, the imagery certainly raised important contemporary issues. John Hand wrote, "*The Card Players* belongs to a type of work that was undoubtedly moralizing. Gambling, whether at cards or dice, was condemned by ecclesiastical and civil authorities alike."[2] When one considers the *Card Players* by Molenaer, not only do these words ring true, but Hand's further description of the National Gallery of Art picture seems to apply as well. "Card games often took place in unsavory surroundings that were conducive to both amorous dalliance and cheating. In this regard it is perhaps significant that in the Gallery's panel two men and two women are playing and that, from the exchange of glances between players and kibitzers, cheating and collusion seem likely."[3]

Exhibitions:
Delft 1965; Delft 1968; Haarlem and Worcester 1993, no. 34.

Literature:
Illustrated London News, 243, no. 6483A (1963), p. 38; Weller 1992, pp. 108–10, 383, fig. 41.

It is also important to assess the impact made by Caravaggio and his untold followers in popularizing this theme from about 1595 to 1630. With uncompromising realism, and in the extreme foreground placement of the figures, the vice and deception of the card players and their accomplices take center stage in these compositions. One of the earliest examples within this genre is *The Cardsharps* at the Kimball Art Museum. Painted by Caravaggio about 1594, the composition focuses attention on the crime. Viewers watch a young cheat responding to his accomplice's signal by removing a card from his clothing. The unsuspecting opponent, like Molenaer's old fool, has little chance of winning against such collusion.

Fig. 1
Card Players by Lamplight,
ca. 1627–28
Oil on panel, 17 ½ x 20 ⅛ in.
Recently art market, Amsterdam

Caravaggio's impact was far reaching, as numerous Dutch and Flemish painters quickly adopted his manner and subject matter. Among those followers who also treated the theme of card players were the Utrecht painters Hendrick Ter Brugghen and Aelbert Jansz. van der Schoor. Collectively they employed similar style and imagery to spotlight cheating directed toward those individuals who foolishly sought riches through the cards. Van der Schoor's Caravaggesque *Cardsharps in an Interior* (fig. 3) provides such an example. Furthermore, the work makes an interesting comparison with Molenaer's *Card Players*, as both show a woman holding a mirror to reveal cards of a bearded old man (see below).

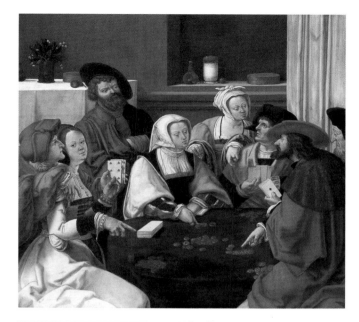

Her partner in crime will respond accordingly.

Eddy de Jongh summarized the tone of contemporary responses to such scenes in his discussion of an engraving depicting a card game by another Caravaggesque painter, the Fleming Theodoor Rombouts.

Card-play was considered disreputable, and was often equated with cheating. It was the devil's game, and players stood to lose all their money and, what was worse, their virtue and conscience as well. Numerous moralists, ministers of religion among them, felt compelled to wax furious on the subject, and the civic authorities never tired of discouraging or even forbidding card games through bylaws and decrees.[4]

In Haarlem, where Caravaggio's long shadow seems to have had less influence, Molenaer took the middle ground between the Van Leyden tradition and the manner of the Caravaggisti. As was typical in genre scenes by Molenaer and his Haarlem colleagues, his figures occupy a clearly defined interior space, extending into the middle ground. Still, he provided his card players with the same "in your face" realism usually associated with Caravaggio and his followers. This approach is particularly evident in the engaging foreground figure at the left. Bogendorf Rupprath, in characterizing the man and his costume, went so far as to speculate he might represent a portrait of an actual member of the militia.[5] At the very least, this man confronts the viewer with a glass of wine and a welcoming smile, and in doing so he demands our attention.

In spite of the popularity of proverbs and other sayings denouncing card playing, including "the devil has shuffled the cards," Molenaer allows the viewer to participate in the game by noticing the mirror held by the woman helping the old man with his cards.[6] This small mirror "is angled in such a way that it reveals the peasant's cards not only to his opponent but to us, the viewer."[7] Onlookers realize that regardless of the strength of the cards he holds, the gullible fool will never win.

Notes

1 As in many of Molenaer's pictures, the foolish old peasant served as a target of condemnation and ridicule. The old fool in *Card Players*, for example, reappears in a number of other works by the artist. In every instance his gullibility contributes to his ruin.

2 Hand and Wolff 1986, p. 142.

3 Ibid.

4 Amsterdam 1997, p. 213.

5 Haarlem and Worcester 1993, p. 308.

6 Amsterdam 1997, p. 213.

7 Haarlem and Worcester 1993, p. 311.

21

*Woman Holding
a Jug*

ca. 1634

Unsigned

Panel, 19 ¼ x 16 in. (48.9 x 40.6 cm.)
Museum of Fine Arts, Boston
Gift of Maida and George S. Abrams
in Memory of Llora and Mark
Bortman

Provenance:
Dealer V. Spark, New York; George
Abrams, Newton, Mass., by 1974; gift
to the Museum of Fine Arts, Boston,
in 1994.

Exhibitions:
St. Petersburg and Atlanta 1975,
no. 11.

Literature:
Boston 1994–95, pp. 16–17, illus.

The large number of half-length, single-figure compositions Molenaer painted during the
late 1620s and the first half of the 1630s points to the enormous popularity of such im-
agery in Haarlem at the time. It is worth noting that after his move to Amsterdam, and no
doubt reflective of market changes, he largely abandoned the format.[1] While still in Haar-
lem, however, Molenaer executed the engaging *Woman Holding a Jug*, another of his vari-
ations on this popular theme. It joins comparable works representing young and old,

Fig. 1
Taste, 1634
Oil on panel, 24 ¾ x 20 ⅛ in.
Koninklijke Musea voor Schone
Kunsten, Brussels

singers and musicians, drinkers and smokers. In many instances the figures personify one or more of the five senses, while in others one of the vices has been suggested. Simple character studies, or *tronies*, may also have been intended in yet others.[2]

The action and emotion of the figure seen in *Woman Holding a Jug* suggest a range of possible interpretations. The economic status of the model and aspects of the work's style also present perplexing obstacles to dating this picture. Typically, peasant figures and tonal palettes reflect Molenaer's artistic interests after mid-decade, following his move to Amsterdam. Nevertheless, its compositional format and to a degree its brushwork argue for an earlier date, about 1634. *Woman Holding a Jug*, for example, shares many features with *Taste* (fig. 1),

a dated picture of 1634. Common to both works are the thinly painted backgrounds, the deceptively controlled and descriptive brushwork used in the modeling of the faces and hands of the figures, and apparently the use of the same female model. While this woman appears slightly older in the Boston picture, the differences are negligible, allowing for a date within a year of each other.

The figure in *Woman Holding a Jug* sets a tone very different from that found in her counterparts appearing in *Taste* or the similarly dated *Girl with a Flute* (Bogendorf Rupprath fig. 11). The broad smiles and impish charm shown in these examples give way to a more tragic figure, one consumed by a weakness for alcohol, as symbolized by the wine jug she clutches. The smoking implements on the table refer to another of her addictions. The placement of the pipe, snuffbox, and brazier with lit coals in the extreme foreground of the composition serves as an invitation for onlookers to consider their participation in such vices. Such invitations to vice were often seen as a call to virtue.[3] Respectable viewers were expected to control such desires; otherwise they might follow the path taken by the disheveled peasant woman.

Molenaer's female figure could be associated with another craving, for jugs and tankards often served as sexual metaphors.[4] The woman's flirtatious smile and the manner in which

she embraces the rounded jug do appear somewhat suggestive. Whether or not these actions symbolized the desires of the flesh remain unanswered. Similarly, weaknesses of the flesh were known to symbolize one of the five senses. It has been suggested elsewhere that *Woman Holding a Jug* was one work from a series of the senses comparable to the similarly executed *Man with a Pipe* (fig. 2).[5]

The focus on looking for messages embedded in *Woman Holding a Jug* overlooks an important aspect of the picture, the wicked joy and vitality expressed by the figure. Regardless of her negative actions, the viewer cannot be immune to her high spirits. The positioning of her heavy-lidded eyes, the width of her smile, the plumpness of her cheeks, even the highlight on the tip of her nose all contribute to her charm. In these details Molenaer showcased artistic skills learned from his presumed teacher, Frans Hals. Suggestive of this connection is a final comparison to the *Woman Holding a Jug*, Hals's *Malle Babbe* (fig. 3). This so-called "Witch of Haarlem," whose unruly, drunken behavior has been interpreted in many ways, is pure genius in painting.[6] Regardless of the veracity of any of these interpretations, viewers always return to the power of the woman's characterization. While Molenaer could never match the spontaneous fury of Hals's suggestive brushwork, he came close to bringing the same emotions and energy to his model in *Woman Holding a Jug*.

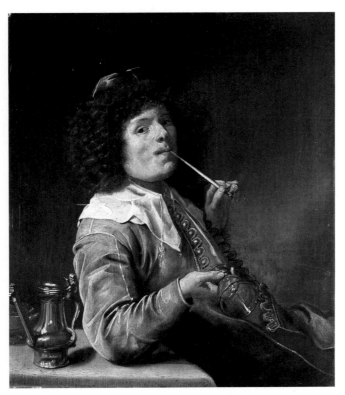

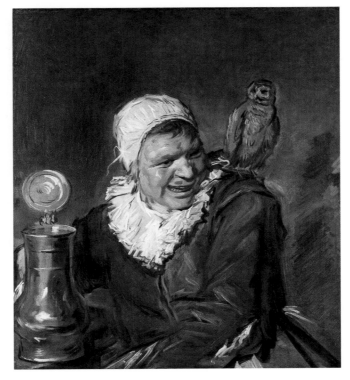

Fig. 2
Man with a Pipe, ca. 1632–34
Oil on panel, 11 ⅜ x 9 ⁷⁄₁₆ in.
Städelsches Kunstinstitut, Frankfurt am Main

Fig. 3
Frans Hals
Malle Babbe, ca. 1633–35
Oil on canvas, 29 ½ x 25 ¼ in.
Staatliche Museen zu Berlin, Gemäldegalerie

Notes

1 The major exception to this tendency is Molenaer's *Self-Portrait with a Skull* (cat. 30), which stems from a very different iconographic tradition.

2 *Tronies*, representing a type of character study popular during the Dutch Golden Age, are discussed by De Vries 1990.

3 This concept appears to be widespread within seventeenth-century Dutch imagery. Typically associated with genre paintings, related messages regarding overindulgence are also found in many still-life pictures from the period. See discussions in Philadelphia, Berlin, and London 1984 and Segal in Delft, Cambridge, and Fort Worth 1988, pp. 29–38.

4 Schama 1987, p. 433. The author does, however, make the distinction between an open and closed jug.

5 Robinson in St. Petersburg and Atlanta 1975. *Man with a Pipe* from Frankfurt may represent a self-portrait of the painter. See discussions of other self-portraits in cats. 22 and 24.

6 For an extensive discussion of the *Malle Babbe*, see Slive in Washington, London, and Haarlem 1989, no. 37.

22

Self-Portrait as a Lute Player

ca. 1635

Unsigned

Panel, 15 ¼ x 12 ¾ in. (38.7 x 32.4 cm.)
Private collection
On loan to the National Gallery of Art, Washington, D.C.

Provenance:
Private collection; sale, Christie's, London, 11 July 1980, no. 112; exported to Switzerland; Galerie Sanct Lucas, Vienna, by 1981; private collection; Galerie Sanct Lucas, Vienna, by 1996; private collection, U.S.A.; on loan to the National Gallery of Art, Washington, D.C., 2001 to present.

Exhibitions:
Vienna 1996, no. 13.

Literature:
Haarlem and Worcester 1993, pp. 306–07, fig. 33e.

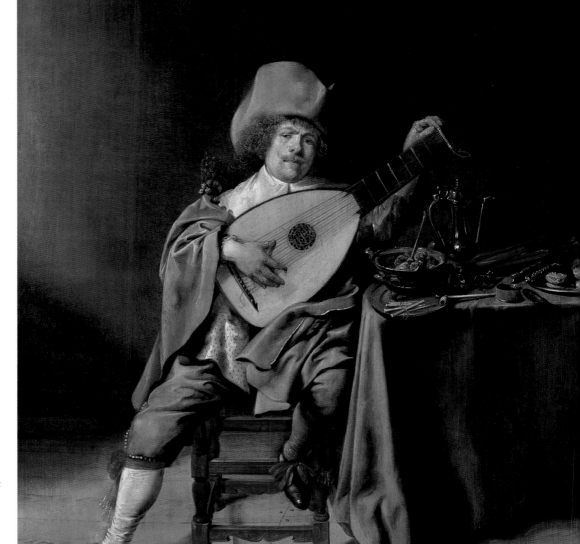

The musician who sits before the viewer while tuning his lute appears in a number of Molenaer's compositions from the 1630s.[1] Previously identified as the male figure in the *Artist in His Studio with an Old Woman* (Bogendorf Rupprath fig. 1), Molenaer returned for a final curtain call in his moving *Self-Portrait with a Skull* (cat. 30) near the end of the decade. These images, seen alongside other examples of his intimate, portraitlike genre paintings with family members (cats. 23, 24), rank among the artist's greatest achievements.

If one considers that the refined execution and uncompromising realism found in the *Self-Portrait as a Lute Player* was more fully articulated in *Woman Playing the Virginal* (cat. 23) and *The Duet* (cat. 24), it follows that this picture predated those examples. Comparing the previously noted *Artist in His Studio with an Old Woman*, however, in which Molenaer pictured himself a few years younger, one may conclude that the *Self-*

Portrait as a Lute Player was painted around 1635. A recent description of the picture captures the quality Molenaer brought to this scene.

The extraordinary care for detail and sensitivity for textures and tonalities, with which this panel was painted, are most conspicuous. Vibrant highlights and clearly defined areas of brilliant colour set the substantial figure of the musician—and the elaborate still life as a contrast—off against the basically monochromatic setting. Delicately detailed areas, for example that of the musician's face and his frizzy hair—the latter painstakingly scratched into the wet paint—alternate with smooth surfaces, in this case the soft textures of hat and collar.[2]

The subject of a lute player was popular with Molenaer and other painters in the Hals circle. Generally, one of two compositional formats was employed. The first drew upon the Caravaggesque model, with influence coming from Utrecht painters such as Baburen, Ter Brugghen, and Honthorst.[3] In these examples a neutral backdrop serves as the setting for half-length musicians who dominate the foreground. Molenaer, for example, chose this format in his *Lute Player* (fig. 1), now in Wuppertal. By contrast, *Self-Portrait as a Lute Player* adopts the other format, one in which full-length figures are integrated into furnished, clearly articulated architectural settings. The pose he chose for himself here seems to have been a favorite, for it was employed with few changes elsewhere in his oeuvre, including *A Young Man and Woman Making Music* (cat. 8).

In the early seventeenth century, lutes and lute players were frequently associated with the personification of music and the harmonious nature of love. Inscriptions on comparable prints suggest their meaning could carry a negative tone as well. Evidence is provided in a print published in Haarlem in 1633. The inscription appearing below the image of a lute player links this activity with vanity and foolishness.

Fig. 1
Lute Player, ca. 1632–34
Oil on panel, 10 7/16 x 9 9/16 in.
Heydt Museum, Wuppertal

QUID NON SENTIT AMOR.
XLIII.

Al wat mint, wonder verfint.　　*Ely metten blyden.*

Fig. 2
Jacob Cats
Emblem from *Sinne-en Minnebeelden*,
The Hague, 1618

Notes

1 In addition to pictures discussed below, this same figure prominently appears in his *Self-Portrait with Family Members* (Weller fig. 1) in the Frans Halsmuseum.

2 Vienna 1996, p. 32.

3 Frans Hals was among the first of the Haarlem painters to respond to the genre scenes by the Utrecht Caravaggisti. His brilliantly painted young musicians, smokers, and drinkers began to appear in the early 1620s. For a discussion of these works, see Slive 1970–74, especially the chapter in vol. I on genre, allegorical, and religious paintings from 1620–30, pp. 72–111.

4 Engraved by Jan van de Velde, the print is illustrated in Haarlem and Worcester 1993, p. 127, fig. 1d. The inscription by the Haarlem historian Samuel Ampzing was translated by Bogendorf Rupprath.

5 Ibid.

6 Kyrova in The Hague and Antwerp 1994, p. 41.

7 Ibid.

I tune my lute, I adjust my strings
In order to achieve sweet sounds, my song and voice har-
　　monize.
I am a rich man's child, so I seek ways of passing my time,
And [I seek] worldly pleasures, and joys of soul and body.[4]

Does Molenaer's image carry a message similar to this inscription and, by association, to the title page of the series containing the print *Vanitas Vanitatum et Omnia Vanitas* (Vanity of vanities, all things are vanity)?[5] If yes, then the still-life elements he incorporated into his composition can be used to support this conclusion. The overturned glass, the empty tobacco tin, the nearly consumed meal, and the extinguished pipes all hint at the transitory nature of sensual pleasure, the vanity of all things.

The figure in *Self-Portrait as a Lute Player* does, in fact, tune his instrument. It should be noted that tuning a lute carried its own iconography, as is reflected in an emblem from Jacob Cats's *Sinne-en Minnebeelden* (fig. 2). "In marriage iconography, the tuning of instruments and playing music together were to remain an accepted metaphor for the harmony between man and woman for a long time."[6] Consequently, the emblem symbolizes two hearts "that vibrate to the same note."[7] Cats emphasized this point by incorporating a second lute lying on the table. Its strings vibrate in anticipation of the arrival of the musician's partner. For Molenaer, no such tryst is suggested, in spite of his best efforts to tune his instrument. One can only wonder if the pained and serious expression on the painter's face reflects his "disharmony."

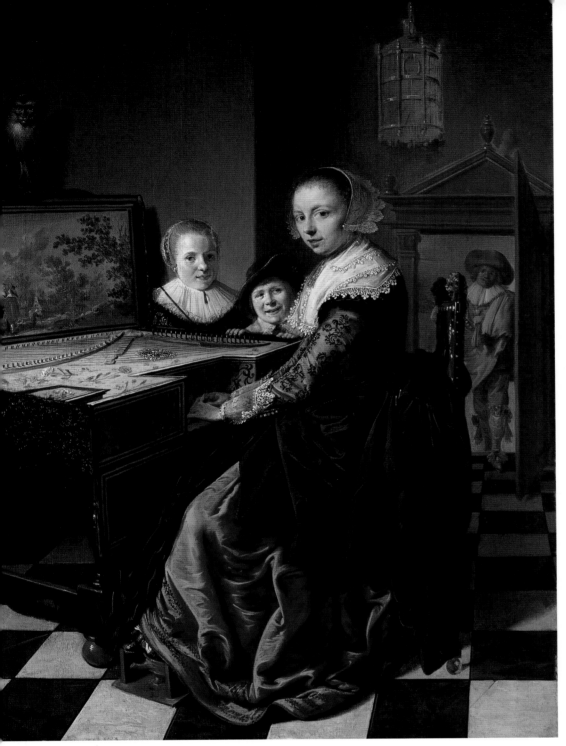

23

(Raleigh only)

Woman Playing a Virginal

ca. 1635

Unsigned

Panel, 15 ⅛ x 11 ⅝ in. (38.5 x 29.5 cm.)
Rijksmuseum, Amsterdam, on loan from the City of Amsterdam

Provenance:
Adriaen van der Hoop, Amsterdam, by 1832 (as Dirck Hals); gift to the city of Amsterdam, in 1854; Museum Van der Hoop, Amsterdam; loan to the Rijksmuseum, Amsterdam, from the city of Amsterdam, since 1885.

Exhibitions:
Brussels 1946, no. 68; Tokyo 2000, no. 64.

Selected Literature:
Bode and Bredius 1890, p. 74; Hofstede de Groot in *Nederlands Spectator* 1897, p. 140; Bredius 1908, p. 42; Roh 1921, fig. 173; Brieger 1922, fig. 62; Harms 1927, pp. 224, 231; Gratama 1930, pp. 73–74, illus.; Martin 1935, vol. 1, p. 376; Pols 1942, p. 53; Bazin 1952, p. 13, fig. 8; Gowing 1952 p. 156, fig. 36; Wilenski 1955, p. 162; Ellenius 1959, p. 118; Plietzsch 1960, p. 29, fig. 16; Bernt 1960–62, vol. 2, no. 542; Bernt 1969–70, vol. 2, no. 779; Slive 1970–74, vol. 3, p. 153; Amsterdam 1976a, p. 391, no. C140. illus.; Daniëls 1976, pp. 329–33, illus.; Wright 1978, p. 142, illus.; Naumann 1981, p. 49, fig. 45; *Spiegel Historiael* April 1987, cover illus. (color); Hofrichter 1989, p. 52, note 3; Weller 1992, pp. 20, 344, fig. 3; Haarlem and Worcester 1993, p. 119.

The small genrelike portraits Molenaer began painting around 1632–33 are remarkable in their overall quality and refinement. In each he portrayed himself or family members, largely his brothers and sisters, in well-defined interiors. The one dated picture from the group, *Three Women at a Virginal* (cat. 24, fig. 1) of 1634, most likely depicts Molenaer's three sisters.[1] This painting seems to have served as the model for the Rijksmuseum's *Woman Playing a Virginal*. The two works share a number of features: a woman seated at a virginal, the checkerboard pattern of the floor, and a partially open door at the back right. In addition, studio props such as the virginal, chair, and foot warmer are common to both pictures.

Woman Playing a Virginal does differ from its counterpart in a number of significant details. Among them are minor spatial and stylistic differences. The exhibited painting, for example, employs a lower vantage point and a deeper recession toward the doorway at the right and uses a slightly more polished and descriptive paint application in the costumes and features of the sitters. In light of these subtle but revealing features, *Woman Playing a Virginal* probably dates just after *Three Women at a Virginal*, about 1635. A more important difference between the two works centers on the identity of the sitters and, by association, Molenaer's intended message.

In spite of the painting's brilliant execution and engaging quality, the focus of scholarly attention for this small painting has centered on the identity of the sitters.[2] It has long been thought that the sitters represent Judith Leyster and her two children who survived infancy, Helena (b. 1643) and Constantijn (b. 1650), but it is easily argued that the children's birth dates refute this identification. The boy and girl are more likely the youngest brother and sister of Molenaer, as the two appear on the far right of the painter's *Self-Portrait with Family Members* at the Frans Hals Museum (Introduction fig. 1).

The identity of the woman presents a more perplexing problem, as limitations based solely on visual analysis without additional documentation become an issue. Leyster has nonetheless remained the prime candidate. Most recently Hofrichter compared this painting with the Leyster *Self-Portrait* (Weller fig. 8) in Washington, D.C., and supported this identification.[3] In light of the fact that Molenaer and Leyster married shortly after the picture was completed, such an identification is tempting but still speculative. In *Three Women at a Virginal*, one notices a female portrait hanging on the wall to the left. The woman's age, facial features, and hair color suggest she could be mistaken for the figure in the *Woman Playing a Virginal*. The same model, however, also appears in the Haarlem *Self-Portrait with Family Members*. She is seated at the far left playing the cittern. Al-

Fig. 1
Johannes Vermeer
A Lady Seated at the Virginal, ca. 1675
Oil on canvas, 20 ¼ x 17 ⅞ in.
The National Gallery, London

though she was previously identified as one of Molenaer's three documented sisters, this conclusion is placed in doubt due to the presence of the painter's three siblings in the *Three Women at a Virginal*.[4] Unfortunately, there seems to be no definitive answer to fully explain this visual ambiguity.[5]

Iconographic evidence in *Woman Playing a Virginal* may, in fact, support the identification of the woman as Judith Leyster. The figure entering through the doorway and a pair of additional motifs provide the key. Although defined by little more than an oil sketch, the man in the doorway shares features with many of Molenaer's self-portraits of the period (cats. 22, 24). Did the painter depict himself paying a visit to his future wife or to one of his sisters? The chained monkey and the young couple who appear in the painting on the virginal's lid could offer clues. A chained monkey is found in Molenaer's Richmond picture (cat. 13), and here, as elsewhere, the fettered animal symbolizes the need to control the temptations of the flesh.[6] Molenaer would not likely convey such a message were the model his sister and not Leyster. This message is amplified by the presence of the courting couple in the painting within a painting on the virginal. Located directly below the monkey in his composition, this couple may well represent the painter and Leyster. They wear costumes similar to those worn by the woman at the virginal and the man entering through the doorway. By setting a tone of courtship and instruction, has Molenaer crafted a scene with a message for himself and his future wife?

The theme of a woman seated at a virginal awaiting her lover held a strong appeal for Dutch painters throughout the seventeenth century. The woman in Vermeer's *A Lady Seated at the Virginal* (fig. 1), for example, is surprisingly close to the Molenaer female musician. But unlike the scene in Molenaer's composition, a male companion has yet to arrive. Still, her expectant look and the silent stringed bass positioned in the foreground suggest his imminent arrival. Their liaison, however, does not carry the same message as the image of Molenaer and Leyster. Hanging prominently on the rear wall just above the head of the woman is another painting within a painting. It is a copy of Dirck van Baburen's *Procuress*, now in Boston.[7] Unlike the story told in Molenaer's painting, the situation conveyed by the presence of this titillating image casts a very different light on the character of the lady playing her virginal.

Notes

1 Recently on the art market in London, following its sale at auction (Christie's, London, 16 January 1992, no. 127), *Three Women at a Virginal* may have originally been slightly wider.

2 See literature above, especially in publications prior to Amsterdam 1976. It should also be noted that the painting had been attributed to Dirck Hals in the late nineteenth and early twentieth centuries.

3 Hofrichter 1989, pp. 52–53, note 3.

4 Weller 1992, pp. 16–20.

5 The question remains whether Molenaer omitted one of his sisters and inserted Leyster into his *Self-Portrait with Family Members*. Although unlikely due to the seeming inclusion of all other family members, including his parents and two half brothers, perhaps the picture served as a vehicle of welcoming Leyster into the Molenaer family.

6 In addition to cat. 13, also see discussions by Van Thiel 1967–68 and Bogendorf Rupprath in Haarlem and Worcester 1993, no. 35.

7 Dirck van Baburen, *The Procuress*, 1622, Museum of Fine Arts, Boston, inv. 50.2721.

24
The Duet

ca. 1635–36

Signed at lower right:
IM MOLENAER

Panel, 16 ½ x 20 ⅛ in. (42 x 51 cm.)
Collection of Mr. Eric Noah

Provenance:
Richard, 2nd Earl of Clancarty
(1767–1837). Lady Katherine A.
Le Poer Trench; sale, London,
Christie's, 10 July 1953, no. 45; dealer
Arthur Tooth & Sons; Lady Duke-
Elder, London; sale, London,

The Duet is among Molenaer's most charming and beautifully crafted paintings. It depicts
a simple but well-appointed interior with a lion's head finial chair, a map of the Italian
peninsula hanging on the rear wall, a heavy curtain, a trunk, and a table.[1] These props are
joined by other elements, including a foot warmer and tankard placed on the floor, and the
remnants of a meal left on the table covered with a white linen tablecloth over a second
one, blue-green in color. The primary focus of the composition rests on the man and
woman seated in the foreground. Each plays a stringed instrument—he a lute and she a
cittern. In *The Duet*, arguably the finest and last painted picture from Molenaer's remark-
able series of genrelike portraits executed between about 1633 and 1636, the painter again
summoned his talents to picturing himself and Judith Leyster. He also struck a pleasing
chord in his iconographic program.

As in the previously discussed picture from Amsterdam (cat. 23), visual similarities be-

tween the seated couple and other portraits showing Molenaer and Leyster can be used to establish their identities. As has been noted, the male figure appears in a number of Molenaer paintings. The closest comparison appears in the Haarlem *Self-Portrait with Family Members* (Introduction fig. 1), where he stands to the right. Serving as the master of ceremonies for the gathering, he looks to the viewer and gestures toward himself with his left hand. Another self-portrait, *Self-Portrait as a Lute Player* (cat. 22) from about a year earlier, finds Molenaer tuning an identical lute to the one he strums in *The Duet*. The earlier picture lacks some of the pictorial refinements found in its counterparts, but it represents another iconographically rich and important work from this group of pictures.

The female cittern player in *The Duet* can be identified as Judith Leyster. Viewers will recognize a representation of the same figure in the *Woman Playing a Virginal*, the portrait on the wall of the *Three Women at a Virginal* (fig. 1), and seated to the far right in the *Self-Portrait with Family Members*.[2] The last of the three comparisons finds her having traded a millstone (or cartwheel) ruff collar for the more fashionable flat lace collar. She plays the same cittern and sits near a sleeping dog identical to the one next to Molenaer's figure in *The Duet*.

The identities of the sitters are supported by the work's iconographic program. Couples making music have a long visual history, and by the seventeenth century a number of interpretations had become commonplace. According to De Jongh, the three were "eroticism or sexuality, harmony, or melotherapy—the consoling or curative effect of sweet sounds."[3] The second of these three possibilities appears in a print by Gilles van Breen, after Cornelis Ijsbrantsz Kussens. *Couple Making Music* (fig. 2) shows a seated and well-dressed man and woman playing stringed instruments. A four-line Latin inscription penned by the Haarlem historian and schoolmaster Theodorus Schrevelius and a two-line Dutch inscription in the lower margin support the call for conjugal harmony and the hierarchical relationship between man and woman in a marriage. In translation the texts read:

Just as the slenderest string reverberates around the male string, and the melodious strings of the heavy-voiced lyre follow, so you, harmonious strings, must accord to the tone of marriage, in which as the consort accepts the commands of her lord.

As the sturdy string in the house, the man's word must weigh the heaviest, The chord is sweet if his wife dutifully bows to it.[4]

Because Van Breen was active in Haarlem during the first quarter of the seventeenth century, Molenaer may have known the print and been attracted to its sentiments as he entered into married life with Leyster. *The Duet* could, in fact, have served as the couple's marriage portrait, as its date of execution falls close to when they exchanged vows. If so, then the picture complements the equally masterful *Woman Playing a Virginal* (cat. 23), a painting that may have focused on their courtship. Serving as documents of

Sotheby's, 5 July 1989, no. 32; dealer Richard Green, London; to present owner.

Exhibitions:
None

Literature:
Welu 1977a, p. 14, fig. 18; Sutton in The Hague and San Francisco 1991, p. 110, fig. 7; Weller 1992, pp. 20–21, 27–28, 343, fig. 2; Haarlem and Worcester 1993, p. 289, note 9; Kress 1994–95, p. 163, fig. 3; Ree-Scholtens 1995, pp. 291, 297, fig. 12.28.

Fig. 1
Three Women at a Virginal, 1634
Oil on panel, 20 x 13 ¼ in.
Private collection

Fig. 2
Gilles van Breen, after Cornelis
Ijsbrantsz Kussens
Couple Making Music, ca. 1600
Engraving
Rijksprentenkabinet, Rijksmuseum,
Amsterdam

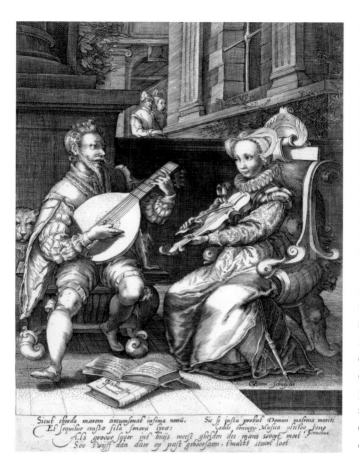

Notes

1 Welu 1977a, p. 14, identified this map of Italy from an original by Pieter van den Keere. It was first published in Amsterdam in 1615.

2 Arguments supporting the woman's identity as Leyster are outlined in the previous entry.

3 Amsterdam 1997, p. 95.

4 Ibid.

5 See Appendix.

6 These pictures may also have been used as a vehicle for Molenaer to obtain the important commission for *The Wedding Portrait of Willem van Loon and Margaretha Bas* during his first months in Amsterdam (Weller fig. 9).

their lives together, both works must have held special importance to the couple. It may not be surprising that listed in the inventory of Molenaer's possessions in 1668 is the following entry: *Twe Conterfijtsels van Jan Molenaer ende sijn huysvrou* (Two Portraits of Jan Molenaer and his wife).[5] Unfortunately, it is impossible to know if *Woman Playing a Virginal* and *The Duet* represented the two portraits of husband and wife still hanging in Molenaer's house at his death. What cannot be doubted, however, is the importance he placed on these paintings as seen through their skillful execution and exceptional quality.[6]

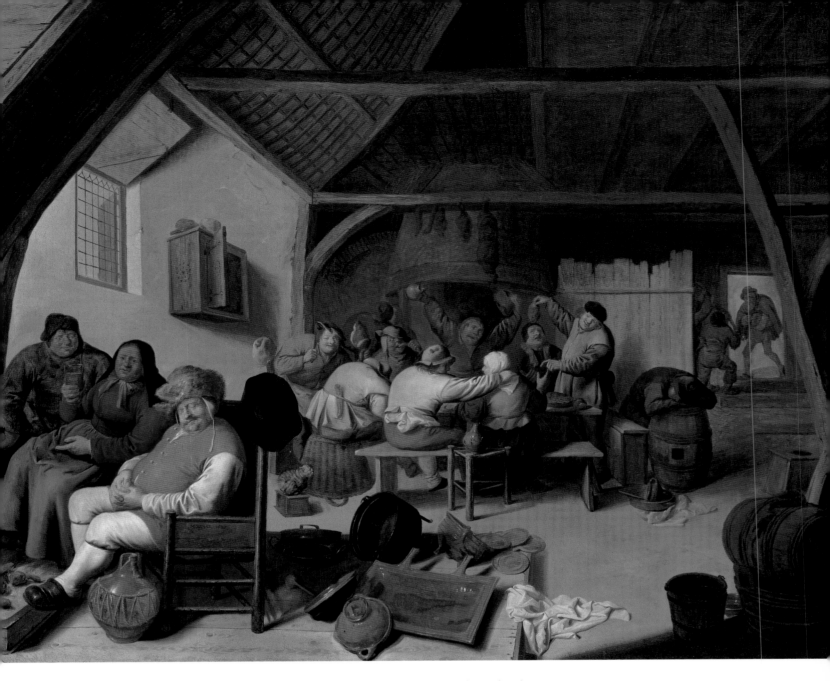

During 1637 Molenaer and his bride, Judith Leyster, must have held great hope for their prospects in Amsterdam. Following a year filled with numerous ups and downs, their move to this city from Haarlem followed a well-worn path. If one considers that the masterful *The Wedding Portrait of Willem van Loon and Margaretha Bas* (Weller fig. 9) carries a date of 1637, it appears the couple's decision to relocate paid rich dividends almost immediately.[1] Equally important to Molenaer's career were the other extant examples he painted in 1637. *The Five Senses* (cat. 26) and *The Fat Kitchen* could not be further from the Van Loon portrait in terms of both style and subject matter. In each, the humorous yet meaningful antics of peasants combine Molenaer's skill and inventiveness alongside his debt to sixteenth-century predecessors.

Peasant scenes tended to be the exception rather than the rule in Molenaer's art prior to his move from Haarlem. This approach changed during his Amsterdam years, no doubt driven by an opportunity to fill a niche in the city's art market. *The Fat Kitchen* serves as an important document in this direction. It also identifies itself as one of the best examples

25

The Fat Kitchen

1637

Signed and dated on arm of chair at left: MOLENAER 1637

Canvas, 32 ⅛ x 40 ⅛ in. (81.4 x 102.5 cm.)
Private collection, United Kingdom

Provenance:
Franzisca von Clavè-Bouhaben; sale, Cologne, Herberle, 4 June 1894, no. 270; Carl A. Beeger, Utrecht; sale, Amsterdam, Mak van Waay, 27 April 1920, no. 8; dealer Fröhlich, Vienna, by 1938; private collection, The Netherlands, by 1939; sale, London,

Sotheby's, 30 October 1997, no. 14; dealer Richard Green, London; sold to present owner.

Exhibitions:
None

Literature:
Unpublished

of his low-genre paintings. In this picture Molenaer described more than a dozen well-fed, contented peasants. While one dozes beside a brightly burning fire at the left, many others continue to overindulge in food and drink at the table to the rear. Symbolizing a total disregard for moderation, a pile of discarded pots, pans, and plates lies unattended in the foreground. But a nearly overlooked confrontation taking place in the background informs the viewer of the scene's true identity. In the doorway a skinny beggar dressed in rags asks for a handout. His plea is soundly rejected by two merrymakers who are about to chase him away.

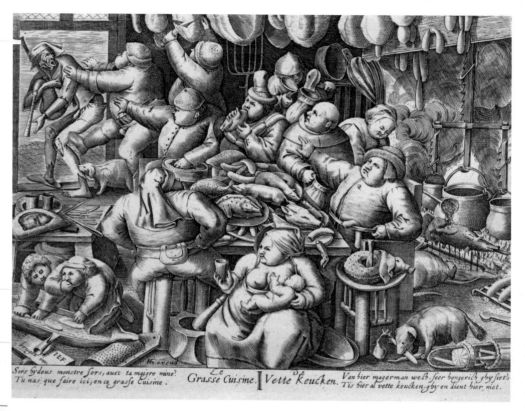

Fig. 1
Pieter van der Heyden, after
Pieter Bruegel the Elder
The Fat Kitchen, 1563
Engraving
Rijksprentenkabinet, Rijksmuseum,
Amsterdam

Representations of the fat kitchen and its converse, the lean kitchen, had become popular in the sixteenth century. Images emphasized the humorous juxtapositions between the two, as well as calls for moderation in the face of overindulgence. For example, a pair of engravings by Pieter van der Heyden, after designs by Pieter Bruegel the Elder, contrasts behavior between greedy, obese villagers who turn a beggar away (fig. 1) and undernourished peasants devouring their meager meal. The *Lean Kitchen* includes a portly visitor fleeing from his hosts. Its inscription states, "You get a miserly meal from a skinny man's pot, which is why I love going to the fat kitchen."[2]

Molenaer also loved going to the fat kitchen, for he painted the subject on numerous occasions. The exhibited painting represents the largest and most ambitious of these works, displaying a quality and an unusually colorful palette often absent from his later peasant scenes. Its imagery accords well with the inscription carried by the Van der Heyden print of the same subject: "Be off with you, you skinny little man, you may be hungry but this is a fat kitchen, and you don't belong here."[3] Viewers witness the same comic appeal in the gluttonous behavior of the figures in Molenaer's picture. The artist went a step further by giving many in his gallery of well-fed peasants animated, cheerful expressions. In spite of their simple costumes and modest furnishings, these merrymakers are understandably content.

The Fat Kitchen serves as another reminder of Molenaer's participation in a Bruegel revival that took place in the 1620s and 1630s. Other artists turned to the theme in the decades to follow, including the Haarlem painter Adriaen van Ostade, but it remained for Jan Steen to stamp his genius on the subject around midcentury. In his *Fat Kitchen* (fig. 2), he appears to have combined elements from Van der Heyden's print and

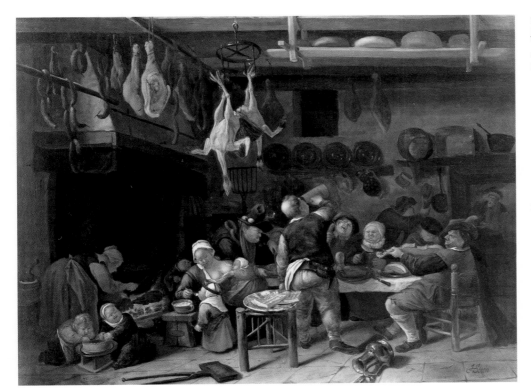

Fig. 2
Jan Steen
The Fat Kitchen, ca. 1650
Oil on canvas, 27 ¾ x 36 ½ in.
Private collection

Notes

1 The Van Loon commission may, in fact, have been partially responsible for this move to Amsterdam. Negotiations for the commission undoubtedly began prior to Molenaer's departure from Haarlem. Molenaer had, in fact, completed a commission for this important Amsterdam family in the early 1630s. In addition, the diversity of subject matter and the high quality of his dated paintings from 1636 further suggest Molenaer was looking ahead to Amsterdam's art market during this year.

2 For a discussion on the theme of the fat and lean kitchens, see Washington and Amsterdam 1996, nos. 2 and 3. The Van der Heyden print *The Lean Kitchen* is illustrated on p. 107, fig. 1.

3 Translated by Kloek; ibid., p. 103.

Molenaer's painting. Clearly, the boisterous merrymakers Steen pictured in his scene were close cousins to the figures described by Molenaer. Once again it appears the artistic worlds of Pieter Bruegel the Elder, Jan Miense Molenaer, and Jan Steen shared the same stage.

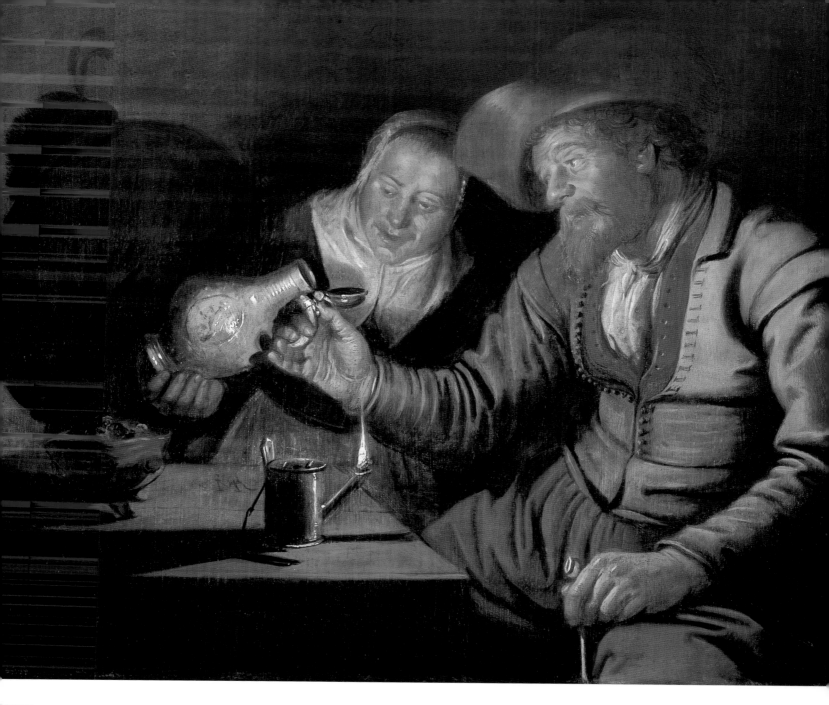

26

The Five Senses: Sight, Hearing, Smell, Taste, Touch

1637

Sight, Smell, Taste, *and* Touch *monogrammed: IMR*
Touch *also dated at lower right: 1637*

Five panels, each about 7 11/$_{16}$ x
9 7/$_{16}$ in. (19.5 x 24 cm.)
Royal Cabinet of Paintings
Mauritshuis, The Hague

Should a survey be taken of Molenaer's most popular works, *The Five Senses* from the Mauritshuis is certain to appear high on most everyone's list. Fortunately, this set, unlike others painted by Molenaer (cat. 3), remained intact over the centuries. Each of the five small panels, at least two of which were cut from a larger prepared oak support, displays an infectious spirit that transcends its individual identity as one of the senses.[1] Completed in 1637 during the year he moved to Amsterdam, the subject and style of the works stand a great distance from Molenaer's major accomplishment of that year, *The Wedding Portrait of Willem van Loon and Margaretha Bas* (Weller fig. 9). As was discussed in the previous entry, however, the year also saw his completion of *The Fat Kitchen* (cat. 25), a work that showcased the painter's turn toward peasant imagery and its attendant stylistic characteristics of a less colorful palette and coarser brushwork.

In considering the animated, painterly style evident in *The Five Senses*, one may find

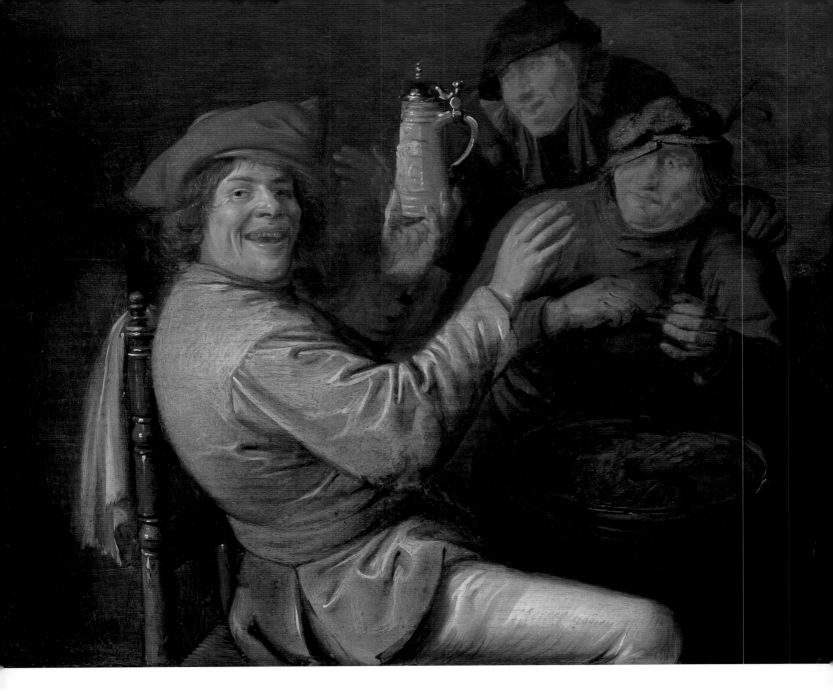

similarities with the genius of Frans Hals, particularly his genre figures from the 1620s, but Molenaer probably took his lead from Adriaen Brouwer.[2] A number of authors have commented on this link, including Seymour Slive, who observed, "The series recalls types painted by Brouwer, but he [Molenaer] misses the latter's bite."[3] This bite centers on the less sympathetic, outwardly aggressive individuals who are interpreted in largely negative terms. By contrast, the overall impression of the dimwitted peasants painted by Molenaer is comical rather than accusatory. Still, important questions arise regarding the seriousness of the message, particularly warnings against excesses.

As in examples by his colleagues, the actions taken by the figures in each of the five panels make the identifications simple. In *Sight*, a man, assisted by his female companion, dejectedly looks into an empty earthenware jug. The flame from the lamp on the table not only aids him in his effort but also reveals the hulking shape of a third person to the left. *Hearing* finds two merrymakers singing a tune. The leader of the festivities appears to be

Provenance:
F. Dittlinger, Castle Zwijnsbergen (near Helvoirt, The Netherlands); from whom acquired by the Mauritshuis, The Hague, in 1893.

Exhibitions:
Haarlem and Worcester 1993, no. 36; Oxford 1999–2000 (unnumbered; color plates 7–11).

Literature:
Hofstede de Groot 1893, p. 112; Hofstede de Groot 1894, pp. 164–65; The Hague 1914, pp. 218–20; Harms 1927, pp. 224–25; Martin 1935, pp. 370, 372, fig. 219 (*Hearing*), 376; Plietzsch 1960, p. 28; Rosenberg, Slive, and Ter Kuile 1966, p. 107;

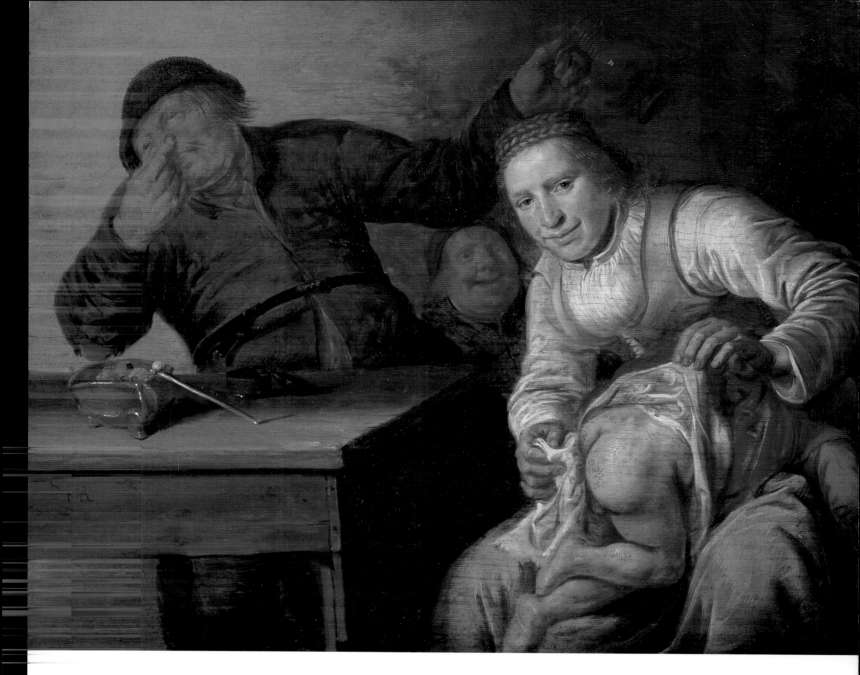

Paris 1970–71, p. 146; The Hague
1977, pp. 158–59 (illus.); Slive
1970–74, vol. 1, pp. 78–79, fig. 56;
Naumann 1981, vol. 1, p. 66, note 14;
Haak 1984, p. 72; Schama 1987,
401, fig. 192 (*Touch*), 483, fig. 237
(*Smell*); De Boer 1991, pp. 45–46,
fig. 30; Christie and Wadum 1992;
Weller 1992, pp. 133–36, figs. 43–47;
Slive 1995, p. 130; Weller 1996,
p. 813.

the gregarious young man looking directly at the viewer. He holds a tankard in one hand and marks time with the other. A third person joins the pair, his hat angled over one eye, his hands busy with wooden sticks struck together to keep the beat. *Smell* speaks (or smells) for itself, as a mother wipes the dirty bottom of her child. Next to her, a young boy shows amusement at the event, although the husband holding his nose clearly shares a far different opinion of the proceedings. A man downing a large draught from a tankard and a man hunched over his pipe signify *Taste*. Joining them is an old woman waiting a turn to feed her addictions. *Touch*, the concluding image from the series (see below), and the only dated panel, reveals a pathetic man beaten with a shoe by his wife. His sad predicament is heightened by the eye contact he makes with onlookers. It seems likely that the viewer's response is echoed by the laughter of the man at the far right.

The peasant players in all of these scenes undoubtedly drew laughs from contemporary viewers. The question remains as to whether these seventeenth-century *liefhebbers* (art lovers) tempered their amusement for these scenes by considering the consequences of such

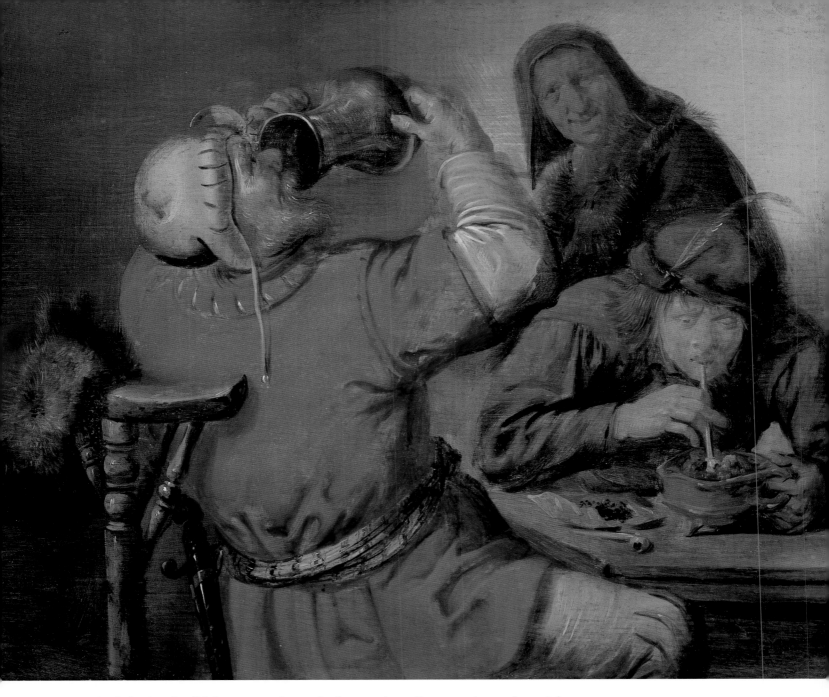

excessive behavior. Or did they assume immunity from such predicaments due to the social (and economic) distance between them and their less fortunate counterparts? Answers are suggested in comparable representations of the five senses. Molenaer was not alone among Haarlem painters to depict the subject matter. Among the other examples are five engravings by Cornelis van Kittensteyn, after Dirck Hals (figs. 1–5). Each offers explicit meaning through their inscription. *Taste* (fig. 4), for example, reads:

Smell is followed by Taste, the sense by which the tongue perceives flavors of every kind. Strive for moderation in Taste! Indeed, sickness, together with [painful] distress is caused by excessive amounts of drink and food.[4]

Unlike the bungling figures painted by Molenaer, however, upper-class couples populate the scenes engraved by Kittensteyn. One wonders, then, if the same well-to-do viewers who may have laughed at Molenaer's panels experienced a "reality check" in witnessing

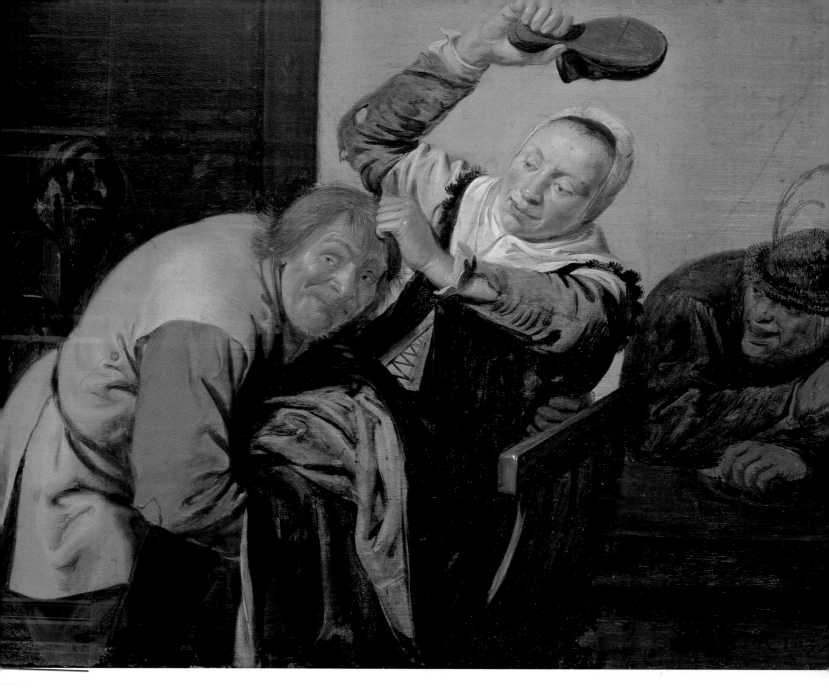

the excessive behavior undertaken by their close contemporaries? Kittensteyn's cautionary tales conclude with the sense of touch. Bogendorf Rupprath, whose exhaustive discussion of Molenaer's *The Five Senses* provides the basis for this entry, wrote that the "warning given to the amorous couple stealing a cuddle [in *Touch*] in Van Kittensteyn's engraving is particularly noteworthy."[5] The inscription on *Touch* offers an explanation while noting its relationship to the other four senses.

To these four, Touch is added, completing this circle of five. A restricted sense, conspicuous as it is impossible to touch anyone [thing] without coming near to them [it], thus making way for enthusiastic familiarity. To what extent the adored disapproves is observed in the way the touch is refused.[6]

In turning to Molenaer's *Touch*, the author concluded that his "image of an offended woman, unmistakably about to clobber her 'admirer' over the head with a shoe, is more to

Figs. 1–5
Cornelis van Kittensteyn, after
Dirck Hals
*The Five Senses: Sight, Hearing,
Smell, Taste, and Touch*, ca. 1630s
Engravings
Rijksprentenkabinet, Rijksmuseum,
Amsterdam

Notes

1 Christie and Wadum 1992 present evidence of the painter's use of a single grounded panel that was then cut for use in the execution of *Hearing* and *Touch*.

2 Molenaer's awareness of Brouwer is understandable considering Brouwer's presence in Haarlem during parts of the 1620s. The inventory of his possessions after his death (see Appendix) shows that Molenaer owned four original works by Brouwer, one copy, and another picture begun by Brouwer and completed by Molenaer.

3 Slive 1995, p. 130.

4 Translated by Bogendorf Rupprath in Haarlem and Worcester 1993, no. 36, p. 332.

5 Ibid.

6 Ibid.

7 Ibid.

the point."[7] He definitely gets the message. Molenaer's simple but effective composition not only makes its point regarding the relationship between the man and the woman, but like the other panels in the series, *Touch* effectively demonstrates Molenaer's genius for comedy. It also represents an approach to subject matter that reached a new and responsive audience in Amsterdam in 1637. In the years to follow, he increasingly played to this audience, crafting scenes depicting the foibles of the lower classes.

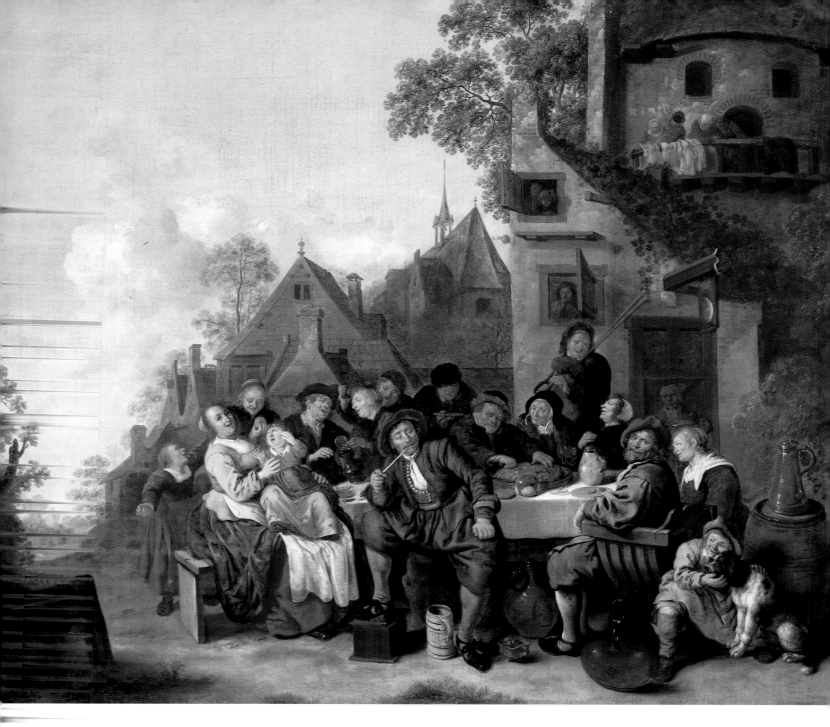

27

Tavern of the Crescent Moon

ca. 1637–40

Signed at lower left on the fence plank: J molenaer

Canvas, 34 ½ x 40 ⅛ in. (87.8 x 102 cm.)
The Museum of Fine Arts (Szép-művészeti Muzeum), Budapest

Provenance:
Collection of Prince Miklós Esterházy

Jan Miense Molenaer's interest in outdoor scenes, which began about 1630, seems to have held his attention for much of the next five years. A few years later in Amsterdam, he returned to the subject with *Tavern of the Crescent Moon*. Here animated merrymakers enjoy an outdoor feast set against a village backdrop. Close cousins to the country bumpkins depicted by Pieter Bruegel the Elder and his followers, Molenaer's figures are clearly set apart from the types popularized by his former Haarlem colleague Dirck Hals. Hals's *Outdoor Merry Company* (fig. 1) reveals these differences, for in this work well-dressed young adults indulge their appetites for food and drink, music and courtship. Compared to the Molenaer picture, Hals's colorful figures travel with a very different crowd. They are smaller in scale and more refined, and they display doll-like features.

The *Tavern of the Crescent Moon* represents a transitional work in Molenaer's oeuvre,

providing clues to his imagery in the late 1630s and early 1640s. Compared to his earlier outdoor scenes (cats. 5, 6), the figures are somewhat smaller and more numerous, and the architectural features of the village are more detailed and complex. Meaning has become increasingly elusive. Nonetheless, Molenaer retained the compositional naïveté found in his earlier works, and he continued to emphasize the unabashed emotions of his merrymakers. In discussing the painting, Mojzer addressed the relationship between these merrymakers and their setting. "The picture is carefully executed, but there is a strange contrast between the painting of the figures, which are full of life, and the background of buildings and trees, which has something of the unreality of a stage back-cloth. The artist shows more skill in the treatment of interiors."[1] Interestingly, Molenaer recycled some of the same figures for his indoor merry companies.[2]

The author raised an important issue by introducing "the unreality of a stage back-cloth" in his assessment of the *Tavern of the Crescent Moon*. It is probably no coincidence that by the time of its execution in the late 1630s, Molenaer had found a small market for paintings of scenes based on theatrical subjects. Examples in this genre, including the *Scene*

(1756–1833), inv. 1820, no. 960, Budapest; by descent; Esterházy Collection acquired by the Hungarian State in 1871.

Exhibitions:
None

Literature:
Bode and Bredius 1890, p. 75; Frimmel 1892, pp. 164–65; De Térey 1906, p. 74, no. 339; Martin 1935, p. 377; Bernt 1960–62, p. 541; Pigler 1967, pp. 454–55, pl. 291; Mojzer 1967, no. 11, color plate; Bernt 1969–70, vol. 2, no. 839, illus.; Budapest 1985, p. 142, illus.; Weller 1992, pp. 247–49, fig. 94; Budapest 2000, p. 110, illus.

from Bredero's "Lucelle" (cat. 29) from 1639, reveal a comparable relationship between the lively and often melodramatic figures and their stage backdrops.

Subject and meaning are clear in Molenaer's depictions of theatrical performances. By contrast, and absent an identifiable literary source or popular iconography such as the five senses (cat. 26), the *Tavern of the Crescent Moon* is largely ambiguous in its message.[3] Molenaer de-

Fig. 1
Dirck Hals
Outdoor Merry Company, 1627
Oil on panel, 30 ¾ x 54 in.
Rijksmuseum, Amsterdam

picted a celebration enjoyed by everyone, with many of the human interactions adding charm to the scene. They include the joy provided by the boy with his dog, the contentment of the smoker at center, the affection shown by the singers who enjoy a tankard of beer, and the shared moment between the mother and child at the left. In light of this sunny outlook, is the viewer warned of possible storm clouds on the horizon? Does the feasting represent gluttony, smoking, a dissolute life, and are the teachings of the church, seen in the distance, ignored by the village population? Does the expression *voor herberg, achter bordeel* (before an inn, behind a bordello) apply to the tavern peopled by young couples in the windows and on the balcony?

Answers to these questions are elusive, even as one attempts to glean clues from contemporary prints. A starting point is the *Village Festival* (fig. 2) by F. de Wit, after a drawing by the Haarlemer Jan van de Velde II. Sharing a number of motifs with the *Tavern of the Crescent Moon*, including a tavern similarly identified by a crescent moon, the *Village Festival* expands upon the theme detailed by Molenaer. A recent description of the print addressed the issue of its meaning and, by association, that of this painting.

Fig. 2
F. de Wit, after a drawing by
Jan van de Velde II
Village Festival, 1630
Engraving
Private collection

Notes

1 Mojzer 1967, unpaginated, no. 11.

2 The smoker in the center fore-
ground, for example, reappears in an
undated work, *Merry Company in a
Tavern*, oil on canvas, 95.5 x 82 cm.,
Sotheby's, Amsterdam, 29 April 1985,
no. 77 (color plate).

3 Issues concerning the possible
interpretation of village/peasant merry
company scenes were central to the
scholarly debate between Svetlana
Alpers and Hessel Miedema in the
1970s. For an excellent overview of
this topic and related issues, see
Stone-Ferrier's essay in Lawrence
1983, pp. 3–35.

4 Ibid., 124.

*The subject and meaning of the print are as inviting as the manner in which it has been
produced. The viewer is likely to be amused by the gentle excess that is manifested by the
lower-class figures. Their festivity was as appropriate and deserved an aspect of their
leisure day as was the finery in which the upper-class figures indulged themselves. The
Latin inscription beneath the image confirms this sentiment by saying that the farmer or
peasant deserves a rest after his hard labors in the field, and that he likes to drink deeply
when he is having his well-earned rest.*[4]

In light of the viewer's positive engagement with the merrymakers in the *Tavern of the
Crescent Moon*, perhaps Molenaer intended for us to be in sympathy with their well-
deserved enjoyment.

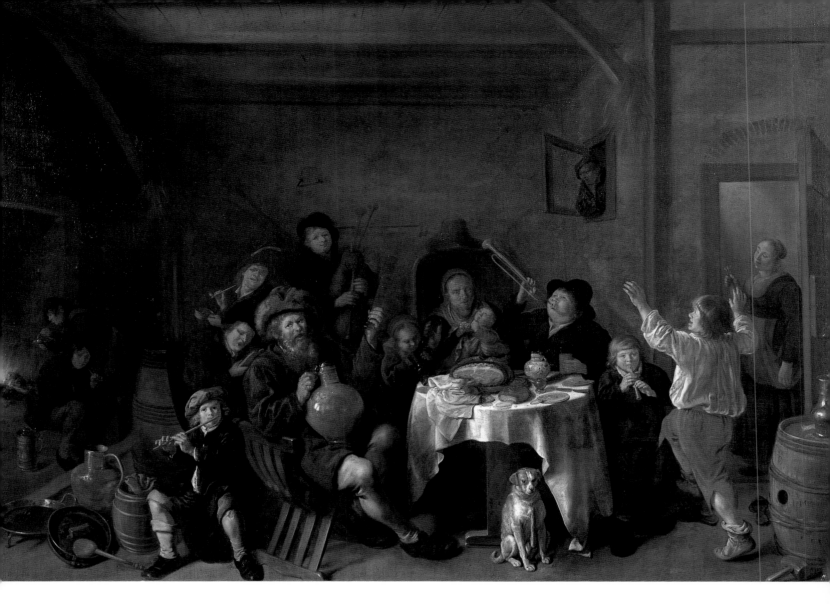

Among the great thrills of wandering through the exhibits at the Victoria and Albert Museum are the surprising discoveries found at nearly every turn. Among them is *A Family Merrymaking*, a painting by Molenaer that hangs in one of the European decorative arts galleries. This large picture provides considerable insight into Molenaer's artistic interests as he defined his peasant style in Amsterdam during the late 1630s and early 1640s. It also represents one of his most ambitious and colorful compositions in this genre, as more than a dozen merrymakers enliven a stark interior. They celebrate by eating, drinking, smoking, and making music. Although none of the figures appear outwardly aggressive in their behavior, their actions allow for a number of possible interpretations. These range from warnings against excess and man's foolishness to a representation of a popular proverb of the day, "As the old sing, so pipe the young."

Peasant scenes were becoming a mainstay in Molenaer's oeuvre by the end of the 1630s. No doubt driven by a demand for such pictures among Amsterdam collectors, these works filled a market niche comparable to the one occupied by Adriaen van Ostade in Haarlem. The composition Molenaer employed in *A Family Merrymaking* marks a change in the relationship between the figures and their surroundings. Smaller in scale than their counterparts in his earlier scenes, the merrymakers are more fully integrated into their environment. A comparison between the London painting and *Children Playing and Merrymaking*

28

A Family Merrymaking

ca. 1638–42

Signed on barrel at right: JMolenaer (JM in ligature)

Canvas, 42 x 60 in. (106.6 x 152.4 cm.)
Victoria & Albert Museum, London (inv. 536-1870)

Provenance:
John Parsons, London; gift to the Victoria & Albert Museum, 1870.

Exhibitions:
None

Literature:
Kauffmann 1973, p. 193, illus.; Weller 1992, pp. 149, 252–53, 395, no. 54.

Fig. 1
Jan Steen
As the Old Sing, So Pipe the Young,
1667
Oil on canvas, 43 ½ x 55 ½ in.
Rijksmuseum, Amsterdam

(cat. 16) reflects this change.[1] These two compositions also share a number of motifs, among them the boy wearing tattered britches and a white long-sleeved shirt who dances to the far right.

Connections between these two paintings may have extended to their respective meanings as well. Parallels between the training of animals and the training of children, for example, have been suggested for works comparable to *Children Playing and Merrymaking.*[2] By extension, the youngsters who actively join their adult counterparts in feasting and music making in *A Family Merrymaking* may represent another facet of instruction. The composition includes children who play flute, recorder, and trumpet. Their actions, and those of their counterparts, may correspond to "As the old sing, so pipe the young." In taking up the issue of imitation versus learning, or, more aptly, the ongoing debate of nature versus nurture, Molenaer again may have anticipated the genius of Jan Steen. In writing about one of Steen's versions (fig. 1) of "As the old sing, so pipe the young," Chapman describes concerns connected with such images.

Aptly, Steen has cast himself and his family in the painting that addresses the themes of learning and imitation in several ways. Seventeenth-century literary usage indicates that this proverb could emphasize either inborn human nature or the importance of example and upbringing. At its most pessimistic, it referred to the eternal regeneration of humankind's innate foolishness.[3]

If human nature is inborn, can merrymakers be prevented from indulging in their pastimes? What were the consequences of overindulgence? Molenaer, like many of his colleagues, returned to these basic questions over and over again in his art. Nevertheless, like Bruegel before him and Steen just a few years later, Molenaer masked his answers with a veil of humor (see Westermann essay). The high spirits given to the participants in *A Family Merrymaking* distract viewers from the overindulgence practiced by adults and children. In searching for clues to Molenaer's message, one may easily overlook a key motif. To the left an owl perches on the lip of a barrel made into a chair.[4] Seemingly out of place, the owl serves as the *clavis interpretandi* to the picture's meaning. Contrary to the notion that owls signify wisdom, this "bird of the night" was also associated with the power of evil over mankind.[5] The owl, which "personifies foolishness, stupidity and ignobility," may have found its equal in the smokers, drinkers, and musicians Molenaer depicted in *A Family Merrymaking.*[6]

Notes

1 In light of its style and composition, *Children Playing and Merrymaking* seems to date to the first half of the 1630s. By comparison, *A Family Merrymaking* may have been executed up to a decade later. This work does carry the figure 42 (or 47) near the top of the barrel to the right. While a date of 1642 is certainly possible, the fact that this figure is not part of the signature seems to discount its relevance in this regard. See Kauffmann 1973.

2 Durantini 1983, p. 278. In speaking specifically on this picture, the same author wrote: "This combination of dancing figures—humans and animals—and the sense of rowdiness and dissipation seem to suggest that these people have descended to the level of the animals in their amusements" (p. 283).

3 Washington and Amsterdam 1996, p. 174.

4 Due to abrasion, this important motif is nearly lost to the viewer.

5 Weller 1992, p. 253.

6 Washington 1989, p. 239. In his catalogue entry on the *Malle Babbe* by Frans Hals, Slive discusses the negative symbolism of the owl.

The figures in many of Molenaer's paintings give the impression of functioning as actors on a stage. Such an observation proves correct in a handful of works Molenaer completed during the second half of the 1630s. All were inspired by the popular play *Lucelle*, written in 1563 by the Frenchman Louis Le Jars and translated into Dutch by Gerbrand Adriaensz. Bredero. First performed in Amsterdam between 1613 and 1615, this tragicomedy follows the trials and tribulations of Lucelle and her search for a husband.[1] A brief synopsis of the events provides the framework for Molenaer's picture.

Lucelle, daughter of the wealthy merchant Carpone, disdains the attentions of Baron van Duytslandt and falls in love with her father's servant, Ascagnes. Lucelle's maid, Margriet, arranges for the lovers to meet under the guise of a music lesson. Leckerbeetje, playing the role of the fool, overhears the plan and tells Carpone who gives poison (actually a sleeping draught) to the couple to avoid a scandal. Just as the lovers succumb, Captain Baustruldus

29

Scene from Bredero's "Lucelle"

1639

Signed and dated on threshold at left:
MOLENAER 1639

Canvas, 31 ⅞ x 39 ⅜ in. (81.2 x 100.3 cm.)
Theatre Museum, Theatre Institute Netherlands, Amsterdam (inv. A 1978–6)

Provenance:
Collection Friesendorff and Bendix, before 1911; M. F. Rappe, Stockholm; sale, Bukowski, Stockholm, 1 November 1977; Leger Gallery, London, by 1978; acquired by museum in March 1978 with fund by the Vereniging Rembrandt.

Exhibitions:
Washington, D.C., Detroit, and Amsterdam 1980, no. 75.

Literature:
Granberg 1911–13, vol. 1, pp. 121–22, pl. 47; Gudlaugsson 1947, pp. 178–83, fig. 6; Gudlaugsson 1954, p. 53; Hummelen 1967, p. 21; Amsterdam 1968, p. 54; Bruyn-Berg 1978; Thomas 1981, p. 87, illus.; Weller 1992, pp. 33–37, 353, fig. 12; Weller 1996, p. 813; Westermann 1997a, p. 380, fig. 132.

appears, sent by the King of Poland, and reveals that Ascagnes is the king's son. A dismayed Carpone summons the apothecary to restore the lovers to life. The play ends with the celebration of their marriage.[2]

Molenaer was not alone in showing an artistic interest in this subject, but the four extant examples from his oeuvre suggest he appears to have been its strongest advocate.[3] *Scene from Bredero's "Lucelle"* represents the painter's largest, most colorful, and arguably most theatrical treatment of the subject, rivaling his other masterpiece in this genre, *Lucelle* (fig. 1), dated 1636. Compared to this earlier work, however, the Amsterdam picture offers viewers a more faithful view of contemporary Dutch theater, specifically the play's staging, costumes, props, and narrative as it unfolded in *Lucelle's* final act. It is conceivable that Molenaer's heightened awareness of theatrical performance came from firsthand experience. During the three years that separate the two paintings, Molenaer and Leyster had moved to Amsterdam. Unlike in Haarlem, where there was at best a modest following for serious theater, the situation in Amsterdam was far different. The public could attend performances on a fairly regular schedule. In 1637 a new theater based on a design by Jacob van Campen opened on the Keizergracht, and at least one performance of *Lucelle* took place the first season.[4]

It is not surprising, then, that Molenaer replaced the church interior used in the Muiden painting with a proper stage set in his *Scene from Bredero's "Lucelle."*[5] Worthy of a Hollywood director from the 1920s, the painter brought the action toward its melodramatic conclusion. Lucelle and Ascagnes, who experience a deep, deathlike sleep, lie in an awkward embrace to the right. At the left Captain Baustruldus, newly arrived from Poland and

Fig. 1
Lucelle, 1636
Oil on panel, 22 7/8 x 33 7/8 in.
Rijksmuseum Muiderslot, Muiden

wearing an exotic eastern European costume, holds the message from his king that provides the true identity of Ascagnes. Standing next to him is the fashionably dressed Baron van Duytslandt, sword in hand. The meddling and foolish Leckerbeetje listens intently to the announcement, and next to him stands the elderly Carpone, who will soon order the antidote to revive the drugged couple. Completing the cast is the wailing Margriet, sitting among the ruins of the couple's clandestine music lesson. While the lute on the table provided the pretext for their rendezvous, the true intent of their meeting is tantalizingly provided in the form of the curtained bed behind the maid.

Stylistically, the *Scene from Bredero's "Lucelle"* is consistent with Molenaer's paintings from the late 1630s. Among the picture's most attractive features are the colorful and diverse costumes worn by the actors. Many are armed with props, and the painter pro-

Fig. 2
Plunder Scene, 1636
Oil on panel, 20 ⅞ x 31 ¼ in.
Museum der bildenden Künsten,
Leipzig

vided each figure with the emotion appropriate to his or her stage role. Accompanying the brilliant palette are the controlled brushwork and descriptive highlights typical of Molenaer's nonpeasant subjects from the 1630s. In anticipation of his peasant mode to follow, the painter significantly reduced the scale of the figures in relationship to the cavernous stage space.

In addition to his depictions of *Lucelle*, a document links Molenaer and Bredero on one other occasion. The Boston Museum of Fine Art's *Peasants Carousing* (cat. 36) represents the artist's late masterpiece. Painted in 1662, its imagery comes from a song included in the popular *Groot lied-boeck* by Bredero. The larger question then arises as to whether Molenaer found inspiration in other contemporary writings. Based on the examples cited above, it would be remarkable if he failed to incorporate other literary works in his oeuvre.[6] One possibility is the equally melodramatic *Plunder Scene* (fig. 2) in Leipzig. Dating to 1636, the same year as the Muiden *Lucelle*, this composition shares many of the staged elements found in all of Molenaer's paintings of the theme. He also provided his figures with many of the same colorful costumes, gestures, and emotions. Further research may eventually identify the scene as a representation of one of the many *kluchten* (farces) in vogue at that time.[7]

Notes

1 Washington, Detroit, and Amsterdam 1980, p. 262; also see Hummelen 1967 and 1982.

2 Washington, Detroit, and Amsterdam 1980, p. 262.

3 In addition to the exhibited work and the one from Muiden discussed below, only the present whereabouts of one of the two others is known; *Ascanio and Lucelle*, oil on panel, 54 x 71 cm., Art Museum, Kharkov, Russia, inv. no. 28. The fourth was auctioned at Hotel Drouet, Paris, 9 March 1981.

4 For discussions of Amsterdam theater, see Meijer 1971, pp. 109–10, Hummelen 1982, and Hunningher 1958.

5 For a discussion of the churchlike setting used in the Muiden picture, see Weller 1992, pp. 33–34.

6 The results of ongoing research in this area, especially by Dutch scholars, offer promising results. Also see Weller 1992, pp. 254–60.

7 Weller 1992, p. 36.

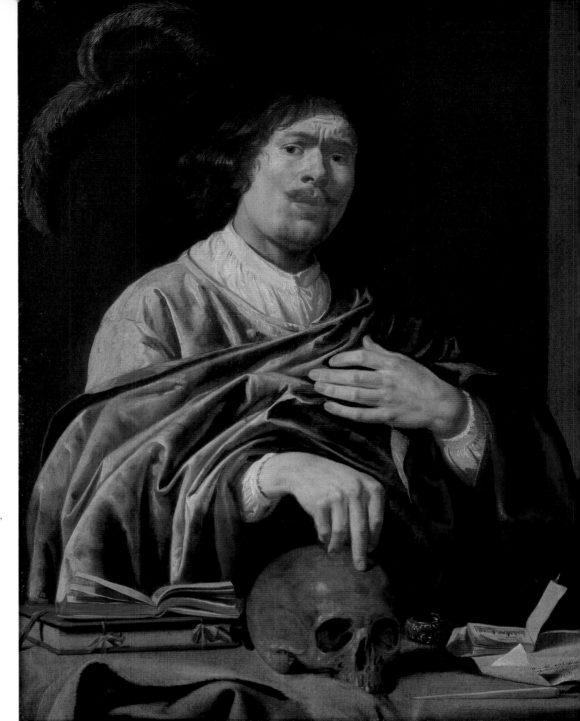

30
(Raleigh only)

Self-Portrait with a Skull

ca. 1639–40

Unsigned

Canvas, 34 ¼ x 26 ¾ in. (87 x 68 cm.)
Bayerische Staatsgemäldesammlungen, Munich (inv. 4872)

Provenance:
Staatsgalerie, Zweibrücken, before 1912 (as Honthorst); Gemäldegalerie, Augsburg, by 1912 (as North Netherlands Master, ca. 1620); Bayerische Staatsgemäldesammlungen, Munich.

Exhibitions:
None

Literature:
Augsburg 1912, p. 51, no. 2563; Raupp 1984, p. 265, fig. 161; Weller 1992, pp. 140–42, 390, fig. 49; Haarlem and Worcester 1993, p. 286, fig. 29a, pp. 304, 307, note 5; Raleigh 2000, unpaginated, fig. 5.

Self-Portrait with a Skull marks a rare moment in Molenaer's art where issues of life and death seem to take center stage. Unlike the high spirits found in his more public, genrelike self-portraits, here he pictured himself with tightly pursed lips, wrinkled brow, and an intense stare toward the viewer.[1] The presence of the skull, which the painter touches with his right hand, identifies the scene as a *vanitas*. In addition to its theme of the transience of life and the inevitability of death, Molenaer may have turned to the *memento mori* theme with more immediate concerns on his mind. The pain and vulnerability shown in the painter's face may, in fact, relate to events in his personal history. The age of the sitter and the style of the work suggest *Self-Portrait with a Skull* dates to 1639 or 1640. It was during

this period that Molenaer and Leyster were celebrating the births of two of their sons. Johannes was baptized in Amsterdam on 17 November 1637, followed by Jacobus on 16 January 1639.[2] Since neither child is cited in any subsequent document, it can be assumed that both failed to survive infancy. In light of these losses, Molenaer's image of himself may have served as an outlet for these tragic events in his life.

Molenaer's composition also serves as another example in which he looked to works by both his predecessors and contemporaries for inspiration. Among them is the engraving by Lucas van Leyden, *A Young Man Holding a Skull*, from about 1519.[3] In the print a young man with an elaborately plumed hat points with his right hand to a human skull partially hidden under his cloak. Molenaer, however, need not look further than his hometown of Haarlem to find others interested in the theme. Hendrick Goltzius's drawing from 1614, *Young Man Holding a Skull and Tulip* (fig. 1), made his message abundantly clear. In addition to the skull, he also included the iconographically charged motifs of an hourglass and a tulip, whose beauty will soon fade like that of his youthful model. He then added the provocative inscription "QUIS EVADET / NEMO" (Who Escapes? No Man).

Fig. 1
Hendrick Goltzius
Young Man Holding a Skull and Tulip, 1614
Pen and brown ink, 18 1/8 x 13 15/16 in.
The Pierpont Morgan Library, New York

By inserting his own likeness as the protagonist in his *Self-Portrait with a Skull*, Molenaer again linked the artist with death and the transience of life.[4] Karel van Mander, a Haarlem artist and theorist, wrote on the broader implications for this subject, as discussed by Bogendorf Rupprath.

Karel van Mander draws a similar parallel when reminding artists that both they and their art "will pass away; however elegant, however witty [they be], Death [will claim everything.]" He warns the painter not to be overly proud of his artistic talent, for it is a gift from God and must be regarded only as a means for making a living.[5]

There was also a long tradition of associating *vanitas* imagery with scenes of scholars and saints in their studies.[6] In the *Self-Portrait with a Skull*, Molenaer assumed the role of the scholar, underscored by the depiction of three books and a letter. At the same time, and in keeping with tradition, he seems to have suggested that the frivolous pleasures of life, represented by his colorful costume and feathered beret, account for little in light of the ultimate questions of life, death, and spiritual necessity. A painting in the Rijksmuseum sheds additional light on the linkage between the act of painting, frivolity, and transience. Previously thought to be by the Haarlem artist Pieter de Grebber, *Self-Portrait in Oriental Dress* (fig. 2) now carries an attribution to Johannes van Swinderen. The painter wears a fanciful costume, holds brushes and a palette, and rests his hand on a skull. The message speaks of worldly pleasures and of the contest between painting and death, which will claim everything.

A final comparison suggests Molenaer may have turned to another, even closer source of inspiration for his *Self-Portrait with a Skull*. Molenaer's presumed training in the studio

Fig. 2
Attributed to Johannes van Swinderen
Self-Portrait in Oriental Dress, 1647
Oil on canvas, 40 ½ x 35 in.
Rijksmuseum, Amsterdam

Fig. 3
Frans Hals
Young Man with a Skull, ca. 1626–28
Oil on canvas, 36 ¼ x 31 ¾ in.
The National Gallery, London

Notes

1 The other notable exception to this tendency is Molenaer's *Self-Portrait with Family Members* (Introduction fig. 1) in Haarlem. In this group portrait, the painter and his siblings wear sober expressions. Their seriousness may be justified, however, since the work may date just after the death of Molenaer's father. The family patriarch, in fact, appears in a portrait on the rear wall. Not surprisingly, he rests his right hand on a skull.

2 For a discussion of the relevant documents, see Broersen in Haarlem and Worcester 1993, pp. 23, 35, note 73.

3 Illustrated and discussed in Washington and Boston 1983, pp. 197–98. The popularity of this print continued into the seventeenth century, for in 1610 The Hague printmaker Hendrick Hondius engraved a copy.

4 See note 1 above.

5 Haarlem and Worcester 1993, p. 304.

6 Many examples of this genre exist, including works by Marius van Reymerswaele (active ca. 1509–67), a South Netherlandish painter who specialized in this and related subjects.

7 Washington, Haarlem, and London 1989, no. 29.

8 Ibid., p. 208.

of Frans Hals during the mid-1620s coincides with the date Slive proposes for Hals's *Young Man with a Skull* (fig. 3), now in London.[7] The two pictures offer many similarities in their compositions and shared motifs. In addition to the skulls, for example, each figure wears a costume and headdress of the "kind the Dutch Caravaggisti used for their stagey genre and allegorical pieces."[8] While Molenaer's controlled brushwork cannot compete with the genius of Hals's painterly touch, the depth of his message was, as has been noted, both personal and moving.

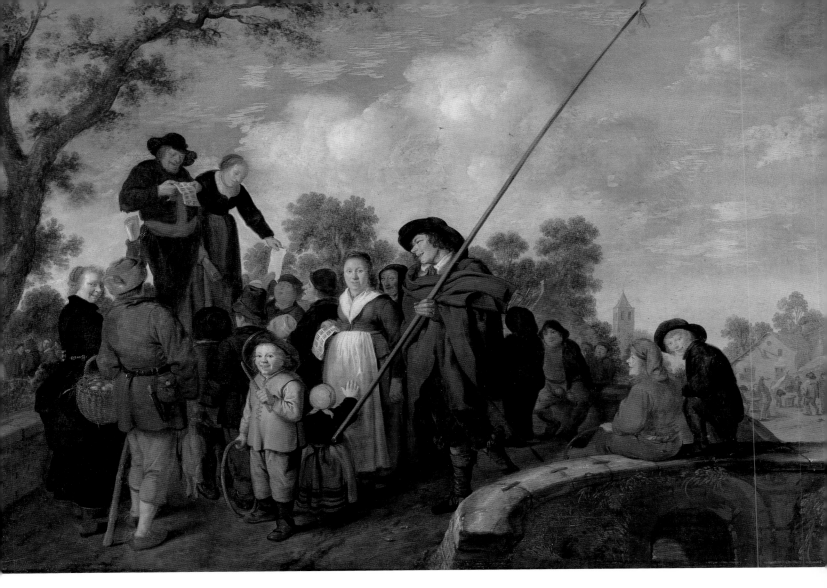

A crowd of villagers, some listening to an itinerant reader mouthing words from a broadsheet, others fixing their gazes on the viewer, occupies the roadway over a small bridge. While the mood is generally restrained, the scene offers hints that Molenaer intended an upbeat, comic reading of events taking place. Painted during the first half of the 1640s, the work also represents Molenaer's return to the subject of outdoor gatherings, after an absence of nearly a decade.[1] Compared to his early village scenes, this composition better integrates the figures to their setting, is more atmospheric, and shows greater subtlety in expressing the emotions of the participants. *An Itinerant Ballad Singer on a Bridge* is among the most iconographically rich and visually rewarding of Molenaer's outdoor scenes. The composition appears to have been based on a drawing by the Haarlem artist Isack van Ostade (fig. 1).[2]

Identified in Berlin as *Der Bänkelsänger* (*The Itinerant Singer* or *Ballad-Monger*), this title may be somewhat misleading as a description of the actions of the man "singing" from the sheet he holds in his hands. Instead of singing, he in fact seems to be reading from a news gazette, or broadsheet. Such events were commonplace, since "these gazettes were fantastically popular with the general public and the passion for reading them became as widespread as the use of tobacco."[3] The same author further noted that "by mid-century The Hague, Delft, Leyden, Rotterdam, and Haarlem all possessed their own gazettes, sheets appearing once or even three times a week in the form of two columns on

31

An Itinerant Ballad Reader on a Bridge

ca. 1640–45

Signed at the lower bottom on the edge of the bridge: JMolenaer (JM in ligature)

Panel, 18 ⅛ x 27 ⅛ in. (46 x 69 cm.)
Staatliche Museen zu Berlin,
Gemäldegalerie

Provenance:
The Prussian Royal Collections, Berlin and Potsdam; Kaiser Friedrich Museum, Berlin.

Exhibitions:
None

Literature:
Berlin 1931, p. 314; Berlin 1932, p. 96, ill.; Schnackenburg 1981, vol. 1, pp. 158, 257, fig. 20; Berlin 1986; Weller 1992, pp. 157–58, fig. 60.

Fig. 1
Isack van Ostade
*Two Ballad Readers with Listeners
on a Bridge,* ca. 1640–45
Pen and ink, watercolor,
7 ⅝ x 12 ⅛ in.
Prentenkabinet der Rijksuniversiteit,
Leiden

Fig. 2
Roemer Visscher
"Beter stil ghestaen," emblem from
Sinnepoppen, Amsterdam, 1614

quarto paper."[4] This description accords well with the look of the sheet held by the reader.

In further addressing the history of these broadsheets, Van Deursen assessed those individuals whose job it was to distribute them in Dutch towns and villages. His intriguing description provides important clues to Molenaer's intended message.

The demand for verses was so great that it could make even street-selling pedlars worthwhile, although this work may have seemed the last remedy of shiftless folk and wastrels, who had landed on rock bottom and could not find any other way of earning a living. They could still "Walk around with almanacs, ballads, and sometimes with 'What wonder! What news!' There are so many lazy scoundrels who earn their bread in that way." In those words "What wonder! What news!" we hear the cries of the street-vender who wanted to persuade the public to buy the news, and thus sold not only ballads but also pamphlets.[5]

Selling rumor went hand-in-hand with selling hard news, as ballad-mongers counted on the gullibility of the villagers who craved sensational headlines. Here, Molenaer promoted the theme of gullibility by combining a few carefully chosen motifs with the knowing looks between some of the villagers and the viewer. Chief among them is the small boy holding a hoop. Wearing a wide grin, this youngster is both physically and psychologically closest to the viewer. His shiny hoop tells the story, as hoops often carried symbolic messages.[6] A boy with a hoop was used by Roemer Visscher, for example, to illustrate his emblem *Beter stil ghestaen* (Better to stand still) (fig. 2). The text associated with this emblem suggests "It is better to stand still than to make oneself tired with work that is useless." Do Molenaer's villagers fit this description as they listen to the useless words of the ballad singer? The look of their knowing smiles suggests only the young boy and a few others seem to have escaped this downfall.

Evidence suggests some of the villagers also may be vulnerable to other types of deceit. The motif of an individual holding a basket of eggs and/or a dead duck reappears in a number of works by Molenaer. In nearly every instance, this person will be robbed of his possessions due to misguided attraction to quack dentists, charlatans, or card players (see below and cat. 20). It appears that at least one person in the crowd has already been duped. At the center of the composition stands a woman in a white apron with a rather unintelligent expression on her face. She holds one of the broadsheets in her hand, proof of her gullibility, and the question arises whether she will be equally vulnerable to the advances of the well-dressed man carrying a lance to her left.

As mentioned, the theme of the ballad-monger can be linked to other crowd scenes where onlookers are tricked by their gullibility. Quack doctors, dentists, and other charlatans were among the culprits tempting the public in compositions by Gerrit Dou, Jan Steen, and others. In another picture by Molenaer, *The Charlatan* (fig. 3), villagers crowd around a couple on a makeshift stage. While the man plays a fiddle, his partner offers for

Fig. 3
The Charlatan, ca. 1630–35
Oil on canvas, 41 ¾ x 26 ¾ in.
Recently art market, Germany

Notes

1 One of the few exceptions to this general trend in Molenaer's art is the *Tavern of the Crescent Moon* (cat. 27) from the late 1630s.

2 For a discussion of the drawing, see Schnackenburg 1981, vol. 1, p. 158, no. 410. Although signed, the drawing is undated.

3 Zumthor 1963, p. 274.

4 Ibid.

5 Van Deursen 1991, p. 142.

6 Durantini (1983, pp. 228–30), among others, discussed hoops and their symbolic roles. Jan Steen, as discussed by Wheelock in Washington and Amsterdam 1996, p. 185, also made use of this motif with a crowd of villagers. *The Toothpuller* by Steen concerns the closely related issue of the gullibility of the patient and onlookers.

7 Note, for example, that a young boy is (successfully) removing a dead duck from the basket of one of the villagers.

inspection an "official" document bearing wax seals. It can be assumed they will be successful in selling their product to some—just as others in the crowd will be robbed.[7] This conclusion seems to be confirmed by Molenaer's inclusion of the same motif as found in *An Itinerant Ballad Reader on a Bridge*. Again, a young boy, wise beyond his years, holds his hoop and provides the onlooker with a charming reality check on unfolding events.

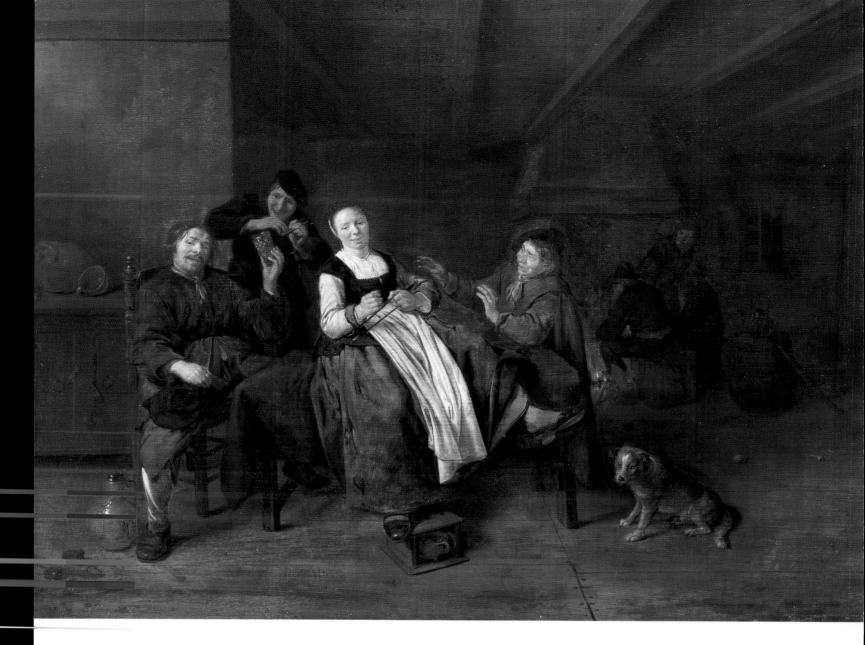

32
A Merry Company

ca. mid-1640s

Signed on the foot warmer: JMolenaer (JM in ligature)

Panel, 14 ⅜ x 19 ½ in. (36.5 x 49.5 cm.)
Private collection, United Kingdom

Provenance:
D. Burckhard, Switzerland; K. and V. Waterman Gallery, Amsterdam, by 1993; sale, Ader Tajan, Paris, 29 March 1994, no. 11; Daphne Alazraki Gallery, New York; acquired by present owner.

Exhibitions:
New York 1995, no. 9.

Literature:
See exhibitions above.

By the mid-1640s, Molenaer had taken a dramatic turn with his art. Seeking inroads into Amsterdam's large art market, he found a niche in depictions of lower-class merrymakers. Modest in their scale, and generally limited to just a handful of figures, these scenes reflect influence from Adriaen Brouwer, Isack van Ostade, Adriaen van Ostade, a longstanding print tradition, and, as has been mentioned elsewhere, Pieter Bruegel the Elder. The decade of the 1640s also saw Molenaer facing the demands of a growing family, involved in a series of legal disputes, and engaged in property speculation. As a result, the painter increasingly sacrificed quality for quantity in the majority of works from this decade and throughout the rest of his career.[1] Compared to his early pictures, these later works are largely disappointing and have generated little interest either from collectors or specialists in the field. Fortunately, exceptions to this rule do exist, including the pictures chosen for the exhibition.

 A Merry Company represents an appealing example of this new direction in Molenaer's art. Displaying a comparatively high quality of execution, the picture's subject matter, modest size, and overall tonality are nevertheless representative of the painter's new artistic interests. Four merrymakers gather around a table in the foreground of a dark interior,

while behind them others seek the warmth generated by the fireplace. The simple floor planks, wooden ceiling beams, barren walls, jugs, and beer barrel identify the room as a tavern. Of all the figures pictured, Molenaer focused his attention on the serving woman seated precariously on the edge of the table. Wearing a tattered skirt and a white apron, she balances herself by placing one of her slippered feet on a foot warmer. In her left hand she holds a pair of metal tongs used to hold hot coals. The manner in which the male merrymakers respond to this woman stands at the heart of the painter's message. Exactly what type of message Molenaer hoped to convey, however, is more difficult to assess.

Has Molenaer directed criticism toward the serving woman and her customers, or, as was suggested in the *Tavern of the Crescent Moon* (cat. 27), were peasant merrymakers, like their more prosperous counter-parts, allowed to partake moments of life's pleasures? In describing a painting by Jan Steen, Perry Chapman outlined the increasing difficulty in applying precise meaning to such images. Her words hold true for Molenaer as much as for his successor Steen.

Steen's Peasants before an Inn *is both cautionary and celebratory, and thus merges these two approaches. On the one hand his treatment of rural life is sympathetic, even idyllic, like Adriaen van Ostade's, to which this picture is indebted compositionally. On the other hand, the intoxicated man in the red cap, reminiscent of Brouwer's smokers, suggests that Steen comments pointedly on the folly of peasant behavior.*[2]

Molenaer's figures drink and sing, but in each instance these activities are downplayed to the extent that they seem not to carry any iconographic weight.[3] The woman, in spite of her less than dignified perch on the table, seems in complete control of her senses. The tongs in her hand appear to function simply as a benign musical instrument rather than a

Fig. 1
Gerrit van Honthorst
Young Girl and a Young Man,
ca. 1620
Oil on canvas, 32 ½ x 26 in.
Herzog Anton Ulrich-Museum,
Braunschweig

Fig. 2
Interior with Five Merrymakers,
ca. mid-1640s
Oil on panel, 14 ½ x 19 ½ in.
Recently art market, New York

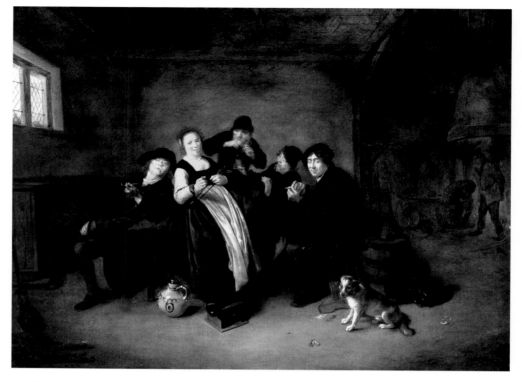

Notes

1 This unfortunate conclusion is
supported by documents and invento-
ries, his extant oeuvre, and prices
realized for his works. For a discus-
sion of Molenaer's late works, see
Weller 1992, pp. 178–209.

2 Washington and Amsterdam 1996,
p. 115.

3 Both the man standing to the left
and the young woman may be keep-
ing time to a melody with the imple-
ments they hold in their hands.

4 Judson 1999, p. 201. The author
also notes the relationship between
Honthorst's composition and the
images and messages appearing in a
number of contemporary emblem
books.

symbol of romantic passion, as is suggested in Gerrit van Honthorst's *Young Girl and a Young Man* (fig. 1). In this example a young woman holds a flaming piece of coal with a similar pair of metal tongs. Judson discussed the picture's intended message: "That we are in the realm of carnal love is supported by seventeenth-century moralizing literary sources, which often equated the love of a woman with that of fire and also warned man that he should be exceptionally careful not to be hurt by it."[4]

Further evidence suggests that increased production rather than a specific message may have been foremost on Molenaer's mind while painting *A Merry Company*. Using it as a representative example of his stock in trade, he recycled a number of its motifs in other paintings from the period. Among them is the equally appealing *Interior with Five Merry-makers* (fig. 2). Here, the same woman in identical circumstances draws the interest of the viewer. As with her twin in the exhibited picture, viewers are neither critical of her actions nor worried about her virtue.

As previously discussed, Molenaer's success in finding a niche in Amsterdam's art market depended heavily on his production of peasant merry companies. Another representative example is *Figures Smoking and Playing Music in an Inn*, a picture recently acquired by the Worcester Art Museum. Here another group of merrymakers occupies a dank, barnlike tavern. Unlike their counterparts in *A Merry Company* (cat. 32), the behavior of the figures in this work is more raucous, portending troubles ahead as they drift toward dissipation. This possibility is enforced by the appearance of a number of telling motifs in the foreground. They include scattered playing cards, a broken pipe, a wine jug, and a sleeping dog. In addition, the drinkers, smokers, musicians, singers, and a couple "dancing" on the left show little resolve to moderate their actions.

Obviously, the extent of Molenaer's possible condemnation of these peasant merrymakers' actions must be gauged against their intended comic appeal. This issue, which stands at the core of the peasant genre, represents a key element in iconographic studies devoted to Northern art. Discussed throughout this volume and debated by scholars for decades, the question remains open whether Molenaer crafted a clear message in *Figures Smoking*

33

Figures Smoking and Playing Music in an Inn

ca. 1640s

Signed on stool: J molenaer

Panel, 15 x 19 ½ in. (38.2 x 49.5 cm.)
Worcester Art Museum, Worcester, Mass., Gift of Robert and Mary Cushman

Provenance:
Private collection, Austria, ca. 1923–24; looted in 1942 by the Germans for Hitler's planned museum in Linz; Allied collecting point, by 1952; transferred to Austrian authorities in 1955; listed in unclaimed

artworks at the Mauerbach
Monastery, near Vienna, in 1986;
returned to ancestors of previous
owner in 1994; sale, Amsterdam,
Sotheby's, 10 November 1998, no. 28;
art market; acquired by The Worces-
ter Art Museum in 1999.

Exhibitions:
None

Literature:
Amblatt zur Wiener Zeitung,
1 February 1986, pl. no. 308; *Apollo
Magazine,* December 1999, p. 27,
illus.

and Playing Music in an Inn.[1] In contrast to his commissioned works linked to literary sources, for example *Peasants Carousing* (cat. 36), pictures devoted to this type of imagery may offer the viewer less to interpret. Because he produced these paintings for the art market in relatively large numbers, Molenaer's thoughts were largely centered on making a sale rather than exploring new iconography. Consequently, ideas about specific meaning need to be viewed against the numbing effect of an endless repetition of merry company scenes coming from Molenaer's studio. Unless evidence to the contrary arises, one should probably refrain from overinterpreting *Figures Smoking and Playing Music in an Inn* and similar pictures.

Such an approach is not new in the study of seventeenth-century Dutch painting. Pictures by Molenaer's successor Jan Steen prompted one researcher to coin the term *iconographic*

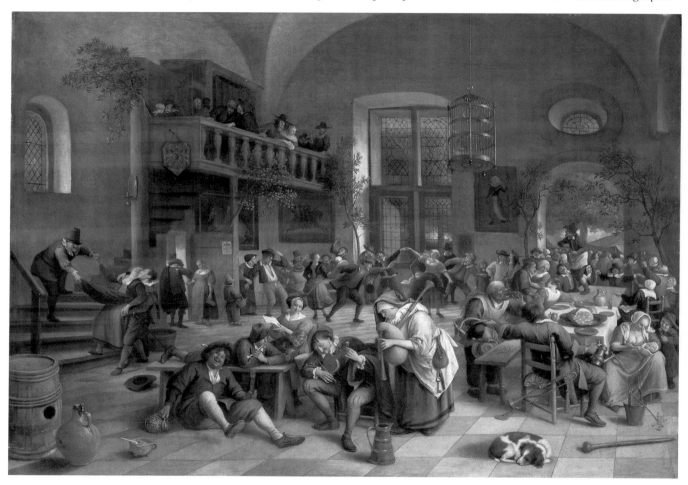

Fig. 1
Jan Steen
Tavern Revel, 1674
Oil on canvas, 46 x 67 ⅛ in.
Musée du Louvre, Paris

erosion in describing the phenomenon.[2] According to this theory, the pointed messages and charged motifs often found in earlier Dutch genre scenes had begun to lose their potency by midcentury, with aesthetic (and comic) considerations now competing with iconographic ones. Steen's *Tavern Revel* (fig. 1) raises some of the same issues as the Molenaer picture, since they both share a number of motifs, such as the sleeping dog, beer barrel, and jug in the foreground. Without Steen's often used device of inserting written texts within his composition, are we to view his image as a call against overindulgence by the many merrymakers, or as a good-humored celebration?[3]

Figures Smoking and Playing Music in an Inn is also intriguing for the clues it provides

to understanding Molenaer's working methods. Extensive underdrawings (fig. 2) show a freedom of technique that rarely surfaces in his finished paintings. Bold and lively lines suggest the basic forms and overall composition, which are then refined and adjusted during the painting process. Consistent with his practice of matching subject matter with palette and style, the completed work, particularly the background, shows a coarse paint application and an overall palette that seldom extends beyond earth tones.[4]

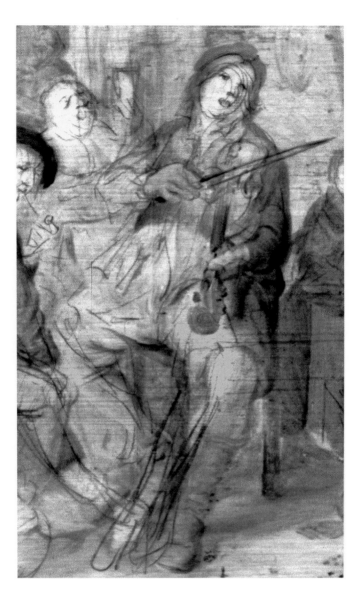

Fig. 2
Figures Smoking and Playing Music in an Inn (detail), ca. 1640–45
IRR computer assembly

Notes

1 Again, the debate between Hessel Miedema and Svetlana Alpers during the 1970s compared the prescriptive versus the descriptive nature of these types of scenes.

2 De Vries 1977, pp. 94–96.

3 Steen often inserted popular sayings and proverbs into his imagery, among them "easy come, easy go," "in luxury beware," and "as the old sing, so pipe the young." See Washington and Amsterdam 1996, nos. 15, 21, and 23.

4 Molenaer's method of adjusting his paint application and palette to specific subject matter is perhaps best seen in the detail of the fighting peasants in his *Allegory of Fidelity* (cat. 13) in Richmond.

34

A Couple in an Interior

1652

Signed and dated on floor tile at lower left: J MOLENAER 1652

Canvas, 20 ⅞ x 16 ⅛ in. (53 x 41 cm.)
The Museum of Fine Arts, Houston
Gift of Mr. and Mrs. John McFadden Jr.

Provenance:
Sir Robert Peel (1788–1850), Drayton Manor, Stafford, before 1841(?); and by descent until 1900; sale, Robinson and Fisher, London, 10 May 1900, no. 233; dealer William C. Dowdeswell, London; C. A. Griscom; sale, 26–27 February 1914, no. 5; dealer Julius Weitzner, New York; Mr. John H. McFadden Jr. by 1950; gift to museum.

Exhibitions:
None

Literature:
Graves 1921, p. 232; Sutton 1986, p. 116.

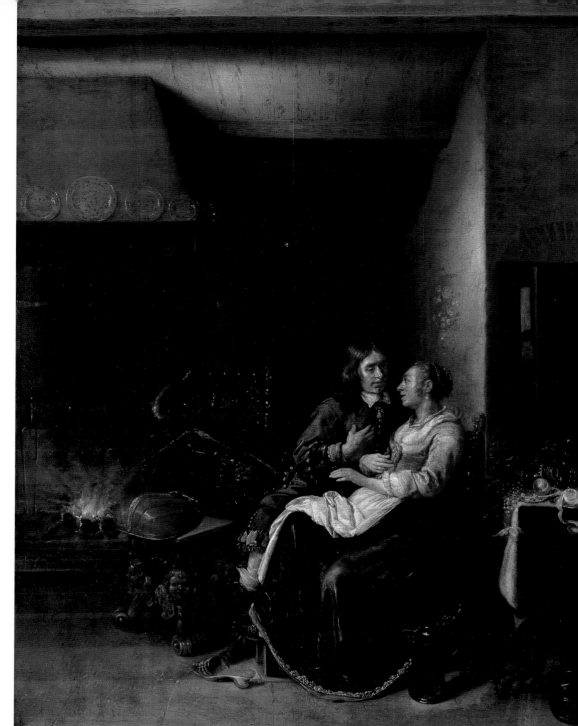

A Couple in an Interior and its date of 1652 come as a surprise in the late oeuvre of Jan Miense Molenaer. For viewers accustomed to the painter's numerous peasant merry companies and outdoor village scenes from the period, this comparatively elegant interior reveals connections with a far different tradition in Dutch genre painting. Representative of the high genre scenes reaching the market in the 1650s, the work shows another side of the artist.[1] This picture and a small group of similarly conceived paintings may also be viewed as "modern" updates of imagery Molenaer had depicted twenty years earlier (cats. 7, 8, and 24).

The 1650s saw Dutch genre painters moving in a new direction that crystallized with the timeless interiors produced by Vermeer and others in Delft after 1658. The simple, rela-

tively naive depictions of merrymakers painted before mid-century by Pieter Codde, Judith Leyster, Dirck Hals, Anthonie Palamedesz., and many others, including Molenaer, were out of fashion by midcentury. In their place appeared the refined scenes of elegantly dressed men and women enjoying the simple pleasures of musical performance, drinking, and letter writing. Besides Vermeer, the painters responsible for these masterpieces include Pieter de Hooch, Gabriel Metsu, Gerard ter Borch, Jacob Ochtervelt, and on occasion Jan Steen. Two others, however, Jacob van Loo and his Amsterdam colleague Gerbrand van den Eeckhout, served as "the progenitors of a new elegant conversation piece around 1650."[2] Molenaer, who was no stranger to Amsterdam, appears to have briefly been attracted to the innovations of one or both of these important but underappreciated painters.

A comparison between *A Couple in an Interior* and Van Eeckhout's *Party on a Terrace* (fig. 1), for example, offers evidence of strong stylistic connections between the two artists. Not only do the pictures share a number of features, but both carry a date of 1652. In each, a well-dressed man with long flowing hair is engrossed in conversation with his female companion. Both men look deeply into the eyes of their willing partners, and each offers himself to the woman with an identical hand gesture. The compositions also include tables with a beautifully rendered still life of fruit, glasses of wine, and other objects, and both artists placed a lute sitting unused next to the figures. Even a cursory inspection of these early examples of the high genre suggests the primary theme is one of love. The music has stopped and more serious concerns take center stage. In the garden of Van Eeckhout's scene, a sculpture representing Cupid confirms an amorous theme, as does the subtle placement of the suitor's left hand on the woman's shoulder in the Molenaer. Do passions run as hot as the blazing fire in *A Couple in an Interior*? Will the woman respond to the man's offer, and if she does, will the figure spying on the couple from behind the partially closed door have tales to tell?

Fig. 1
Gerbrand van den Eeckhout
Party on a Terrace, 1652
Oil on canvas, 20 ¼ x 24 ½ in.
Worcester Art Museum, Worcester, Mass.

Fig. 2
Lovers in a Bedroom, ca. 1650–53
Oil on panel, 14 ¼ x 13 in.
Whereabouts unknown

By contrast, another example painted by Molenaer in this refined manner appears more obvious in its amorous message. *Lovers in a Bedroom* (fig. 2), which must date to about the same time, reveals the subject of the choice between age and youth.[3] Related to the traditional theme of unequal lovers, it finds a foolish old man offering money for the attentions of a vivacious young woman. Her flirtatious response and the role played by her young male companion serve as the punch line to the long-playing comedy routine.

Although the style employed in *A Couple in an Interior* conveys many of the elements developed by Molenaer's more famous contemporaries, it should not be confused for one of their pictures. Molenaer remained a painter of his generation, and not the succeeding

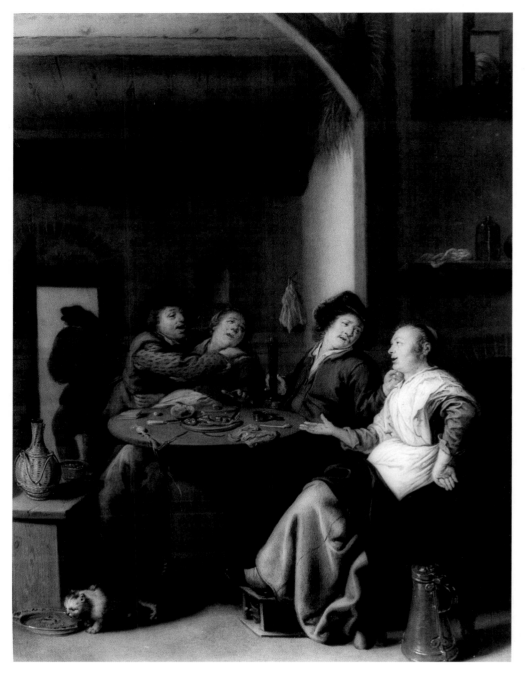

Notes

1 This issue is surveyed by Sutton in Philadelphia, Berlin, and London 1984, pp. xxxii–xxxiii, xliv–xlvi, and lii–lvii.

2 Otto Naumann, ibid., p. 238.

3 Another example by Molenaer in his high-genre style (private collection, Columbus, Ohio, oak, 36 x 32.5 cm.) reflects a similar choice between age and youth.

4 *A Couple in an Interior* did find two famous supporters early in the nineteenth century, as Sir Robert Peel acquired the picture through John Smith upon the advice of Sir David Wilke.

one. The couple's fine clothing and the fancy table still life cannot obscure the simple interior setting, comparatively limited palette, and underlying coarseness in the paint application. After painting just a handful of pictures in this manner, Molenaer seems to have abandoned high genre during the remaining sixteen years of his career. He quickly returned to the representation of boisterous peasant merrymakers. Such examples drew upon works he had painted during the 1640s, including *A Tavern Interior* (fig. 3). It will never be known if this decision to briefly flirt with high genre was based on the art market, his temperament, or some other reason.[4]

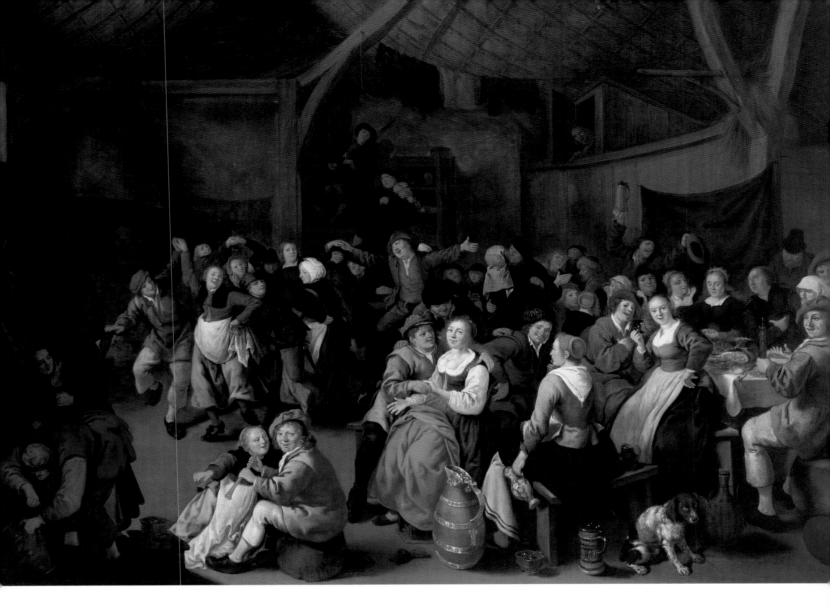

Molenaer showed a remarkable resolve to turn adversity to his advantage during the most momentous periods in his life. In the year 1636, for example, bankruptcy, the death of his father, and an impending move from Haarlem to Amsterdam seem to have accelerated his output and inventiveness. To a lesser degree, the same could be said for the period beginning in 1659 and lasting until 1662. In the autumn of 1659, Molenaer and his wife, Judith Leyster, "were so ill that they had a joint will drawn up at The Lamb in Heemstede on Thursday, 6 November, at 4 o'clock in the afternoon."[1] Sadly, Judith Leyster passed away a few months later in February 1660. Molenaer not only survived, but this period of illness and loss of his wife fell between the completion of arguably the most accomplished and ambitious paintings from the last three decades of his career.

Although undated, the *Peasant Wedding Feast* is stylistically related to two important signed and dated pictures from 1659 (fig. 1) and 1662 (cat. 36). All three works share many motifs and architectural details, and the infectious spirit Molenaer imparted to the crowds of merrymakers is enhanced by his use of lighting, passages of strong local colors set against tonal backdrops, and a contrast between smooth and coarse brushwork. Nearly twice as large as its counterpart in Berlin (fig. 1) and painted on canvas rather than oak, the *Peasant Wedding Feast* seems to have been executed about the same year. The two are similar in brushwork and lighting, and the feasts take place in nearly identical interior

35
Peasant Wedding Feast

ca. 1659–60

Monogrammed on leather pouch at lower right: JM (in ligature)

Canvas, 36 ⅝ x 52 ⅛ in. (93 x 133 cm.)
Private collection, Europe
By courtesy of Art Dealers Hoogsteder & Hoogsteder, The Hague, The Netherlands

Provenance:
Private collection

Exhibitions:
The Hague and Antwerp 1994, no. 28, pp. 242–47.

Literature:
Weller 1992, pp. 199, 480, fig. 79; Buijsen 1997, pp. 57–58.

spaces with many of the same motifs.[2] Like elements of the slightly later documented painting in Boston (cat. 36), the scale, complexity, and high quality of the *Peasant Wedding Feast* suggest it represented an important commission for Molenaer.

The *Peasant Wedding Feast* depicts nearly four dozen village merrymakers celebrating the event with food and drink, music and dancing. The bride sits to the far right before a hanging wedding cloth, a reserved behavior common in her day.

She wears a bride's crown on her loose hair, as does the woman next to her who may be one of the bridesmaids. According to the then prevailing custom, the bride had to remain seated, motionless and with folded hands throughout the entire wedding. Furthermore, she was not allowed to eat a thing. As in most sixteenth- and seventeenth-century representations of wedding celebrations, the groom cannot be identified. Is he the merry tippler at the far right raising his flute glass, or has he joined the crowd on the dance floor?[3]

Among the crowd are a seated young girl and boy in the foreground. They, in fact, may be previewing their future, for behind them are many other couples, young and old alike. As a subject type, village weddings figured significantly in Molenaer's oeuvre from the 1650s and 1660s.[4] His many depictions of wedding processions and feasts followed the tradition established by Pieter Bruegel the Elder, and clearly Molenaer was an active participant in a Bruegel revival as early as the late 1620s. In the case of the *Peasant Wedding Feast*, however, the painter's ties to this Flemish master were quite literal. As a form of homage to the elder Bruegel, Molenaer inserted one of the dancing couples from the Flemish master's *The Wedding Dance* (fig. 2) into his crowd of merrymakers. They appear as one of the two pairs in the middle ground at the left, specifically the man wearing a codpiece and looking over his shoulder to his partner

in the white headdress. It is probably no coincidence that, in the inventory of Molenaer's effects taken after his death, there appears "*Een grote pannebrul(o)ft nae Breugel* (A large pancake [wedding] party after Bruegel)."[5]

Peasant feasts, particularly those representing village weddings, carried a variety of mes-

sages regarding overindulgence and other types of misbehavior. It seems little had changed in the decades separating Bruegel and Molenaer, as warnings against such activities continued to be commonplace in emblem books, on inscriptions for prints, and in other writings from the first half of the seventeenth century. One notable source was Bredero, whose impact on Molenaer's art has already been discussed in his *Scene from Bredero's "Lu-*

Fig. 3
Marcus Gheeraerts
The Ape and the Cat, in J. van den Vondel, *Vorstelijke Warande der Dieren*, Amsterdam, 1617

Notes

1 Haarlem City Archives (GAH), Notary archive W. van Kittensteyn, 285, folio 211. For a summary and transcription of this document, see Weller 1992, pp. 334–37.

2 As has been noted elsewhere, Molenaer constantly repeated motifs and figures in his compositions. Bogendorf Rupprath, writing on workshop practice, addresses this issue.

3 Buijsen in The Hague and Antwerp, p. 242.

4 In addition to numerous indoor wedding feasts, Molenaer also painted wedding processions on a few occasions. They include a dated example from 1652, *Wedding Party* (canvas, 74.5 x 106 cm., Frans Halsmuseum, Haarlem, inv. I-260), and *Village Wedding* (panel, 66.5 x 87 cm., Museum of Art and History, Geneva, inv. 1873-2). Both are illustrated and discussed in Weller 1992, figs. 71–72.

5 The work was inventoried in the second-story front room of Molenaer's Haarlem house on the Burgwal. The date was 10 October 1668 (Haarlem municipal archive [GAH], NA 303, unfolioed). An incomplete inventory was first published by Bredius 1915–21, pp. 1–9. Hofrichter 1989, pp. 87–103, published the entire inventory.

6 The Hague and Antwerp 1994, p. 245.

7 Discussed and illustrated by Buijsen 1997.

celle" (cat. 29). Buijsen, in writing on the *Peasant Wedding Feast*, linked the painter and the writer, as well as the tradition established by Bruegel. He stated that the work "is composed entirely in the spirit of Bredero. There is plenty of 'drinking, singing, roaring and dancing,' though not without a warning."[6]

The warning comes in the form of a small, easily overlooked detail in the background of Molenaer's picture. Hanging on the far wall to the left of center is an image of an ape holding the paw of a cat to a fire. This image can be identified with a print first appearing in a 1567 Dutch edition of *De Warachtige Fabulen der Dieren* (*True Fables of the Animals*) by the Greek writer Aesopus and later adapted by the printmaker Marcus Gheeraerts (fig. 3) for Joost van den Vondel's *Vorstelijke Warande der Dieren* (*Royal Hunting Grounds of Animals*) of 1617.[7] The print can be associated with the expression "u pijne voel ick niet" ("I do not feel your pain"), a message intended for the dancing couples, who, like the monkey and cat, link their hands. While the cruel ape is immune to the pain it inflicts on the cat, viewers are forewarned against being lured into overindulgent behavior that could put them at risk and ultimately cause pain.

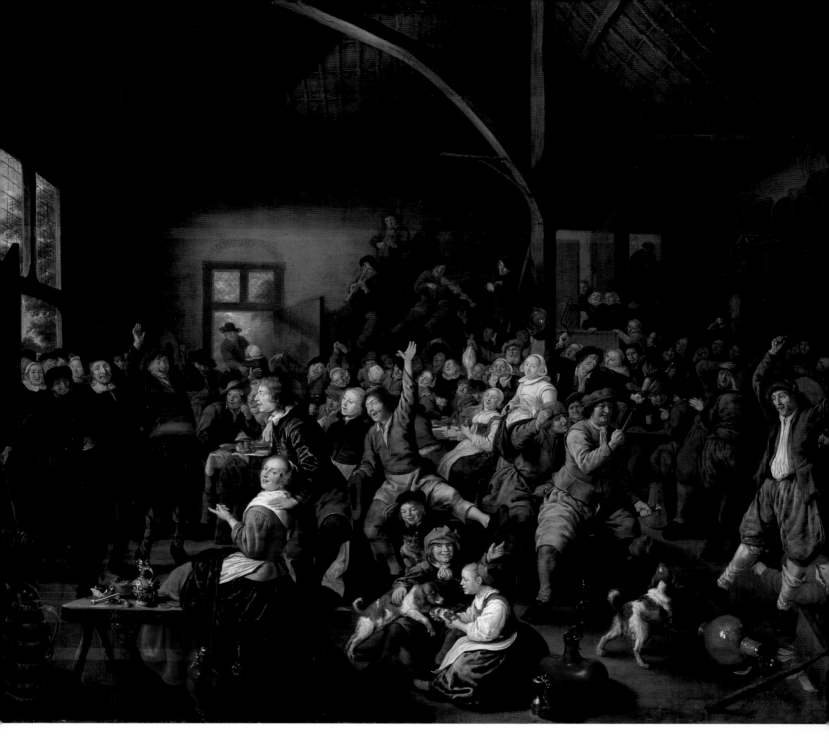

36

Peasants Carousing

1662

Signed and dated on bench at lower left: Jan Molenaer 1662

Canvas, 42 ⅞ x 49 ⅝ in. (109 x 126 cm.)
Museum of Fine Arts, Boston
Purchased from the James Collection

With the ambitious *Peasants Carousing*, dated 1662, Molenaer supplied a finishing touch to his series of late masterworks begun three years earlier. Described as continuing "the Haarlem tradition of peasant scenes founded by Adriaen Brouwer and Adriaen van Ostade," and resembling "in many ways the work of Molenaer's younger contemporary Jan Steen," the picture effectively summarizes the career of the painter.[2] Strong evidence related to the scale, quality, and imagery found in *Peasants Carousing* links the work to a specific document outlining the circumstances of its commission in 1662.

The composition centers on a large, barnlike structure that serves as the setting for scores of spirited merrymakers. In many ways the work provided Molenaer with a vehicle to

survey subject matter that had long been part of his pictorial repertoire. Children holding pets first appeared in the late 1620s, beautifully described still-life arrangements in the 1630s, and merrymakers with portraitlike features throughout the first half of his career. Another recurring motif, a well-dressed couple in close proximity to their peasant counterparts, is represented by the man and woman just to the left of center. Typically, such pairs point and gesture to their unfortunate brethren, who are usually engaged in less than virtuous activities. Such is the case here, for the scene is filled with a variety of excesses. One vice naturally leads to another, as viewers are subjected to a knife fight that has broken out between a few of the drinkers and card players at the right.

The care of execution lavished by the painter on so many of the figures is rarely found in his oeuvre after 1640. A subtle but wonderfully effective silvery light illuminates the room and the many merrymakers who participate in a peasant kermis. Popularized a century earlier in images by Pieter Bruegel the Elder, this type of subject was central to the iconographic controversy among scholars during the 1970s.[3] Lacking specific information on the commissions and literary sources for such scenes, researchers were at a disadvantage in reaching firm conclusions about intended messages for the contemporary viewer. *Peasants Carousing* may shed light on the controversy, as the literary source for the imagery can be documented, thus providing insights into the work's meaning.

The genesis of the large and engaging *Peasants Carousing* is summed up in a document dated 2 February 1662. Molenaer and Jacob van Amersfoort had entered into an agreement with regard to an interest payment on the painter's home in Heemstede. Functioning as a form of barter, the paintings mentioned in this important document provide a rare glimpse into the commissioning of genre pictures by a seventeenth-century Dutch painter.

Jacob van Amersfoort, now living in Haarlem, declares to have bought and received from Mr. Jan Miensen Molenaer, master painter, some piece of painting of Arent Pieter Gijsen, painted by Jan Miensen Molenaer himself for 380 guilders.

Jacob van Amersfoort has to pay for the frame, on condition that Molenaer will make for him a small piece of painting, that has to be however of more value than the foresaid frame.

Provenance:
Jacob van Amersfoort, Haarlem, in 1662.[1] Private collection; probably sale, London, Christie's, 22 November 1902, no. 56; Edward Balfour, Balbirnie, N.B.; sale, London, Christie's, 31 May 1907, no. 142; dealers, Gooden and Fox, London; acquired by museum in 1907.

Exhibitions:
Hartford 1950, no. 36.

Literature:
Boston 1907, pp. 57–58; Bredius 1915–22, p. 23; Walsh and Schneider 1979, pp. 504–05, fig. 6; Boston 1985, p. 203, illus.; Weller 1992, pp. 194–98, 254–56, 418, fig. 77; Buijsen in The Hague and Antwerp 1994, pp. 242–45, fig. 1; Weller 1996, p. 814, illus.; Westermann in Washington and Amsterdam 1996, p. 65, note 16; Westermann 1997, p. 127, note 46, pp. 210–12, fig. 113.

Wie sal niet vande feest en boerekermis walgen: Men doet er anders niet als veeten swelgen balgen: Men vedel snreingt en danst, men sackpijpt en men fluyt, En eer di kennis scheid soo raeckt het mesken uyt.

Fig. 1
Michel le Blon (?)
Merry Company, 1621, in G. A. Bredero, *Boertigh, amorous, en aendachtig Groot lied-boeck*, Amsterdam, 1622

Notes

1 As discussed below, it appears that
Jacob van Amersfoort commissioned
the painting from Molenaer. The
value of the picture represented part
of an interest payment on the painter's
home in Heemstede.

2 Walsh and Schneider 1979, p. 504.

3 See, for example, Miedema 1977
and Alpers 1975–76.

4 This document (Haarlem Municipal
Archives [GAH], Notary archive [NA]
290, folio 59, verso) was first pub-
lished by Bredius 1915–22, vol. 1,
p. 23. Also see Weller 1992,
pp. 194–97, 254–55.

5 Ibid. This popular text went
through a number of editions during
the seventeenth century. For a discus-
sion of the book and its illustrations,
see Stuiveling 1983.

6 The print has been attributed to
various artists, including Jan van de
Velde, Michel de Blon, and Pieter
Serwouters after De Blon. See Van
Thiel in Stuiveling 1983, pp. 89–95.
The inscription (in Dutch) reads:

Wie sal niet vande feest en boereker-
mis walgen? / Men doeter anders niet
als vreten swelgen balgen? / Men
vedelt speingt en danst, men sackpijpt
en men fluijt, / En eer de kermis
scheid soo raekt het mesken uijt.

7 Miedema 1977, p. 213.

8 Ibid.

Molenaer gives his promise to do so. The 380 guilders
will be used to deduct the interest of the capital, which
was set up [on] Molenaer's house or farmstead in
Heemstede.[4]

The Boston picture clearly matches the parameters set
forth in this document and, more important, identifies the
literary source for the picture. Described as a "piece of
painting of *Arent Pieter Gijsen,*" these words represent the
beginnings of a comical song entitled "Boeren-Gezelschap"
("Peasant Company") taken from the *Boertigh, amorous,*
en aendachtig Groot lied-boeck of 1622.[5] Written by the
Dutch writer Gerbrand Adriaensz. Bredero, this popular
book largely denounces the riotous behavior of the peas-
ants. A translation of the inscription on the print opposite
the first page of the song makes its message clear (fig. 1). In
a similar vein, Molenaer's painting expresses much of the same spirit, and presumably a
similar message.

Who isn't sickened by the feast and the peasant kermis?
All they do is guzzle, swill and get bloated.
They fiddle, caper and dance. Play the bagpipes and the fife,
And before they get fuddled out come the knives.[6]

Bredero described in some detail the events that preceded the knife fight. Miedema pub-
lished a summary translation.

Six peasants from an unspecified village travel together to the village of Vinkeveen, be-
tween Amsterdam and Utrecht, where there is to be a contest to see who can snatch up a
goose while riding on a farm cart. One of the peasants is dressed in sober colors, like a
townsman. His hat is tilted at a jaunty angle. The other five are colorfully dressed in the
traditional peasant fashion. In Vinkeveen these six peasants encounter another eight. Oth-
ers are mentioned in the course of the poem. The local girls are also dressed up in their
finery, and one of them has rented a piece of frippery from another girl. The peasants
gorge themselves, drink, sing, caper and dance, play dice and gamble. They call for wine,
and each one reckons he's cock of the walk. The first knife is drawn; five, six peasants are
wounded. The girls flee, tankards and candlesticks are overturned. One of the Vinkeveen
villagers is killed.[7]

The description closely parallels Molenaer's visual translation of the song's closing
scenes. Not surprisingly, Molenaer seems to have turned to *Arent Pieter Gijsen* on other
occasions. One of his rare extant drawings (fig. 2), for example, shows "six peasants,"
including one whose "hat is tilted at a jaunty angle," on their way to parts unknown.
Mimicking the words of Bredero, Molenaer may have intended such scenes to fulfill
the same function as the writer's comic song: to amuse and instruct. At the end of the
"Boeren-Gezelschap," Bredero appealed to his readers to avoid joining in coarse country
life. "Ye gentlemen, ye burghers, pious and in good spirits, Avoid peasant feasts, they are
rarely so pleasant as not to cost someone his blood, And drink with me a rummer of wine,
For that is far better for you."[8] One may speculate whether Molenaer intended the same.

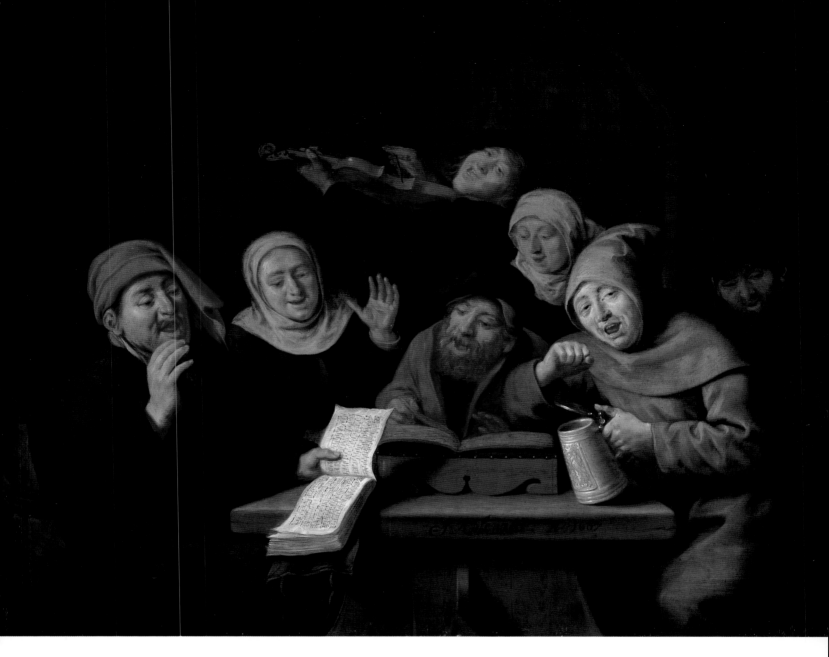

Although their demeanors are similar, the brash, young merrymakers Molenaer captured in paint early in his career have aged considerably in his last dated picture, coming just a year before his death. Molenaer focused his interest on seven large-scale figures occupying the foremost reaches of a dark interior. This secular choir belts out lyrics read from songbooks and accompanied by music provided by a younger fiddle player.[1] Counted among them is a monk, whose open mouth is contrasted with his nearly closed eyes. His appearance undoubtedly results from overindulgence in alcohol, evidenced by the tankard he holds in his left hand.

While the presence of the monk may hold iconographic secrets, it seems the tone of the scene is neither critical nor overly negative. This picture also serves to summarize the painter's career, but in ways far different from the previously discussed *Peasants Carousing* (cat. 36). In addition, the imagery again suggests links between Molenaer, his predecessor Pieter Bruegel the Elder, and his successor Jan Steen. In discussing a comparable picture by Steen painted just a few years later, for example, the author could have been speaking of Molenaer and the *Merry Company at a Table*.

37
*Merry Company
at a Table*

1667

Signed and dated on edge of tabletop:
JMolenaer A 1667
(JM in ligature)

Panel, 19 ¼ x 20 ⅞ in. (48.8 x 52.9 cm.)
Private collection

Provenance:
Ronald Cook, London; Waterman
Gallery, Amsterdam, by 1986; acquired
by present owners in 1986.

Exhibitions:
None

Literature:
Unpublished

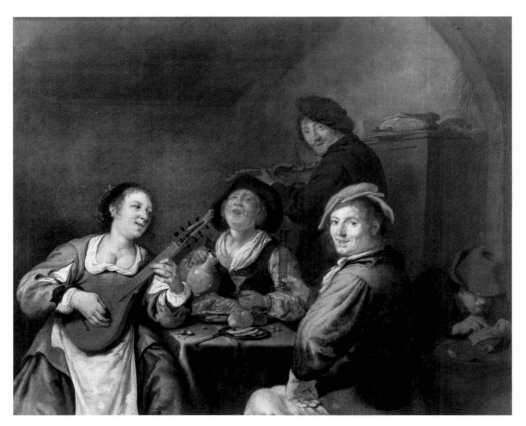

Fig. 1
Merry Company, ca. 1650s
Oil on canvas, 27 ⅞ x 30 ⅛ in.
Museum Boijmans van Beuningen,
Rotterdam

It was Steen's genius that he could imbue stock characters with such new life and impart to an old, by his time clichéd, subject such clever narrative possibilities. Throughout his career, Steen was often deliberately anachronistic in playing on pictorial traditions that his contemporaries would have recognized as old-fashioned, but in his late works this witty, eclectic archaizing seems to have become intensified and more varied.[2]

Considering its compact composition, the scale of the figures, and the use of stock characters, one is tempted to connect the *Merry Company at a Table* to Molenaer's early rather than late career. But stylistic characteristics, particularly the orange-tinted palette and broad, somewhat coarse brushwork, are characteristic of his last few pictures. Why Molenaer employed such an outdated compositional mode is unknown—perhaps for a commission—but such a practice is not unique in his oeuvre. In addition, Molenaer periodically returned to this particular compositional format from time to time, as he did in the *Merry Company* (fig. 1).[3]

Signed but not dated, *Merry Company* from the Museum Boijmans van Beuningen may have been executed during the same decade as the *Merry Company at a Table*.[4] More important, the painting shares a number of compositional features with the exhibited picture. They include the forward placement of the expressive, three-quarter-length figures around a table and the cursory treatment of the background. The number of participants has been reduced from seven to five, however, and their behavior strikes a somewhat different tone. While music remains a focus, as evidenced by the seated cittern player and the standing fiddler, it appears the other merrymakers have eating, drinking, and smoking on their minds. Molenaer may intend us to weigh the impact of their overindulgence.

Although none of the characters in the present painting [fig. 1] are guilty of the worst excesses such as fighting or vomiting, Molenaer's view of peasant life is unflattering. It is in any event clear from the woman's low décolleté, the raised glass, and the smoker who all but disappears into the brazier, that they are not exemplars of moderation.[5]

The call for moderation in light of overindulgence is certainly a theme Molenaer celebrated throughout his career. In the *Merry Company* (fig. 2) from the late 1620s, for example, he had already addressed these concerns. Did he apply the same sentiments to the *Merry Company at a Table*?

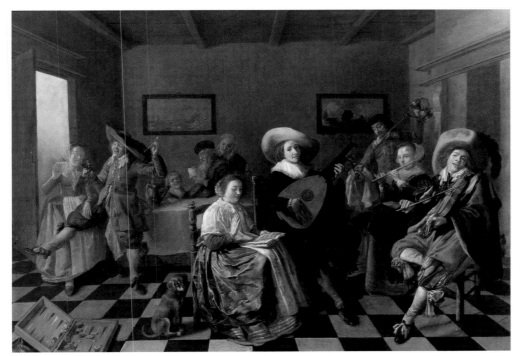

Fig. 2
Merry Company, ca. 1628–29
Oil on panel, 22 ½ x 31 ½ in.
Courtesy of David Koetser Gallery,
Zurich

Notes

1 This violinist reappears in a number
of pictures by Molenaer. Among them
is the *Tavern Scene* from the Uffizi,
Florence; see color illustration in
Florence 1987, p. 42.

2 Washington and Amsterdam 1996,
p. 237.

3 Discussed by Lammertse in Rotter-
dam 1998, pp. 116–17.

4 The lighter tonality and somewhat
more colorful palette suggest a date
early in the 1660s if not the 1650s.

5 Rotterdam 1998, p. 117.

6 One of the few exceptions is found
in the *Battle between Carnival and
Lent* (cat. 18). In this example, the
presence of the monks is obviously
dictated by the subject matter.

7 The presence of the monk as a
participant in the festivities again
emphasizes Molenaer's ties to the
Bruegel tradition. In Pieter Bruegel
the Elder's *Peasant Wedding Feast*
in Vienna, for example, a monk sits
among the celebrants at the far right.

Although it lacks specific links to the forms of overindulgence detailed in this work or the Rotterdam picture, how might the *Merry Company at a Table* be interpreted? Certainly the inclusion of a drunken monk might hold the key to any possible meaning, but how significant is his presence? Since monks rarely appear in Molenaer's pictures, it is difficult to assess possible meaning based on earlier usage.[6] Is Molenaer being critical of the Catholic faith from which he may have converted prior to marrying Leyster? Does the monk simply function as a comedic device to be enjoyed uncritically by the viewer? Perhaps Molenaer purposely left the question of meaning ambiguous, for to reveal too much ultimately detracts from the mystery and joy of the work.[7]

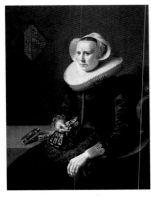

CATALOGUE 15
Portrait of a Woman with Embroidered Gloves
Courtesy of Otto Naumann Ltd., New York

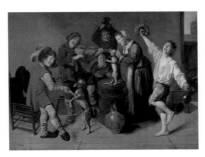

CATALOGUE 16
Children Playing and Merrymaking
Peter and Hanni Kaufmann

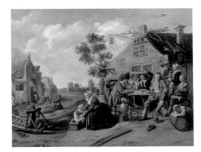

CATALOGUE 17
Peasants near a Tavern
Frans Hals Museum, Haarlem, loan Institute Collection Netherlands

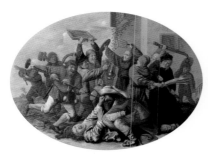

CATALOGUE 18
Battle between Carnival and Lent
Indianapolis Museum of Art

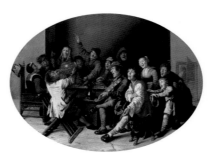

CATALOGUE 19
The King Drinks
Collections of the Prince of Liechtenstein, Vaduz Castle

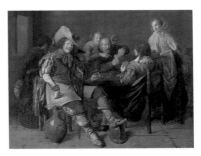

CATALOGUE 20
Card Players
Currier Museum of Art, Manchester, N.H.

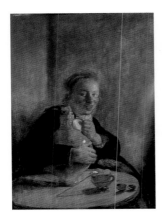

CATALOGUE 21
Woman Holding a Jug
Museum of Fine Arts, Boston

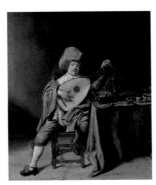

CATALOGUE 22
Self-Portrait as a Lute Player
Private collection

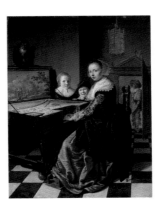

CATALOGUE 23
Woman Playing a Virginal
Rijksmuseum, Amsterdam

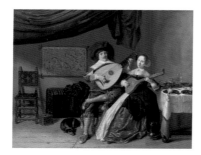

CATALOGUE 24
The Duet
Collection of Mr. Eric Noah

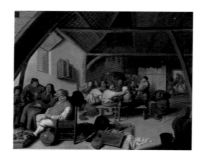

CATALOGUE 25
The Fat Kitchen
Private collection, United Kingdom

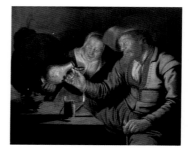

CATALOGUE 26
The Five Senses: Sight
Royal Cabinet of Paintings,
Mauritshuis, The Hague

Hearing

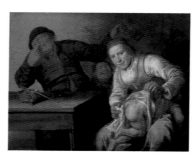

Smell

Taste

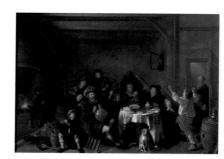

CATALOGUE 27
Tavern of the Crescent Moon
The Museum of Fine Arts, Budapest

CATALOGUE 28
A Family Merrymaking
Victoria & Albert Museum, London

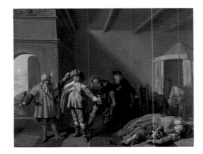

CATALOGUE 29
Scene from Bredero's "Lucelle"
Theatre Museum, Theatre Institute
Netherlands, Amsterdam

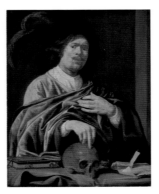

CATALOGUE 30
Self-Portrait with a Skull
Bayerische Staatsgemäldesammlungen,
Munich

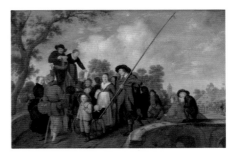

CATALOGUE 31
An Itinerant Ballad Reader on a Bridge
Staatliche Museen zu Berlin, Gemäldegalerie

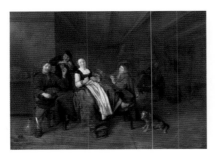

CATALOGUE 32
A Merry Company
Private collection, United Kingdom

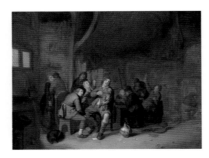

CATALOGUE 33
*Figures Smoking and Playing Music
in an Inn*
Worcester Art Museum, Worcester, Mass.

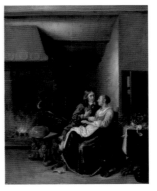

CATALOGUE 34
A Couple in an Interior
The Museum of Fine Arts, Houston

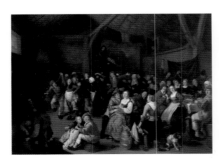

CATALOGUE 35
Peasant Wedding Feast
Private collection, Europe

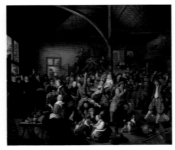

CATALOGUE 36
Peasants Carousing
Museum of Fine Arts, Boston

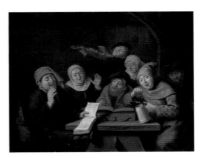

CATALOGUE 37
Merry Company at a Table
Private collection

Bibliography

Books and Articles

Alpers 1972–73. Svetlana Alpers. "Bruegel's Festive Peasants." *Simiolus*, vol. 6 (1972–73), pp. 163–76.

Alpers 1975–76. Svetlana Alpers. "Realism as a Comic Mode: Low-Life Painting Seen through Bredero's Eyes." *Simiolus*, vol. 8 (1975–76), pp. 115–41.

Amerson 1975. Lawrence Price Amerson Jr. "The Problem of Écorché: A Catalogue Raisonné of Models and Statuettes from the Sixteenth Century and Later Periods." Ph.D. diss., Pennsylvania State University, 1975.

Ampzing 1628. Samuel Ampzing. *Beschryvinge der Stad Haerlem in Holland.* Haarlem, 1628.

Angel 1642. Philips Angel. *Lof der schilder-konst.* Leiden, 1642.

Ayres 1985. James Ayres. *The Artist's Craft: A History of Tools, Techniques, and Materials.* Oxford, 1985.

Bal 1987. Mieke Bal. *Lethal Love: Literary Feminist Readings of Biblical Love Stories.* Bloomington, Ind., 1987.

Bauch 1960. Kurt Bauch. *Der frühe Rembrandt und seine Zeit: Studien zur geschichtlichen Bedeutung seines Frühstils.* Berlin, 1960.

Bazin 1952. Germain Bazin. "La notion d'intérieur dans l'art néerlandais." *Gazette des Beaux-Arts*, vol. 39 (1952), pp. 5–26, 62–67.

Beaujean 2001. Dieter Beaujean. *Bilder in Bildern: Studien zur niederländischen Malerei des 17. Jahrhunderts.* Weimar, 2001.

Bernt 1960–62. Walter Bernt. *Die niederländischen Maler des 17. Jahrhunderts.* Munich, 1960–62.

Bernt 1969–70. Walter Bernt. *The Netherlandish Painters of the Seventeenth Century.* Trans. P. S. Falla. London, 1969–70.

Biens 1636. Cornelis Pietersz Biens. *De Teecken-Const.* Amsterdam, 1636.

Bode 1871. Wilhelm von Bode. "Frans Hals und seine Schule." *Jahrbuch für Kunstwissenschaft*, vol. 4 (1871), pp. 1–66.

Bode 1883. Wilhelm von Bode. *Studien zur Geschichte der holländischen Malerei.* Braunschweig, 1883.

Bode 1894. Wilhelm von Bode. "Die Kleinmeister der holländischen Schule in der Galerie des Fürsten von Liechtenstein." *Die graphischen Künsten*, vol. 17 (1894), pp. 79–102.

Bode and Bredius 1890. Wilhelm von Bode and Abraham Bredius. "Der haarlemer maler Johannes Molenaer in Amsterdam." *Jahrbuch der königlich preussischen Kunstsammlungen*, vol. 11 (1890), pp. 65–78.

De Boer 1991. Marjolein de Boer and Josefine Leistra. *Bredius, Rembrandt en het Mauritshuis!!!* Mauritshuis, The Hague, 1991.

Bok 1994. Marten Jan Bok. "Vraag en Aanbod op de Nederlandse Kunstmarkt, 1580–1700." Ph.D. diss., Universiteit van Utrecht, 1994.

Boston 1994–95. *The Museum Year: The One Hundred Nineteenth Annual Report of the Museum of Fine Arts, Boston.* Boston, 1994–95.

Bredero 1622. G. A. Bredero. *Boertigh, Amoreus en Aendachtigh Groot Lied-Boeck.* Amsterdam, 1622.

Bredero 1885–90. G. A. Bredero. *De werken van G. A. Bredero.* Ed. J. ten Brink et al., 3 vols. Amsterdam, 1885–90.

Bredius 1888–90. Abraham Bredius. "Het verblijf van Jan Miense Molenaer te Amsterdam, in documenten." *Obreen's Archief voor Nederlandsche Kunstgeschiedenis*, vol. 7 (1888–90), pp. 289–303.

Bredius 1908. Abraham Bredius. "Jan Miense Molenaer: Nieuwe gegevens omtrent zijn leven en zijn werk." *Oud Holland*, vol. 26 (1908), pp. 41–42.

Bredius 1915–22. Abraham Bredius. *Künstler-Inventäre: Urkunden zur Geschichte der holländischen Kunst des XVI-ten, XVII-ten und XVIII-ten Jahrhunderts*, 7 vols. The Hague, 1915–22.

Brieger 1922. Lothar Brieger. *Das Genrebild: Die Entwicklung der bürgerlichen Malerei.* Munich, 1922.

Brongers 1964. Georg A. Brongers. *Nicotiana Tabacum: The History of Tobacco and Tobacco Smoking in the Netherlands.* Amsterdam, 1964.

Brown 1984. Christopher Brown. *Images of a Golden Past: Dutch Genre Painting of the Seventeenth Century.* New York, 1984.

Bruyn-Berg 1978. C. E. Bruyn-Berg. "Bredero's 'Lucelle,' Jan Miense Molenaer (ca. 1610–1668)." *Vereniging Rembrandt: Nationaal Fonds Kunstbehoud*, 1978, pp. 25–28.

Buijsen 1997. Edwin Buijsen. "Marcus Gheeraerts (1521–ca. 1604)." *Delineavit et Sculpsit*, no. 17 (March 1997), pp. 57–58.

Bulletin 1958. "Le Musée des Beaux-Arts en 1957: Nouvelle aquisitions." *Bulletin du Musée Hongrois des Beaux-Arts*, vol. 12 (1958), pp. 77–84.

Bulwer 1644. John Bulwer. *Chirologia: Or the Naturall Language of the Hand . . . Whereunto Is Added Chironomia: Or the Art of Manuall Rhetoricke.* London, 1644.

Carroll 1987. Margaret Carroll. "Peasant Festivity and Political Identity." *Art History*, vol. 10 (1987), pp. 289–314.

Chaney 1992. Liana DeGirolami Chaney, ed. *The Symbolism of Vanitas in the Arts, Literature, and Music.* Lewiston, N.Y., 1992.

Christie and Wadum 1992. Nicki Christie and Jørgen Wadum. "De grond der zinnen." *Mauritshuis Nieuwsbrief*, vol. 5 (May 1992), pp. 9–11.

Daniëls 1976. G. L. M. Daniëls. "Doe heb ick uyt verkooren . . . " *Antiek*, vol. 11 (November 1976), pp. 329–41.

Decker and Roodenburg 1984. R. Decker and H. Roodenburg. "Humor in de zeventiende eeuw: Opvoeding, huwelijk en seksualiteit in de moppen van Aernout van Overbeke (1632–1674)." *Tijdschrift voor Sociale Geschiedenis*, vol. 10 (1984), pp. 243–66.

Dekker 2001. Rudolf M. Dekker. *Humour in Dutch Culture of the Golden Age.* Basingstoke and New York, 2001.

Van Deursen 1991. A. T. van Deursen. *Plain Lives in a Golden Age.* Cambridge, 1991. Trans. Maarten Ultee.

Diepen and Snethlage 1990. Alice van Diepen and Henriëtte Fuhri Snethlage. *Haarlem en Hals: Een stad en zijn schilder.* Zwolle, 1990.

Durantini 1983. Mary Frances Durantini. *The Child in Seventeenth-Century Painting.* Ann Arbor, 1983.

Eastlake 1847. Charles Lock Eastlake. *Materials for a History of Oil Painting* (1847). New York, Dover reprint, 1960, 2 vols.

Van Eck 1999. Xander van Eck. "The Artist's Religion: Paintings Commissioned for Clandestine Catholic Churches in the Northern Netherlands, 1600–1800." *Simiolus*, vol. 27 (1999), pp. 70–94.

Eisler 1977. Colin Eisler. *Paintings from the Samuel H. Kress Collection: European Schools Excluding Italian.* Oxford, 1977.

Ellenius 1959. Allan Ellenius. "Reminders for a Young Gentleman: Notes on a Dutch Seventeenth-Century Vanitas." *Figura*, vol. 1 (1959), pp. 108–26.

Emmer 1991. Michele Emmer. *Bolle di sappone: Un viaggio tra arte, scienze e fantasia*. Florence, 1991.

Enderle 1992. Alfred Enderle et al. *Kleine Menschen: Große Kunst*. Hamm, 1992.

Van Eynden 1787. R. Van Eynden. *De Nationaalen Smaak der Hollandse School in de Teeken-en Schilderkunst. Teylers Tweede genootschap*, vol. 5 (1787).

Falkenburg et al. 1999. R. L. Falkenburg et al., eds. *Kunst voor de Markt/ Art for the Market 1500–1700. Nederlands Kunsthistorisch Jaarboek*, vol. 50 (1999).

Ferrero 1971. Giuseppe Guido Ferrero. *Opere di Benvenuto Cellini*. Turin, 1971.

Franits 1993. Wayne Franits. *Paragons of Virtue: Women and Domesticity in Seventeenth-Century Dutch Art*. Cambridge, 1993.

Freedberg and De Vries 1991. David Freedberg and Jan de Vries, eds. *Art in History: History in Art*. The Getty Center, Los Angeles, 1991.

Freud 1905. Sigmund Freud. *Der Witz und seine Beziehung zum Unbewußten*. Leipzig and Vienna, 1905. (Trans. by J. Strachey as *Jokes and Their Relation to the Unconscious*. London, 1960.)

Frimmel 1892. Th. Frimmel. *Klein Galeriestudien*. Bamberg, 1892.

Gaskell 1983. Ivan Gaskell. "Art for the Oligarchs." *Art History*, vol. 6 (June 1983), pp. 236–41.

Van Gelder 1937. H. E. van Gelder. "*Een schilder aan den arbeid*." *Mededeelingen van den Dienst voor Kunsten en Wetenschappen der Gemeente's-Gravenhage* 4 (1937), pp. 70–73.

Van Ghistele 1555. Cornelis van Ghistele. *Terentius comedien nu eerst wt den latine in onser duytscher talen . . . over ghesedt*. Antwerp, 1555.

Gibson 1977. Walter Gibson. *Bruegel*. New York and Toronto, 1977.

Goeree 1668. Willem Goeree. *Inleydinge tot al-ghemeene teyckenkonst . . .* Middelburg, 1668.

Goodman 1968. Nelson Goodman. *Languages of Art: An Approach to a Theory of Symbols*. Indianapolis and New York, 1968.

Gorney 1978. Michaelene Gorney. "Musical Instruments: Strings." *Toledo Museum of Art News*, vol. 20 (1978), pp. 91–96.

Gowing 1952. Lawrence Gowing. *Vermeer*. London, 1952.

Granberg 1911–13. Olof Granberg. *Inventaire géneral des trésors d'art en Suide*, 3 vols. Stockholm, 1911–13.

Gratama 1930. G. D. Gratama. "Het Portret van Judith Leyster door Frans Hals." *Oud Holland*, vol. 47 (1930), pp. 71–77.

Graves 1921. Algernon Graves. *Art Sales from Early in the Eighteenth Century to Early in the Twentieth Century*, 3 vols. London, 1921.

Van der Grinten 1962. E. F. van der Grinten. "Le cachalot et le mannequin: Deux facettes de la réalité dans l'art hollandais du seizième et du dix-septième siècles." *Nederlands Kunsthistorisch Jaarboek*, vol. 13 (1962), pp. 149–79.

Gruber 1994. Alain Gruber, ed. *The History of Decorative Arts: The Renaissance and Mannerism in Europe*. New York, London, and Paris, 1994.

Gudlaugsson 1947. S. J. Gudlaugsson. "Bredero's 'Lucelle' door eenige zeventiende-eeuwsche Meesters uitgebeeld." *Nederlands Kunsthistorisch Jaarboek*, vol. 1 (1947), pp. 177–87.

Gudlaugsson 1954. S. J. Gudlaugsson. "Twee uitbeeldingen van Bredero's 'Lucelle' door Molenaer en Cornelis(?) Steen." *Oud Holland*, vol. 69 (1954), pp. 53–56.

Haak 1984. Bob Haak. *The Golden Age: Dutch Painters of the Seventeenth Century*. New York, 1984.

Hahn 1996. A. Hahn. " . . . dat zy de aanschouwers schynen e willen aanspreken." *Untersuchungen zur Rolle des Betrachters in der Niederländischen Malerei des 17. Jahrhunderts*. Munich, 1996.

Harms 1927. Judith Harms. "Judith Leyster: Ihr Leben und Ihr Werk." *Oud Holland*, vol. 44 (1927), pp. 112–26, 145–54, 221–42, 275–79.

Harmsen 1989. A. J. E. Harmsen. *Onderwys in de tooneel-poëzy: De opvattingen over toneel van het kunstgenootschap Nil Volentibus Arduum*. Rotterdam, 1989.

Haverkamp-Begemann 1959. Egbert Haverkamp-Begemann. *Willem Buytewech*. Amsterdam, 1959.

Hecht 1986. Peter Hecht. "The Debate on Symbol and Meaning in Dutch Seventeenth-Century Art: An Appeal to Common Sense." *Simiolus*, vol. 16 (1986), pp. 173–87.

Van Hees 1959. C. A. van Hees. "Archivalia betreffende Frans Hals en de zijnen." *Oud Holland*, vol. 74 (1959), pp. 36–42.

Helgerson 1998. Richard Helgerson. "Genremalerei Landkarten und nationale Unsicherheit in Holland des 17. Jahrhunderts." *Bilder der National: Kulturelle und politische Konstruktioner des Nationalen am Beginn der europaischen Moderne*. Hamburg, 1998.

Hinz 1973. Berthold van Hinz. "Das Familienbildnis des J. M. Molenaer in Haarlem." *Städel-Jahrbuch*, vol. 4 (1973), pp. 207–16.

Hofrichter 1989. Frima Fox Hofrichter. *Judith Leyster: A Woman Painter in Holland's Golden Age*. Doornspijk, 1989.

Hofrichter 1995. Frima Fox Hofrichter. "A Telescope in Haarlem." In *Shoptalk: Studies in Honor of Seymour Slive, Presented on His Seventy-Fifth Birthday*. Cambridge, Mass., 1995, pp. 114–17.

Hofstede de Groot 1893. Cornelis Hofstede de Groot. "Judith Leyster." *Jahrbuch der Königlich Preussischen Kunstsammlungen*, vol. 14 (1893), pp. 190–98, 232.

Hofstede de Groot 1894. Cornelis Hofstede de Groot. "De Haagsche Schilderijenmusea." *Haagsch Jaarboekje* (1894), p. 163ff.

Hofstede de Groot 1910. Cornelis Hofstede de Groot. *Beschreibendes und kritisches Verzeichnis der Werke der hervorragendsten holländischen Maler des XVII. Jahrhunderts*, 8 vols. Esslingen, 1910. Trans. E. G. Hawke, London, 1910.

Hofstede de Groot 1929. Cornelis Hofstede de Groot. "Schilderijen door Judith Leyster." *Oud Holland*, vol. 46 (1929), pp. 25–26.

Honig 1998. Elizabeth Alice Honig. *Painting and the Market in Early Modern Antwerp*. New Haven, 1998.

Van Hoogstraeten 1678. Samuel van Hoogstraeten. *Inleyding tot de hooge schoole der schilderkonst: Anders de zichtbaere Werelt*. Rotterdam, 1678.

Houbraken 1718–21. Arnold Houbraken. *De groote schouburgh der Nederlantsche konstschilders en schilderessen*, 3 vols. Amsterdam, 1718–21.

Hummelen 1967. W. H. M. Hummelen. *Inrichting en gebruik van het toneel in de Amsterdamse Schouwburg van 1637*. Amsterdam, 1967.

Hummelen 1982. W. H. M. Hummelen. *Amsterdams Toneel in he Begin van de Gouden Eeuw*. The Hague, 1982.

Hunningher 1958. B. Hunningher. "De Amsterdamse schouwburg van 1637: Type en karakter." *Nederlands Kunsthistorisch Jaarboek*, vol. 9 (1958), pp. 109–10.

De Jongh 1970. Eddy de Jongh. "Homo Bulla en Vrouw Wereld: Allegorische figuren in geëigende en camouflerende dracht." *Vrij Nederland* (1 August 1970), p. 7.

De Jongh 1971. Eddy de Jongh. "Realisme en schijnrealisme in de Hollandse Schilderkunst van de zeventiende eeuw." *Rembrandt en zijn tijd*, Paleis voor Schone Kunsten, Brussels, 1971, pp. 143–94. Translated in Wayne Franits, ed. *Looking at Seventeenth-Century Dutch Art: Realism Reconsidered*. Cambridge, 1997.

De Jongh 1973. Eddy de Jongh. "Vermonningen van Vrouw Wereld in de 17de eeuw." *Album Amicorum J. G. van Gelder*. The Hague, 1973, pp. 198–206. Trans. De Jongh, 2000.

De Jongh 2000. Eddy de Jongh. *Questions of Meaning: Theme and Motif in Dutch Seventeenth-Century Painting*. Leiden, 2000.

Judson 1956. Jay R. Judson. *Gerrit van Honthorst*. The Hague, 1956.

Judson 1999. Jay R. Judson and Rudolf E. O. Ekkart. *Gerrit van Honthorst, 1592–1656*. Doornspijk, 1999.

Kavaler 1999. Ethan Matt Kavaler. *Pieter Bruegel: Parables of Order and Enterprise*. Cambridge and New York, 1999.

Kettering 1983. Alison Kettering. *The Dutch Arcadia: Pastoral Art and Its Audience in the Golden Age*. Montclair, N.J., 1983.

Keyes 1984. George Keyes. *Esaias van den Velde, 1587–1630*. Doornspijk, 1984.

De Klerk 1982. E. A. de Klerk. "De Teecken-Const: A Seventeenth-Century Dutch Treatise." *Oud Holland*, vol. 96, no. 1 (1982), pp. 57–60.

Kren 1980. Thomas Kren. "Chi non vuol Baccho: Roeland van Laer's Burlesque Painting about Dutch Artists in Rome." *Simiolus*, vol. 11 (1980), pp. 63–80.

Kyrova 1982. M. Kyrova. "*Muziekopvatting in de beeldende kunst*." *Het Strijkinstrument*. Rotterdam, 1982, pp. 29–42.

De Lairesse 1701. Gerard de Lairesse. *Grondlegginge ter Teekenkonst.* Amsterdam, 1701.

De Lairesse 1740. Gerard de Lairesse. *Het Groot Schilderboek waar in de Schilderkonst.* Haarlem, 1740.

Leiden 1663. *Biblia dat is de gantsche Heylige Schrifture.* Johan Elzevier, Leiden, 1663.

Leppert 1978. Richard D. Leppert. "David Teniers the Younger and the Image of Music." *Jaarboek van het Koninklijk Museum voor Schone Kunsten, Antwerpen* (1978), pp. 63–155.

Leuker 1992. M.-T. Leuker. *"De last van 't huys, de wil des mans": Frauenbilder und Ehekonzepte im niederländischen Lustspiel des 17. Jahrhunderts.* Münster, 1992.

Liedtke 1984. Walter A. Liedtke. "Dutch Genre Painting in Philadelphia, Berlin, and London." *Tableau,* vol. 7 (September 1984), pp. 61–64.

Van Mander 1604. Karel van Mander. *Het Schilder-boeck.* Haarlem, 1604.

Martin 1905–07. W. Martin. "The Life of a Dutch Artist in the Seventeenth Century." *The Burlington Magazine,* vol. 7 (1905), pp. 125–28, 416–27; vol. 8 (1905–06), pp. 13–24; vol. 10 (1906–07), pp. 144–54; vol. 11 (1907), pp. 357–69.

Martin 1935. W. Martin. *De Hollandsche schilderkunst in de zeventiende eeuw: Frans Hals en zijn tijd.* Amsterdam, 1935.

Meijer 1971. Reinder P. Meijer. *Literature of the Low Countries.* New York, 1971.

Meyerhöfer 1992. Dietrich Meyerhöfer. "Tanzendes Paar auf der Dorfstraße." *Kleine Menschen–Große Kunst.* Hamm, 1992.

Miedema 1973. Hessel Miedema. *Karel van Mander: "Den Gondt der edel vry Schilderconst,"* 2 vols. Utrecht, 1973.

Miedema 1977. Hessel Miedema. "Realism and the Comic Mode: The Peasant." *Simiolus,* vol. 9 (1977), pp. 205–19.

Miedema 1980. Hessel Miedema, ed. *De archiefbescheiden van het St. Lucasgilde te Haarlem 1497–1798,* 2 vols. Alphen aan den Rijn, 1980.

Miedema 1981. Hessel Miedema. "Feestende boeren-lachende dorpers: Bij twee recente aanwinsten van het Rijksprentenkabinet." *Bulletin van het Rijksmuseum,* vol. 29 (1981), pp. 191–213.

Mirimonde 1962. A. P. de Mirimonde. *"La musique dans les oeuvres hollandaises du Louvre."* La Revue du Louvre et des Musées de France 12 (1962), no. 4, pp. 175–84.

Mirimonde 1964. A. P. de Mirimonde. "Les concerts parodiques chez les maîtres du nord." *Gazette des Beaux-Arts,* vol. 64 (November 1964), pp. 253–84.

Mirimonde 1978. A. P. de Mirimonde. "Les vanités à personnages et à instruments de musique." *Gazette des Beaux-Arts,* vol. 92 (October 1978), pp. 113–30.

Mojzer 1967. M. Mojzer. *Dutch Genre Paintings.* Budapest, 1967.

Monballieu 1987. A. Monballieu. "Nog eens Hoboken bij Bruegel en tijdgenoten." *Jaarboek van het Koninklijk Museum voor Schone Kunsten, Antwerpen* (1987), pp. 185–206.

Montias 1987. J. M. Montias. "Cost and Value in Seventeenth-Century Dutch Art." *Simiolus,* vol. 18 (1987), pp. 455–66.

Montias 1990. J. M. Montias. "Socio-Economic Aspects of Netherlandish Art from the Fifteenth to the Seventeenth Century: A Survey." *Art Bulletin,* vol. 72 (1990), pp. 358–73.

Moxey 1982. Keith Moxey. "Pieter Bruegel and 'The Feast of Fools.'" *The Art Bulletin,* vol. 64, no. 4 (1982), pp. 640–46.

Moxey 1989. Keith Moxey. "Pieter Bruegel and Popular Culture." In *The Prints of Pieter Bruegel the Elder.* Exhibition catalogue by David Freedberg. Bridgestone Museum of Art, Tokyo, 1989, pp. 42–52.

Muller 1997. Sheila D. Muller, ed. *Dutch Art: An Encyclopedia.* New York and London, 1997.

Müller-Hofstede 1995. Justus Müller-Hofstede. "Jan Miense Molenaer's 'Departure of the Prodigal Son': In Search of the Allegorical Form." *Shop Talk: Studies in Honor of Seymour Slive.* Cambridge, 1995, pp. 181–83, 373–75.

Nagler 1858–79. G. K. Nagler. *Die Monogrammisten und diejenigen bekannten und unbekannten Künstler aller Schulen,* 6 vols. Munich, 1858–79.

Naumann 1981. Otto Naumann. *Frans van Mieris, the Elder, 1635–1681,* 2 vols. Doornspijk, 1981.

Near 1985. Pinkney Near. "European Paintings and Drawings: The Williams Collection and Fund." *Apollo,* vol. 122 (December 1985), pp. 440–51.

Németh 1990. Istvan Németh. "Het Spreekwoord 'Zo d'ouden zongen, zo pijpen de jongen' in Schilderijen van Jacob Jordaens en Jan Steen: Motieven en Associates." *Jaarboek van het koninklijk museum voor schone kunsten, Antwerpen* (1990), pp. 271–86.

Peacock 1993–94. Martha Moffit Peacock. "Geertruydt Rogman and the Female Perspective in Seventeenth-Century Dutch Genre Imagery." *Woman's Art Journal,* vol. 14 (Fall 1993/Winter 1994), pp. 3–10.

Vanden Plasse 1638. C. L. vanden Plasse, ed. *Alle de wercken so spelen gedichten brieven en kluchten van den gheest-rijcken poëet Gerbrand Adriaensz. Bredero Amsterdammer.* Amsterdam, 1638.

Pleij 1975–76. Herman Pleij. "De sociale functie van humor en trivialiteit op he rederijkerstoneel." *Spektator,* vol. 5 (1975–76), pp. 108–27.

Pleij 1979. Herman Pleij. *Het gilde van de Blauwe Schuit: Literatuur, volksfeest en burgermoraal in de late middeleeuwen.* Amsterdam, 1979.

Plietzsch 1960. Eduard Plietzsch. *Holländische und flämische Maler des 17. Jahrhunderts.* Leipzig, 1960.

Pliny the Elder. *Natural History.*

Pols 1942. A. M. Pols. *De Ruckers en de klavierbouw in Vlaanderen.* Antwerp, 1942.

Raupp 1984. Hans-Joachim Raupp. *Untersuchungen zu Künstlerbildnis und Künstlerdarstellung in den Niederlanden im 17. Jahrhundert.* Hildesheim, Zurich, and New York, 1984.

Raupp 1996. Hans-Joachim Raupp. *Genre: Niederländische Malerei des 17. Jahrhunderts der SØR Rusche-Sammlung.* Münster, 1996.

Ree-Scholtens 1995. G. F. van der Ree-Scholtens. *Deugd boven geweld: Een geschiedenis van Haarlem, 1245–1995.* Hilversum, 1995.

Roh 1921. Franz Roh. *Holländische Malerei.* Jena, 1921.

Roodenburg 1993. H. Roodenburg. "Over scheefhalzen en zwellende heupen: Enige argumenten voor een historische antropologie van de zeventiende-eeuwse schilderkunst." *De zeventiende eeuw,* vol. 9 (1993), pp. 152–68.

Rosenberg, Slive, and Ter Kuile 1966. Jakob Rosenberg, Seymour Slive, and E. H. ter Kuile. *Dutch Art and Architecture, 1600–1800.* Harmondsworth and Baltimore, 1966.

Sadie 1980. Stanley Sadie, ed. *The New Grove Dictionary of Music and Musicians,* 20 vols. London, 1980.

Salomon 1986. Nanette Salomon, "Political Iconography in a Painting by Jan Miense Molenaer." *Hoogsteder-Naumann Mercury,* no. 4 (1986), pp. 23–38.

Schama 1987. Simon Schama. *The Embarrassment of Riches.* New York, 1987.

Schatborn 1973. Peter Schatborn. "Olieverfschetsen van Dirck Hals." *Bulletin van het Rijksmuseum,* vol. 21 (November 1973), pp. 107–16.

Schillemans 1992. Robert Schillemans. "Schilderijen in Noordnederlandse katholieke kerken uit de eerste helf van de zeventiende eeuw." *De zeventiende eeuw,* vol. 8 (1992), pp. 41–52.

Schmitt 1993. Stefan Schmitt. *Diogenes: Studien zu seiner Ikonographie in der niederländischen Emblematik und Malerei des 16. und 17. Jahrhunderts.* Hildesheim etc., 1993.

Schnackenburg 1981. Bernhard Schnackenburg. *Adriaen van Ostade. Isaak van Ostade. Zeichnungen und Aquarelle. Gesamtdarstellung mit Werkkatalogen,* 2 vols. Hamburg, 1981.

Schnackenburg 1984. Bernard Schnackenburg. "Das Bild des bäuerlichen Lebens bei Adriaen van Ostade." In *Wort und Bild in der niederländischen Kunst des 16. und 17. Jahrhunderts.* Edited by H. Vekeman and J. Müller Hofstede. Erftstadt, 1984, pp. 30–42.

Von Schneider 1933. Arthur von Schneider. *Caravaggio und die Niederländer.* Marburg-Lahn, 1933.

Schneider 1989. N. Schneider. *Stilleben. Realität und Symbolik der Dinge: Die Stillebenmalerei der frühen Neuzeit.* Cologne, 1989.

Schrevelius 1648. T. Schrevelius. *Harlemias, Ofte, om beter te seggen, De eerste stichtinghe der Stadt Haerlem.* Haarlem, 1648.

Schwartz 1985. Gary Schwartz. *Rembrandt: His Life, His Paintings.* New York, 1985.

Scriverius/Ampzing 1630. Petrus Scriverius. *Saturnalia ofte Pietisch Vasten Avondspel vervattende het gebruyk ende misbruyk vanden Taback.* Trans. Samuel Ampzing, Haarlem, 1630.

Singleton 1907. Esther Singleton. *Dutch and Flemish Furniture*. London, 1907.

Slatkes 1987. Leonard J. Slatkes. "Preparatory Drawings for Prints by Adriaen van Ostade." In *Drawings Defined*. Edited by Walter Strauss and T. Felker. New York, 1987, pp. 229–40.

Slive 1970–74. Seymour Slive. *Frans Hals*, 3 vols. London and New York, 1970–74.

Slive 1995. Seymour Slive. *Dutch Painting*. New Haven and London, 1995.

Sluijter 1988. Eric J. Sluijter. "Een stuck waerin een jufr: Voor de spiegel van Gerrit Douw." *Antiek*, vol. 23 (October 1988), pp. 150–61.

Smith 1982. David Smith. *Masks of Wedlock: Seventeenth-Century Dutch Marriage Portraiture*. Ann Arbor, 1982.

Smith 1986. David Smith. "Courtesy and Its Discontents: Frans Hals's *Portrait of Isaac and Beatrix van der Laan*." *Oud Holland*, vol. 100 (1986), pp. 20–22.

Smith 1829–42. John Smith. *A Catalogue Raisonné of the Works of the Most Eminent Dutch, Flemish, and French Painters*, 9 vols. London, 1829–42.

Smits-Veldt 1991. Marijke B. Smits-Veldt. *Het Nederlandse renaissance-toneel*. Utrecht, 1991.

Stallybrass and White 1986. Peter Stallybrass and Allon White. *The Politics and Poetics of Transgression*. London, 1986.

Stuiveling 1983. G. Stuiveling. *G. A. Bredero's "Boertigh, Amoreus, en Aendachtigh Groot Lied-Boeck."* Leiden, 1983.

Sullivan 1994. Margaret Sullivan. *Bruegel's Peasants: Art and Audience in the Northern Renaissance*. Cambridge, 1994.

Sutton 1986. Peter C. Sutton. *Dutch Art in America*. Grand Rapids, Mich., 1986.

Taverne 1972–73. E. Taverne. "Salomon de Bray and the Reorganization of the Haarlem Guild in 1631." *Simiolus*, vol. 6 (1972–73), pp. 50–69.

Van Thiel 1965. Pieter J. J. van Thiel. "Cornelis Cornelisz van Haarlem as a Draughtsman." *Master Drawings*, vol. 3 (1965), pp. 124–29.

Van Thiel 1967–68. Pieter J. J. van Thiel. "Marriage Symbolism in a

Musical Party by Jan Miense Molenaer." *Simiolus*, vol. 2 (1967–68), pp. 90–99.

Van Thiel 1983. Pieter J. J. van Thiel. "Werner Jacobsz van den Valckert." *Oud Holland*, vol. 97 (1983), pp. 165–78.

Thomas 1981. Haye Thomas. *Het Dagelijks Leven in de 17de eeuw*. Amsterdam and Brussels, 1981.

Vandenbroeck 1984. Paul Vandenbroeck. "Verbeeck's Peasant Weddings: A Study of Iconography and Social Function." *Simiolus*, vol. 14 (1984), pp. 79–123.

Valentiner 1956. William R. Valentiner. "The Raleigh Museum's First 220 Paintings: Notes on the Collection." *Art News*, vol. 55 (April 1956), pp. 46–55, 91–92.

Vasari 1968. Giorgio Vasari. *The Lives of the Artists*. Baltimore, Md., 1968.

Vos 1667. Jan Vos. *Medea*. Amsterdam, 1667.

Vredeman de Vries 1604–05. Hans Vredeman de Vries. *Perspective*. The Hague and Leiden, 1604–05. Facsimile with introduction by A. Placzek, New York, 1968.

De Vries 1977. Lyckle de Vries. "*Jan Steen 'de kluchtschilder.'*" Ph.D. diss., Rijksuniversiteit, Groningen, 1977.

De Vries 1990. Lyckle de Vries. "Tronies and Other Single-Figured Netherlandish Paintings." *Nederlandse Portretten. Leids Kunsthistorisch Jaarboek*, vol. 8 (1990), pp. 185–202.

De Vries 1992. Lyckle de Vries. *Jan Steen: Prinsjesdag*. Bloemendaal, 1992.

Wagenberg-Ter Hoeven 1993–94. Anke A. Van Wagenberg-Ter Hoeven. "The Celebration of Twelfth Night in Netherlandish Art." *Simiolus*, vol. 22 (1993–94), pp. 65–96.

Währen 1958. Max Währen. *Der Königskuchen und sein Fest*. Bern, 1958.

Walsh and Schneider 1979. John Walsh Jr. and Cynthia P. Schneider. "Little-Known Dutch Paintings in the Museum of Fine Arts, Boston." *Apollo*, vol. 110 (December 1979), pp. 498–506.

Weller 1992. Dennis P. Weller. "Jan Miense Molenaer (ca. 1609/10–1668): The Life and Art of a Seventeenth-Century Dutch Painter." Ph.D. diss., University of Maryland, 1992.

Weller 1997. Dennis P. Weller. "Haarlem." *Dutch Art: An Encyclopedia*. New York and London, 1997, pp. 165–68.

Welu 1977a. J. A. Welu. "Vermeer and Cartography." Ph.D. diss., Boston University, 1977.

Welu 1977b. J. A. Welu. "Job Berckheyde's 'Baker.'" *Worcester Art Museum Bulletin*, vol. 6 (1977), pp. 1–9.

Welu 1982. J. A. Welu. "Arrangements with Meaning: Dutch and Flemish Still Life." *Six Hundred Years of Netherlandish Art: Selected Symposium Lectures*. Memphis State University, 1982, pp. 22–28.

Westermann 1997. Mariët Westermann. *The Amusements of Jan Steen: Comic Painting in the Seventeenth Century*. Zwolle, 1997.

Westermann 1997a. Mariët Westermann. "Theater and Theatricality." *Dutch Art: An Encyclopedia*. New York and London, 1977, pp. 380–83.

Westermann 1999a. Mariët Westermann. "*Fray en Leelijck*: Adriaen van de Venne's Invention of the Ironic Grisaille." *Nederlands Kunsthistorisch Jaarboek*, vol. 50 (1999), pp. 215–51.

Westermann 1999b. Mariët Westermann. "Farcical Jan, Pier the Droll: Steen and the Memory of Bruegel." In Jeroen Stumpel et al., eds., *Memory and Oblivion: Proceedings of the XXIXth Congress of the History of Art*. Leiden, 1999, pp. 827–36.

Westermann 1999c. Mariët Westermann. "Adriaen van de Venne, Jan Steen, and the Art of Serious Play." *De Zeventiende Eeuw*, vol. 15 (1999), pp. 32–45.

Weyerman 1729–69. Jacob Campo Weyerman. *De levensbeschrijvingen der Nederlandsche konst-schilders en konst-schilderessen*, 4 vols. The Hague and Dordrecht, 1729–69.

Wheelock 1983. Arthur K. Wheelock Jr. "Northern Baroque." *Encyclopedia of World Art, Supplement*, vol. 16. New York, 1983.

Wilenski 1955. R. H. Wilenski. *Dutch Painting*. New York, 1955.

Van der Willigen 1870. Adriaan van der Willigen. *Les artistes de Harlem: Notices historiques avec un précis sur la gilde de St. Luc*. Haarlem and The Hague, 1870.

Winternitz 1946. E. Winternitz. "Music for the Eye." *Art News*, vol. 45 (June 1946), pp. 24–27, 55–58.

Woordenboek der Nederlandsche Taal 1995. *Woordenboek der Nederlandsche Taal*, CD-ROM edition, Amsterdam, 1995.

Wright 1978. Christopher Wright. *The Dutch Painters: 100 Seventeenth-Century Masters*. New York, 1978.

Zafran 1981. Eric M. Zafran. "Unfamiliar Aspects of Dutch Art." *Apollo*, vol. 113 (1981), pp. 328–29.

Zumthor 1963. Paul Zumthor. *Daily Life in Rembrandt's Holland*. New York, 1963.

Exhibition and Collection Catalogues

Allentown 1965. *Seventeenth-Century Painters of Haarlem*. Allentown Art Museum, Allentown, Pa., 2 April–13 June 1965.

Amsterdam 1968. *'t Kan verkeeren: Gerbrand Adriaensz Bredero, 1595–1618*. Amsterdams Historisch Museum, 26 September–25 November 1968.

Amsterdam 1976. *Tot Lering en Vermaak*. Rijksmuseum, Amsterdam, 16 September–5 December 1976. Catalogue by Eddy de Jongh et al.

Amsterdam 1976a. *All the Paintings of the Rijksmuseum in Amsterdam: A Completely Illustrated Catalogue*. Maarssen, 1976.

Amsterdam 1978. *Lucas van Leyden: Grafiek (1494–1533)*. Rijksprentenkabinet, Rijksmuseum, Amsterdam, 9 September–3 December 1978.

Amsterdam 1994. *Bier!: Geschiedenis van een Volksdrank in Holland*. Amsterdams Historisch Museum, Amsterdam, 10 June–4 September 1994.

Amsterdam 1997. *Mirror of Everyday Life: Genreprints in the Netherlands, 1550–1700*. Rijksmuseum, Amsterdam, 8 February–4 May 1997. Catalogue by Eddy de Jongh and Ger Luijten.

Amsterdam 2001. *Salomon Lilian: Old Masters*. Amsterdam, 2001.

Antwerp 1987. *Beeld van de andere, vertoog over het zelf: Over wilden en narren, boeren en bedelaars*. Koninklijk Museum voor Schone Kunsten, Antwerp, 5 September–8 November 1987. Catalogue by Paul Vandenbroeck.

Augsburg 1912. *Gemäldegalerie*. Augsburg, 1912.

Baltimore 1946. *Musical Instruments and Their Portrayal in Art.* Walters Art Gallery, Baltimore, 26 April–2 June 1946.

Basel 1987. *Im Lichte Hollands.* Kunstmuseum Basel, 14 June–27 September 1987.

Baumstark 1980. Reinhold Baumstark. *Meisterwerke der Sammlungen des Fürsten von Liechtenstein. Gemälde.* Zurich and Munich, 1980.

Berlin 1931. *Beschreibendes Verzeichnis der Gemälde im Kaiser-Friedrich-Museum und Deutschen Museum.* Berlin, 1931.

Berlin 1932. *Staatliche Museen Berlin. Die Gemäldegalerie. Die Holländischen Meister 17. und 18. Jahrhundert.* Berlin, 1932.

Berlin 1986. *The Complete Catalogue of The Gemäldegalerie, Berlin.* New York, 1986.

Blankert 1977. Albert Blankert. *Museum Bredius.* The Hague, 1977.

Blankert 1978/80. Albert Blankert. *Museum Bredius: Catalogus van de schilderijen en tekeningen.* Zwolle/The Hague, 1978, reprinted 1980.

Blankert 1991. Albert Blankert. *Museum Bredius: Catalogus van de schilderijen en tekeningen.* Zwolle/The Hague, 1991.

Bodnár 1995. Sz. Bodnár, ed. *The Museum of Fine Arts Budapest.* Budapest, 1995.

Bonn 1959. *Verzeichnis der Gemälde.* Rheinisches Landesmuseum, Bonn, 1959. Catalogue by Franz Rademacher.

Bonn 1982. *Gemälde bis 1900.* Rheinisches Landesmuseum, Bonn, 1982.

Boston 1907. "Three Dutch Pictures." *Museum of Fine Arts Bulletin*, Boston, vol. 5 (October 1907), pp. 57–58.

Boston 1985. *European Paintings in the Museum of Fine Arts, Boston: An Illustrated Summary Catalogue.* Boston, 1985. Catalogue by Alexandra R. Murphy.

Boston 1992. *Prized Possessions: European Paintings from Private Collections and Friends of the Museum of Fine Arts, Boston.* Museum of Fine Arts, Boston, 1992. Catalogue by Peter C. Sutton.

Braunschweig 1978. *Die Sprache der Bilder.* Herzog Anton Ulrich-Museum, Braunschweig, 6 September–5 November 1978.

Braunschweig 1983. *Die holländischen Gemälde.* Herzog Anton Ulrich-Museum, Braunschweig, 1983. Catalogue by Rüdiger Klessman.

Brown 1992. Christopher Brown. *Catalogue of the Dutch School, 1600–1800.* The National Gallery, London, 2 vols., 1992.

Brünn 1925. *Alte Meister aus Mährischem Privatbesitz.* Mährischer Kunstverein, Brünn, 1925.

Brussels 1946. *La peinture hollandaise: De Jérome Bosch á Rembrandt.* Palais des Beaux-Arts, Brussels, 2 March–28 April 1946.

Budapest 1985. *Das Museum der Bildenden Künste in Budapest.* Budapest, 1985.

Budapest 2000. *Museum of Fine Arts Budapest: Old Masters Gallery.* Szépmûvészeti Múzeum, Budapest, 2000.

Caen 1990. *Les vanités dans la peinture au XVIIe siècle.* Musées des Beaux-Arts, Caen, 1990.

Cologne and Utrecht 1987. *Nederlandse 17de eeuwse schilderijen uit Boedapest.* Wallraf-Richartz-Museum, Cologne, 8 April–31 May 1987; Utrecht, Centraal Museum, 13 June–16 August 1987. Catalogue by Ildikó Ember.

Delft 1965. *XVIIe Oude Kunsten Antiekbeurs.* Het Prinsenhof, Delft, 24 June–14 July 1965.

Delft 1968. *XXe Oude Kunsten Antiekbeurs.* Het Prinsenhof, Delft, 20 June–10 July 1968.

Delft, Cambridge, and Fort Worth 1988. *A Prosperous Past: The Sumptuous Still Life in the Netherlands, 1600–1700.* Stedelijk Museum Het Prinsenhof, Delft; Fogg Art Museum, Cambridge, Mass.; and the Kimbell Art Museum, Fort Worth, Tex., 1988.

Detroit 1935. *An Exhibition of Fifty Paintings by Frans Hals.* Detroit Institute of Arts, 10 January–28 February 1935.

Florence 1987. *The Age of Rembrandt: Dutch Painting of the Seventeenth Century in the Florentine Galleries.* Pitti Palace, Florence, 27 June–9 September 1987.

Frankfurt 1993–94. *Leselust: Niederländische Malerei von Rembrandt bis Vermeer.* Schirn Kunsthalle, Frankfurt, 1993–94.

Garas 1973. K. Garas. *Paintings in the Budapest Museum of Fine Arts.* Budapest, 1973.

Garas 1985. K. Garas. *The Budapest Museum of Fine Arts.* Budapest, 1985. English edition 1988.

Grand Rapids 1940. *Masterpieces of Dutch Art.* Grand Rapids Art Gallery, Grand Rapids, Mich., 1940.

Haarlem 1955. *Frans Halsmuseum, Municipal Art Gallery at Haarlem.* Haarlem, 1955.

Haarlem 1969. *Frans Halsmuseum, Haarlem.* Haarlem, 1969.

Haarlem 1986. *Portretten van echt en trouw. Huwelijk en gezin in de Nederlandse kunst van de zeventiende eeuw.* Frans Halsmuseum, Haarlem, 15 February–13 April 1986.

Haarlem and Worcester 1993. *Judith Leyster: A Dutch Master and Her World.* Frans Halsmuseum, Haarlem, 16 May–22 August 1993; Worcester Art Museum, Worcester Mass., 19 September–5 December 1993.

The Hague 1914. *Catalogue raisonné des tableaux et des sculptures.* The Mauritshuis, The Hague, 1914.

The Hague 1977. Mauritshuis. *The Royal Cabinet of Paintings: Illustrated General Catalogue.* The Hague, 1977.

The Hague 1992. *Old Master Paintings: An Illustrated Summary Catalogue.* The Netherlands Office for Fine Arts, The Hague, 1992.

The Hague 2001. *Onder de Huid van Oude Meesters.* Museum Bredius, The Hague, 2001. Catalogue by Edwin Buijsen.

The Hague and Antwerp 1994. *Music and Painting in the Golden Age.* Hoogsteder and Hoogsteder, The Hague, 11 May–10 July 1994; Hessenhuis Museum, Antwerp, 29 July–30 October 1994.

The Hague and San Francisco 1990. *Great Dutch Paintings from America.* Mauritshuis, The Hague, 28 September 1990–13 January 1991; The Fine Arts Museums of San Francisco, 16 February–5 May 1991. Catalogue by Ben Broos.

Hand and Wolff 1986. J. O. Hand and M. Wolff. *Early Netherlandish Painting.* Systematic catalogue, The National Gallery of Art, Washington, D.C., 1986.

Hartford 1950. *Life in Seventeenth-Century Holland: Views, Vistas, Pastimes, Pantomimes, Portraits, Peep Shows.* Wadsworth Atheneum, Hartford, Conn., 1950. Catalogue by C. C. Cunningham.

Indianapolis and San Diego 1958. *The Young Rembrandt and His Times.* John Herron Art Museum, Indianapolis, Ind., 14 February–23 March 1958; The Fine Arts Gallery, San Diego, Calif., 11 April–18 May 1958.

Kauffmann 1973. C. M. Kauffmann. *Catalogue of Foreign Paintings.* The Victoria and Albert Museum, London, 1973.

Kress 1994–95. *A Gift to America: Masterpieces of European Painting from the Samuel H. Kress Collection.* The North Carolina Museum of Art, Raleigh, N.C., 5 February–24 April 1994, and three other venues.

Lawrence 1983. *Dutch Prints of Daily Life: Mirrors of Life or Masks of Morals?* The Spencer Museum of Art, The University of Kansas, Lawrence, Kans., 8 October–31 December 1983. Catalogue by Linda A. Stone-Ferrier.

Leiden 1970. *Ijdelheid der Ijdelheden. Hollandse vanitas-voorstellingen uit de zeventiende eeuw.* Stedelijk Museum, Leiden, 26 June–23 August 1970.

Lisbon 1996–97. *Genrebilder.* Museum Abtei, Lisbon, 22 September 1996–2 March 1997.

London 1899. *The National Gallery,* vol. 2. London, 1899.

London 1904. *Dutch Exhibition.* Whitechapel Art Gallery, London, 1904.

London 1973. *Exhibition of Fine Old Master Paintings.* Brian Koetser Gallery, London, 15 October–31 December 1973.

London 1976. *Art in Seventeenth-Century Holland.* The National Gallery, London, 30 September–12 December 1976.

London 1978. *The National Gallery Lends Dutch Genre Paintings.* Organized by the National Gallery, London, 1978. Catalogue by Christopher Brown.

London 1982. *The Dutch Pictures in the Collection of Her Majesty the Queen.* London, 1982. Catalogue by Christopher White.

London 1986. *National Gallery: Illustrated General Catalogue.* The National Gallery, London, 1986.

London 1986a. *Dutch Landscape: The Early Years.* The National Gallery, London, 3 September–23 November 1986. Catalogue by Christopher Brown.

London 1995. *The National Gallery: Complete Illustrated Catalogue*. The National Gallery, London, 1995.

Lucerne 1948. *Meisterwerke aus den Sammlungen des Fürsten von Liechtenstein*. Kunstmuseum, Lucerne, 1948.

Maclaren 1960. Neil Maclaren. *The National Gallery Catalogues: The Dutch School*. London, 1960.

Milan 1995. *Rembrandt, Rubens, Van Dyck e il Seicento dei Paesi Bassi*. Palazzo della Permanente, Milan, 1995. Catalogue by Ildekó Ember.

Milwaukee 1966. *The Inner Circle*. Milwaukee Art Center, Milwaukee, Wis., 15 September–23 October 1966.

Mönchengladback 1998. *Von Kavalieren, Dirnen und Quacksalbern*. Stäatisches Museum Schloß Rheydt, Mönchengladback, 19 April–21 June 1998.

Montreal 1933. *A Selection from the Collection of Paintings of the Late Sir William van Horne, K.C.M.G., 1843–1915*. Art Association of Montreal, 16 October–5 November 1933.

Nagasaki 1987–88. *Dutch Masterworks from the Bredius Museum: Rembrandt and His Contemporaries*. Holland Village Museum, Nagasaki, 1987–88.

New Brunswick 1983. *Haarlem, the Seventeenth Century*. Jane Voorhees Zimmerli Art Museum, Rutgers, the State University of New Jersey, February 20–17 April 1983. Catalogue by Frima Fox Hofrichter.

New York 1985. *Liechtenstein: The Princely Collections*. The Metropolitan Museum of Art, New York, 26 October 1985–1 May 1986.

New York 1995. *Dutch and Flemish Seventeenth-Century Paintings*. Daphne Alazraki Old Master Paintings, New York, 1995.

New York et al. 1985–87. *Dutch Masterworks from the Bredius Museum*. National Academy of Design, New York, 10 November 1985–5 January 1986, and six other venues.

Oelde 1998. *Von Kavalieren, Dirnen und Quacksalbern*. Rathaus, Oelde, 1 October–1 November 1998.

Osaka 1988. *The Golden Age of the Seventeenth Century: Dutch Painting from the Collection of the Frans Hals Museum*. The National Museum of Art, Osaka, 19 March–15 May 1988.

Oxford 1999–2000. *Scenes of Everyday Life: Dutch Genre Paintings from the Mauritshuis*. Ashmolean Museum,

Oxford, 9 November 1999–9 January 2000.

Paderborn 1998. *Genre–Niederländische Malerei des 17. Jahrhunderts*. Städtische Galerie in der Reithall Schloß Neuhaus, Paderborn, 16 January–22 March 1998.

Paris 1912. *Troisième catalogue de la Galerie Charles Brunner*. Galerie Charles Brunner, Paris, January 1912.

Paris 1970–71. *Le siècle de Rembrandt: Tableaux hollandais des collections publiques françaises*. Musées du Petit Palais, Paris, 17 November 1970–15 February 1971.

Philadelphia, Berlin, and London 1984. *Masters of Seventeenth-Century Dutch Genre Painting*. Philadelphia Museum of Art, 18 March–13 May 1984; Gemäldegalerie, Staatliche Museen Preussischer Kulturbesitz, Berlin, 8 June–12 August 1984; Royal Academy of Arts, London, 7 September–18 November 1984. Catalogue by Peter Sutton.

Pigler 1967. A. Pigler. *Katalog der Galerie Alter Meister: Museum der Bildenden Künste, Budapest*. Budapest, 1967.

Pittsburgh 1954. *Pictures of Everyday Life: Genre Paintings in Europe, 1500–1900*. Carnegie Institute, Pittsburgh, Pa., 14 October–12 December 1954.

Pittsburgh 1986. *Gardens of Earthly Delight: Sixteenth- and Seventeenth-Century Netherlandish Gardens*. Frick Art Museum, Pittsburgh, Pa., 3 April–18 May 1986. Catalogue by Kahren Jones Hellerstedt.

Potterton 1986. Homan Potterton. *Dutch Seventeenth- and Eighteenth-Century Paintings in the National Gallery of Ireland*. Dublin, 1986.

Princeton 1979. *Van Dyck as Religious Artist*. The Art Museum, Princeton University, Princeton, N.J., 1979.

Providence 1938–39. *Masterpieces of Dutch Painting*. Museum of Art, Rhode Island School of Design, Providence, R.I., December 1938–January 1939.

Providence 1984. *Children of Mercury: The Education of Artists in the Sixteenth and Seventeenth Centuries*. Bell Gallery, List Art Center, Brown University, Providence, R.I., 2 March–30 March 1984.

Raleigh 1956. *Catalogue of Paintings*. North Carolina Museum of Art, Raleigh, N.C., 1956. Catalogue by W. R. Valentiner.

Raleigh 1983. *Introduction to the Collections*. North Carolina Museum of Art, Raleigh, N.C., 1983.

Raleigh 1986–87. *Dutch Art in the Age of Rembrandt*. North Carolina Museum of Art, Raleigh, N.C., 25 October 1986–15 February 1987.

Raleigh 1995–96. *Face to Face with the Dutch Golden Age*. North Carolina Museum of Art, Raleigh, N.C., 1995–96.

Raleigh 1998. *Handbook of the Collections*. North Carolina Museum of Art, Raleigh, N.C., 1998.

Raleigh 2000. *Like Father, Like Son?: Portraits by Frans Hals and Jan Hals*. North Carolina Museum of Art, Raleigh, N.C., 12 February–7 May 2000. Catalogue by Dennis P. Weller.

Richmond 1966. *European Art in the Virginia Museum of Fine Arts: A Catalogue*. Richmond, Va., 1966.

Rotterdam 1998. *Dutch Genre Paintings of the Seventeenth Century: Collection of the Museum Boijmans van Beuningen*. Museum Boijmans van Beuningen, Rotterdam, 1998. Catalogue by Friso Lammertse.

Rotterdam 2000–01. *Jesus in de Gouden Eeuw*. Kunsthal, Rotterdam, 2000–01.

Saint Louis and Cambridge 1995. *The Printed World of Pieter Bruegel the Elder*. The Saint Louis Art Museum, 4 April–25 June 1995; Arthur M. Sackler Museum, Harvard University, Cambridge, Mass., 2 September–12 November 1995. Catalogue by Barbara Butts and Joseph Leo Koerner.

St. Petersburg and Atlanta 1975. *Dutch Life in the Golden Century: An Exhibition of Seventeenth-Century Dutch Painting of Daily Life*. Museum of Fine Arts, St. Petersburg, Fla., 21 January–2 March 1975; High Museum of Art, Atlanta, Ga., 4 April–4 May 1975.

San Francisco 1939. *Masterworks of Five Centuries*. Golden Gate International Exposition, San Francisco, 1939.

San Francisco 1942. *Vanity Fair: An Exhibition of Styles of Women's Headdress and Adornment through the Ages*. California Palace of the Legion of Honor, San Francisco, June–July 1942.

San Francisco, Baltimore, and London 1997–98. *Masters of Light: Dutch Painters in Utrecht during the Golden Age*. Fine Arts Museums of San Francisco, 13 September–30 November 1997; The Walters Art Gallery, Baltimore, Md., 11 January–5 April

1998; The National Gallery, London, 6 May–2 August 1998. Catalogue by Joaneath A. Spicer, with Lynn Federle Orr.

San Francisco, Toledo, and Boston 1966–67. *The Age of Rembrandt*. California Palace of the Legion of Honor, San Francisco, 10 October–13 November 1966; The Toledo Museum of Art, 26 November 1966–8 January 1967; Museum of Fine Arts, Boston, 21 January–5 March 1967.

Sarasota 1980–81. *Dutch Seventeenth-Century Portraiture: The Golden Age*. John and Mable Ringling Museum of Art, Sarasota, Fla., 4 December 1980–8 February 1981. Catalogue by W. H. Wilson.

Seattle 1954. *European Paintings and Sculpture from the Samuel H. Kress Collection*. Seattle Art Museum, Seattle, Wash., 1954.

Seattle 1997. *The Samuel H. Kress Collection at the Seattle Art Museum*. Seattle Art Museum, Seattle, Wash., 1997. Catalogue by Chiyo Ishikawa.

De Térey 1906. Gabriel de Térey. *Tableaux anciens du Musée des Beaux-Arts de Budapest*. Budapest, 1906.

Tokyo 2000. *Dutch Art in the Age of Rembrandt and Vermeer: Masterworks of the Golden Age from the Rijksmuseum Amsterdam*. The National Museum of Western Art, Tokyo, 4 July–24 September 2000.

Toledo 1976. *European Paintings*. Toledo Museum of Art, Toledo, Ohio, 1976. Catalogue by W. Hutton.

Vaduz 1970. *Holländische Maler des 17. Jahrhunderts. Sammlungen seiner Durchlaucht des Fürsten von Liechtenstein*. Vaduz, 1970.

Vienna 1780. *Description des tableaux et des pièces de sculpture que renferme la gallerie de Son Altesse Françoise Joseph Chef et Prince Regnant de la Maison de Liechtenstein*. Vienna, 1780. Catalogue by J. Dallinger.

Vienna 1873. *Katalog der Fürstlich Liechtensteinischen Bilder-Galerie im Gartenpalais der Rossau zu Wien*. Vienna, 1873.

Vienna 1885. *Katalog der Fürstlich Liechtensteinischen Bilder-Galerie im Gartenpalais der Rossau zu Wien*. Vienna, 1885.

Vienna 1977–78. *Gemälde Alter Meister*. Galerie Sanct Lucas, Vienna, Winter 1977–78.

Vienna 1996. *Gemälde Alter Meister*. Galerie Sanct Lucas, Vienna, Autumn 1996.

Washington and Amsterdam 1996–97. *Jan Steen: Painter and Storyteller*. National Gallery of Art, Washington, D.C., 28 April–18 August 1996; Rijksmuseum, Amsterdam, 21 September 1996–12 January 1997.

Washington and Boston 1983. *The Prints of Lucas van Leyden and His Contemporaries*. National Gallery of Art, Washington, D.C., 5 June–14 August 1983; Museum of Fine Arts, Boston, 14 September–20 November 1983. Catalogue by Ellen S. Jacobowitz and Stephanie Loeb Stepanek.

Washington, Detroit, and Amsterdam 1980. *Gods, Saints, and Heroes: Dutch Painting in the Age of Rembrandt*. National Gallery of Art, Washington, D.C., 2 November 1980–4 January 1981; The Detroit Institute of Arts, Detroit, Mich., 16 February–19 April 1981; Rijksmuseum, Amsterdam, 18 May–19 July 1981.

Washington, London, and Haarlem 1989. *Frans Hals*. National Gallery of Art, Washington, D.C., 1 October–31 December 1989; Royal Academy of Arts, London, 13 January–8 April 1990; Frans Halsmuseum, Haarlem, 11 May–22 July 1990.

Wheelock 1995. Arthur K. Wheelock Jr. *Dutch Paintings of the Seventeenth Century*. Systematic catalogue, The National Gallery of Art, Washington, D.C., 1995.